The Canadian Home

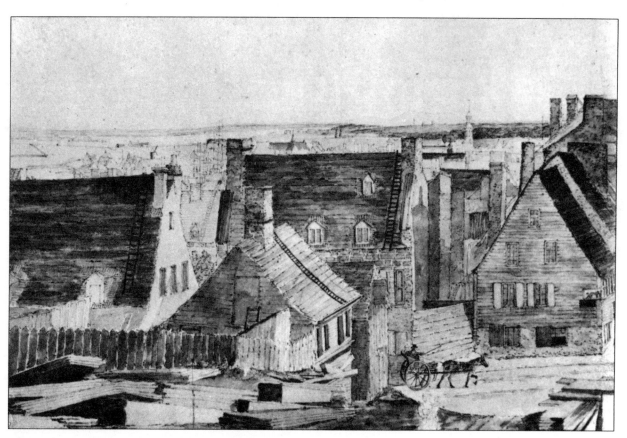

Site on the eve of home construction, Montreal, 1824.

The Canadian Home

FROM CAVE TO ELECTRONIC COCOON

MARC DENHEZ

Dundurn Press
Toronto & Oxford
1994

Dedicated to the men and women
who have put roofs over
Canadian heads for the past
twenty thousand years.

Editor: Dennis Mills
Printed and bound in Canada by Gagné Printing Ltd.,
 Louiseville, Quebec, Canada

The publisher wishes to acknowledge the generous assistance and ongoing support of the **Canada Council**, the **Book Publishing Industry Development Program** of the **Department of Communications**, the **Ontario Arts Council**, the **Ontario Publishing Centre** of the **Ministry of Culture, Tourism and Recreation**, and the **Ontario Heritage Foundation**.
 Care has been taken to trace the ownership of copyright material used in the text (including the illustrations). The author and publisher welcome any information enabling them to rectify any reference or credit in subsequent editions.

J. Kirk Howard, Publisher

Canadian Cataloguing in Publication Data

Denhez, Marc, 1949–
 The Canadian home : from cave to electronic cocoon

Includes bibliographical references and index.
ISBN 1-55002-202-4

l. Dwellings – Canada – History. I. Title.

GT228.D46 1994 392'.36'00971 C93-095506-4

Dundurn Press Limited Dundurn Distribution Dundurn Press Limited
2181 Queen Street East 73 Lime Walk 1823 Maryland Avenue
Suite 301 Headington, Oxford P.O. Box 1000
Toronto, Canada England Niagara Falls, N.Y.
M4E 1E5 0X3 7AD U.S.A. 14302-1000

Contents

Abbreviations

AHOP — Assisted Home Ownership Program

CAREB — Canadian Association of Real Estate Boards (later CREA)

CBC — Canadian Broadcasting Corporation

CHBA — Canadian Home Builders' Association (formerly NHBA and HUDAC)

CHIP — Canadian Home Insulation Program

CHRP — Canada Home Renovation Plan

CIPREC — Canadian Institute of Public Real Estate Companies

CMHC — Canada (formerly Central) Mortgage and Housing Corporation

CMHI — Canadian Manufactured Housing Institute

COSP — Canadian Oil Substitution Program

CREA — Canadian Real Estate Association (formerly CAREB)

CRSP — Canadian Rental Supply Program

DREE — Department of Regional Economic Expansion

EMR — Energy, Mines & Resources Canada (later Natural Resources Canada)

GDP — Gross Domestic Product

GNP — Gross National Product

GST — Goods and Services Tax

HUDAC — Housing and Urban Development Association of Canada (formerly NHBA, later CHBA)

MLS — Multiple Listing Service

MSUA — Ministry of State for Urban Affairs

MURB — Multiple Unit Residential Building (or tax credit for)

NGO — Non-governmental Organization

NHA — National Housing Act

NHBA — National House Builders' Association (later HUDAC, then CHBA)

NIP — Neighbourhood Improvement Program

NRC — National Research Council

PC — Progressive Conservatives

RAIC — Royal Architectural Institute of Canada

R&D — Research and Development

RHOSP — Registered Home Ownership Savings Plan

RRAP — Residential Rehabilitation Assistance Program

RRSP — Registered Retirement Savings Plan

SRTC — Scientific Research Tax Credit

UDI — Urban Development Institute

UFFI — Urea Formaldehyde Foam Insulation

WHL — Wartime Housing Limited

Foreword
by Pierre Berton

In his fascinating study of Canadian shelter, Marc Denhez takes us on a 20,000-year journey from the days of the cave, the tipi, and the igloo, to the H-bomb shelter and the mobile home.

He looks at native longhouses, sod homes, log cabins, Victorian gingerbread, Art Deco showpieces, wartime housing, modern apartments, and condos.

He explains that the all-Canadian bungalow was actually designed for the tropics (the name comes from Bengal) and brought to the New World by returning British officers, themselves influenced by the extravagances of the Brighton Pavilion.

He reminds us that the paint roller is a Canadian invention and that the co-development of drywall foretold the decline of plaster.

He points out that the houses in the Atlantic provinces are brightly coloured because the Bluenoses were fed up with losing their homes in the fog.

He reveals that the concept of the modern home came about in Holland as a result of the Dutch desire to reduce taxes.

He tells us that mansard roofs were once banned by law and that Queen Victoria's father left a legacy of round rooms.

And he explains that the drawing room was originally a *withdrawing* room, into which the women could retire after dinner while the menfolk indulged in strong brandy and stronger cigars.

This is, in short, a lively as well as an erudite study of the development of housing, with a special reference to Canada. Denhez has done his home-work. He looks at the various fads and fashions in houses — from the Newfoundland Tilt, to Expo 67's Habitat. He looks at building codes, the growth of suburbia, urban renewal, the move to the "rec room," and the brief, ugly rise of "brutalism." The influence (or lack of it) of the great architects from Christopher Wren to Le Corbusier is touched on, as is that all-Canadian phenomenon, the CMHC.

It is sobering to learn that in the days immediately following World War II, when the government decided to take a plunge into subsidized housing, barely half the dwellings in Canada had flush toilets.

This is a highly readable book and an important one. Denhez writes with both wit and authority. His literary allusions run the gamut from Robert Service, Stephen Leacock, Gustave Flaubert, and Aldous Huxley, to Richard Gwyn and Charlie Farquharson.

They all belong in this fascinating history, which deserves a permanent position on any library shelf.

Kleinburg, Ontario
October 1993

Acknowledgments

The idea to produce this book originated when officials at the Canadian Home Builders' Association decided that CHBA should give itself a birthday gift to celebrate its fiftieth anniversary. What began as a modest project — to document organized homebuilding over the past half-century — grew into a description of Canadian homebuilding "from its inception." CHBA provided not only the impetus, support, and advice, but also opened its files to provide an unprecedented picture of the many power plays that underlay the construction of millions of Canadian homes. This was done with total candour.

The research for this endeavour was further supported, generously, by the Ontario Heritage Foundation, associated with the Ministry of Culture, Tourism and Recreation.

I also owe a debt of gratitude to great Canadians like Sam Gitterman, John Kenward, Robert McGhee, Doug Franklin, Richard Martineau, Maurice Clayton, Jamie Cooke, Robert Sloat, and many others. Their wise counsel proved invaluable to me in researching this subject. Robin Anderson, Sharon and Steven Budnarchuk, Sara Iley, Linda McKnight, Paula Chabanais, Dennis Mills, and Sydna Patrick helped guide me to its published form. Last, but not least, I received moral support from the consummate interpreter of Canada's fabric, Pierre Berton.

Hearts, Souls, and a Cast of Millions
Introducing the Characters

In which the author describes the dramatis personae, *including himself; acknowledges that the pen is mightier than the saw; reflects on onions and the Crash of Fifty-Two; and notes that everyone in Canadian housing gets tense together.*

"Ian, don't wipe peanut butter on the cat!" There was a time when I didn't think about domesticity: that was before I was married, before I had two sons, before I had a house and a mortgage, and before my home was filled with sounds such as my wife's remonstrations on goober-covered felines. I am, at least, in good company. Socrates, too, had a fairly vacuous existence until he was married, whereupon he became a philosopher.

The very word *domesticity* is derived from the Latin *domus*, or house. The word *house* in old English was *hus* — hence a *hus*band meant a man who was "house-bound," which is how I feel when I contemplate my mortgage. The word *house* is also loaded with other subliminal meanings which have evolved with the language over the centuries:

> The house, too, is a ruling-place as in the Houses of Parliament ... It is [also] the ruling family's ... designated 'house' as in the House of Hanover ... There is [also] a family of English terms that refer back to the Latin *domus:* domicile, domesti-

cate, dominate, dominion, domain ... domineer ... that which is in*dom*itable is literally that which we cannot bring within our house: untamable ... Just to have a house is to possess symbolic authority, and the house is the embodiment of our dominance.[1]

The word "home" is even trickier. It derives from the Old English *ham*, similar to the Old High German *heim* or Norse *heimr;* but as we shall see, its equation with the idea of a "welcoming abode" is relatively recent in world history. The Latin *domus* does not do justice to those connotations — nor does any other Latin word, for that matter.

Writers over the centuries have focused on housing. It is "the primary artistic product of the human intellect,"[2] according to the German philosopher Hegel. "We do not dwell because we have built," said Martin Heidegger, "but we build because we dwell, because we are *dwellers.*"[3] "Gimme shelter," said the Rolling Stones.

I expect that my house will be my largest single

1

investment. From time to time, I actually think about this, before or after extracting the cat from the tender mercies of my sons. And from time to time, I ask questions like

- what is my house doing here, anyway?
- why was it built the way it is?
- why does it cost what it does, and how do I pay for this thing?

Hence this book.

Our homes come in both single-family and multi-family versions — and have done so since time immemorial: the Canadian home goes back at least 20,000 years. The very name "Canada"[4] means "the place of the houses." Yet if I had lived in another era, my dwelling would have been very different from what it is today. Some "experts" would have insisted, for the sake of the political correctness of the day, that my accommodations be so alien to my present surroundings as to be unrecognizable. My suburban single-family home is not, as some people assume, the inevitable habitat of *yuppicus domesticus* (the Common Domestic Yuppie), but the outcome of social, technical, financial, and political forces which have frequently been at loggerheads with each other.

There is an ancient Inuit game called *kalataq*, in which the participants hold a blanket taut and heave one of their number into the air, as on a trampoline. The people holding the blanket must continuously tug in different directions, to adjust for the bounce. Canadian housing works on the same principle: builders, officials, architects, and lenders are pulling on the blanket, and prospective homebuyers or tenants are suspended somewhere in mid-air wondering whether they are about to be propelled to new and entrancing heights, or about to break a leg.

The key to *kalataq* is what some people call "creative tension": everyone is pulling at the blanket, but no one will actually jerk it out from under their hapless, airborne colleague. In the history of Canadian housing, there has been no shortage of tugging. The first group, which is responsible for the vast majority of roofs over Canadian heads, is composed of builders. The term "builder" refers to one in a series of entrepreneurs who are responsible for private-sector housing — and they do not necessarily

even like each other. Before land is allotted to residential purposes, it typically belongs to a farmer or cottager, and might be bought by a speculator who, in turn, might sell it to a "developer." Contrary to popular usage, "developer" is not synonymous with "builder": the developer's task is to make the property *ready* for building, by lining up the construction of roads, utilities, and other "services" for the lots. It is at that point that the builder, who is at the nexus of the process, can orchestrate the creation of housing. The "builder," however, does not necessarily do the actual building, but may assign that task to sub-contractors and trades people. The builder's suppliers, for their part, try to persuade the builder to use their latest and most innovative products. Finally, if the builder does not have sales staff, the task of selling may be assigned to a real-estate broker.

This can all be a bit confusing, even to the participants. The skills required to be a "developer" are so different from those of a "builder" that few firms (aside from downtown apartment specialists) dare attempt both. In Halifax, for example, several companies tried in the 1960s to be both builders and suburban developers; all but a couple went belly up in the process. By the same token, very few builders have their own crews to build anything; since the late 1950s, most have preferred to be project coordinators, and hire sub-contractors to do the actual building. Take Robert Campeau: although he would show up at job sites at 8:00 o'clock every morning, he wielded a pen, not a saw. To paraphrase singer Sneezy Waters, there was no "sawdust on the floor of his heart."

There is even less sawdust in the hearts of the second group holding on to the *kalataq* blanket, the officials. Some are politicians, others are bureaucrats. Their concern is not only shelter, but how the housing budget of Canadian families affects the gross domestic product, the national money supply, and politics generally. The interests of public-sector agencies are as divergent as those of the private sector: these agents include housing officials, guardians of the public treasury, Bank of Canada gnomes, technological researchers, planners, engineers, architects, and many others. And no governmental presence in Canada would be complete without the occasional intergovernmental row, as a matter of national honour.

Then there are the private-sector architects. A Canadian with neck trouble might conclude that architects had no presence in housing at all: their direct influence is invisible, unless one looks *up*. The residential highrise and the skylines of Canadian cities are the brainchildren of the architectural profession, and each such building is intended to make a "statement" of cosmological Truth, as taught by the only profession (other than theology) to have its own metaphysics.[5] As we get closer to earth, however, the picture changes, and the influence of architects becomes diluted. For starters, builders have not hired architects when they thought they could crib information from journals or from the published advice of Canada Mortgage and Housing Corporation (CMHC), which distilled and filtered the necessary architectural input nationally. Even among large homebuilding companies with architects on staff (or a phone call away), the design has usually been the builder's, with nothing to do with what any faculty of architecture would have recommended. In any event, builders have wondered whether those faculties had anything to say to them anyway; as one concerned professor admitted, "Architecture students were unanimous: the suburbs, like fast food, big business, and styrofoam cups were bad, beneath contempt, certainly beneath study."[6] This was not only because the students had read that "very few of our buildings … can by any stretch of the imagination be considered good architecture, or even architecture at all,"[7] but also because their attention was called to more esoteric things, such as a recent textbook which praises houses which "are not meant to provide shelter from rain, cold, and so on, … [but] shelter from narrow-mindedness."[8] Shelter from narrow-mindedness does not help builders meet their obligations under a home warranty program.[9]

The influence of the architecture schools, however, has been felt in other, more pervasive ways. Because of their input into the textbooks on aesthetics and planning, plus the fact that so many planners are graduate architects, the schools helped dictate a vision of what an entire twentieth-century city *should* be. This vision included not only instructions on what to build, but also on the "blighted" dwellings and districts which were to be surgically removed in order for the city to "shine." On this advice, the equivalent of entire cities rose and fell in a lifetime. The Canadian city or town as it exists today is not the result of chance: virtually every element of it was scripted. For every feature that we see in and around our homes today, there is a source.

The fourth group in the *kalataq* game is composed of financial institutions. Their money allows most Canadians to buy their homes. On a $100,000 mortgage with twenty-five-year amortization, each rise of 1 percent in interest rates will add $69 to the borrower's monthly payment — or a total of over $20,000 to the cost of the home during the lifespan of the mortgage. Furthermore, financing is essential not only to homebuyers: builders must also rely on it, so as to stay afloat while their projects are under construction. This gives the lender a direct say in what is built; the lender will insist on what is called "curb appeal," a likelihood that the project will find buyers literally walking in off the street, just in case the lender has to foreclose and resell it.

If builders, officials, architects, and lenders are the four main groups who have shaped the Canadian home (above and beyond the tastes of homebuyers and tenants themselves), are there other parties who should also be listed? Should we include *the home itself*, as some theorists insist?

At this early juncture, and in fairness, this writer is obliged to confess a personal failing. I am neither an architect nor an architectural historian; least of all am I a theorist. I can't even carry on a learned discussion on the fate of my house's soul. I have thus missed out on what has been called "the theology of architecture"[10] — for example, whether the design of my house respects what architect Louis Kahn called "what the house wants to be."[11] I confess that I have never had a single heart-to-heart talk with my house on this subject. I am told that my house has primal urges, which Yale University's Gavin Macrae-Gibson calls "the secret life of buildings,"[12] inside what architectural guru Peter Eisenman calls their "deep structure." Nor do I know whether my house's soul is on its way to perdition: in the words of Macrae-Gibson, my house's form can only have "legitimacy" if it displays a "return of meaning from the aesthetic to the moral world, achieved through the resonance of the one with the other."[13] My inattention to housing's spiritual well-being may get me (and this book) into

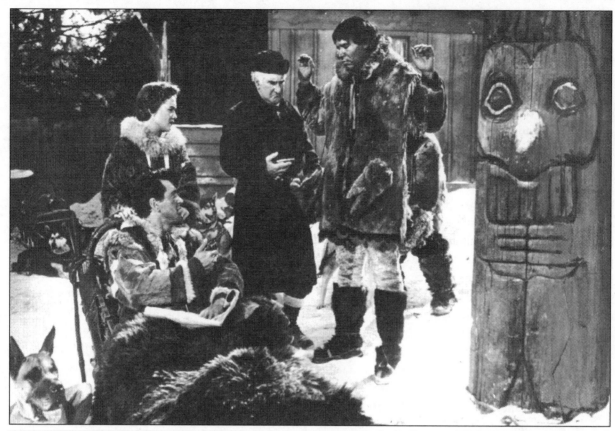

The Canadian home, according to Rock Hudson and Hollywood (*Back to God's Country*, 1953). The house is decorated with what Pierre Berton called "one of the worst totem poles ever carved."[14]

Does your house affect your spiritual well-being, and vice versa? In 1910, the Sears Roebuck Company told church-goers that "to get the most out of life as Our Creator intended it to be, a home of your own is an absolute necessity."[15]

trouble for "moral obtuseness,"[16] as expert Aldo Rossi calls it. I admit, with trepidation, that I seldom ponder whether my house "addresses the issue of human magnanimity"[17] or "the catastrophe of man's ordinariness"[18] when my real concern is whether the upstairs toilet is plugged again.

I take some small solace in an aphorism by McGill's Witold Rybczynski: "Domestic well-being is too important to be left to experts,"[19] particularly those spouting the latest theory. At the centre of the topic, in his view, is The Onion Theory of Comfort, namely that comfort has several layers of meaning, has developed historically, and "at any particular time ... consists of *all* layers, not only the most recent."[20] That is the onion which I propose to peel in this book. By describing how our homes have come about, since earliest times, I hope to convey the sense of wonder I personally feel at the accomplishments of so many generations of Canadians in creating the houses which we enjoy today.

However, it is impossible to discuss closets, say, without mentioning skeletons. The history of homes has had its share of misrepresentations. Consider John Howard Payne: he was the American who wrote *Home Sweet Home*. His wife ran off with another man, leaving Payne with their three children, his sweet home, and his song. And then there was the immortal Sereno E. Todd, who said that the "home is not merely four square walls adorned with gilded pictures, but it is where love sheds its light on all the dear ones who gather around the sweet home fireside, where we can worship God with none to molest or make us afraid."[21] Sereno E. Todd was a real-estate promoter — an occupation whose sweet godliness has sometimes been debated.

Canada, like any other country, has had its share of Sereno E. Todds, in both the public and private sectors, for the simple reason that, regardless of sweetness, the monetary stakes were and are gigantic. In any given year in the 1990s, it is expected that some $100 billion will change hands for new, existing, or renovated homes. Yet despite the temptations, most of the people who have stood around housing's *kalataq* blanket have been reasonably decent Canadians who sincerely wanted a better product for homebuyers and tenants. When we look at the result — today's Canadian house, condo, or apartment — it is easy to look back in time and identify the mistakes which some people made, and which could have had disastrous results if not corrected. In fairness, however, it should be emphasized that aside from a few scoundrels, the vast majority of Canadians who shaped the course of our housing acted on their best judgment at the time.

Take the post-war era. Many experts were deadlocked in bitter disputes over the course which Canadian housing policy should follow. When reading those debates today, some of the ideas look bizarre — or at least they looked bizarre to me. I shared this view with Sam Gitterman, who is as close to being a *bona fide* housing expert as anyone can get.

"Marc," said Sam gently, "you're forgetting 'the Crash of Fifty-Two.'"

"Eh?"

"The Crash of Fifty-Two. After World War II, there were a lot of economists expecting a euphoric buying spree to prop the economy for a few years, which would eventually peter out — and when that happened, we would be straight back where we were before the war: the Dirty Thirties all over again. The best estimate was that this would happen around 1952. Top housing strategists like David Mansur at CMHC, and Frank Nicolls, had great arguments over how to buffer against that. They knew how much mortgages meant to the Canadian economy, and that their decisions could affect whether the crash would be serious or mild. As it turned out, a lot of things happened to prevent the crash altogether. So sure, those writings look a bit strange today, and 'the experts' make an easy target. But people did their best with the information at their disposal."

That situation still prevails today, only more so: although most Canadians have probably heard too many clichés about "public-private-sector partnerships," the fact remains that, like ball lightning, these mysterious phenomena sometimes do exist. Housing is an example. Although organizations like CMHC and the Canadian Home Builders' Association have had their share of ups and downs, there is more cooperation than most Canadians would ever realize. That does not mean that the relationship ceases to be one of "creative tension" (some meetings are more creatively tense than others), but there is little doubt that their mutual objective is to work together for the best housing in the world.

Chronic sceptics who consider that notion a lost cause are not confined to the pundits who deplore Canada's "lack of architecture." There are also those who share Simone de Beauvoir's view that "nostalgia isn't what it used to be": by their reasoning, the only residential construction worth studying is restricted to "historic monuments," and there is no life after plywood.

It would, of course, be so much simpler to believe that every house in Canada should have been built as a set for *Brideshead Revisited*. However, despite the claims of everyone's maiden aunt, it is simply not true that all Canadians were brought up on antique-filled country estates while munching those little cucumber sandwiches. At least two generations of Canadians have experienced a habitat called "suburbia." Sceptics have asked whether our suburbs were intended to be so boring, or whether they just

happened that way. From their perspective, the history of this country's housing is as exciting as that other great Canadian invention, Pablum.

Some people agree; take my cousin. She is a classic Parisian — well intentioned but sometimes hampered by the mindset of the country which gave the world chateaux on the Loire. While visiting the Museum of Civilization in our nation's capital, she groped for words to say something nice about its exhibits, which evoke the evolution of Canadian communities. "You know," she commented finally and carefully, "for a country with so little to display, you display it extremely well."

Perhaps my cousin had trouble grasping the significance of log cabins. Sod houses might be even more difficult to explain, as would the sand on the floor of many traditional Newfoundland kitchens. Old Town in Yellowknife would be hopeless. How do you explain to a European why tour buses visit the 1940s cabins on Ragged Ass Road? Can a Parisian ever understand why Yellowknife residents post memorial signs in front of the houses where local characters lived, drank, and died, though not necessarily in that order?

Many people, including Canadians, still think of notable houses only in terms of palatial museum-category buildings: carefully restored artifacts, scrubbed and ready to put under a glass case. In that category, other countries have it all over us. Even people who acknowledge that "heritage" can cover a much broader scope are reluctant to make comparisons between ourselves and the rest of the world.

But if we measure a building tradition by its capacity to "inspire and edify," our housing has important lessons to communicate to the world. Foreigners may wonder about Ragged Ass Road, but they have never had to drag a community, cabin by cabin, across Great Slave Lake in winter by cat train. They have never shovelled snow in Quebec City, sunk ankle-deep in prairie "gumbo," or sought sanctuary from a cloud of mosquitos that qualified for consideration under the Small Birds Act. Canada is a most improbable building site. Many communities in Atlantic Canada cling to the shore by their fingernails, and no one who has spent a winter in Montreal or Winnipeg (or summer in black-fly country) needs to be reminded how intimidating this land is.

The buildings of Europe are the projection of circumstance, but the buildings of Canada are the defiance of circumstance. Our housing tradition is like Ravel's Piano Concerto for the Left Hand — admirable enough in its own right, but of even greater significance considering the challenges that had to be overcome. Last but not least, it is thanks to this housing tradition that "Canada leads the world in housing technology"[22] — the words of one Scandinavian professor.

So let's look at those houses again. Let's also take another look at our reputation. Under circumstances more adverse than almost anywhere else on earth, Canadians have developed housing which today ranks second to none. We should take a back seat to no one in terms of the human and technological achievement it represents, and its message to all humanity.

Including my cousin.

In the Beginning ...
Caves and Abstract Theories

In which we find Canada's first home ... but ask where "homebuilding" starts; Creation affects good room alignment; Canadian site selection targets mosquito avoidance; builders' associations are banned for heresy; and philosophers contemplate eternal truths, including good rooms for alchemy, the return to zero, and the musical house.

There wasn't much homebuilding going on in Canada 30,000 years ago.

That is the date, say some archaeologists, when Canada started to be populated. The scenery was not like today's. You could walk from Siberia to Alaska without getting your feet wet, but most of Canada was sitting under ice a kilometre thick. The ice eventually melted, making this country, according to Eric Nicol, the first to have automatic defrosting.[1]

It was not as automatic as our first inhabitants might have liked. The weather was barely fit for man or beast. Those were the days of the "caveman" who, according to popular mythology, was busy patenting fire, spending time with the club, and battling bears and other co-tenants. Unfortunately, Canada had no profusion of caves; if people had relied exclusively on them for shelter, there would have been a prehistoric housing crisis. Camping was still the main order of the day.

The first question in housing is *where* you put it. Did ancient happy campers discover arcane secrets applicable to site selection today? Inhabited caves were not the only legacy of these early peoples: the ancient Canadian prairies were also marked by circles of large stones. Although these medicine wheels are believed by archaeologists to be astronomically based, some recent European authors couldn't resist comparing them to Stonehenge and other monolithic monuments around the globe — whether Canadian natives agreed or not. Some writers theorized that medicine wheels and Stonehenge are part of a grid of "power points" from which invisible juices renew the earth.[2] They call these forces "telluric currents" or, translated into Californian, "good vibes." Inhabitants of ancient Canada had purportedly discovered the way to ideal home location: you build in the path of a telluric current, which supposedly conveys a sense of visceral well-being, like a dog with its head stuck out a car window. One recent book speculates that to be metaphysically correct, your optimal location is just outside Flin Flon, Manitoba.[3]

Others have different beliefs. Feng Shui, an ancient Chinese theory on positioning everything from furniture to cities,[4] was imported into Canada in the nineteenth century. Its strongest advocates are in Hong Kong: when the owners of a recently built

hotel were told that its concrete wall blocked the path of the nine dragons of Kowloon en route to their regular dip in Hong Kong harbour, the proprietors installed giant windows (dragons pass through glass, but not concrete). In the words of the hotel's PR director, "No one wants nine irritated dragons stranded in the lobby."[5]

The Nabdam of Africa have a precise way of determining good home location.[6] First, you ask your witch-doctor to do a housecall. He reaches into his bag and pulls out a chicken, wrings its neck, and heaves it into the air in the direction of the site. If it lands beak up, the location is excellent. If it lands beak down, it is time to replace either your lot or your witch-doctor.

Vitruvius, the "father of Roman architecture," addressed home location differently in his authoritative book *On Architecture*: "I cannot insist too strongly on the need to return to the method of old times. Our ancestors, when about to build a town, sacrificed cattle that fed on the site and examined their livers."[7] The "science" of assessing construction sites according to beef livers was called hepatoscopy. Although some people would like to think that Vitruvius was using bovine metabolism to signal contaminated lands — doing an ancient version of an environmental impact assessment — it is likely that the basis for his views on good location was at least as occult as it was ecological.

Can Canadians claim home-grown counterparts telling us where to put our homes? With our profusion of native peoples, isn't Canada peppered with such theories? Innumerable locations were sacred ground — but although foreign peoples might pick "sacred sites" or "telluric hot spots" to build on, sacred sites for Canada's first residents were exactly those places to avoid. Foreigners more readily ascribe mystical qualities to Canadian locations than Canadians do themselves: it was Sir Arthur Conan Doyle, for example, who assessed our great cosmological sites and concluded that, in the world, "Winnipeg stands very high among the places we have visited for its psychic possibilities."[8]

But the absence of a Canadian Feng Shui doesn't mean ancient homebuilding was haphazard. The principles were pragmatic:

- you don't locate the door into the wind (this is, after all, Canada);
- a southern exposure is nice;
- most everyone likes a view of the water; and
- prime locations are on a ridge or other elevation.

To this day, those are assets in the real-estate market, whether you are in Toronto; Montreal; Utopia, Ontario; or Paradise, Newfoundland. However, the prehistoric rationale for these attractive features (sheltered entrance, southern exposure, water view, elevation) was different. If cavemen real-estate agents had been around, the advertisement for a class-A cave might have read:

> Outdoorsman's Dream. Good view of water supply. Lots of sunshine. Easy to spot game and marauders. Higher up than mosquitos.

These were prime factors in the market for quality caves 20,000 years ago — and on that basis, Yukon's Bluefish Caves would probably have been at the top of the list. They are North America's first known home.[9]

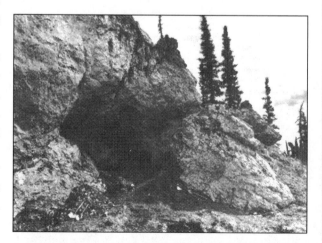

Located in Yukon's Keele Range, the Bluefish Caves have a beautiful southern exposure looking over the Bluefish River. They were occupied some 20,000 years ago. This was a temporary home for generations of people who brought mammoths home for dinner. This first known Canadian home is divided by mother nature into three rooms with a total area slightly under 200 sq. ft.

One American archaeologist told *Time* magazine that regardless of the findings at the Bluefish Caves, younger remains in Pennsylvania may prove to be "the oldest archaeological site in North America."[10] How North American homebuilding originated in Pennsylvania is not explained — unless you believe, as one book argues, that humanity itself was invented in the U.S.A.[11]

There may be even earlier undiscovered habitations in Canada; however, is this the right point to begin a history of the Canadian home? In these days of animal rights, should we start with the beaver? Although it is the fur trade which stamped the beaver on public consciousness for two centuries, it is this animal's industrious homebuilding which promoted it to Canada's official national rodent. As Kildare Dobbs says in his classic poem *The Beaver*,[12]

> A nation is, because I am.
> For Canada I give a dam
> And think that I shall never see
> A dinner lovely as a tree.

But if we push discussion of Canadian homebuilding back to beavers, why stop there? Some argue that the proper chronology of homebuilding starts before the first Albertosaurus curled up in its lair. There were natives of the great plains who believed that the sun invented the tipi at the time of Creation, and that medicine wheels were oversized blueprints to teach humanity how to get the proportions right: "The sun made the medicine wheel to show us how to build a tipi."[13] The Iroquois went one better: they believed housing predated Creation. Long before the earth was formed on the back of the Great Turtle, the spirits of the Upper World already lived in their cozy longhouses. By this reasoning, the roots of Canadian housing were not only supernatural but undatable.

European writers over the centuries also argued that the *only* place to begin a history of homebuilding is at Creation itself. To this day, some people believe that Creation witnessed the origins not only of physics but also of cosmological truths that dictated the correct configuration of your roof or front porch.

Are there *a priori* "laws" of good design and layout? Is there a "perfect house"? Where would this

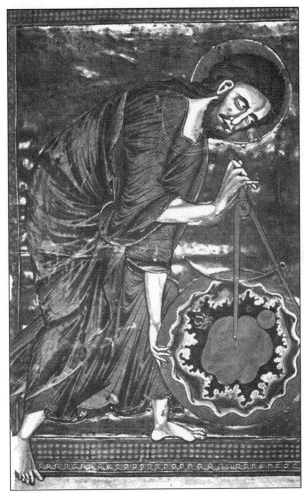

A famous thirteenth-century picture depicts God as a builder (complete with measuring tools — suggesting the Almighty had trouble with the dimensions).

information come from, and how reliable is it? Theorists have speculated about this for centuries. Almost every home today has features that originated as a supposed allegory of principles purportedly dating from the primeval sludge. You can't discuss the *origins* of the Canadian home without taking at least a perfunctory glance at that sludge.

The notion that architecture has its own metaphysics is not confined to those who believe, say, that the intrinsic sinfulness of highrises was decreed at Babel (by an Authority whose zoning could not be appealed to the Ontario Municipal Board). To this day, two theories from antiquity colour the Canadian urban landscape: Cabala and Platonism.

The first came from the Middle East, "directly from God": He pre-ordained the measurements of

the Ark of the Covenant (2.5 cubits long, 1.5 wide, and 1.5 high, a relationship of 5:3:3) and its ·Tabernacle. Those proportions were therefore reputed to have mystical significance, and Solomon adopted them for his Temple.[14] "The temple of Jerusalem became a natural focusing point for the cosmological-aesthetic theories of proportion ... for was it not God himself who had enlightened Solomon to incorporate the numerical ratios of celestial harmony into his building?"[15] By extension, a house in which these ratios were used could be a psychic lightning-rod, like the apartment building in *Ghostbusters*.

Greek discovery spawned a different belief. Pythagoras (the bane of students struggling with triangles) demonstrated the unity of music and mathematics by calculating the length of strings necessary to produce musical chords: "This staggering discovery made people believe that they had seized upon the mysterious harmony which pervades the universe ... Plato [then] explained that cosmic order and harmony are contained in certain numbers ... [which] contain not only all the musical consonances but also the inaudible music of the heavens and the structure of the human soul."[16] Since Plato's "music of the spheres" was governed by mathematical ratios, the design of buildings could similarly correspond to ratios which "harmonized" with this divine Muzak. Platonism thus introduced the theory of the musical house: does your home hit the right chord?

Cabala and Platonism are not to be confused with another belief reputedly from the Mediterranean world, namely that it is best to live inside a pyramid. Enthusiasts of these structures spawned their own theories about metaphysical powers and the key to immortality.[17] Some recent authorities claim that living in pyramids will do everything from keeping your razor blades sharp to conserving your yogurt.[18]

In Europe, Cabala and Platonism passed from view in the Dark Ages — for a while. Even basic math fell to such low ebb that it is a wonder many buildings stood at all. The greatest European mathematicians of the eleventh century would have flunked today's high-school geometry tests.[19] Then came the Crusades, and scholars were suddenly re-acquiring ancient texts, allowing European builders not only to relearn geometry but also to develop a

taste for more exotic ideas. The result was an intellectual brew which started circulating at job sites.

These ideas didn't influence home construction at first. In those days (as today) homebuilders couldn't afford the luxury of putting roofers and carpenters on hold while an architectural theorist speculated on the destiny of room alignment. Castle-builders didn't have time for cosmology either, because of military deadlines. Bridge-builders, however, had breathing room; and cathedral-builders had a field day. As more ideas from the East circulated on European jobsites, eavesdropping clergy became nervous.

In fourteenth-century France, three builders' associations were banned for heresy, whereupon they went underground.[20] However, builders had already grown more secretive. A French directive from 1268 said, "Masons, mortar-makers and plasterers may have as many assistants and valets as they please ... provided they teach them nothing about their trade."[21] An English manuscript from the next century is equally specific: "The apprentice keeps and guards his master's teachings and knows of his fellows. He tells no man what he learns in the privacy of his chamber, nor does he reveal anything which he sees or hears."[22] A decree adopted at an international builders' convention held in Germany in 1459 resolved that "no workman, no master, no journeyman will tell anyone who is not of the craft and who has never been a mason how to take an elevation from a plan."[23] And in 1481, there was a meeting between London officials and a group whose official title was "The Mystery of Masons."

Some say the "secrets" in question were merely tricks of the trade: even the secret signs and handshakes (from Scotland) were merely precautions against unqualified competition. "There is no reason to suppose," argue some writers, "that these secrets contained anything more esoteric than the remarks or discussions in the lodge (which did not need to be told to employees) as well as technical secrets of the trade concerning, for example, the design of an arch or the manner of placing stone."[24] Others suggest more unusual scenarios. French mystic Louis Charpentier believed Cabalistic formulas for room dimensions were tied to alchemy: if you laid out your house exactly right, you might duck into the back room from time to time to turn lead into gold.[25]

We don't know how widespread such views were in the Middle Ages: anyone expressing them in public would have become toast. The Renaissance, on the other hand, was freer. Beliefs which united great architectural practitioners of that era were *not* learned from architecture courses, because they had none: Brunelleschi, the genius of Florence's cathedral, was a goldsmith; Alberti, whose *Ten Books on Architecture* are influential to this day, was a lawyer; Michelangelo, who built St. Peter's, was a sculptor; and Palladio, whose style spawned American Colonial, was a stonecutter. What they had in common was a shared awe of ancient civilization. This was fertile ground for warmed-over Platonism. For instance, Alberti "follows here a tradition unbroken from classical times … that music is geometry translated into sound, and that in music the very same harmonies are audible which inform the geometry of the building … The key to the correct [building] proportion is Pythagoras's system of musical harmony."[26] But Alberti was hardly alone. "This man-created harmony was a visible echo of a celestial and universally valid harmony, for Alberti and for other Renaissance artists."[27]

Welcome back to the musical house.

There was then an attempt to *merge* this theory with writings on the Temple of Solomon. One monk[28] "published a large folio on the harmony of the universe in which [Judeo-]Christian doctrines and neo-Platonic thought were blended, and the old belief in the mysterious efficacy of certain numbers and ratios was given new impetus."[29] This reached[30] Andrea di Pietro, nicknamed "Palladio," who focused on applying to housing the theories he "borrowed" from Plato.[31]

Beyond the Alps stood the royal *Surintendant* of sixteenth-century French architecture, Philibert de l'Orme, "a test-case for the philosophical endeavour of the Renaissance to reconcile Plato and the Bible."[32] He influenced Mansart (of roof fame) and, in Anthony Blunt's opinion, was "one of the founders" of French architecture.[33] This, in turn, influenced the design of countless Canadian houses, which therefore trace their design ultimately to God.

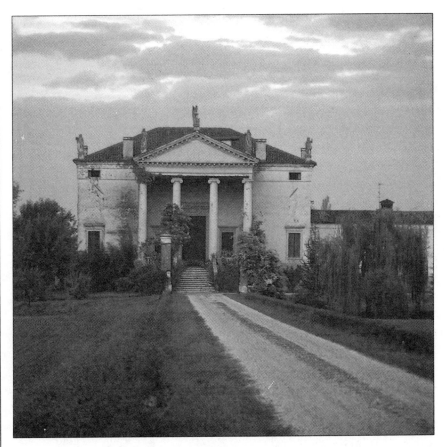

Where do Canadian tastes in housing come from? Colonial and Georgian styles were borrowed from experiments in Northern Italy on merging architecture with ancient philosophy. Palladio wanted his houses, like the Villa Chieriata (1554), to harmonize with the music of the cosmos. On this side of the Atlantic, Thomas Jefferson, the inspiration for American Colonial, referred to Palladio's work as "the Bible."[34]

Another source of inspiration, for centuries of Canadian housing, is reflected in Philibert de l'Orme's house, Paris (1554). This founder of French architecture undertook to apply "the divine proportions which came from heaven." In the words of Anthony Blunt, noted art historian and KGB agent, "The basic principle was to deduce the true laws of proportion from the accounts given in the Old Testament ... [since] these proportions were divinely dictated."[35]

Palladio, for his part, mesmerized British architects of the eighteenth century and laid the foundation for American Colonial. His characteristic window design has witnessed a major resurgence in Canada in the last five years; thus our suburbs are still contributing their occasional note to the celestial Muzak.

Amazingly, these theories produce aesthetic results. Leaving aside beef livers, Vitruvius's success was based upon his slogan *Utilitas, Firmitas, et Venustas,* translated in 1624 as "Commoditie, Firmeness, and Delight"[36] (or today as "Convenience, Solidity and Aesthetic Pleasure"). With endorsements from Alberti and Palladio, these became overriding objectives in homebuilding until the twentieth century. If you follow Vitruvius, Alberti, and Palladio carefully, you wind up with some of Canada's favourite houses, like the lieutenant-governor's house in Charlottetown or Uniacke House near Halifax. Sceptics may argue that their aesthetic appeal is simply based on familiarity (Western civilization has been staring at these proportions since the Parthenon); nonetheless,

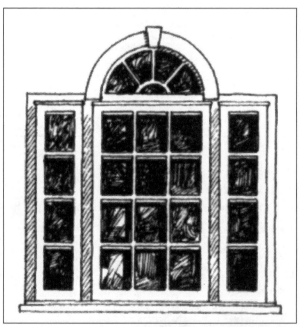

The "musical" window: the Palladian window, one of Palladio's most imitated flourishes, was expected to do its part for cosmic "harmony" — and is still doing so today.

whether these houses are divinely or musically inspired, those that get the proportions right look like temples, whereas those that get them wrong look like funeral parlours.

The grand cosmological theories of the Renaissance took some turns in subsequent centuries. Some became diluted in "speculative Freemasonry"; others were buried by the Enlightenment. By the nineteenth century, theories on "correct" homebuilding had been secularized, and by the turn of our century, rules pertaining to "architectural idioms" were routine (such as when to use a triumphal staircase or a certain kind of column) — but no one argued that there was a "cosmologically correct" way to predetermine the metaphysical alignment of your front porch.

Then came the twentieth century: *a priori* "eternal truths" were back.

A Canadian's typical first exposure to the metaphysics of twentieth-century architecture might come from a debate among architects over a given building. Beyond appearance and practicality, there will invariably be discussion on whether the building is honest and ethical.

"Honest"? "Ethical"? In a bungalow, split-level, or highrise?

The notion that buildings have a "morality" is an important signal: anyone who hears, say, that his front porch is "dishonest" must know that he is facing a philosophical construct more complicated than the porch itself. According to architectural Modernism, "having a theory [has become] as vital and natural as having a telephone."[37] Architectural textbooks have argued vigorously for the application of these theories to *all* housing; with single-family homes, they have been largely unsuccessful, but among highrise apartments they have ruled the century. Just as the owner of a French-style house lives in a latter-day incarnation of the Book of Ezekiel — and the resident of an Anglo-American-style cottage is the direct heir to the musings of Plato — so does today's twentieth-floor condo owner inhabit the architectural first cousin to Zen.

The underlying philosophy of the Modern movement was "Everything starts at zero" (as opposed to Zen's admitted preference for *one*), but the correct dwelling from both perspectives would be a kind of architectural *haiku* — taking minimalism to its extreme. In doing so, doctrinal imperatives or "Absolutes" had to be observed; but since they sometimes had to be traded off against one another, they were what Canadian architect Macy Du Bois called "a *changing* series of Absolutes":[38]

- The objective remained the *return to zero*: "Less is More."[39]
- *Machine-made* housing was closer to zero. The movement "believes the machine to be our modern medium of design, resulting in an 'inner logic' [which] will be radiant and naked, unencumbered by lying facades and trickeries."[40]
- Spheres enclose the most space in relation to perimeter, but are not machine friendly. That left the *cube* as the optimal architectural expression. To think otherwise was retrograde: "Curved shapes [are] characteristic of primitive architecture."[41]
- Ornament departed from zero. "The modern ornamentalist is either a cultural laggard or a pathological case … a latent criminal … The true greatness of our age [is] that it can no longer bring forth ornament. We have vanquished ornament."[42]
- Despite hazards in profiling materials (e.g., the grain on wood might be busy), this might have been acceptable if those materials were both necessary and *elemental*: wood as a statement for its *wood-ness*, brick for its *brick-ness*, etc.
- Colour added busyness. White was preferred; in a pinch, you could use black, grey, or the most neutral beige available.[43]
- The surroundings of buildings followed the same rules. That meant open plazas. These further allowed a building to make its Statement without distractions.
- The architect's task was to identify the minimum way to achieve that building's objective: "Form follows function."[44]

Architects would ponder the elemental nature of the building: office designers did *office-ness*, church architects did *churchey-ness* (a train station like Ottawa's could be "busy" if it illustrated *train-ness*). But this criterion ran into difficulties when applied to *homes*,

because no architectural consensus was reached in seventy years on how to address *homey-ness*.

Modernism claimed that it was not a style, but a philosophical morality: the training offered by its predecessors was perverted.[45] "The dark night of eclecticism"[46] would "leave behind a mortifying testimony to the spiritual fall from grace of our generation."[47] But there was still hope of salvation in Modernism: "To be a user of the machine is to be of the spirit of this century. It has replaced the transcendental spiritualism of past eras."[48]

Finally, Modernism announced that it went beyond *style:* it was "a method of approach ... which is unbiased, original and elastic."[49] In 1990, six Canadian architectural experts agreed that "Modernism never ended ... We are in a Modern condition, and that's not simply a style."[50] Modernism as a "condition" is an intellectual state: it is hence above time and place, and impervious to them. We are unlikely to understand the vocation of homes and cities, says one 1991 textbook, unless we grasp the "theology of architecture."[51]

So we are back to the "eternity" business.

Among eternal truths, the rest of society generally acknowledges only two: death and taxes (to which Canada adds a third, intergovernmental squabbles). It is these truths which, over the past fifty years (when most Canadian homes were built), have had more impact on housing than all the cosmological theories put together. In fact the builders of Canadian housing stock overtly turned their backs on such theories (in 1944) and announced that they would prefer to be governed by the tastes of the marketplace than by abstract ruminations. To Vitruvius's paradigm of "Commoditie, Firmeness, and Delight" they replied with a trio of their own: "Quality, Affordability, and Choice." Although these builders agreed with Modernists about the role of *technology,* that is almost all they agreed on. The "eternal truths" of Canadian homebuilding therefore focused on still another paradigm: "Government, Money, and Technology." That is a far cry from debates over the musical house, the haiku house, or the home designed by God.

But it still leaves the question of the connection between these "ancient truths" and Canada's ancient inhabitants. If Canada's first inhabitants (and any generations since) had waited to *resolve* these weighty questions before actually building their homes, they would have all frozen to death. They acknowledged — and we must consider — the fourth Absolute: climate.

That resurrects the original question: where *does* the subject of "homebuilding" start? From a *physical* standpoint (as opposed to a metaphysical one), the Canadian home indisputably starts with the cave. In due course, more creative approaches to homebuilding emerged; and those approaches exhibited no less imagination than all the metaphysical theories put together. Admittedly, ancient Canadians had no way of anticipating today's triumvirate of government, money, and technology; although they quickly mastered ingenious construction techniques, their reaction to eventual bureaucratization and mortgages would presumably have been identical to that of Toronto ex-mayor Allan Lamport: "Let's jump off that bridge when we get to it."[52]

14

Buffalo, Whales, and Other Building Supplies
Canada to 1600

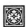

In which we discover our first mobile homes, pyramid power, and entryways à la Santa Claus; Inuit check the seal on their windows; houses are lit with burning fish; Ojibwa invent the airlock entry; vapour barriers are introduced to tipis; and the West Coast meets the Jimmy Hoffa school of foundation-laying.

In Canada, caves were used only rarely for homes because they were "damp and dismal places to live."[1] Archaeological artifacts show that during the last ice age, most people lived in settlements in open country. After the end of that ice age (12,000 years ago), according to a literal reading of Plato's *Timeus* and *Critias*, we purportedly became part of the Atlantis Empire, centred near the Grand Banks. If it had survived, it would have been part of Newfoundland. The unlikelihood of the Atlantis story didn't stop the writing of 25,000 books on the subject. Plato says that springs gave Atlantis our first hot and cold running water; its temple was as high as Place Ville Marie; and building the emperor's house set a record for construction delays — 2,500 years. Atlantis was reputedly engulfed in a day and a night: no trace of this putative part of Newfoundland remained the following dawn (or a half-hour later).

By 6500 BC the picture is more reliable. This is the date of Canada's oldest known dwelling made by people, a tent in the Keewatin District of the Northwest Territories. Tents were made all over Canada for short-term or long-term use, coming in every shape, size, and material; but early Canadians were probably not happy campers. Canada was even colder than now; and much of the territory not blanketed by ice was covered by meltwater (Montreal's Ste-Catherine Street, Toronto's Bay Street, and Winnipeg's Portage Avenue all had fish swimming in them). But how do you improve comfort in a tent? That was the challenge facing Canada's native peoples — and hence the dawn of thermal upgrading.

Every fan of grade-B westerns knows the most famous tent, the "tipi" (Sioux for "dwelling"). Small models (in the east) used birchbark, but *real* tipis (on the plains) used buffalo hides. A TV screen doesn't convey their size: they were typically six metres in diameter and taller than a two-storey building.

Prior to the seventeenth century, tipis were smaller. Some experts argue that the Cree introduced mid-sized models to the plains around 1600 AD;[2] but the largest arrived in the early eighteenth century, with the horse. The old transport method for tipis — dog team — was like running a Winnebago on two cylinders; but with horsepower, there was almost no

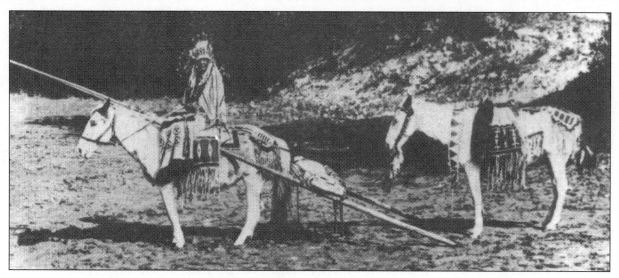

The tipi was Canada's first mobile home. Tipis don't look very portable. Would people teeter across the prairie with 8-metre (25-ft.) poles stacked on their backs? No: poles were lashed to sleds, which were pulled by horses or (earlier) dogs.

limit to a tribe's range, prompting one of the largest games of musical chairs in North America's history. Cree, Ojibwa, Sioux, Blackfoot, Assiniboine, and others were in motion, but since horses made motion easier, tipis increased in size.

The record was set by the Blackfoot. Some of their tipis required "as many as thirty-eight buffalo hides and were sometimes so heavy they had to be cut in half for transportation. Up to forty poles might support such a tipi, and the two parts were buttoned together up the back with old Hudson's Bay Company brass buttons ... [The] floor area was large enough to accommodate three or four fire pits."[3] This design was far from simple: "The fully developed plains tipi was not a true cone. Its steeper, rear side braced the tilted structure against the prevailing winds, and its doorway faced the rising sun. Nor was it a true circle; the wider end of its egg-shaped base lay in the rear."[4] Since the top was a smoke-hole, what kept warm air from being sucked out? And how could you keep the inside dry during a classic prairie cloudburst? The solution was a special flap tethered to a separate pole, to cover the top. This was Canada's first chimney flue.

The tipi also introduced double-walled insulation: a liner — a second layer of hides — was installed as Canada's first "vapour barrier," the ancestor of basic insulation technology. "The bottom of the lining was then turned inwards and was covered by a floor of buffalo [bison] skins. Incoming air at ground level was directed upward between the inner lining and the outer cover. It also prevented vermin from getting in. The stack effect drew smoke from the fire and expelled it from the top of the tipi."[5] The liner also assisted sweet dreams: it kept rainwater slithering down the poles from dribbling on sleepers.

Room design is tricky when you have no walls. During waking hours, men had the north side of the tipi and women the south. Sleeping spaces were demarcated by household goods, and the preferred style of interior decoration was geometric designs on the liner's borders.

At some point in the distant past, collections of tipis stopped being a hodgepodge. Peoples like the Assiniboine pitched camp in a giant circle, with an invisible north-south line running through it to divide the "Sky" from the "Earth" clans. This not only represented prehistoric urban planning; it also demonstrated that from time immemorial, there was an incipient belief in Canada that a "community" is greater than the sum of its parts.

A book about tipi construction could be nicknamed *101 Uses for Dead Buffalo*. The tipi's semicircular "skin" was typically made of tanned hides so carefully stitched together with buffalo-sinew thread that it was waterproof. This cover would be smoked (for durability) with aromatic sagebrush, Canada's first counterpart to Glade. Buffalo laces secured the door

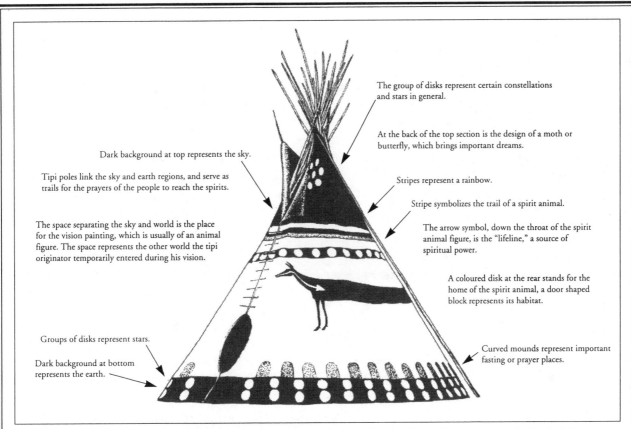

The group of disks represent certain constellations and stars in general.

At the back of the top section is the design of a moth or butterfly, which brings important dreams.

Stripes represent a rainbow.

Stripe symbolizes the trail of a spirit animal.

The arrow symbol, down the throat of the spirit animal figure, is the "lifeline," a source of spiritual power.

A coloured disk at the rear stands for the home of the spirit animal, a door shaped block represents its habitat.

Dark background at top represents the sky.

Tipi poles link the sky and earth regions, and serve as trails for the prayers of the people to reach the spirits.

The space separating the sky and world is the place for the vision painting, which is usually of an animal figure. The space represents the other world the tipi originator temporarily entered during his vision.

Groups of disks represent stars.

Dark background at bottom represents the earth.

Curved mounds represent important fasting or prayer places.

Blackfoot tipi decorations (southern Alberta). The most popular exterior tipi decorations were symbols of visions. If you had no vision at hand, then you fasted until you got one.

flaps together, and adjustment of the poles would "stretch the cover as smooth and taut as a drum."[6]

A tipi usually lasted about a year, and when the dwelling became too tattered, it was cannibalized for parts. The prized area was around the smoke-hole, where the leather had become most supple. Its finale was an indignity: this part of the consummate romantic symbol of the Old West was sliced up and turned into — diapers.

By 2500 BC another model of circular dwelling, later labelled a "lodge," was developed; it remained popular in Canadian Shield country and Atlantic Canada for 4,500 years. Some people (possibly Algonquin) hit on the idea of excavating the floor of their tent area to a depth of a foot, and using the soil to keep cold air from seeping under the bottom edge of the tent. A dwelling of this description, found in the Keewatin and dating to 2500 BC, measures approximately three by four metres: it represents the first known instance of a Canadian homebuilder who started by excavating his site. The next step in building lodges was to construct a circular frame of poles lashed at the top. This structure was then clad with earth, peat, and moss. In Shield country these dwellings grew, covering some 200 square feet with a dome or cone. Porches (raised flaps held by poles) were added. Flooring was of evergreen boughs (balsam was a favourite — another application of the "room freshener" principle). This model spread to the Montagnais, Woodland Cree, and Ojibwa; a smaller variation with bark cladding was used by the Micmac and Beothuks. The Micmac sewed their bark cover together.

The hearth was in the middle — under a hole in the roof (like a tipi); this made for a wet time during a thunderstorm, unless someone was able to stuff a moss plug there in time. Furthermore, how did they keep the warm air from floating out through the smoke-hole? The answer is that heat from the hearth would be conveniently retained by a dense layer of smoke which tended to float benignly in the upper part of the dwelling. This caused no problem as long as you stayed seated — but if you stood up for too long, you could suffocate.

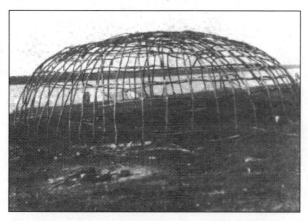

Algonquin lodges used Canada's first "balloon frame" construction. Balloon frame technology means that instead of the walls and ceiling being supported by a few heavy timbers, they are held up by many light-weight supports or "studs" joined together to distribute the load.

This basic lodge had a cousin, the wigwam (an Ojibwa word), which was a bio-degradable Quonset Hut. It had little in common with tipis. In the eighteenth century, a wigwam was described as "an Indian House, in building of which, they take small flexible Poles and stick them into the Ground, round such a space as they intend for the Bigness of their House … making an Arch over Head … After which they cover the whole with Bark or with Trees, leaving a Hole in the Top for Smoak to go out."[7] Ojibwa wigwams had a second hide or blanket in the doorway — the first known Canadian airlock entry.

Explorers' opinions of native housing varied. William Strachey wrote in 1620: "Snowe or raine cannot assalt them, nor the sun in summer annoye them, and the roof being covered, as I say, the wynd is easily kept out."[8] But Father Paul Le Jeune said: "This prison, in addition to the uncomfortable position that one must occupy upon a bed of earth, has four other great discomforts — cold, heat, smoke and dogs."[9] In 1691 Canada recorded its first known debate over house models (cabins vs. wigwams); a French colonist favoured cabins, to which an Algonquin gave the following reply: "We can always say, more truly than you, that we are at home everywhere because we set up our wigwams with ease wherever we go and without asking permission of anybody."[10]

Again, the wigwam was based on the "open concept," but "invisible boundaries divided the interior and rules governed everyone's movements to ensure order and relative privacy."[11] In the 1850s, German scientist Johann Kohl wrote this about Ojibwa homes around Lake Superior: "Stillness is usual in all Indian wigwams … As with every step you invade the territory of another family, and might see all sorts of things that a stranger ought not to see, respect demands that the guest should sit down directly, and fix his eyes on the ground. Indians, as a general rule, are not fond of restless people."[12]

The Ojibwa also decorated their interiors, alternating their materials in checkerboard fashion in the outer and inner wall layers. The comfort level relied on another basic principle of homebuilding: good wigwams utilized different kinds of leaf mats, and used "the principle of insulation by means of walls enclosing a *dead airspace* in which convection currents are retarded by filaments. The walls are the outer layers made up of the hard lower half of the leaves, while the filaments are the inner layers of thin leaf tips."[13] Duncan Campbell wrote of Micmac wigwams in 1873:

> There is a place for everything and everything in its place. Every post, every bar, every fastening, every tier of bark, and every appendage, whether for ornament or use, in this curious structure, has a name, and every section of limited space has its appropriate designation and use. Perhaps it would be impossible to plan a hut of equal dimension in which the comfort and the convenience of inmates could be so effectively secured.[14]

In central British Columbia, another model was developed which also remained popular for over 4,500 years. Carriers, Kootenay, Okanagan, Shuswap, Lilooet, Chilcoten, and Ntlakapamux (called "Thompson" because the river in their territory is more pronounceable) built pyramids to live in. This model was also adopted by some Athapaskans in Yukon. Like their counterparts in Shield country,

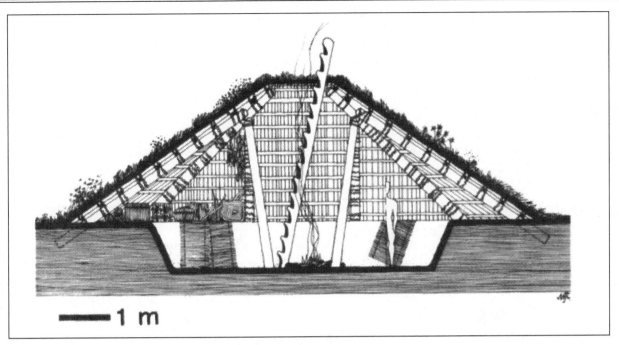

A pyramid house. By the thirteenth century, the floor area (surrounded by a "sofa") was typically 8–12 metres (25–40 ft.) across. The pyramid was supported by four beams carefully oriented to the semi-cardinal directions, and clad in wood and sod for insulation. The result was a house which accommodated 15 to 30 residents under its 4.5-metre (15-ft.) ceiling. Some sources say this style of building is so old that it originated in Asia.[15]

builders excavated their sites to a depth of about a metre (hence the unceremonious title of "Pit House").

Turf would be left around the edges of the excavation to make a grass wrap-around sofa. Just because there were no interior walls didn't mean there weren't rooms with names (although "living room" and "dining room" weren't among them). "In the main space, the areas marked by the four main posts and beams were known as 'rooms' and each was named for a semi-cardinal direction."[16]

This design created a major problem: where do you put the door? The answer — for men — was to scramble up the exterior of the house and descend an elaborately decorated log ladder through the chimney hole. Dropping in through the roof had religious and ceremonial significance; it was proper to descend the ladder facing *northeast*, supporting yourself by gripping the grooves in the back of the ladder with the *right* hand. (Northern Shuswap reversed that etiquette, keeping the *left* hand on the ladder and turning their faces to the *southeast*.) A side entrance was reserved for women and children, because they were not allowed to use the ladder: "Climbing the log was

considered an ascent to the upper world."[17] People could play Santa Claus indefinitely. That could, however, mean problems for anyone dropping in at dinnertime.

Although several Indian peoples shared this technology, it was obviously inapplicable to Inuit because they all lived in igloos, right? Wrong. Inuit also had houses nicely excavated like B.C.'s; and some even had wood, as in Labrador and the Mackenzie Delta. Inuit from the latter region, called Inuvialuit, developed variations with a "distinctive cruciform floor plan. Since trees were available, the roof was framed of axe-dressed and cribbed logs, with four long posts holding up the major roof beams. The leaning-log walls were … layered with dirt and snow and sometimes finished with a ladling of water, which quickly froze into a heat-retaining ice shell. The living area inside was divided into three single-family alcoves, each with its own sleeping platform."[18] In the Delta town of Kittigazuit, one such house was 18 metres (60 ft.) long.

Yes, the typical sixteenth-century Inuk was hardly your stereotypical Nanook of the North, constantly on the move. Most Inuit lived in houses of

stone and sod, with communities reaching (in the case of Kittigazuit) populations of over a thousand. Igloolik, NWT, is a case in point. It had originally been settled around 2000 BC, and its role as a regional gathering place was maintained by the Inuit. The typical Igluligmiut (residents of Igloolik), like other Inuit, reserved igloos for winter trips; but otherwise they would pick up their harpoons in the morning, go whale hunting a short distance away, and return within in a reasonable time to their sturdy homes.

Although this picture of Inuit commuters is tempered by the absence of an Inuktitut translation for "Honey, I'm home," other traits were classically suburban, such as the emptying of communities in summer. When dampness made their houses uninhabitable, this was the ideal time to take the family camping. Furthermore, the large summer gathering places like Igloolik (or Povungnituk in northern Quebec) allowed you to catch up on how friends and relations were doing. The only drawback was that there was no plumbing on the permafrost. In typically candid Inuit fashion, Povungnituk translates as "the place that smells rotten."

But these Inuit, unlike their Inuvialuit cousins in the Delta, had no wood; so where did people get their beams? Inuit got them where they picked up many of their supplies: from whales.

The vestibule of an Inuit home was carefully designed with an entrance which sloped downward and then led upward through a trapdoor into the main room. The Inuit were more serious about good vestibules than almost anyone else on earth: they wanted their airlock to work horizontally and, as an extra precaution against heat loss, vertically. This contrasts with many American housing catalogues on the Canadian market today, which assume that our climate requires no airlock entry at all. It took some agility, however, to make one's entrance through this vestibule; and when Moravian missionaries reached Labrador, their inability to negotiate this course led to a change in design "because the missionaries took exception to the long crawl through the excrement of the dog-team living there."[19]

Interior air quality left something to be desired: Inuit lighting was provided by a lamp that ran on seal oil. The house had a smoke hole (called "the nose") which, when not in use, was blocked with a turf plug.

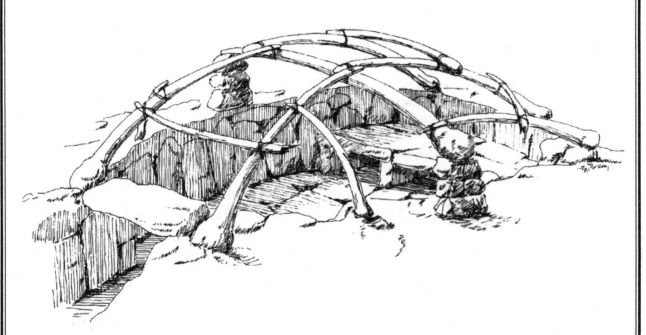

Inuit house under construction. Whale ribs were used to create houses of up to three rooms in a clover-leaf pattern, plus a vestibule. The vestibule, which was passable only on all fours, was roofed with slabs of rock; but the room ceilings were whalebone covered with turf.[20] The jawbone served as an arch over the doorway. The floor was excavated to a depth of a foot or two and finished with flat stones, and the area farthest from the door was fitted with a kind of stone sofa. Clothing racks were also made of whalebone. In short, whales served as a kind of prehistoric Beaver Lumber.

The [lamps] were constantly tended and were crucial "monitors" of the air quality in the heavily insulated structures. If heavy bad air was not forced back down the passageway, and the lighter bad air was not sufficiently vented through a central ... "nose," the flame turned yellow. The turf plug in the nose would then be pulled until the flame burned white again ... With such constant fine tuning of the winter house's climate, the inhabitants could even feel layers of temperature. At one's feet the air could be quite cool, at waist level a temperate zone prevailed, while one's head ... projected "a good way into the tropics."[21]

But what if lamps could not only illuminate the interior but also serve as a *beacon* in the long arctic night? A hunter returning in pitch darkness could then locate his home from a distance.

Inuit therefore invented the first Canadian window. Materials were a problem. Inuit might have considered using blocks of clear ice (that is what they used as windows in igloos), but if temperatures fluctuated, your window could melt or fall on your head. Glass and paper were unknown. The solution required imagination.

So they used stretched, translucent seal guts.

Dryness was important for a bearable comfort level inside the home. If a person with a snowy parka entered the living area, the humidity from the melting snow would have a chilling effect. That is another reason an Inuit house invariably included a vestibule — a place to leave wet apparel. That also meant (fortunately or unfortunately) that anyone entering the living area would usually be doing so in his or her underwear.

When food sources were outside commuting distances or when people went on trips, they resorted to igloos for temporary shelter in the deadly arctic climate. We don't know who invented the igloo. Experts say that there is scant sign of Inuit use of igloos in their Alaskan homeland before they started their march into Canada, around 900 AD. At that time, northern Canada was occupied by a kindred but distinct population called Tunit, who inhabited an area (from the Beaufort Sea to eastern Greenland and as far south as the Gulf of St. Lawrence) larger than the Roman Empire. Aside from some traditions in eastern Greenland, the Tunit had disappeared by 1400 AD. Ancient Inuit accounts describe large Tunit, or Tunit so small that they used caribou ears for sleeping bags; but none answer the question of what they lived in. If they invented the igloo, the hard evidence has melted.

Whether Tunit slept in caribou ears or something else, they would have had to bundle up tight. The interior temperature of an igloo hovers around the freezing point.

Igloos are built by assembling carefully shaped blocks of hard-packed snow, which spiral toward a keystone in the dome. The blocks are banged together to melt and refreeze the ice, thus "welding them together."[22] The traditional ritual of Igloo construction was complex:

> As work progressed, special taboos were often observed, some suggesting a symbolic tie between house and womb. The first blocks to be cut were what were known as the "long sides" - where the vital soapstone lamps were to be placed.

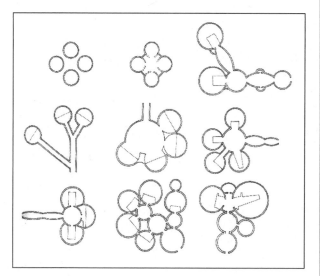

Aside from the basic model of igloo (main room and vestibule), you could get two-room, three-room, and multi-family igloos.

Blocks for the "broad side," or the rear of the igloo where people slept, were cut next to ensure good luck. If a man desired many children he used a serrated knife to cut the first block of the broad side, slicing outward so the household would not suffer bad fortune. Loose snow chips had to be cleared away from the interior so the house's children would enjoy good luck. Special attention was given to the final building step: the opening for the keystone block had to be as large as possible to ensure easy childbirth for the women. If a family hoped for a son, that block had to be bigger than the block preceding it, and its softest side had to face the rear of the house.[23]

Igloos came in a remarkable variety of models. The interior could reach eight metres in diameter and four metres in height. For special occasions, oversize igloos (*qaggi*) could be built: one nineteenth-century igloo in Labrador measured twenty-one metres across and nearly five metres high — perhaps the trickiest engineering in Canadian housing until the twentieth century.

But for centuries, the igloo still took second place to the permanent family house. These northern houses survived in isolated instances until the twentieth century; but most of the large, stable villages were wiped out by an ecological disaster. Canada had had its share of environmental catastrophes before: in eighth-century Yukon, a volcanic explosion[24] many times that of Mount St. Helen's so devastated the landscape that the resulting emigration had a domino effect (one of the NWT's Dene peoples, the Navaho, wound up in Arizona). What happened to the North shortly after 1600 AD, however, had an extraterrestrial origin. A decrease in sunspots caused a climatic shift that cooled the entire Northern Hemisphere. This Little Ice Age, which lasted some two hundred years, choked northern waterways with ice, and barred the whales. The Inuit food supply collapsed. It is arguable that the Inuit never fully recovered:

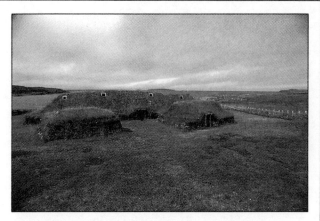

Viking houses in Newfoundland have been rebuilt. Sleeping platforms ran along the interior of the walls 400 mm (1 ft. 4 in.) above the earth floor. Walls nearly 2 metres (6 ft.) thick were made of peat slabs, and the roofing poles were covered with turf.

there were well over 50,000 people living in the Inuit homeland at the time of Martin Frobisher;[25] but Canada and Alaska barely have that many Inuit today. Many communities were abandoned in desperation; their people packed up their dogsleds and headed off into *nalunartuq* — "future uncertain."

The main holdout was the Inuvialuit "metropolis" itself, Kittigazuit. It not only withstood the Little Ice Age, it was the only true "town" in Canada between Lake Huron and the Pacific coast until the late nineteenth century. It almost made it into the modern era, but after five hundred years of survival despite all odds, Kittigazuit was wiped out within two months in 1902, by an epidemic of measles.

The Little Ice Age set the Inuit back six hundred years, to a nomadic lifestyle reminiscent of the time they first ran into the Vikings in Greenland. There had also been Inuit-Viking skirmishes around Newfoundland and Labrador, where the Vikings were trying to establish colonies, including the one at L'Anse aux Meadows.

The population at L'Anse aux Meadows was about sixty Norse, housed in three longhouses. "Fires were located in each room. Although the [Viking] longhouse may appear primitive on a raw dank day … the warmth inside, even without fires, is quite remarkable."[26] This was important, since of all the sites available on the coast, the Vikings inexplicably had picked one of the most windswept. After less than twenty years, the chilly colonists gave up.

But Viking longhouses were small compared to most of those elsewhere in Canada. With a few exceptions in B.C., longhouses were the largest residential buildings in Canada before the twentieth-century highrise. The Iroquois believed that multi-family longhouses predate humanity: spirits of the skyworld lived in such longhouses, and this model of housing was transmitted to mortals below.

In 1570 AD, the Iroquois had the most sophisticated political system in the world. Led by Deganawidah and Hiawatha (not to be confused with the travesty of Longfellow's poem), they founded a five-nation confederacy, with a capital of sorts in New York State. The Hurons (who were similar culturally) formed the four-sided Wendat Confederacy. Far from being nomadic scavengers, the Iroquois and Huron economies were agricultural. Jesuit Joseph-Francois Lafitau said, in the early eighteenth century: "It is not without reason that the name 'Hotinnosioni,' or builders of houses, has been given to the Iroquois: they are indeed the most comfortably lodged in all America."[27] But if they were so

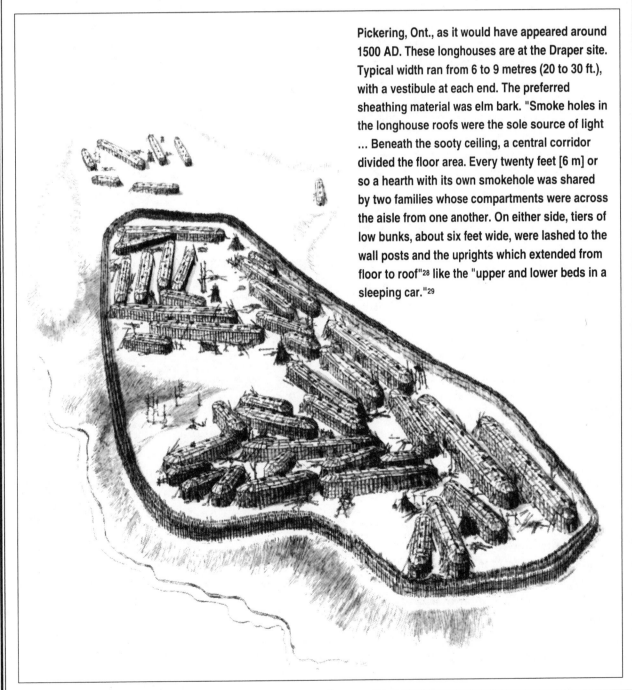

Pickering, Ont., as it would have appeared around 1500 AD. These longhouses are at the Draper site. Typical width ran from 6 to 9 metres (20 to 30 ft.), with a vestibule at each end. The preferred sheathing material was elm bark. "Smoke holes in the longhouse roofs were the sole source of light ... Beneath the sooty ceiling, a central corridor divided the floor area. Every twenty feet [6 m] or so a hearth with its own smokehole was shared by two families whose compartments were across the aisle from one another. On either side, tiers of low bunks, about six feet wide, were lashed to the wall posts and the uprights which extended from floor to roof"[28] like the "upper and lower beds in a sleeping car."[29]

well organized, with stable communities of thousands of people, why didn't they build more permanent buildings? Not a single original longhouse remains. The main materials were wood and bark: why didn't Iroquois and Hurons do the obvious, and build in stone? The thought must have occurred to them; and with the wherewithal at their disposal, they could easily have built European-type towns.

But this is Canada.

First, their crop rotation for corn, beans, and squash was not as advanced as they might have liked: the typical community quickly experienced soil depletion; and the poorly insulated buildings meant that they must have chopped down most of the local firewood within two decades. They also had an urban planning problem that does not exist today: from time to time, "invasions of fleas made the town unlivable."[30] Every twenty years or so, communities would have to pick up and move (hopefully not far). It was pointless to build with more permanent materials.

This lack of permanence did not lead the Iroquois and Hurons to minimize the scale of their buildings. Many longhouses were over a football field in length. In 1500 AD, the Nodwell site near Lake Huron included twelve buildings for five hundred people; the Draper site in Pickering, near Toronto, covered six hectares, had forty-five to fifty structures, and housed at least two thousand people. In 1615, Cahiague, between Lake Simcoe and Georgian Bay, contained some two hundred buildings and would have housed four thousand people. Hochelaga, which Jacques Cartier visited at the site of present-day Montreal, was estimated to house some 3,600 people in fifty buildings. Hochelaga also included the first reported balconies in Canada, used not for pleasure but for hurling projectiles at any enemy attacking the stockade.

The longhouse was so important to the Iroquois that they officially named their confederacy "The People of the Longhouse." According to tradition, when the historic founding meeting of the confederacy concluded in 1570, delegates recited "Have built longhouse" — the new confederacy's political slogan. "To an Iroquois, the League was not *like* a longhouse. It *was* a longhouse."[31] The Mohawks were "keepers of the eastern door"; the Seneca were "keepers of the western door"; the Onondaga were "keepers of the fire"; the clan leaders were "braces"; and tribal chiefs were "posts."

The longhouse met an ironic end. In 1763, the British government rewarded Iroquois military support with a Royal Proclamation protecting Indian lands from colonial encroachment. Land-hungry American colonies, already protesting taxes, were enraged. When hostilities finally broke out between colonists and the British, the Iroquois predictably sided with the Crown. The scorched-earth policy of the colonists led to the destruction of forty entire longhouse towns. Neither the confederacy nor its lifestyle fully recovered.[32] Iroquois Loyalists in Canada called political assemblies "longhouses," and again sided with the Crown in the War of 1812, but by now the longhouse was an embattled political symbol rather than a social reality. In 1924, Ottawa finally discarded its longtime ally and suppressed the last vestiges of the "longhouse" political tradition to shoehorn the Six Nations into the Indian Act.

The scene was different at the other end of the country. Most peoples in ancient Canada (Inuit,

The peoples of the B.C. coast had the largest closets in Canadian history. There was such affluence (thanks to reliable fisheries and climate) that residents could spend time and wealth just storing goods and planning how to upstage their neighbours in the ultimate blowout. Nowhere else in Canada, before or since, has housing been so singularly focused on partying.

Cree, Ojibwa, etc.) occupied gigantic territories; but B.C. was utterly balkanized by its mountains. Nonetheless, the coastal peoples shared cultural traits, except their languages. A lasting legacy was their design of housing.

Humorist George Carlin once defined a house as "a place to put your stuff." He would have liked these peoples: prehistoric B.C. was the golden age of Canadian storage space. This space was immense for a wonderful reason: people were stocking up for the next party. Such parties (called "potlatches," from the Chinook word for gift) were status symbols beyond the wildest dreams of other societies. Although the throwing of a good party today allows *arrivistes* to climb the ladder of prestige, the West Coast carried this game to extremes unimagined elsewhere. In the same era, Europe generally had three classes: nobles (subdivided into ranks), freemen, and serfs; but "there is a record of a Kwakiutl feast in which each of the 658 guests from thirteen subdivisions of the chiefdom knew whether he was, say, number 437 or number 438."[33] People could spend years (or decades) stocking up, while waiting for the right moment to make their big move up the social ladder. The voluminous houses to store this "stuff" became assertions of prestige in their own right. Interiors and exteriors were elaborately decorated. For some peoples the focal point of the facade, the door opening, evolved so that the largest possible sculptures could be displayed to honour the lineage and exploits of the owner.

Hence the totem pole, Canada's most famous architectural symbol. "A totem pole was intended to outface and browbeat the neighbours by telling how distinguished its owner and his ancestors were. Several of the carved beings on one pole in the old Haida village of Old Kassan are undoubtedly Russian priests. The owner of the pole was extremely proud of having successfully resisted attempts by the priests to convert him."[34]

In 1788, fur trader John Meares attended a Nootka party on Vancouver Island. At the home of the host, "The door was the mouth of one these huge images ... we ascended by a few steps on the outside, and after passing this extraordinary kind of portal, descended down the chin and into the house."[35] There were some eight hundred people inside.

Top: the Haida community of Skidegate, as it appeared in 1878. The roofs of these buildings were supported by gigantic beams. Typically, the Tlingit and Tsimshian would use two beams; the Nootka, Bella Coola, and Kwakiutl, four; and the Haida, six. These beams were supported by large pillars, and the house was finished in planks. Above: today's reconstructed Gitksan houses at K'san, near Hazelton, B.C.

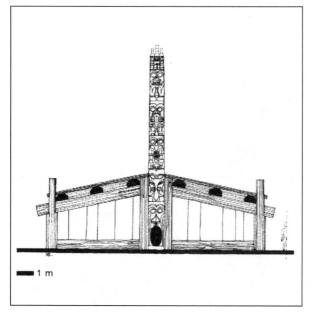

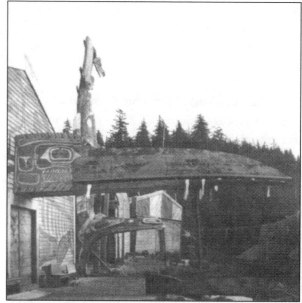

The entrance to a house might be through the totem pole or under the house's beak.

Meares estimated that "the trees that supported the roof were of a size which would render the mast of a first-rate man-of-war diminutive. Three enormous trees, rudely carved and painted, formed the rafters, supported at the ends and in the middle by gigantic images."[36] Another Nootka house had a single central supporting ridge pole for its roof, over 100 feet long. One Bella Coola village was raised on pilings which were two and a half storeys high. A Salish house in Langley was described by Simon Fraser in 1808 as being 18 metres (60 ft.) wide and two football fields in length (almost 40,000 square feet).

It is thus not surprising that each house had its own name — houses were considered to take on a life of their own. "The prominent, permanent winter houses were not considered the property of their occupants but rather of family lines or lineages Kwakiutl called *numema*. A house was considered a 'spiritual associate' of the current lineage chief."[37] "Villages such as these were not only home, but also metaphors for the structure of the world ... [which] was seen as a large plank house ... On another level, the house was seen as the body of an ancestor: the spine was represented by the ridgepole, from which descended the rafters, representing ribs ... According to legend, the various kinds of animals lived in similar ranked villages."[38]

The construction of one mid-nineteenth-century Haida home, aptly named "The Monster House," employed some 2,000 people (directly or indirectly). It had eight giant beams (instead of the customary six) and had mezzanines leading down to the central fireplace. By 1850 several such homes included furnishings from traders.

Outside the house was a kind of terrace or street paved in planks. A site across from Victoria in Washington State shows that, even in the year 1520 AD, residents were building wooden drainage systems around and under their houses to carry away run-off water. The native archaeological record is clear: there were infrastructure programs centuries before Jean Chrétien.

B.C. witnessed Canada's first love affair with cedar panelling. How do you get *planks* when you don't own a saw? These peoples had experts who could split trees along their grain merely with carefully placed stones and shells used much like a sculptor's adze. The preference for cedar was summarized by one of Canada's foremost exponents of the recent native artistic renaissance, Bill Reid: "The wood is soft, but of a wonderful firmness, and a good tree, so straight-grained, will split true and clean into forty-foot planks, four inches thick and three feet wide with scarcely a knot ... It is light in weight and beautiful in colour, reddish brown when new, silvery grey when old ... You can build from the cedar tree the exterior trappings of one of the world's great cultures."[39]

Although the production of planks could occur by felling a tree, this was not the preferred method: "Before cutting into a standing tree the Kwakiutl prayed and offered gifts to its spirit ... When the Kwakiutl cut a tree down it was considered 'killed,' but a standing tree from which boards were taken had been 'begged from' ... [Construction] was governed by elaborate protocol. Between the first feast announcing the project and the actual move, three years may elapse. It would require of the host-builder a substantial outlay of gifts and periodic feasts."[40] The Kwakiutl

regarded red cedar and its products as living substances. Its reddish hue was equated with blood, lending the tree what the Kwakiutl called *nawalak*, or supernatural force ... the tree's heart was sometimes trimmed into a pole used in the winter season's ceremonies. Planted in the middle of the sunken house floor and jutting forty feet [twelve metres] through the smoke hole, the pole was climbed by shamans during highly dramatic performances. It symbolically linked the three layers of Kwakiutl cosmology: the underworld [the housepit], this world [the house and its occupants], and the skyworld [through the smoke-hole].

This house model goes back at least 5,000 years.[41] Portable siding was dear to the Nanaimo, Cowichan, and Saanitch: when a family left home in summer to spend time at a favourite fishing spot, it would dismantle the planks from the walls and bring them to its summer place as instant construction material. When it was time to "pack up" the summer place, the family would do so, literally.

Captain Cook recorded the contents of a Nootka tool box, compiling the first inventory of the tools of the trade for a prehistoric Canadian builder. It included: "a maul, chisels, wedges, D-adze, straight adze, simple drill, grindstones or sandstone for finishing, shark skin for fine polishing ..."[42] There was not a metallic item among them. The early architectural accomplishments, which set the style for generations to come, were accomplished with clams, mussels, wood, and stone. When metal tools were introduced, productivity merely grew.

The method of payment for homebuilders was different from today's. When one Kwakiutl chief commissioned a new house, he went to three sub-tribes for staff; distinct assignments were given for selection of main beams, other beams, house posts, rafters, and planks, which were cut and trimmed by a crew of fourteen, then floated to the site. This work took four days and was punctuated with speech-making, feasting, and public presentations of gifts. Before artisans began carving the pieces to be assembled, the chief's spokesman proclaimed: "Indeed, truly long ago, it was said by the Creator of the ancestors of all the tribes that we should do it this way when we build houses."

The spokesman also emphasized prehistoric financial planning: "Do not be too quick, when you build a new house ... for you will bring disgrace upon yourself if the property [to pay the partici-

pants] gives out before you finish the house."[43] That advice is still distressingly accurate today.

When the work was completed[44] a participating Kwakiutl headman announced to his host: "Go and sing in the house tomorrow evening and let the inviting canoes go to all the different tribes that they may."[45] The place of honour was "in the middle rear of the building and in descending order ranking family members occupied the right side, left side and door side."[46] Mats covered the floor boards, insulated exterior walls, and served as room dividers suspended over half-walls. Interior mezzanines were organized: in Haida homes, "fires and working would be on the bottom level; sitting or even sleeping on the interme-

diate level and sleeping and the storage of private possessions on the upper level … This arrangement of terraces formed an ideal miniature amphitheatre for various types of gatherings."[47]

Fish-oil lamps provided light. The olachen fish was a kind of kerosene bottle with fins. The olachen trade routes were guarded by fortress towns which charged tolls. In the hundred or so fortress towns built in northern B.C., large cellars became necessary: various groups were regularly laying siege to one another, in disputes over tolls. One such establishment, Kitwanga, had the most booby-trapped buildings in prehistoric Canada: their eaves could be dropped on unwelcome visitors.

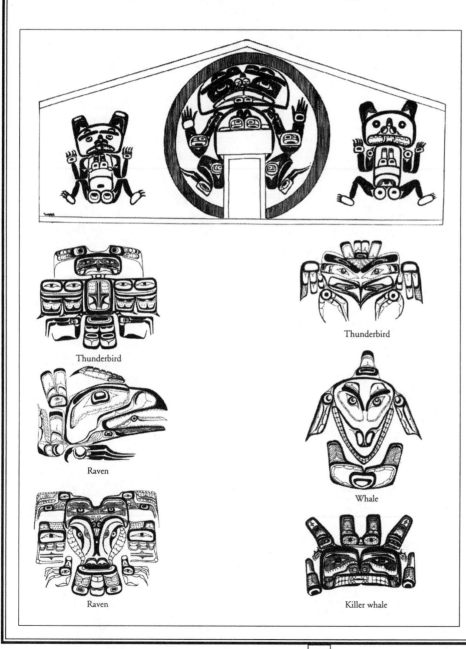

Kwakiutl house decoration. Having such a symbol over your doorway could turn the act of walking through the entrance into an allegory of death and rebirth. The bears on each side of the doorway at the top were considered the house's "ancestors."

Thunderbird

Thunderbird

Raven

Whale

Raven

Killer whale

How could a culture so rich wither within a single generation? By the late nineteenth century, the native populations of the coast were under intense pressure to abandon their heritage (and housing) to assimilate into white-inspired communities. The collapse was triggered when the government of B.C. banned the potlatch. The new white establishment (notably missionaries) had been seeking a pretext to do so, and the natives had created the instrument of their own undoing: inflation.

By the nineteenth century, "tipping reached astounding proportions ... and a man who wanted to maintain his rank was almost constantly handing out small gifts ... He left his house in the morning, wearing several blankets, that he could give to people who performed important services for him during the day; he also carried many lesser presents that he tossed away as a modern American tips a delivery boy."[48] This practice would reach its climax at a good party. Participants at one Kwakiutl party gave away eight canoes, six captives, fifty-four elk skins, 2,000 silver bracelets, 7,000 brass bracelets, and 33,000 blankets. Such occasions led the coastal peoples to invent their own system of promissory notes and debentures.

IOUs had been common in Europe since the Middle Ages; but B.C. natives hit on the concept independently. Instead of paper, indebtedness was recorded on pieces of copper. One "copper" reached a denomination of 23,000 blankets. As soon as ancient B.C. had invented a way to record indebtedness, it spawned usury:

> A typical interest charge for a loan of less than six months was about 20 percent; for six months to a year, 40 percent; for one year, 100 percent. But if the borrower had poor credit, the rate might rise to 200 percent for less than a year. The borrower then promptly loaned out what he had borrowed to someone else at an even higher rate of interest if he could get it. Within only a few decades, everyone was in debt to everyone else. In one Kwakiutl village, the population of somewhat more than a hundred people possessed only about four hundred actual blankets. Yet, so pyramided had the system of debts, credits, and "paper" profits [make that "copper" profits] become that the total indebtedness of everyone in the village approached 75,000 blankets.[49]

When the government halted potlatches, it brought down the curtain on the native economy, its culture, its totems, its housing, and almost everything else. Some of those elements are sorely missed today, and various spokesmen, including Bill Reid, have been leading a revival. In housing, this finds its expression at K'san, near Hazelton.

Some aspects of this housing, however, might best be abandoned indefinitely. For all their art and grandeur, some homes had also been associated with the most disgusting foundation-laying ceremony in Canada: "Among the Tlingit, for example, it was the custom to put the body of a captive in the bottom of the hole dug to secure the heavy post for a new house. This was not intended to sanctify or bless the house in any way, but just to show that the builder was of such high rank that he could not only put up a house, but he could also dispose of one of his assets."[50]

Mercifully, most North Americans have not witnessed this foundation-laying practice since then — with the possible exception of some "close friends" of Jimmy Hoffa.

La Douce France Meets 40° Below
1600–1763

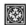

In which Louis XIV gets tucked in; the "modern" home is invented for tax reasons; Old Masters bundle up; Champlain's nails get stolen by les Anglais; France invents the bedroom; New France gets a building code; hookers work on construction; and builders say their prayers.

It would be quaint to imagine that when Champlain reached Canada in 1604, he introduced new French housing ideas like glass doors, checkered tablecloths, and the *ménage à trois*. Unfortunately, Europe hadn't even invented the notion of "home" yet.

The poor didn't live in "homes" but "hovels."[1] Nobles, on the other hand, had hordes of servants and pages (sons of other nobles or "*garçons*" to wait on tables); and their abodes weren't "homes" but "courts." Louis XIV had so many people to tuck him in at night that a railing was installed by his bed for crowd control. The bourgeois, for their part, lived in their corporate headquarters: wares were trotted out during business hours, and rolled away at mealtimes. Non-family members (apprentices, clerks) slept in the main hall; the family snuggled in the same bed. The Great Bed of Ware,[2] for example, was designed for eight people.

Or, Europeans had a "hall." An Irish ballad romanticized the era — until the dastardly English dropped by:

> They killed his father in the hall
> His gentle mother too
> And all the old retainers
> So faithful and so true.

(Today, injury to retainers is not specified in a typical homeowner's policy.)

Then, in the early seventeenth century, the Dutch invented the modern home for one of the most common reasons for many "inventions": to reduce taxes.[3]

Holland was pursuing a familiar goal: to tax the rich more than the poor. This wasn't an attempt at social equity; the rich simply had more wealth to tax. In due course, England taxed windows (easy to count, and rich people had more of them); France taxed closets (the rich had more clothes). English homeowners promptly boarded up their windows, and the French developed such an aversion to closets that to this day they prefer *armoires*. Holland's taxes varied directly with the number of domestic servants, so the typical Dutch family promptly fired them; but

this forced Holland to create homes that worked without platoons of servants. This was the origin of the modern home.[4]

Holland's building boom would revolutionize Europe. Not only were houses designed for a single family, without mobs of servants, but they also had huge expanses of windows. A passion for light wasn't the reason. In that waterlogged country, buildings rested on piles, and a normal masonry facade would have been too heavy: lots of windows (which are lighter than bricks) kept Dutch houses from teetering into the canals. However, when the Little Ice Age (1620–1820) hit Holland, dampness, cold, and countless leaky windows made life miserable. Dutchmen began wearing hats twenty-four hours a day (except at prayer), and people waddled about in seven layers of clothes. The Dutch house explains why Rembrandt's subjects look less dressed than upholstered. If they had known what Canadians today know about weatherstripping, the history of Western art would have been different.

Dutch windows and their proliferation also signalled the growing security of homeowners. In previous centuries, "streetproofing" meant making your house riotproof. Mob violence had been routine; so instead of sporting many windows, well-to-do urban homes throughout medieval Europe appeared to have been designed by inspired jailers. Even if a home-owner had been unconcerned about what might come off the street, he had to remember what might fly through the air. Apart from the usual sieges, there had been instances, like one war between Florentines and Sienese, where belligerents catapulted dead donkeys and excrement onto each other. This is a concern which owners of picture windows need not have today.

Prior to the novelties that Holland introduced, the housing tradition throughout Northern Europe had been surprisingly homogeneous. Builders had installed large timbers in the façades of their houses; but since these were unprocessed wood, any Canadian who has built a deck or a wharf must wonder how these walls were kept from warping. Medieval builders hit on the idea of slicing beams, reversing the halves, then sticking them together so that the stresses pressed against and neutralized each other. That gave them reliable timbers which could even support a façade. Architectural historians, in their original way, call this "half-timber" construction. These were pre-fab homes with pre-cut parts.[5] This half-timbered construction was popular in Normandy and Gascony, which were two main departure points for many French colonists sailing to America.

This was the technological baggage which Champlain brought to Canada; but when he reached

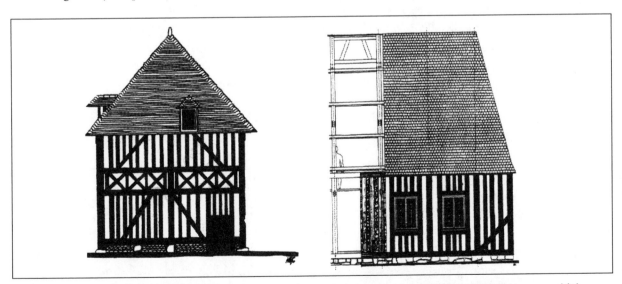

Countless Canadians in this century have dreamt of modelling their home on early "half-timbered" houses, which were later labelled "English Tudor" even though (a) they often predate the Tudor kings, (b) they are not necessarily English, and (c) the Tudors' homes weren't in that style anyway. The pigeon house at left was built in Normandy (1561); the home at right (including view of components) was built on Île d'Orléans, Quebec (1733).

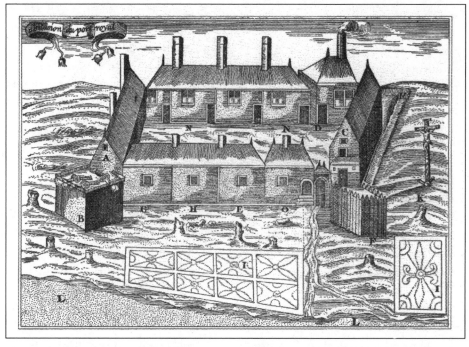

France was lucky that Champlain was a better explorer than builder, though it wasn't for lack of trying: he came staffed with two master masons plus assorted blacksmiths, carpenters, joiners, stonecutters, and even locksmiths. Nevertheless, his first Port Royal (on St. Croix Island on the present New Brunswick-Maine border) was built at the wrong place: it had no fresh water. The very next year, 1605, it had to be pulled apart and moved. Furthermore, neither the scale nor the perspective of his drawings works; and the roofs leaked.

Nova Scotia in 1604 and saw all those trees, was he inspired to build log cabins instead? No: he sliced the logs into planks, and built as he would have in France.

Some American pundits argue that classic log cabins were invented by Swedes in the Delaware Valley in 1638.[6] Canadian experts call this theory "beyond belief … It strains credibility to think of influence coming north from this quarter, [because] the Iroquois Confederacy lay across any direct lines of communication."[7] When New France built log cabins, it was probably because it invented them independently.

But that was after Champlain. Port Royal was a major first in Canadian building. For starters, it had *stairs* (natives used ladders). Stairways had existed in the Old World since Mesopotamian times and had subtle refinements. In areas like western England, they invariably spiralled clockwise because "keeping up with the Joneses" meant handling a Welsh raiding party that had broken in and was charging upstairs. The sword of a right-handed person fighting his way *up* the stairs was encumbered by the walls of the staircase, whereas

the owner fighting his way *down* had ample room to decapitate visitors. (Woe betide the unfortunate inhabitants faced with a left-handed Welshman.)

Another imported concept at Port Royal was *glass*. Glass windows had been used throughout the Middle Ages, but were expensive. Competent glaziers were so valued during those times that they were granted the highest honour of their day: to wear a cape and sword like nobility. (What a window-maker was expected to *do* with a sword wasn't specified.)

A third innovation was the *nail* — though not that many were actually used. Each was arduously hand-made by a blacksmith. Nails were so precious that some New England colonists specifically bequeathed them in their wills.[8] Inheriting a bequest of 2,000 nails was the seventeenth-century equivalent of winning a lottery.

Then came 1613. English colonists from Virginia seized Port Royal and burnt it to the ground — but not until they had pulled out and stolen every hinge and nail. Champlain had better luck holding on to his nails at his next development, Quebec (1608). By 1636, its population had reached 250 and

Governor Montmagny introduced Canada's first "city plan."[9] In 1642 Paul de Chomedey, sieur de Maisonneuve, felt ready to launch a community at what is now Montreal. By coincidence, his name meant "the knight of the new house." He followed in the grand tradition of Champlain at Port Royal and the Vikings at L'Anse aux Meadows: with unlimited territory to choose from, he put the development in the wrong place. The colony promptly had to be moved to avoid flood waters.

The population had remained limited throughout New France, however, because of a shortage of wives; so in 1663 the colony wrote to the king and requested boatloads of women. The king complied, producing what Peter Whalley called "the golden age of Canadian longshoring."[10] However, there were some bad apples. History records that in 1687, "two women of bad character"[11] were sentenced to serve as support staff on construction projects (another first in Canadian building). History does not record, however, what this assistance did for productivity or overtime.

There were already visible concerns about construction delays. In 1685, a Montreal mason was actually prosecuted for spending his time in taverns instead of finishing his job.[12] By 1689 the government was sufficiently worried about absenteeism that builders could be arrested and their property confiscated for non-fulfilment of contracts.

But tensions between government and "the construction industry," such as it was, were already long-standing. In the previous decade, Governor Frontenac had introduced Canada's first building permits[13] because houses were being built in the most improbable places. For example, "Montrealers built houses on top of the fortifications and in front of them":[14] musketeers would be useless against *les Anglais* if there was a suburb in their line of fire. Furthermore, willy-nilly construction offended successive governors' senses of order. The French nobles admired René Descartes, laid out their gardens in straight lines, and had a passion for symmetry. Louis XIV was known to lecture his mistresses about straightening the furniture.[15] The street plan of Montreal had been symmetrically laid out by the Superior of the Sulpician Seminary himself.[16] The dictates of logic, however, had to be reconciled with certain practical realities.

For starters, Canada did not enjoy the bucolic pleasures of *la douce France* (mellow France). To withstand snow loads — particularly in the middle of the Little Ice Age — roofs were built at 55-degree angles: that meant two-thirds of the height of the house was gobbled up by the roof. Any openings or cracks in the walls meant that "the wind can feel like needles driven into the skin."[17]

Builders would stuff almost any available material between timbers or stone. This fill for cracks and

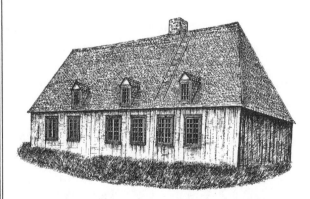

New France would have sympathized with the *All in the Family* episode where Archie Bunker said he would install aluminum siding on his house, whereupon Meathead observes that Archie already had a brick house. French colonists even had a special word (*lambriser*) for putting cladding over masonry houses, such as this house in Beaumont, Quebec.

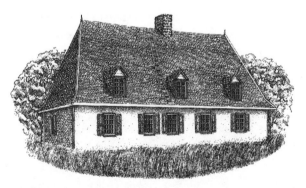

In recent years, many homes, similar to this one in Charlesbourg, Quebec, have been lovingly renovated by removing the *crépi* to expose the "honest authentic stone walls" which the French never saw and would have despised.

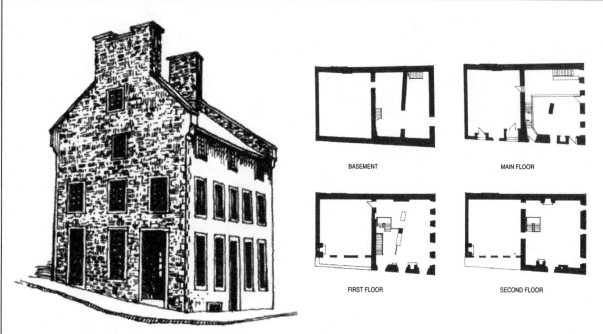

The Du Calvet house (1731) was reputed to have had some of the best parties Montreal ever saw. The immense fire gables were originally a code requirement. Its rooms were large and not subdivided. The counting of floors is on the European model (which is enough to confuse anyone), not the American model.

holes is called chinking. In half-timber construction, the chinking could fall out from around vertical timbers, so builders decided to use only horizontal timbers. (This energy-efficient change was promoted by builder Etienne Trudeau, whose direct descendant Pierre Elliot Trudeau introduced a home-insulation program three centuries later.) When the chinking was finished, the builder would seal the exterior with a goop called *crépi* (a cross between plaster and mortar). The resulting concoction looked like pastry.

The main floor of a typical house was almost totally occupied by a country kitchen. The upper-storey sleeping area was "narrow, poorly-lighted, and provided with tiny windows or minuscule dormers, for only the night hours are spent there."[18]

But Parisian tastes would eventually change all that: onto the stage of history strode Catherine de Vivonne de Savelli, Marquise de Rambouillet. In 1630 she converted her oversized closet into a private bedroom: there were no more multi-purpose rooms with crowds milling about. The demise of the multi-purpose room took Paris by storm. The first recorded mention of a *salle à manger* (dining room) came in 1634; and although it still took some time for the rest of Europe (including Louis XIV) to catch up, a new trend had developed in the art of home design.

One exception to the specialization of rooms was the bathroom. There wasn't any. Baths were rare in the country that had perfected perfume; Louis XIV took three baths in his life. Nature's urges were handled by a portable piece of furniture appropriately called a *meuble odorant*. This was not entirely satisfactory; the Duchess of Orléans wrote: "There is one dirty thing at [Versailles] I shall never get used to: the people stationed in the galleries in front of our rooms piss into all the corners."[19] The problem was at least as serious in New France, where no one wanted to gallop to an outdoor privy on a winter's night. The situation reached such a crisis that in 1727 some balconies were outlawed because, in the words of the Crown attorney, "the occupants of the house used [the balcony from which] to throw rubbish and other unseemly things."[20] The government had passed an edict in 1673 demanding "adequate latrines and privies," but had to re-issue that demand in 1676 and 1706.

The government also focused on fire protection, issuing decrees that insisted on very thick walls, which suited the builders perfectly, since they were paid *à la toise*, namely by the *volume* of the wall built.[21] So walls got thicker and thicker! Firewalls between houses had

Since mansard roofs included a lot of wood which could (if burning) collapse into the street, Canada's first building code (1727) tried banning them altogether, but failed to stop the spread of this design.

to extend above the roof lines, and detailed rules dictated the dimensions of chimneys. However, "The officials, alas, had no control over the dimensions of the chimney-sweeps, and in 1729 they were forced to request the dispatch of replacements from France because the two previously sent were now 'too plump' to get into the chimneys."[22]

This confusing web of regulations did not appeal to orderly French governmental minds, so they enacted Canada's first building *code*, in 1727.[23] It consolidated the previous rules; it banned wooden shingles (as a fire hazard), preferring roofing boards instead; and it banned mansard roofs.

Construction in Acadia followed similar lines. Louisbourg, for its part, undertook Canada's first zoning by-law in 1721, to reserve the harbourfront zone for uses directly related to shipping. The government backed down, however, when merchants protested that in an area frequented by sailors, other uses were essential. This lobby was headed by the tavern-keepers.[24]

By now, the French colonies had a healthy homebuilding industry. Big-time building contractors had been around since the 1690s. They included Claude Bailiff, Jean Le Rouge, François De Lajoue, and Madeleine Chrestien (Canada's first woman building contractor).[25] Some had copies of Vitruvius and de l'Orme for inspiration. They were probably closely knit: those in Quebec City even lived in the same neighbourhood.

Business was good. In 1704, less than a quarter of Montreal's houses were built of stone, whereas by 1731, so many houses had been constructed or upgraded with masonry (which was more solid and more prestigious than wood) that over half the city's houses were now made of stone.[26] Builders in Louisbourg were sufficiently prosperous that they could afford to buy their brick and boards in Boston.

In the Little Ice Age, the building season was only five months long. Homebuyers would meet a builder (preferably in the fall) and agree on the house to be constructed. The builder assembled materials over the winter; then the race against the weather began in the spring. "Workers wages here are high," said a 1693 report, "because of the rigour of the winter; these men can only work for five months of the year, and in this time they have to earn enough to survive in the seven other months."[27] The resulting distorted prices prompted a litigation parade, as contractors complained of being stiffed on the final instalment, and buyers claimed that prices were out of proportion with the quality received. Most of those seven "idle" months were spent trying to collect.

But they were also devoted to other things. In 1657, Jean Levasseur (alias Lavigne) got together with other timber-framers and joiners to found Canada's first recorded builders' association.[28] Its purposes were not commercial, but devotional — under the auspices of St. Anne, the patron saint of builders. Some say the members felt the need to pray together to get paid. The question of any builder's saintliness, however, remained a hot topic in New France.

Then came the fateful day when, as Charlie Farquharson put it, Montcalm woke up to find "yer Wolfe at yer … door."[29] A different era was dawning, with an infusion of novel housing ideas.

Amusing, Artificial, and Awful
1763–1850

In which the English arrive with their dead-pledges and scissors; lords continue lording; builders discover they have two feet; columns have good hair design; bungs are born; and things go bump in the night.

Victory at Quebec hardly represented the first British toehold in Canada. Martin Frobisher had attempted to establish a colony in the Arctic in 1578. The walls of his modest stone home overlooking Frobisher Bay, the first British house in North America, still exist. His development scheme turned out to be as sensible as the Rhinoceros Party's proposal for a pulp and paper plant there four centuries later. The British were more successful at Churchill in 1685, establishing a community that lasts to this day. In 1713, Britain consolidated her hold on most of Atlantic Canada.

In 1763, Britain wound up with central Canada after France traded away these "few acres of snow" (as Voltaire called them) to retain its islands in the West Indies. This was not a high point in the history of French real estate. However, the change in empires also raised other real-estate questions, such as how do you buy a house? Do you draft what the English redundantly call an "agreement of purchase and sale" (with mortgage financing), or do you go to your *notaire* and have your agreement written up with a *hypothèque?* In 1763, the answer wasn't obvious.

Like other jurisdictions in the Western world, New France's legal system had been preoccupied with land law. Its customs were anchored in Roman principles, and the jurists of New France had picked a Parisian variant as their model. This *coutume de Paris* had been superbly systematized by a writer named Pothier; and although there were still feudal wrinkles, it followed a logical course.[1]

English common law was another matter. "No one by the light of nature," said the jurist Lord Macnaghten, "ever understood an English mortgage."[2] More succinctly, Oliver Cromwell called the whole of English property law "an ungodly jumble."[3] It was unique.

This was thanks to William the Conqueror. Although most of eleventh-century Europe had some form of military feudalism, William carried it to such lengths that Roman principles could never make a comeback. The resulting vacuum was filled by legal stopgaps handed down by English courts: during the centuries when French jurists were busy re-establishing the grand design of classical legal "doctrine," English jurists were engulfed in the day-to-day

brushfires of specific cases. It is said that if civil and common lawyers had to design a path, the civil lawyers would ask engineers for the straightest logical route; the common lawyers would wait ten years, see where the grass was worn, and put their path there.

How did this distinct approach influence the way the medieval English bought houses? At first, the effects were unnoticeable: people had houses awarded to them for military service, or they inherited them; they almost never *bought* them. In due course, however, building and buying houses became more prevalent; but how did you then pay for them?

The buyer could pay cash; but if he wanted to finance the deal, there was a problem. For the loan, he could pledge collateral: this was called a *gage* (nobles in England spoke French, not English, at the time). However, this pledge was good only during the lifetime of the borrower: if Uncle Fauntleroy pledged his sword and his horse as security for a loan and then died, the lender was out of luck because the horse and sword would revert to Uncle Fauntleroy's heirs.

That arrangement was unsatisfactory in a society whose idea of recreation was to don armour, mount horses, then collide at sixty miles an hour. In order for creditors to have better security (just in case Uncle Fauntleroy got an axe in the head), they invented a contract called a "dead pledge," namely security which would survive when the borrower didn't. This, in Norman French, was a *mort gage*.

But this simply spawned more problems. What would the heirs of Fauntleroy Manor do when a stranger showed up at the door with a "mort gage" *purportedly* signed by their late uncle, who was no longer around to authenticate it? This raised the possibility of another familiar feature in the history of real estate: fraud.

So clerks hit on a precaution. On ridiculously long sheets of vellum (later, paper), they wrote the contract at the top, and a copy of it below. When the parties were satisfied that each half said the same thing, they took scissors and haphazardly cut an indentation across the middle. One party got the top half, the other the bottom. Later, if the indentation between the two halves fit, the parties knew they had an authentic version; otherwise one was a forgery. These indented contracts were called, what else, indentures.

Despite the growing number of property transactions, land and houses were still a sign of either family status or military status. This reached so profoundly into the soul of a property owner that when a noble's property changed, so did his name. In Shakespeare's historical plays, the parties are almost never referred to by their name, but by their lands: in *Henry V*, the king says "Go, Uncle Exeter, and Brother Clarence, and you Brother Gloucester." Imagine someone saying today, "Go Uncle 42 Elm Street, and Brother 10 Main Street, and you Brother Cottage at Fish Lake." The fact that King John (nicknamed "John Lackland") owned no significant lands in his own name was one of the sources of derision against him. Centuries later (when people were named after families instead of lands), they still had the habit of giving names to their houses. A.A. Milne's Piglet lived at Trespassers William, and as every Japanese high school student knows, this practice was transplanted to Canada (or at least to Canadian literature) in Anne Shirley's P.E.I. home, "Green Gables."

By the time the British took over Canada, they already had a built-in respect for property and property law. Although they introduced their system to unsettled parts of their new territory, they retained the civil law system, even with its feudal ornaments, in the settled areas. For example, the Sulpicians, who were *seigneurs* (lords) of Montreal since 1663, were among many *seigneurs* who had enjoyed privileges like a monopoly on local milling and collection of feudal rents. In 1763 Britain abolished the more quirky feudal rights in Canada, but for the sake of stability allowed seigneurs to keep their titles and rents. This turned out to be less stabilizing than expected: the ongoing privileges of the nobility helped provoke the 1837 Rebellion.[4] In the 1840s, the government therefore undertook to abolish the feudal system; but the seigneurs claimed "vested rights," and insisted on being bought off. The government set up a mathematical formula to do so — which took more than a century to be carried out. One exception to this legislation was granted to the powerful Sulpician Order, that lobbied successfully for an exemption for their lands on Mount Royal.[5] Most homebuyers on those lands paid off the Sulpicians for clear title; but there are still households

near the Montreal Forum that pay small dues, on the only feudal lands left in North America.

The changeover from the French to the English system had other complications. French measurement was different: the French *pied* (foot) in those pre-metric days was different from the English foot.[6] Builders eventually mastered the new measurement (better than the more recent changeover to metric) but no one bothered to change the registry of deeds, still in French measure. This meant that anyone buying property had to double-check whether the dimensions were in French or English feet; and title-searchers for homes in the older areas of the Province of Quebec must be alert to this discrepancy to this day. The resulting concerns led one learned jurist to write a treatise entitled *L'inconvénient d'avoir deux pieds* ("The Inconvenience of Having Two Feet").[7]

And what about new houses? In many respects the eighteenth-century British house was not significantly different from its French predecessor. For starters, there was no preoccupation with bathrooms. Queen Elizabeth I had insisted on having at least one bath per month "whether she need it or no";[8] but this was viewed as an eccentricity. Anne, wife of James I, had her taste for this practice shaken when gases from her mineral bath momentarily ignited.[9] The rest of the population justly deserved the title "the great unwashed." Kitchen staff wore hats to keep fleas from swan-diving into the turnip soup. On those rare occasions when a bath was *de rigueur*, a portable tub could be removed from a closet, and hence no room needed to be allocated for the purpose. Other fixtures were also dispensed with: although the French nobility had adopted bidets in the eighteenth century ("a useful device in this ardent period"),[10] the English considered this an affectation. The humble privy, for its part, remained in the back yard.

By the 1750s, however, another invention was making its presence felt in British architecture, as elsewhere: the *hallway*. In previous centuries, builders had installed doors in each room to open onto the next; architects preferred to align these doors (*en filade*)[11] so that any self-respecting voyeur could see into five bedrooms in one glance. This practice suffered a severe setback from the Marquise de Rambouillet and her closet-bedroom; but it would take a century for the repercussions to be felt throughout conventional homebuilding.

Still another step forward was the popularization of stoves. Open hearths had a tendency to fill rooms with smoke, and they were so costly that one masonry fireplace was expected to heat a relatively large, open area. Stoves were a cleaner, cheaper source of heat, and their proliferation allowed builders to make rooms smaller.

The largest difference in English homebuilding, however, was style. In the 1600s England had fallen in love with columns, porticos, and anything ersatz Roman: this was the legacy of Christopher Wren. The entrances of public buildings looked like temples; Italian-style domes abounded; and Wren would have rebuilt the entire city of London in this image had he been given the chance.[12] One British cabinet minister described Wren and his influence as "amusing, artificial and awful."[13] In the usage of the day, these were the highest compliments imaginable: the style was "amusing" since it was clearly inspired by the Muses; it was "artificial" because it was an extension of art; and it was "awful" since it inspired awe.

In due course (and with the help of English translations of Palladio), this fixation permeated domestic architecture, particularly among rich colonials. Every property owner with money was busy installing columns, Palladian windows, and rigorously symmetrical façades in the best classical tradition. Monarchist architectural historians later named the style Georgian after the reigning kings, which obviously wouldn't do for post-revolutionary America. The Americans named it "colonial," and generations of citizens in the new republic expanded the term's use to include the furnishings as well. No other society on earth has been so devoted to the style of the period it felt so compelled to rebel against.

Most fans of Georgian/colonial homes were oblivious to the style's ancient roots: various decorations harked back to pagan sacrificial rituals. Putting these on a house is an architectural allegory for the liturgical slaughtering of a sheep. But it didn't stop there: "Columns, which are the building blocks of classical architecture, are generally assumed to have originated as tree-trunks ... [where] the

ancient Greeks conducted their religious sacrifices ... The flutes ... also suggested the folds of clothing; the capital was a headdress; the base, a foot. And the general proportions were intentionally human."[14] This may suggest that the Greeks and Romans had feverish imaginations; but a society which was able to discern hunters and bears in the constellations of stars was equally capable of discerning hairdos in the columns of buildings. But there were limits to how faithful a Georgian home could be to models of antiquity: countless property owners who wanted their homes to look like Roman buildings had never seen any. After the discoveries at Pompeii (1748–), a flood of new literature hit the market: as in other countries, Canada's version of Georgian evolved into "the neoclassical style ... which was much the same thing but with greater latitude and freedom."[15]

One particular flourish which this revised "neoclassical" style brought to homebuilding was a taste for round or oval rooms. However, Canada had its own reason for building circular rooms, which was supplied by Edward, Duke of Kent and father of Queen Victoria. His three visits to Quebec and Nova Scotia, between 1791 and 1800, left a legacy of round rooms and even round forts. There is an apocryphal story that Edward intended their occupants to avoid being cornered by the devil.

But the elegance of Georgian and neoclassical architecture was reserved for the top stratum of society. The rest of the population had no such luck. The founding of Halifax was an example:

> The street-wise, city-bred Cockneys were completely unprepared to face the Nova Scotian wilderness. Lacking construction skills and a realistic appraisal of the winter to come, most failed to build adequate shelters for themselves. Although Cornwallis, the Captain-General of the expedition ... sent to Annapolis Royal for house joiners and masons, the ratio of skilled workers to those who were either unskilled or unwilling was just too great. By spring more than a thousand settlers were dead.[16]

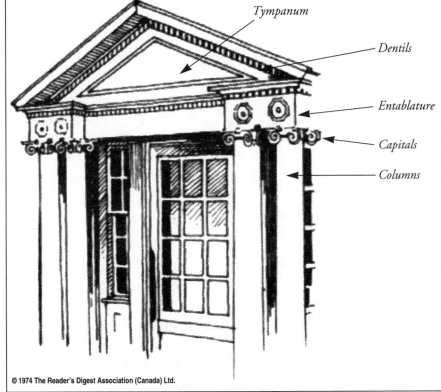

Tympanum

Dentils

Entablature

Capitals

Columns

© 1974 The Reader's Digest Association (Canada) Ltd.

Architectural terminology reveals the pagan roots of Georgian design. Part of a typical Georgian cornice is called the entablature (namely the "table" or sacrificial altar). Another part is referred to as the dentils (namely "the teeth"). A capital was supposed to evoke a Greek woman's hairdo; columns evoked sacred groves. The triangular area under the roof line was called a "tympanum after the structure of bones and animals skin that was used as a drum but could also double as a sacrificial table."[17]

In its simplest form, the Georgian style is an exercise in symmetry, like this house at Ship Harbour, N.S. (top left). With time (and money), it developed into more complex, neoclassical forms, like the 1829 Billings Estate in Ottawa (above) and the lieutenant-governor's home (left) in Charlottetown (1835). Technology played its role, too: improved glass-production techniques allowed larger panes and larger windows.

Canada's first affordable housing, for European immigrants, was the log cabin. Over the course of several centuries, it evolved into this twentieth-century creation in Whitehorse.

Most immigrants' first exposure to Canadian housing was the familiar log cabin, except in Newfoundland; there, timbers were aligned vertically and the house had the inauspicious name of "Tilt." Population skyrocketed after the American Revolution, when 7,000 Loyalists moved to what became Upper Canada, and 35,000 arrived in the Maritimes. By the 1830s log homes in Upper Canada still outnumbered all other types, two to one. Their average size was 300/400 square feet. For insulation, colonists used whatever could be found. Inland settlers used evergreen boughs; in the Maritimes every cavity in a house would be filled with a combination of mud and seaweed. As soon as a sawmill was erected in the area, homeowners would add a layer of clapboard to help keep out the cold. In Upper Canada's capital of Newark (now called Niagara-on-the-Lake), the buildings at Fort George were among the first to be clapboarded — which the Canadian Parks Service does not dare restore for fear of upsetting tourists who prefer the "rustic look" of logs. At least log cabins were cheap. In the 1840s Henry David Thoreau boasted of building a $28 house:[18]

After the disaster of Halifax's first winter, Lt. Col. Edward Cornwallis deduced that his superiors should send no more Englishmen, thank you. In due course, Nova Scotia found itself with large populations of Scots and Germans instead. The major Scottish migrations of the 1790s introduced Scotland's peculiar five-sided dormers; and the Germans in Lunenburg, where this house is located, created Canada's most elaborate dormer, resembling Bavarian pastry and called the "Lunenburg Bump."

Boards	$ 8.03½
Refuse shingles for roof and sides	4.00
Laths	1.25
Two secondhand windows with glass	2.43
1000 old brick	4.00
Two casks of lime ("That was high," said Thoreau)	2.40
Hair ("More than I needed.")	.31
Mantel-tree iron	.15
Nails	3.90
Hinges and screws	.14
Latch	.10
Chalk	.01
Transportation ("I carried a good part on my back.")	1.40
In all (Thoreau chopped down his own framing timbers.)	$28.12½

The tricky part of the work for rich and poor alike was the masonry, notably chimneys, fireplaces, and the like. The indispensability of masons, however, was no guarantee of payment, as one nineteenth-century anecdote records.

A mason builds a new fireplace for a wealthy man. When the mason finishes the job, he asks for his money, but the wealthy client says he can't pay just now. He doesn't have the right change. That's alright, the mason says. But if he has to wait, then the client does too. The wealthy man agrees. He won't build a fire in his new chimney until he pays the

mason. The mason goes home. Just an hour or so later, his wealthy client appears at the door. "My house is full of smoke, goddammit!" "I told you not to use that chimney until you paid me," says the mason. "When you pay me, I'll fix it." So the client gets out his wallet, which is full of change after all and the mason returns to the rich man's house. The mason brings a brick with him. He carries the brick up a ladder to the roof and drops it down the chimney, smashing out the pane of glass he'd mortared across the flue.[19]

This bungalow in Colborne, Ont., dates from the early nineteenth century, but would have been "at home" in any Canadian suburb over a century later.

In the early nineteenth century, people would probably have continued to want neoclassical houses, but for the tastes of a single individual. That individual was the Prince Regent. King George III was now thoroughly insane and his son (the future George IV) had taken over the reins of monarchy. In 1815 the Prince Regent commissioned a palace at Brighton, to be built on a theme from Britain's richest possession, India. Soon every self-respecting property owner in the British Empire also wanted something appropriately "Indian." Mazo de la Roche's fictional Whiteoak family, for instance, named their home after a place in India, "Jalna." English returnees from the sub-continent reported on a pleasant house style there — low-slung, and often surrounded by a large balcony to capitalize on the sub-tropical breezes. The Portuguese had named those balconies "*varandas*" (which the English misspelt) but the house design itself had no name. The style was therefore labelled simply with the Hindustani word meaning "from Bengal": bungalow.

Naturally, "retiring British officers came to Canada and wished to emulate the Prince Regent."[20] If they could not afford anything like the Brighton concoction, they could have "bungalows" instead. The fact that this was a housing style designed for the tropics was no deterrent: functional rationality seldom stood in the way of taste.

Although neoclassical was still the predominant style throughout Canada in the early nineteenth century, and many people had lain awake nights dreaming of a house like Tara in *Gone With the Wind*, competition from bungalows and other styles opened the floodgates. Some writers even espoused a revival of that most despised style, "Gothick." Soon, houses would have lancet (small gothic) windows, bargeboard (more commonly known as "gingerbread"), profusions of dormers and gables, finials, bay windows, and more. Alternatively, bits and pieces were added, inspired by Italy, Greece, or anywhere else exotic. "This marks the beginning of eclecticism in Ontario architecture, a characteristic trait visible in many houses today."[21]

How did an owner choose a style? The answer, said the "architects," was to consult an architect. That was not easy, since the profession did not formally exist. A school for architects had been founded in Rome under the emperor Constantine I (310–337), and another had been founded in France in the 1730s; but although the profession had nominal recognition from Louis XIV as early as 1671, it was not a force to be reckoned with anywhere in the Western world, least of all Canada. Architectural education would not even be formalized in Britain until 1850. References to the "great architects" of earlier periods has been a whimsical rewriting of history by subsequent generations of architects. The one thing these maestros had in common was the *absence* of any formalized architectural training. During the nineteenth century, people played fast and loose with the title "architect": one entrepreneur in Guelph signed the plans for his first two houses "George

42

Hall, builder," but signed the third "George Hall, architect."

How could "architects" hustle business? One way was to declare that anyone who built houses *without* calling himself an architect was a charlatan. Not only would "architects" read your plans, but they understood the principles of both design and economics; and the population should believe this to be true, because the "architects" said so. Canada was no different than the United States, where the nineteenth century is the story of architects attempting to take over the privilege of designing homes from builders:

> From colonial times until around 1850, clients and builders designed almost all houses in America. Architects had to create their profession against the odds. They had to persuade their countrymen that important distinctions existed between the art of designing and the act of building … Between 1830 and the Civil War, architects published scores of pattern and style books. At one point or another, most of those volumes argue that an architect offers the client protection from the builder … The argument plays upon the suspiciousness of clients about builders, a wariness that seems to have been around for so long that it probably deserves to be called natural. "There is a glaring want of truthfulness sometimes practised in this country by ignorant builders, that deserves condemnation at all times," wrote Andrew Jackson Downing in 1850, in one of his very popular style books. In this case, "truthfulness" means right-minded aesthetic sensibility. [When] competing with builders for the patronage of people with the money to build, in an age of emerging specialization, architects staked a claim on taste.[22]

This movement was reinforced by one of the most prolific aesthetic gurus of all time, John Ruskin. "It is very necessary in the outset of all inquiry," he thundered, "to distinguish carefully between architecture and building." Architecture was what was built by architects; what was built by non-architects would later be labelled (by architects) "vernacular." However, "architects" would continue to have a rough ride throughout the nineteenth century: "Architects were then, as they are now, interested more in the appearance of buildings than in their functioning. They were not prepared, by either training or inclination, to involve themselves in such mechanical matters as plumbing and heating. They also paid more atten-

The *Canada Farmer* touted "Gothic" houses as "a cheap country dwelling house." They took all of Canada by storm.

tion to the exterior rather than to the interior."[23]

But at least "consulting your architect" sounded better than "consulting your upholsterer." "The upholsterer was a business man who organized himself to respond to the homeowner's need for expert advice. By the time that architects realized that they had lost control of the interior arrangement of the house, it was too late. Upholsterers, or interior decorators as they were later called, came increasingly to dominate domestic comfort."[24]

As the nineteenth century progressed, the interiors of houses underwent substantial changes: "During the seventeenth century it had been customary for the women to go to a *withdrawing* room after dinner while the men stayed in the dining room to drink brandy, smoke cigars and indulge in boisterous conversation. Although the post-dinner separation continued for over a century, the now-renamed *drawing* room became a larger, more important space, usually located next to the dining room."[25] However, there were still no bathrooms available. "The 1794 edition of Hepplewhite's [furniture] guide ... described a pedestal and vase which he suggested using in the dining room ... after the ladies had withdrawn [the pedestal] was opened and the vessel was brought out for the convenience of the gentlemen."[26] In later years, a washroom would be installed directly off the dining room to substitute for this practice. The kitchen, on the contrary, was nowhere near the dining room: in well-to-do homes, it was typically in the basement, next to the servants' quarters.

These homes were constructed by professional builders. Although most members of the lower strata of society still built their own cabins, there were many contractors in Canada (who tended to be French Canadian) for years following 1760. Their techniques were reflected in the first buildings of western Canada, such as those in Upper and Lower Fort Garry and even the oldest unchanged house in British Columbia, Dr. Helmcken's home in Victoria. However, the number of English-speaking builders was growing, and stronger influences were now being felt from the United States.

For centuries, the basic system of house construction had been "post-and-beam": the house was held up by large posts, which, in turn, supported large beams. One builder near Antigonish used standing trees for his posts: he left them where they stood and built his house onto them. In the nineteenth century, however, the mass production of nails led to the development of a new system of framing: a lot of small pieces of wood nailed together could perform even better than a handful of large beams. In fact, the components could be as small as a new standardized dimension: "two by four." Old-time builders looked at this new technique with derision: they called it a "balloon frame" or, even less charitably, "stick-built." It nonetheless brought about a revolution in homebuilding.

Americans claim, of course, that this invention was a "peculiarly American method."[27] Some texts argue that George Snow originated it in Chicago in 1832, while others credit Augustin Deodat Taylor of Hartford, of the same era. The problem with these "discoveries" is that balloon-frame methodology had already been published in Britain in 1775, a year when Americans presumably had too many other revolutionary ideas on their minds to notice.[28]

Did stick-built houses truly cause the "demise of traditional craftsmanship"? Today, it is easy to assume that early housing was invariably a labour of love, but the heritage homes available for our admiring inspection are not necessarily representative. The houses still extant were usually the best built; the "jerry-built" ones have long since fallen down. There is no truth to the notion that "the early craftsmen could do no wrong."[29] One colonial builder "was constantly being hauled into court to answer charges that he'd made a floor so sloppily a person could put his hands between the boards, that he'd used badly splintered wood, that he'd built a windmill 'not sufficiently underpined' nor tightly covered. Answering charges about the windmill, this old-time craftsman's son said that he and his father 'did not care if the Divell had the windmill' as long as they got their money."[30]

But other builders took a different view. One of the visceral beliefs, if not superstitions, that British builders brought with them to Canada was the notion of *hubris:* to strive for perfection was one thing, but to actually achieve it in a house was so presumptuous that it invited retaliation from above. Sometimes a window would be placed in a deliberately asymmetrical position. The favourite technique,

The kitchen, like this one in nineteenth-century New Brunswick, was often a social centre. This role stems not only from Canadians' sense of conviviality; the kitchen was often the only warm room in the house.

The main differences between Italian villas, such as these, and their Gothic predecessors was that the new (Italian) style used less steeply pitched roofs and nearly always featured a tower. In opposition to their neoclassical counterparts, these buildings were as asymmetrical as possible. The one to the left is in Morrisburg, Ont.; the house above belonged to Sir John A. Macdonald, in Kingston.

To this day, the occasional renovator runs into something he would rather not. "Thorndean, an 1834 home in Halifax, also has the reputation of having spectral presences who have bothered restoration staff ... One night during restorations to the house, a workman was awakened by the persistent nudging of a ghostly presence who then beckoned [him] toward the indoor well in the old kitchen. The workman was frightened of being pushed in, and absconded from the job at daybreak."[31] This is a risk not covered in a typical renovation contract.

however, was the ubiquitous creaking staircase — the bane of tardy husbands.

The influence of unseen forces is, today, easier to believe when one looks at the style which emerged next: it later became identified with every novel beginning with the line "It was a dark and stormy night ..." This style was popularized by aesthetic pundit extraordinaire John Ruskin,[32] and was purportedly inspired by "Italian villas," although the connection is not very obvious. Stir these ingredients together, add some bombastic cornices, and you have the setting for every grade-B ghost movie ever made.

Admittedly, Canada has no site like the English village of Pluckley, which claims so many hauntings as to be in the *Guinness Book of Records*. Furthermore, renovators today need no longer worry about a case described by John Robert Colombo: the McDonald farmhouse near Wallaceburg, Ontario. "Between 1829 and 1831 the house was the focus of hails of bullets, stones and lead pellets; water and fire descended upon the house as if from the heavens ... the farm was heaved from its foundations, caught fire and burnt to the ground."[33] This is the most perplexing case ever of a Canadian house committing suicide.

Electrifying!
1850–1914

In which Canada turns on, Charlottetown has a gas, and Toronto gets enlightened; building sprees hit Canadian communities but bypass Punkeydoodle's Corners; houses turn green in the spring; and, thanks to Thomas Crapper, even the Crown meets the throne.

Although he may toil in silence, and remain unknown, and may not receive the least encouragement among his labours, or reward for his pains, yet when [the hapless inventor] disappears he leaves something in the hands of his successors that may administer to their wants, and render them wiser and more happy.

Abraham Gesner[1]

If it weren't for Edison, we'd all be watching television by candlelight.

Apocryphal[2]

In the centre of the Italian city of Como stands a Roman-looking "temple." Beyond the statue of toga-clad Alessandro Volta at the high altar sits … a battery. Yes, this is a shrine to the local son who gave the world what is invariably "not included" with Junior's new fire engine. Our country has no comparable tradition of honouring Canadian inventors who changed the world. We let Americans claim that Fulton built the first commercial steamboat (when Molson did so on the St. Lawrence); we let Marconi claim the wireless radio (instead of Canada's Reginald Fessenden); and there is no statue, let alone temple, in St. Catharines honouring the immortal Gideon Sundback, who gave the world that item so vital to its survival, the zipper. And what about the men who caused the world to look at itself in a different light?

Perhaps a country with long, dark winters naturally produces inventors with a preoccupation with lighting. Nova Scotia's Abraham Gesner was a medical doctor, a professional geologist, founder of the first natural history museum in Canada (in New Brunswick), and the inventor of kerosene, which he first demonstrated in Charlottetown in 1846. Thomas "Carbide" Willson, the discoverer of acetylene, began his inventing career when his mother threw him out, for "fear of the house exploding."[3] From the mid-nineteenth century onward, technology would play a greater role in the character of the Canadian home; this would affect its lighting, heating, and plumbing.

The only problem with Canadian technology is that we don't have a Hollywood to rewrite history. Not only do our neighbours to the south claim that Alexander Graham Bell and his telephone were American,[4] but conventional wisdom also postulates that a good American, Thomas Edison, invented the light bulb — and almost everything else. In the years leading up to his "discovery," however, Edison was struggling. He was accused by one critic of wasting his time on some 1,200 unsuccessful formulas for light bulbs. "I have not failed," replied Edison: "I have discovered 1,200 materials that won't work."[5] So in 1875, Edison bought the ideas that Toronto's Henry Woodward had patented and which helped Edison to announce later that he had "invented the light bulb." Woodward died in obscurity, while Edison spent the rest of his life encouraging people to do their own thinking, as he had done.[6]

The effects of electric light were far-reaching. Oil lamps had been used for thousands of years but not even Leonardo da Vinci was able to improve on them. Wax candles had been invented by the Phoenicians; however, a chandelier of one hundred candles cast less light than a single, hundred-watt bulb does today. Both Bach and Handel went blind trying to scribble music by candlelight. Furthermore, since only the rich could afford beeswax, the rest of society had to use tallow candles, made of animal fats, which added to the stench of their houses. Switzerland introduced a more efficient oil lamp in 1783; in nineteenth-century North America, the oil came from whales (in Europe, from turnip seeds); but Gesner, followed by Woodward and Edison, helped civilization avoid falling prey to any possible whale shortage or turnip crisis. Edison's light bulb, however, was filled with so much platinum that it wasn't affordable. It took Canada's Reginald Fessenden to design a more practical bulb. Furthermore, Edison's bulb (and his other electrical inventions) ran on direct current (DC), but rivals like George Westinghouse pointed to the advantages of alternating current (AC). Edison replied that this would never be tolerable in a home. To discredit his competitors, Edison demonstrated the supposedly unsafe aspects of AC for domestic use by electrocuting fifty cats and dogs, one horse, and a cow. Nonetheless, AC took hold for domestic use, while

Edison's experiments made him the father of the electric chair.

Electricity could also be used to power Mr. Bell's new "telephone." Prime Minister Alexander Mackenzie became Canada's first subscriber … even though he had no one to speak to yet. Canadian homes (particularly those with teenagers) would never be the same again.

But public fascination with this new source of power and light didn't stop there. Toronto inventor J.J. Wright, who had gone to Philadelphia to install the first electric-arc streetlamp in 1879, set up the first generator for Canadian customers: it had twenty-five horsepower, and was hooked up to a total of twenty electric-arc lamps in downtown Toronto. And if electricity was already being delivered into

Electricity was a sensation. Dr. Jenny Trout, the first Canadian woman licensed to practise medicine, jumped on the bandwagon — but, like other doctors, got lower billing than the "electrician."

buildings for light, how about inventing *electrical appliances?* American textbooks state that the first electrical appliance was a New York coffee grinder (1883),[7] but Wright demonstrated one in Toronto in 1881. The world's first known electrical appliance was a partial success: the electricity worked well, but the grinder exploded, and the witnesses scraped sprayed coffee grounds off the premises (and themselves).

Wright was not necessarily the best advertisement for his own cause: his own offices were so poorly lit that his customers often paid by candlelight. The new source of light was also denounced by Toronto clergy as "an instrument of evil," which would "release girls from honest toil to wander the streets and fall prey to the wiles of Satan."[8] And then there was Pious Pete, the deranged Yukon prospector immortalized in Robert Service's ballad:

> I tried to refine that neighbour of mine, honest to God, I did.
> I grieved for his fate, and early and late
> I watched over him like a kid.
> I shadowed him down to the scrofulous town;
> I dragged him from dissolute brawls;
> But I killed the galoot when he started to shoot
> Electricity into my walls.[9]

But Wright's timing was perfect: Toronto's population tripled in the twenty years between 1871 and 1891 (from 59,000 to 181,000). The company set up by Wright and his partner, Henry Pellatt, served 200 buildings in 1890; but by 1895, some 35,000 indoor electric lights had been installed. In 1892, Thomas Ahearn served up Ottawa's (and the world's) first electrically cooked meals.

It took time for Canada to digest. Manufacturers were producing bulbs, sockets, and fixtures, with different specifications, and all were incompatible with each other. Appliances were also meeting a sceptical response. Electric irons, kettles, coffee percolators, grills, etc., were displayed at the Toronto Industrial Exhibition of 1893, and the Exhibition tried to entice people by offering free electric moustache/whisker curling; but most Canadians still considered electrical appliances too expensive, and their widespread acceptance would have to wait until the twentieth century.[10] Another inhibiting factor was the

Courtesy Elaine Kilburn.

Thanks to the spread of electric light, Henry Pellatt became so rich that he could afford to build a new Toronto home, Casa Loma, equipped with over 4,000 electric lights. It represented everything twentieth-century architects hated: "Not one single quality of good architecture does it display ... It is unfunctional, inconvenient ... its use of materials dishonest ... Architecturally it is one hundred percent hopeless ... Its like, we may hope, will never be seen again."[11]

absence of power delivery to many parts of Canada — which governments eventually helped remedy with a variety of "electrification" programs.

Electricity gradually superseded kerosene and banished tallow candles, thereby improving a house's smell; but other efforts along the same lines were under way. Some urban Victorians were so offended by kitchen odours that they installed their kitchens as far away as possible from the dining room. This tendency was resisted in many rural parts of Canada, which considered the kitchen the focus of family and community life. In parts of Newfoundland, for example, the kitchen could expect so many visitors that the floor was covered in sand to help keep it clean; it was also in the kitchen that you would hold "a scoff on d'floor" ("a scuff on the floor": a party) on weekends. The academic literature nonetheless expressed unabashed horror at kitchen smells and other airborne evils. In 1880 Britain, a doctor and an engineer wrote that room ventilation required fifty cubic feet of fresh air per minute per person; an American doctor recommended sixty cubic feet[12] (today's standards are five to fifteen). But as more ventilation ducts and grates were introduced, heating became more difficult. One inventor proposed "a

system of five-foot-high tubes that supplied fresh air at the level of the ceiling. This seemed to have worked well, except when house owners used the tubes as pedestals and placed potted plants or decorative ferns over the openings."[13]

The paranoia about ventilation also obstructed the spread of more efficient heating systems. To introduce hot-air heating would, according to one pundit, result in an "oppressive atmosphere [like] the Sahara."[14] Stoves, said another, "imprison all the cheerfulness of the fireside, and they are not economical, for though they save fuel, they make large doctors' bills."[15] As late as 1898, one American book insisted that fireplaces were the only acceptable form of heating for people of good breeding: "The good taste and *savoir vivre* of the inmates of the house may be guessed from the means used for heating it."[16] Perhaps refrigeration was considered a good way of keeping one's blood blue.

But air quality was also affected by another factor: dust. The Victorian home was virtually knee-deep in velvet, brocade, and other fabrics — all of which were excellent collectors of soot from the burning lamp fuel. Although some authorities suggested removal of all carpets, most people ignored this advice, and rugs continued to present a constant cleaning problem.

Household servants were still indispensable to the upper-class home. The foremost writer on housing on this side of the Atlantic, Andrew Jackson Downing, said that this went to the very definition of the word "house": he "differentiated between houses and cottages according to the number of servants that they contained — anything with less than *three* servants was a cottage."[17]

However, the upper crust had to be increasingly sensitive to another factor that would affect the prestige of their home: *location*. Centuries ago, it was easy to identify which house was in a "good" area: it was the one with the moat. By the nineteenth century, however, the distinction between "good" neighbourhoods and "bad" ones was more subtle. Aside from avoiding obvious factors (like not building your home downwind from the stables), owners and builders jockeyed for prestige by building next to other "prestigious" buildings. As the Industrial Revolution set in, it was popularly assumed that the

choice locations would be upwind from the belching stacks of the cities; in most northern countries, that meant that premium locations would be north and west of the core, not south or east. In Canada, where distance remained such a key factor in everyday life, access to transportation routes was also important. In due course, Canadian homebuilding would fall under the sway of real estate's most famous aphorism: the three foundations of value are "location, location, and location."

In nineteenth-century Canada, however, the challenge of finding the correct location for homebuilding was not confined to identifying good districts: you also had to pick a town which promised growth and prosperity. Immigration patterns were erratic. Some predictions were easier than others: it was usually safe to bet on "trans-shipment points" — towns where goods had to be moved from one transport system to another. Montreal, for example, sat astride a harbour and a railhead — and its population almost tripled between 1840 and 1860. These were more promising ingredients for development than the situation in the mining town of Barkerville, B.C., which was accessible principally by camel.[18]

Growth was nation-wide. In Quebec, a population boom spawned development beyond the St. Lawrence heartland. New communities were being named after their parish church; but when the supply of simple names like St-Chrysostome and St-Tite ran low, you could resort to double-barrelled names like Ste-Émélie-de-l'Énergie and St-Louis-du-Ha!Ha! In regions originally named by Loyalists, the double-barrelled effect produced hybrids like St-Élie d'Orford, St-Paul d'Abbotsford, and St-François Xavier à Pike River.

Elsewhere in Canada, some communities figured that they would improve their prospects for development with more appealing names. In due course, Gastown became Vancouver; Pile Of Bones became Regina; and Newburgh, west of Kingston, sounded like a better place to live than Rogues' Hollow. Other communities did not change their names, and suffered the consequences: Dog's Nest, Ontario, is still merely a speck on the map near Port Dover, and the fast lane also bypassed the hamlet west of Kitchener named Punkeydoodle's Corners.

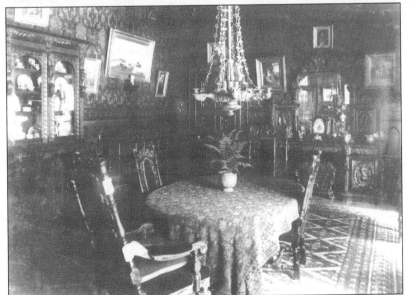

Victorian interiors, with their maximization of dust collectors. Canada owes the custom of "spring cleaning" to the latter part of the nineteenth century. Various species of manually operated "vacuum" cleaners, based on the principle of the bellows, were attempted: one "required the user to push the handle up and down like a pogo stick [and another] consisted of two bellows which the hapless maid was to wear as shoes, and which caused the nozzle to suck air as she walked around."[19]

One of the communities in dire need of a name change was Bytown: it was a rowdy lumbertown beside the Rideau Canal, which had been spawned by Lieutenant-Colonel John By (who was also the first official from "Ottawa" to be investigated for overspending). Bytown had become synonymous with one of its favourite weekend occupations: rioting. Nonetheless, it had grand aspirations, and the major issue of the day provided the opportunity for self-promotion. That topic was the most controversial housing issue in Canadian history: during the rebellions of 1837–38, many Canadians saw their homes shot at, blown up, or otherwise damaged; and in the 1840s they demanded compensation in a Rebellion Losses Bill. The Tories of the day, however, argued that most Canadians whose houses had been burnt to a crisp probably *deserved* it for sympathizing with the rebels; and Tory indignation over "rewarding disloyalty" was increased when Governor General Lord Elgin supported the bill (the governor general was being disloyal to himself!). The Canadas' capital was still in Montreal, and a Tory mob demonstrated its allegiance to proper authority by torching the Parliament Buildings. In Canada's most notable example of closing the barn door after the horse is out, Montreal chose this site for its Fire Station No. 1.

Jockeying for a new capital ensued, but Montreal was too dangerous, Quebec City was too far, Kingston was too invadable, and Toronto was too Toronto. When Bytown threw its hat in the ring and invited the governor general, local Tories decided on a reprise of Montreal: the rioting lasted for days. At its climax, the region's population divided between Grits and Tories and lined up on each side of the Rideau Canal armed to the teeth; the only thing keeping them apart was a formation of soldiers on the single bridge, with a cannon at each end. The standoff continued until the participants got hungry and went home for supper. Bytown avoided self-destruction, went on to rename itself Ottawa, and the rest is history. Canada's future capital was thus saved by the call of the kitchen.

Ottawa's most famous resident in the nineteenth century would be the man described as being "most charming when he exhaled."[20] Sir John A. Macdonald had owned several houses in Kingston, notably a spacious house in the "Italian villa" tradi-

tion, which he named Pekoe Pagoda. His Ottawa homes were in a different style, which was fast becoming more popular: their many gables were decked out in "gingerbread."[21]

Sir John A.'s taste in homes reflected that of the population at large. After 1850, the so-called Italianate style lost its "villa" designation. One favourite architectural peccadillo was a "widow's walk" — a cupola with a commanding view of the surroundings. This feature was originally associated with coastal houses, purportedly to allow seafarers' wives to watch for the return of their husbands' ships; but these soon became equally popular in landlocked areas, perhaps to enable their occupants to look down on their neighbours.

But other ideas abounded. American writer Orson Fowler proclaimed the virtues of octagonal houses to followers, including many Canadians. Fowler, who believed in phrenology (assessing personality by feeling the bumps on a person's head), said that eight-sided houses met two phrenological needs: "inhabitiveness and constructiveness."[22] He admitted, however, that the shape had more to do with practicality than with the bumps on your head: octagons enclose more space with less wall. Fowler also advocated a new material called "gravel wall" (now known as concrete) and he suggested "speaking tubes" (a primitive intercom).[23]

Sir John A. Macdonald's Victorian gingerbread home in Ottawa. This grand house, and the even grander title of its occupant, the Prime Minister of the new Dominion of Canada, did not prevent him from having chickens and a cow at his home. According to Lady Macdonald, there was nothing like a fresh breakfast to start a prime minister's day.

Countless Canadians chose their housing styles from publications like the *Canada Farmer*, printed in 1865. "Italian villas" evolved into "Italianate": corner towers disappeared. Designers borrowed increasingly from previous styles (like neoclassical and Georgian) and the resulting concoctions were labelled "eclectic." One of this style's most distinctive features, aside from the "eyebrowlike" arched windows, is the oversize brackets installed around the eaves, as if to keep the roof from sliding off the house.

In the latter part of the century, mansard roofs were in vogue, and the style associated with them was often referred to as Second Empire, thanks to their popularity during the reign of France's Napoleon III. This style gleefully pilfered bits and pieces from others: neoclassical elements around doors and windows, and Italianate features on cornices. A variant was the chateau style, which attempted to carry French inspiration into replicas of the Loire Valley. This worked well for giant public buildings such as the new railway hotels, but was more difficult for houses. Adopting the window styles of the chateau and creating the occasional turret on a small house never quite conveyed the grandeur of French chivalry.

A more eclectic approach was the Queen Anne style, which borrowed the old concept of half-timbers in the walls, and added tiles, shingles, and almost anything else. Chimneys were stretched, and windows might even turn up in the middle of them.

Choice of house colour often reflected the owner's occupation. Farmers tended toward conservative choices: the house was often white, with occasional colour on the shutters or trim. In fishing communities, tastes were reversed: houses were painted as brightly as possible. "Nowhere in the world ... is colour as effectively used as in the Maritimes."[24] The

reason is simple: Canadians living in coastal areas were fed up with losing sight of their houses in the fog.

The period from 1850 to 1914 was an era of social and technological change. In many rural parts of Canada, existing houses were being renovated to accommodate expanding families: a large addition would house the eldest son and his wife, who would work the family farm, while his parents stayed put in the original wing of the house. Metal coal-burning stoves allowed builders to install larger windows and smaller chimneys. Heating would have been even further advanced if the world had taken the advice of Canadian engineer Henry Ruttan, who, in 1860, advocated double-glazing windows.[25]

In 1841, American Catherine E. Beecher, sister of author Harriet Beecher Stowe (*Uncle Tom's Cabin*), had launched a long battle for more intelligent house design.[26] Her revolutionary suggestions included adequate closet space, comfortable kitchens, drawers for towels, space to store soap under the sink, continuous work surfaces, and other notions which had never appeared in architects' textbooks, because of what she called "the ignorance of architects, housebuilders, and men in general."[27] With Harriet she co-wrote *The American Woman's Home*, which insisted on central heating, pressurized water, and two (!) water closets. The Beecher sisters' model house could accommodate eight people within 1,200 square feet, whereas C.J. Richardson's *The Englishman's House* of the same era prided itself on the "compactness of arrangement" and "the economy of space" of a "small suburban villa" of 6,000 square feet. "It would have taken the continuous labour of at least two persons to dust, sweep and clean the seventeen large rooms of Richardson's 'small suburban villa.'"[28] The Beecher sisters also advocated a coat closet next to the front door, a broom closet in the kitchen, a linen closet in the upstairs hall, a medicine cabinet in the bathroom, and other equally "bizarre" new ideas.[29]

But the Industrial Revolution was honouring this advice in the breach after it hit Canada in the mid-nineteenth century. Canadians discovered the perils which had afflicted workers' housing in other "advanced" countries. Industrial civilization, combined with the massive influx of immigrants to Canadian cities, rapidly produced slums.

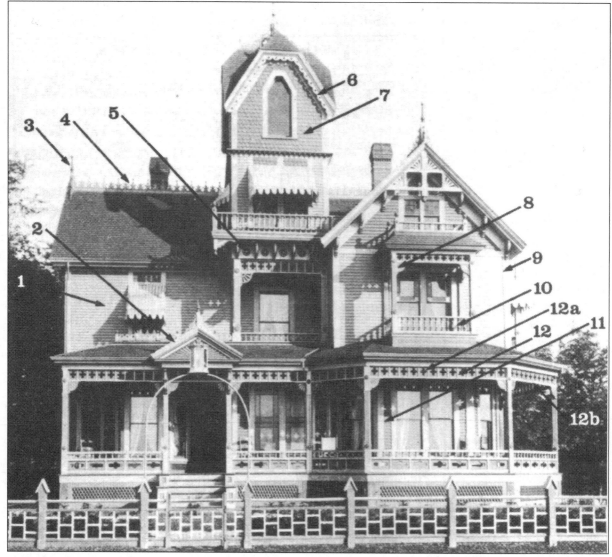

The late nineteenth century was marked by the Queen Anne style, like the Shand House in Windsor, N.S. The style is named after the early-seventeenth-century monarch, but has dubious links to anything built during her reign, let alone anything she lived in.

1. Shingles (shingle machine)
2. Moulding (moulding machine)
3. Finial (lather)
4. Cresting (scroll saw)
5. Rosette (lathe)
6. Verge board (scroll saw)
7. Ornamental shingles (shingle machine and bandsaw)
8. Bracket, perforated (scroll saw)
9. Smooth corner board (planing machine)
10. Balusters (lather)
11. Clapboard (planing machine with clapboard attachment)

12. Perforated panel trim: Each panel (panelling/carving/moulding machine) is separate and slides into grooves (planer/matcher) cut in the dividers (12a) and rails (12b). The dividers have a tenon (tenoning machine) cut on each end. The complete decorative units of 10 panels each could be assembled, then installed as a 10-panel length of trim. A panelling/carving/moulding machine (ancestor of the router) could produce the panels. A tenoning machine could cut the tenons on the dividers and a planer/matcher cut the grooves into which the panels slide.[30]

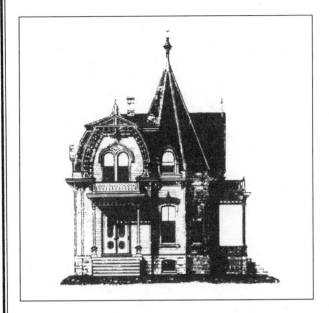

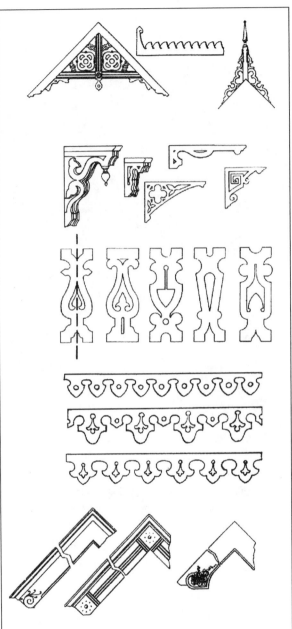

Canadians could buy a house plan from a catalogue, like this design published in Montreal (above) in 1871 and built in Bridgetown, N.S. (below), in 1873.

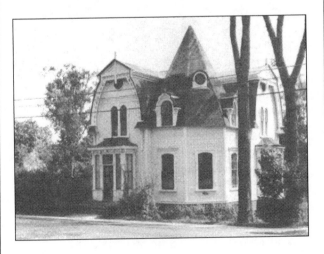

Victorian ornamentation knew almost no limit. One factory in Shelburne, N.S., advertised no less than 1,500 styles of moulding. That variety would have been impossible before 1850, but with the spread of machinery to produce "gingerbread" for Victorian buildings, decorative possibilities were limitless. In Nova Scotia alone, there were over 100 such companies operating at the turn of the century.

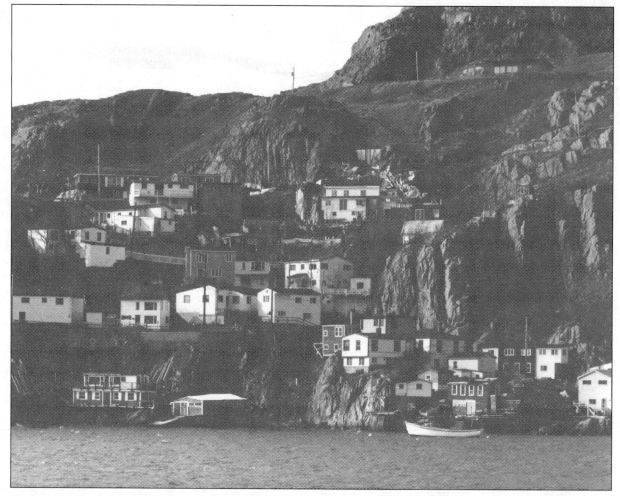

The Little Ice Age had worn off toward the beginning of the nineteenth century, and with the advent of bituminous shingles (which were more water resistant than wood), builders were no longer obliged to build roofs with such steep slopes. Coastal climates and lower snow loads allowed roofs to be almost flat. These houses, such as the ones in the St. John's suburb of The Battery, were elegantly named the "Maritime Box."

Countries responded to this problem differently. In England, Octavia Hill (bankrolled by John Ruskin) began a campaign for subsidized housing, on the premise that "the spiritual elevation of a large class depended to a considerable extent on sanitary reform."[31] In 1855, the New York Society for Improving the Condition of the Poor built a "Big Flat" with eighty-seven apartments, whose fate would foreshadow public projects to come. "The home was not successful ... By 1886 the Big Flat was a pesthole ... The ground floor rooms were given over to prostitutes and cheap saloons; in the early 1880s, police raided the six opium dens that were operating there." The Big Flat was torn down: "Poor design and miscalculation destroyed it. As a home for poor but honest working women, the house failed because poor

but honest women did not want to live in the neighbourhood. Rent is not the only factor in the choice of a dwelling. There are expenses and benefits which affect rent but are not part of the usual calculation. People buy neighbourhoods and are willing to pay for neighbourhoods."[32] Other writers just gave up on slums altogether: "Wickedness and vice gravitate toward [the slum] and are ten-fold aggravated, until crime is born spontaneously of its corruption. Its poverty is hopeless, its vice bestiality, its crime desperation. Recovery is impossible under its blight. Rescue and repression are alike powerless to reach it. *There is* a connection between the rottenness of the house and that of the tenant."[33] This pessimism was sometimes combined with the attitudes of the Victorian age: "[Slum dwellers] seem inaccessible to

any good influence, and it is only by removal and a change of circumstances that we have much hope of seeing these barriers broken down, and a willingness manifest to listen to the truths of the Gospel."[34]

Sermons on the evils of slums have been made ever since the days of Babylon, and have seldom had lasting effects. Even Queen Elizabeth I introduced a property tax to subsidize social welfare — the ancestor of many taxes today (it was the only form of tax which she could manoeuvre at the time) — but for centuries, wealthy taxpayers found ingenious ways of stonewalling such initiatives. The rich might have continued to do so during the Industrial Revolution had it not been for a French chemist named Louis Pasteur. Pasteur's importance to world history was already assured (he improved French wine) when he announced, in 1865, that disease could be spread by germs. Although slums and their open cesspools had long been suspected as a breeding-ground for disease, Pasteur's discoveries proved it. Historically, this was environmentalism's first major coup, because the corollary was obvious: conditions in the slums were not just a nuisance for the occupants, but a clear and present danger to even the rich and powerful living miles away. The wealthy were as vulnerable to epidemics as anyone else: well-to-do Victorian houses usually included a "sick room," near the kitchen, since the typical family usually had at least one member who was ill at any given time. Now that Pasteur had given new urgency to the war against disease, local authorities were under intense political pressure to build sewers and water mains — and to use the most common revenue-producing device of the day, the property tax, to pay for them. This set a pattern for development for the next century; this incipient environmentalism helped lay the philosophical groundwork for urban planning and infrastructure.

Urban crowding, combined with the Canadian tendency toward wood construction, also created a staggering fire hazard. Fredericton burnt to the ground in 1825; Saint John, N.B., in 1837 and again in 1877; St. John's, Nfld., in 1846 and 1892; Toronto in 1849; Quebec in 1864; Vancouver in 1886; and Ottawa in 1890. The task of firefighters in St. John's in 1892 was made no easier when their hoses caught fire. The only city which seemed to derive any benefit from these conflagrations was

Saint John, N.B.: as the residents rebuilt, they capitalized on ballast that British vessels were unloading. It was a "useless" African wood whose main virtue was supposed to be its weight: mahogany.

The typical urban Canadian in the latter 1800s who wanted a house would first buy a home-design book. He would then approach one of the many lumber mills, which offered a wide variety of ornamental options. In an early example of vertical integration, lumberyards and building firms were often controlled by the same people: on his return from the lumberyard, the owner might have already arranged every conceivable aspect of the construction, short of carrying his bride across the doorstep.

The Industrial Revolution also produced a new housing arrangement: the company town. "Dependency was considered stronger if the company retained ownership of the houses, renting them below the going private-market rates. Programs of hiring and firing — or threatening to discharge an employee — worked most effectively in conjunction with company control of the housing stock."[35] For example, miners could be evicted from their houses during a strike.[36] Alternatively, a company could sell a home with a gigantic mortgage to a miner: "A miner blacklisted by the company could never hope to make his mortgage payments."[37] This was compounded when companies located in remote areas with no existing private-sector developers. At Sydney Mines, for example, row housing was built "often without foundation, always without insulation, sewage systems or wells ... Town planning in a mining community followed a simple concept: leave enough space at the pit-head so the families do not get underfoot, and then build the houses."[38]

Conditions were miserable. "After 1910 ... none of the advances that had lately taken place in the field of public sanitation were introduced into mining towns. Thirty to forty families might share a well, located within forty feet of a stable. The companies did not think it necessary to provide a privy for every family ... The rents for these properties did not cover the cost of repairs. The rents could not be raised because the wages were too low. The long working hours and low wages engendered a resentment so strong that the tenants themselves would not make

improvements because they were company property."[39]

> The houses generally have no kitchen or cellar, and in certain districts, in default of waterworks, water is either delivered by the operators in carts or has to be carried from a distance ... There is an almost total absence of bathrooms or water closets, due, we are informed, to the lack of sewers. There is much complaint of the lethal conditions of the roofs, of ill fitting doors and windows, of floors that are rotted or badly worn, and of walls on which paper and plaster are in shreds and patches.[40]

Although the victims of the Industrial Revolution in other countries could do little but sense a growing feeling of entrapment, Canadians had a ready-made escape: they could move west. In the 1890s, Canada opened the floodgates to immigration. Lord Strathcona of the CPR predicted that Canada would have 80 million people by the end of the twentieth century.[41] Among the first arrivals in the West were Chinese, who put their own stamp on the neighbourhoods they built. In Victoria, for instance, their labyrinthine alleyways are still prominent.

The ancient Chinese belief in Feng Shui prescribes precise rules concerning not only house construction itself, but also location. The preference for front doors facing alleys, instead of major thoroughfares, is simple. Evil spirits have bad brakes; they can't manoeuvre around sharp corners into alleys. For that matter, Feng Shui dictates that every entranceway, whether to a home or a business, should include a vestibule with a right-angled turn, for the same reason. The walls adjacent to such an entry are presumably littered with the invisible remains of countless evil spirits foolish enough to try flying through the door, but not agile enough to avoid disaster.

Feng Shui also addresses the layout of every room within a house. A misaligned bedroom, for example, is expected to cause its unfortunate occupants "headaches, surgery, failure of careers," etc.[42] Of almost equal importance is the street number. An address with a *nine* brings luck; the owner of a home at 999 Ninth Street would be borderline delirious. Four is unlucky, so a Chinese buyer of 44 Elm Street might be expected to drop by City Hall to negotiate a change of address. The Chinese are hardly alone, of course: in most Canadian and other "Western" highrises, the thirteenth floor is conveniently mislabelled to the present day.

Thanks to Chinese labour came the railroads, which in turn brought would-be farmers lured by the prospect of homesteading on 160 acres of prairie — which sounded like an empire. The Saskatoon Board of Trade announced: "It is not surprising that our farmers succeed so well, the crop never fails."[43] "No better climate for children," said another such board, "than that of Northern Alberta is to be found in America."[44] Not everyone shared such enthusiasm for the prairie lifestyle, however; in 1876, the YMCA named Winnipeg second on its list of "the wickedest communities in Canada," after Barrie (Ont.).[45] Winnipeg had only a hundred permanent residents when Manitoba entered Confederation in 1870; three years later, it had some 2,000 and wanted incorporation as a "city." "When its bill of incorporation was delayed ... indignant citizens seized the Speaker of the House, dragged him from the build-

The forces of law and order pose in front of Vancouver City Hall, 1886. Two years later, Vancouver had Canada's first official "real-estate board" (association of real-estate brokers and agents), which thrived until World War I, faltered, and then was resuscitated in time for the Roaring Twenties.

A walking real-estate ad in Exeter, England (1909). "Nothing to compare with the great mass migration into western Canada ... ever happened in the world before. Nowhere ... were more people enticed, cajoled, persuaded, induced, gulled, and just plain bamboozled into tearing themselves up by their roots to journey half a continent or half way around the world to a land where not a single constructive step had been taken by anybody to prepare for their arrival."[46]

The rush for property, Prince Albert, 1909. Elsewhere on the prairies, new arrivals would camp overnight awaiting their crack at "the last best west."

ing and treated him to a tarring and feathering."[47] Another major trading post on the prairies, Fort Edmonton, had only 263 adults in 1881; and prior to 1875, Calgary didn't even exist. Vancouver was little more than a few shacks assembled around the community's founding structure, Gassy Jack's Saloon; but all that was about to change.

Saskatoon was an example. In 1882, the Toronto-based Temperance Colonization Society founded Saskatoon as a utopia "free forever from the threat of distilled damnation."[48] Booze could cost you your home, under the terms of the covenant which each prospective resident was expected to sign: "I hereby, for myself, heirs, executors, administrators and assigns covenant and agree ... not [to] sell or exchange in wines, beer, ale, spirits, intoxicating liquors, or intoxicants of any kind whatever on or

upon any of the lands ... *on the penalty of forfeiting the same in case of non-observance.*"[49] Due to a legal miscalculation, however, the Society's covenant applied only to every second lot, and its restrictions collapsed. At the turn of the century, Saskatoon had 113 people; a decade later, it had more real-estate agents than that — and 10,000 acres outside the city limits had already been subdivided for residential lots. In the words of the Saskatoon Board of Trade, "Life here is by no means crude and uncouth; on the contrary it is cultured and refined. The general prosperity has not outcropped in vulgarity, but, in an unostentatious indulgence in such things simple, comfortable and beautiful as are dear to the soul of a tasteful and well-bred people."[50]

New arrivals in the West had two housing choices: they could try a rooming house or build for themselves. Public authorities tried to control conditions in rooming houses, but it was a losing battle. One court description heard of two Winnipeg operators:

M. Simok and M. Selenk endeavoured to ascertain how many adults they could crowd into a given space. Selenk managed to accommodate 43 occupants in five rooms where only 14 could hope to find suffi-

cient atmosphere for healthy respiration. Simok ran his neighbour close, having 24 in one room where only seven should have been. His rooms were too low and lacked ventilation. In consideration of the immense profits made by such economic means, magistrate Daly, at this morning's police court, charged Selenk $15 in costs and Simok $10 in costs.[51]

Comparable conditions, however, prevailed throughout much of Canada.

In 1912 Edmonton had a severe outbreak of typhoid fever … traced to rooming house congestion … In one rooming house there were seven rooms containing 31 single beds on the first floor and twelve rooms holding 29 single beds on the second floor. On Jasper Avenue a former store 24 feet by 60 feet was cut into two rooms. One side contained 19 double beds and the other five bunks for ten men. Neither of these dwellings contained sanitary facilities of any kind.[52]

The alternative, building your own home, was tricky when there were no materials, not even trees. The first challenge was to reach your property physically. "I would not like to put in words, here, the things I said about Canada," said one migrant, "what with the mosquitos and the oxen lying down with their tongues hanging out, and the horses kicking everything to pieces."[53] Then came construction itself — usually with sod. Some people were lucky and had other materials. In the words of one settler,

Winnipeg scene at the turn of the century. As one Winnipeg magistrate told a rooming-house operator, "People are supposed to live like human beings and not like hogs. In your house there was not space for a dog, let alone a man."[54] Despite that kind of problem (or perhaps because of it) Winnipeg founded Canada's oldest continuous real-estate board in 1903.

Our houses were made of spruce logs mostly. We had only two windows ... no upper floors, no glass, but a rawhide skin of a calf, deer or moose calf was used ... It was put on the window while wet, and nailed on with wooden pegs on slats around the window. When dry, it would be taut and might be used as a drum. It was not transparent, but gave light. Though not as good as glass, it had one advantage: no peeping tom was going to peep through your window ... but before the house had been occupied two days, the owner had to invite the neighbours to a big dance.[55]

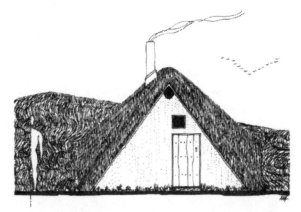

"To build a sod house, the farmer would have to cut the turf first with his plough, then with a flat spade or axe. Blocks a foot square were piled seven feet high, and poplar poles would be laid on top to support the sod roof. The roof would continue to drop water on the floor two to three days after a rainstorm had stopped. The house would turn green in summer. The insides were coated with clay, then whitewashed. Stoves were built of mud bricks. More than one family became stranded in their own home when several feet of snow piled against an out-swinging door. If no one came along or if the family lived alone in the country, the only alternative was having someone climb through the chimney."[60]

Coping with the cold was less fun. "Overnight, your eyelashes would freeze ... while those who had a beard like my father would be covered with icicles and white with frost."[56] This didn't do much for the prospects of *haute cuisine* in the kitchen either: "One morning it was quarter to twelve before I got the kettle to boil for breakfast. Everything liquid in the house was frozen solid. The kettle was frozen on the stove, my boots under the stove were also frozen ... the first blizzard that came left six feet of snow in the well, which did not melt until June ... It was interesting even if it were cold."[57] Another settler had similar "interests": "When it was cold and the door had to be opened to fill the water barrels, by the time the waterman had gone the kitchen floor was a sheet of ice."[58] Fortunately, the demands on the kitchen were not too onerous: "Our fare consisted mostly of mush and milk for breakfast, fried mush for dinner, and milk and mush for supper."[59]

Some sod houses were better than others. The Ukrainians were the best prepared. Typical Ukrainian construction on the prairies began with the excavation of the site: this was the same insulation principle which had been used by the natives for thousands of years, but which was also used in the mother country under the name "zemlianka." The roof was in four layers: poles, grass, a mixture of clay and chopped hay, and finally sod.

None of these houses had adequate bath facilities. The native populations of western Canada were usually far cleaner than the white settlers: they had "sweat lodges" which, along with their communal and spiritual function, also served nicely as first cousins to a Scandinavian sauna. This immediately aroused suspicion. White settlers deduced that anyone who could spend that much time on cleanliness had to be up to something: "Many a raid and many a deed of darkness has been started in the sweating booth."[61]

The absence of running water was hardly confined to rural areas. During the first decade of the twentieth century, Edmonton's population grew by over 700 percent and Calgary's by almost 1,000 percent; so neither sewer construction nor water mains could keep pace. "They became cities of back-yard privies which filled the surrounding countryside with nauseous odours on the hot summer nights."[62]

The condition of other components of the building stock were not much better. At the beginning of the century in Regina, "Lumber was hammered into stores and houses as fast as it could be unloaded, but the method of construction could

only be described as jerry-building at its worst. There was neither time nor inclination to be bothered with foundations. The crude clapboard buildings were erected on wooden beams laid on surface footings ... Few of the buildings were painted and, as the occupants were to discover to their sorrow, even fewer were weather-tight to the cold."[63] Regina's population between 1901 and 1911 increased by almost 1,400 percent. "Among Regina's 599 houses, only 48 had plumbing and only 15 had baths. It was not uncommon to have a flock of chickens in the kitchen [and] 60 percent of the dwellings were too poorly built to make water connections possible. When it rained the whole area became a sea of mud and manure."[64]

These were the circumstances under which various western communities "arrived" within the ranks of Canada's great cities. One newcomer among them was Dawson City, with its 16,000 residents housed mostly in tents. Dawson knew it had hit the big time, since its hockey team was in the Stanley Cup finals (it lost to Ottawa). Another newcomer was Calgary, which was described by one writer in 1912 as

> one of the great triumphs of the late 19th and early 20th centuries; it is a city which has arisen in a night, but it rests on long centuries of experience, and has arrived at full age at the moment of its birth ... a full modern life in a bracing upland air and amid delightful natural surroundings — these are but some of the good things within Calgary's gift. The mere thought of them has the stimulus of a mountain breeze.[65]

This assessment of the breezes was challenged by another observer, who described Calgary as "the horse-smellingest town I could ever remember."[66] In the words of one writer,

> Within that downtown area there was a livery stable in every other block ... the coal piles [beside the railway] gave off an odour all their own which somehow accentuated

the piquancy of the aromas being wafted from the bars and stables. The alleys behind the livery stables were usually piled so high with manure that access was impeded and the city fathers were continually complaining ... When the wind was blowing, and it usually was, Calgary was the dustiest and smelliest city between the lakehead and the Pacific. On calm days it was only the smelliest.[67]

Despite the occasional onslaughts of withering heat, no one had yet thought of air-conditioning buildings in Canada, despite the fact that the machinery to provide it had been invented in the 1840s. The invention is attributed to Dr. John Gorrie, who theorized — incorrectly — that since malaria is absent in cold climates, its victims could be cured by refrigeration. He worked in what was considered at the time to be one of the most pestilential hell-holes on earth, Florida, where he built the first air-conditioned clinic.[68] His therapy was not very successful: instead of dying from malaria, his patients died of hypothermia.

Another invention, however, would also have an impact on air quality. The days of urban stables were numbered with the advent of the automobile.

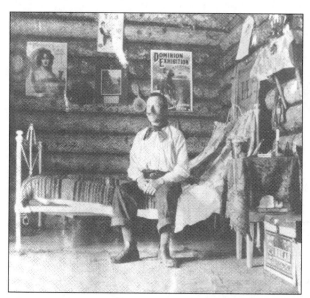

Belgian cowboy in a relatively luxurious log home, Millarville, Alberta, 1908.

Although the first horseless carriage had been built in France in 1769[69] (a model called the Andromonon was wheeling through the streets of Saint John, N.B., in 1851),[70] its international impact began only at the turn of the century. For example, in the 1880s France saw a two-storey steam-powered contraption which could careen around at a breathtaking five kilometres per hour. Unfortunately, no one knew where to *garer* ("place" or "park") this thing. Shelters were needed to protect these prized inventions from the elements; and the French, in their inimitable way, simply called such a structure "the parking": *le garage.*

In turn-of-the-century Canada, all roads led to the sprawling metropolis, Montreal. Although populations were mushrooming in cities across the country, many of Canada's new arrivals never went further than their port of entry. In 1913, Canada admitted over 400,000 immigrants. Proportionately, this was the same as if Canada were, today, to admit an immigrant population the size of metropolitan Vancouver — annually. Over 1,100 new settlers were reaching our shores every day. Many were crowding into Montreal's innumerable walk-up apartment buildings.

The homes of the rich and famous, of course, had no such dilemma. The residential area west of McGill University became known as the "golden square mile": "Those who thought that the government of Canada was in Ottawa were mistaken, it was *here.*"[71] But Montreal was not satisfied with its "natural" population growth due to immigration: between 1883 and 1914, it also annexed twenty-seven neighbouring municipalities. It wanted to present a better face to the rest of the world, in order to attract people and money.

As early as 1851, Montreal was acquiring the reputation of being exhibition-happy — and not only because of its continuous "civic jubilifications."[72] This city was also an exhibitor at the very first world's fair, the London Exhibition of 1851. Montrealers took particular pains to respond to that scurrilous newspaper *The Times* of London, which stated that Canadians had to take their thermometers inside in winter to thaw them out.[73] If Montreal had an Achilles' heel, however, it was its philosophy on politics and urban development. Stephen Leacock compared the Montreal politics of the era to the nursery rhyme of Little Jim:

His friends were much hurt
To see so much dirt,
And often they made him quite clean,
But all was in vain;
He got dirty again
And never looked fit to be seen.[74]

But the entire world was indeed becoming a cleaner place. Pressurized water had become increasingly accessible in the 1870s; and this opened the door to significant changes. A major innovation was the introduction of the *shower.* Another change was introduced in the United States, which rightly claims credit for having invented bathrooms in which the

In the late nineteenth century, the Montreal walk-up had been given a new feature: to save heat, the stairs were placed on the outside. These graceful stairways, usually made of wood or cast iron, would invariably ice over in winter, creating one of Canada's best make-work projects for lawyers.

water closet and the bathtub were in the same room. (In Europe, to this day, it is hardly uncommon to see a wall separating the two.)

The water closet itself had changed drastically over the years. Although the idea for toilets had existed since Minoan times, three thousand years ago, and had been revived by the Holy Roman Emperor Frederick II, a modern toilet (of sorts) was invented in 1596 by Sir John Harrington, Elizabeth I's godson. He was also a poet and a satirist when he wasn't inventing toilets — and had better luck with his poetry because the lack of pressurized water limited his invention's practical applications. Refinements were introduced in 1778 by Joseph Bramah; but these were also of limited use in the absence of pressurized water. The true revolution in toilets would have to await the arrival of Thomas Crapper, who was born in Yorkshire in 1837, trained as a plumber, and had set himself up in business as a "sanitary engineer" in London by 1861. His "valveless water waste preventer" went on exhibition in 1884. In short order, it would become a necessity in all "civilized" countries. As described in Crapper's biography *Flushed with Pride*, his invention followed many trials

The bath finally comes into its own — with a distinctly Victorian flavour — in the late nineteenth century.

which occasionally drenched the experimenters. He was undaunted: "There is no question that Crapper's heart was in the toilet."[75] The public's interest in this new appliance was reinforced when it learned that Queen Victoria made a detour into the English town of Doncaster to use Mr. Crapper's invention. This line of toilets was called The Unitas — not to be

Nineteenth-century shower. Although hot water was not easy to pump through the system, the Victorians preferred cold water anyway because it was considered more "bracing." There were limits, however; according to one report of the time, "Nearly freezing water from a Shower Bath produces a feeling somewhat akin to what might be imagined to result from a shower of red-hot lead; the shock is tremendous, and the shower if continued for any length of time, would assuredly cause asphyxia."[76]

Various models of toilet by Thomas Crapper, who also developed the cantilevered toilet: working parts were all concealed in the wall. In recent decades, this was considered "terribly modern," but Crapper had developed it for use in prisons, so that no movable parts could be yanked loose in a riot.

confused with other Victorian models with daunting labels like The Deluge or The Tornado. There has been speculation on whether Queen Victoria's preferences in this regard were the origin of the nickname "throne."[77]

The high point in Crapper's career occurred when he was engaged to produce a custom-made toilet with velvet-upholstered arms and back. This was by order of none other than his Britannic Majesty King Edward VII. However, this king of loos was not intended for His Majesty's convenience but rather for that of Edward's darling, lovely Lily Langtry. Unfortunately, the history of Canadian housing shows no comparable record of such a romantic gift.

Criminals and Pathological Cases
1914–1939

In which architects meet Tut and the truckers; planners get wisdom from the chocolate factory; houses and stoves are tailored to fly; and, in housing, Canada makes the world safe for bureaucracy.

It was 1906. Architect Stanford White sat with Evelyn Nesbitt Thaw in the rooftop cabaret of his Madison Square Garden. Although he was world famous (he had also designed Montreal's Mount Royal Club), White's mind was frequently on other things — including the lovely Evelyn, who, inconveniently, was otherwise married to railway heir Harry Thaw. As patrons awaited the show, Harry approached White and put three bullets in his head. Too rich for the electric chair, however, Harry did time and during those eighteen years the world underwent an architectural revolution. On his release in 1924, Harry took one look at one of these new concoctions and exclaimed, "My God, I shot the wrong architect!"[1]

Dramatic events occurred in Canada, too, while Harry was up the river. The era's building boom was already slowing down in 1913, and World War I killed it. Construction was at "a virtual standstill."[2] The Great War not only swallowed the GNP, but even forced Ottawa to introduce a "temporary income tax" in 1917. Many prairie communities had so expected to become the next Chicago that they named their first street 101st Street, fully expecting development to quickly fill in the missing 100. Some are still waiting.

But the time was getting ripe for an upheaval of another kind. Victorian tastes had run their course. The modern age, said the pundits, would need to be less cluttered and devote itself to no-nonsense practicality. Style was not an end in itself: "Form follows function."[3] The artistic establishment took to the warpath: in painting, Seurat "reduced" art to its "constituent points" and Kandinsky eliminated "representation" of a subject altogether. In music, Schoenberg reduced composition to its elemental mathematics. Oscar Wilde's consummately Victorian quip that "nothing succeeds like excess" gave way to Robert Browning's "less is more."[4] Last but not least came architects, who agreed with P.G. Wodehouse that "whatever may be said in favour of the Victorians ... few of them were to be trusted in reach of a trowel and a pile of bricks."[5]

This was hardly the first time that the Western world's aesthetic establishment had done a 180-degree flip: since the Renaissance there had been at

least four instances where European tastes jumped from asceticism to extravagance, and back. The flamboyance of the sixteenth century was replaced by the sobriety and puritanism of the seventeenth — which was overwhelmed in the eighteenth century, when Europe decided to go for baroque. The nineteenth century reacted to that with austere classicism — which succumbed to Victorian gingerbread. Western civilization, apparently manic depressive, was about to suffer yet another major mood swing, which would have far-reaching effects on housing styles.

The first of the revolutionaries was an American college drop-out named Frank Wright. His mother had chosen architecture for Frankie's future while he was still *in utero*; she also insisted that he add her maiden name, Lloyd. In Wright's time, mainstream housing stayed busy reviving previous "colonial styles," regardless of whose colony was involved. Americans led the way with English colonial, Dutch colonial, Spanish colonial, etc., to which Canada added French colonial; and plutocrats favoured the aura of stability and power conveyed by a Tudor revival.

Before the turn of the century, Frank Lloyd Wright began building and then popularizing what he called Prairie style, which sounded better than "the Chicago suburb style," which is where his studio actually was. Much of Wright's work was experimental: "The best friend of the architect," he said, "is the pencil in the drafting room, and the sledgehammer on the job."[6] "The physician can bury his mistakes, but the architect can only advise his client to plant vines."[7] Wright's intent was "frank use of materials and definite absence of historical ornament ... Aesthetic form became a natural result of the organic growth ... of structure and materials."[8] Canadian Francis Sullivan, a Wright apprentice, transplanted these ideas to Canada at an ideal time (1911–16), which coincided with the revival of bungalows, broad roofs, and "frank" exposure of framing materials.

"Part of Wright's appeal was his outrageousness ... [he] never let his listener, or reader, forget that he was in the presence of a Great Man."[9] Wearing a cape helped. But Wright was Caspar Milquetoast compared to Adolf Loos, the frequently unemployed Viennese architect who referred to people who ornamented their houses as "latent criminals"[10] and

After the turn of the century, the "prairie style" and its close cousins from California started to influence Canadian housing; but in World War I, almost no one could afford to build, and if they could, it wasn't for cash. This advertisement appeared in 1918.

"pathological cases."[11] Loos's diatribes might have been dismissed as sour grapes, but they were picked up by an academic, Walter Gropius.

Gropius, the "Silver Prince"[12] who directed a small German design school named Bauhaus, labelled people who ornamented buildings "perverts."[13] Into Gropius's circle gravitated two further designers, Ludwig Mies and Charles-Edouard Jeanneret. Like Wright, Mies had no formal architectural education, but Jeanneret had taken a couple of years of courses during his painting career.[14] Mies

From *Walter Gropius*, copyright © 1960 by James Marston Fitch. Reprinted by permission of George Braziller, Inc.

Architecture lessons from Germany: Gropius's designs for apartments (1931), townhomes (1926), or interiors (1925) were, in the words of one professor of architecture, "ventilated by justice, lighted by reason."[15]

changed his name to a more aristocratic Mies van der Rohe; Jeanneret did likewise, renaming himself Le Corbusier. They then devoted their lives to denouncing artifice and pretension on the part of every other designer, living or dead.

Wright loathed them all. He called Gropius "Herr Gropius"; and whenever Le Corbusier finished a building, Wright told his associates, "Now that he's finished one building, he'll go write four books about it."[16] Nonetheless, the writings of Gropius, "Corbu," and Mies would so engulf architecture faculties that they named this triumvirate and its friends the Heroic Modernists.[17]

The result was total war on the home. Stripping exteriors and interiors became necessary, to "prevent us from falling prey to dullness, to habit and to comfort."[18] A house, said Corbu, should be merely "a machine for living"[19] instead of "labyrinths of furniture." A home should not have "furniture" but merely "equipment."[20]

The Heroic Modernists got their opportunity to preach the minimalist gospel at the 1925 Paris world exhibition: they had their own pavilion called Esprit Nouveau, "new spirit."[21] This "home of the future" did not get heroic reviews: it had the "prosaic literalness of a cold storage warehouse cube."[22] Esprit Nouveau had distinctive features:

> The colour scheme was stark: predominantly white walls contrasted with a blue ceiling; one wall of the living room was painted brown; the storage cabinets that served as room dividers were painted bright yellow … The staircase … was made out of steel pipes … the kitchen was the smallest room in the house, the size of a bathroom, and the bathroom, which was intended to double as an exercise room and had one entire wall built out of glass blocks, was almost as big as the living room. Even more surprising was the furniture; not only was there little of it, it seemed intentionally lacklustre.[23]

The whole idea came from a Parisian trucker's café.[24] This "machine-for-living" business had some loose screws: Corbu's "manual of the dwelling"[25] did not mention heating, barely mentioned ventilation, and proposed the kitchen be at the top of the house. "The job of the designer was to identify the 'correct' solution; once it was found, it was up to people to accustom themselves to it."[26] This was not a question of "taste": this was, according to Gropius, adherence to the undeniable "laws of design."[27] Wright's philosophy had similar overtones: "Progress," he said, "must be in spite of [the common man] although for him."[28] Corbu went further: humanity should not be given the option of hanging on to its reactionary homes. The Esprit Nouveau Pavilion displayed his plan to flatten downtown Paris and replace it with highrises of his own design. "The fear that individuality will be crushed out by the growing 'tyranny' of standardization," he said, "is the sort of myth which cannot sustain the briefest examination … It is obvious that repetition of the same things for the same purposes exercises a settling and civilizing influence on men's minds."[29] Since architecture was "the supreme custodian of civilization and the source of all progress, using technology as its model," any rational person[30] "had to either agree with the proposals expounded or become, by implication, an enemy of human survival."[31]

Mies agreed with Corbu's objective of depersonalizing everything: "The individual is losing significance; his destiny is no longer what interests us … [This is] part of the trend of our time toward anonymity."[32] To Mies, the basic appearance of a building would always be the same; variations would be strictly in the detailing. "God is in the details,"[33] he said, plagiarizing Gustave Flaubert, who borrowed the phrase from Saint Theresa of Avila. The essence of design is that "less is more," said Mies (plagiarizing Browning), so he undertook to bring architectural honesty to both buildings and their contents. Mies found designing a chair more daunting than designing his routine glass skyscraper. The result of Mies's considerable efforts was a chair displayed in Barcelona. "It exemplifies the ideals of contemporary chair design: it is lightweight, it uses machined materials, and it contains no ornament. It is a structure of bent chromed-metal tubing, across which unpadded

In due course, said Le Corbusier, all existing cities could be obliterated in favour of his own *villes radieuses* ("shining cities").

leather is stretched to form the seat, back and armrests."[34] It and two similar kinds of furniture were later chosen as among "the 100 greatest products ever produced by civilization"[35] according to a list assembled in 1957 by an influential group of designers. This reflects the extent to which the Heroic Modernists had enthralled the European intelligentsia — which loved the product even more when its stripped-down, "luxury-free" features were priced beyond the means of the bourgeoisie. Modernist home layouts would eventually be described as "conspicuous austerity."[36] "Modern simplicities are rich and sumptuous," said Aldous Huxley. "We are Quakers whose severely cut clothes are made of damask and cloth of silver."[37] With that objective in mind, the Modernists undertook to replace the world's housing with highrises, townhouses, and — wherever possible — single-family homes of their own design.

Heroic Modernism was not the only revolutionary housing philosophy sailing toward Canadian shores. Another arrived in 1914 in the person of Thomas Adams,[38] armed with Ebenezer Howard's book *Garden Cities of Tomorrow,* the bible of Britain's Garden City Movement. This campaign for model suburbs was backed by George Cadbury and other industrialists, who believed that there was more to life than chocolate. Adams was lured here by Dr. Charles Hodgetts, Ontario's medical health officer, who argued that only planning could avert a Canadian outbreak of the urban atrocities of the Industrial Revolution. Cadbury, Adams, and other

believers advocated communities where activities were divided by zones, greenbelts, and winding streets. Canada was fertile ground: Sir Wilfrid Laurier had established a Canadian Commission of Conservation in 1909, which was interested in better ways of planning almost anything. By 1919, Adams had founded what is now the Canadian Institute of Planners; he even drafted planning legislation for eight of the nine existing Canadian provinces. Adams felt he was fulfilling a moral obligation to those who fell in Flanders: "It is a question of simple fact that we have to pay a debt to these men; we have to live up to the ideal for which they fought, [meaning] to secure the full measure of justice for those at home."[39] This included a system of rational urban planning.

Just as Pasteur had opened the door to a first stage of environmental awareness when he proved that certain conditions are conducive to germs, so Adams and the growing movement toward urban planning heralded a second stage: Adams emphasized that urban issues are interdependent. "No matter what you decide to do, you will make mistakes. Housing problems are most intricate and most difficult … [For example] it depends a great deal on how you standardize, whether as a result of standardization you do not produce a remedy worse than the disease … [Furthermore] the question is how can we assist private enterprise by the distribution of public funds instead of injuring it? It requires the best brains of the country to be applied to it."[40]

But Adams's toughest assignment lay in Halifax. On December 6, 1917, that city had witnessed the largest non-nuclear man-made explosion in world history. Over 1,600 were killed and two and a half square kilometres of the city were totally levelled when a munitions ship was rammed in the harbour, and exploded. The blast was heard in P.E.I. The homes of over 40 percent of the population were heavily damaged or obliterated. For once, the Citadel played a defensive role (inadvertently): if it had not been there to shield the south and west districts, the entire city might have been blown away.

Eight days later, with his architect George Ross, Adams started to rebuild. Instead of Modernist cubes, his new housing had walls of pressed concrete (hydrostone), half timbering, and other features "to sustain the English cottage style."[41] This reconstruction scheme's major flaw was financing: the "Hydrostone" district's rents were supposed to bankroll disability pensions of injured Haligonians, but awkward financing priced the housing beyond the means of many of its intended beneficiaries.

Adams then worked on Ottawa's model working-class suburb, Lindenlea. The federal government's interest was not coincidental. In November 1917, an obscure writer named Vladimir Ilyich Ulyanov seized Moscow. He called himself Lenin and called the coup the October Revolution. This "first step in the Great World Proletarian Revolution" caused twinges as far away as Canada. Ottawa's growing concern over "the restive masses" led to a Royal Commission on Industrial Relations in 1918, which identified poor housing as one of the primary causes of social unrest.

Pressure for action on housing had been building. In 1909, the Commission of Conservation had preached a housing policy in "the light of science and modern sanitary methods … [which are] at the root of all happiness."[42] In 1913, Ontario first anticipated public housing by permitting municipally guaranteed bonds for such projects. Only Toronto responded, but its Toronto Housing Company went on to build 330 houses at Spruce Court and Riverdale Court. In 1919, the federal government used its powers under the War Measures Act to lend $25 million (at low interest) to the provinces for housing. This resulted in a four-year mini-spree: 179 municipalities built 6,242 houses with money transferred by the provinces. This was the public sector's first significant effort at fostering homebuilding in Canada.

Was the advent of government housing policy in Canada a sincere effort to tackle the slums or, as some argued, a sinister ruse by capitalists and their running-dogs to manipulate the toiling masses? To this day, some texts revile how governments, aided and abetted by chauvinists, tore the working class away from the breeding grounds of the Proletarian Revolution and imprisoned it in the ideological hell of the Canadian suburb. "The bourgeois … fought against any further articulation of working-class [housing] forms … The creation of the suburbs was in some sense a reactionary heightening of the myth of the ideal home, and of the myth of the woman and the family, in an effort to retain the preferred tra-

ditional practices … [as well as] a further isolation of the wife from the family, and from the social realm in general."[43] But the public sector's initiative collapsed under its own bureaucratic weight. There was so much criticism of municipal bungling that the program was terminated. Lindenlea itself generated a host of accusations pertaining to cost overruns, lax supervision, and outright fraud within the Ottawa Housing Commission.[44] Many officials were jailed.

The private sector, for its part, was growing more organized. Six new local real-estate boards were founded between 1918 and 1921.[45] In 1921, the first homebuilders' association in Canada was founded: the Toronto Home Builders' Association would foster exchanges of views, and help builders to respond better to public tastes.[46] The tastes of the entire world, however, were about to undergo still another jolt: on

November 4, 1922, archaeologist Howard Carter discovered a stone step carved into the rocky soil of Egypt. What lay below was the tomb of an obscure pharaoh named Tutankhamen. Although it took six years to record and retrieve all the treasures, Carter's discovery immediately ignited the popular imagination. The world went Tut-crazy. The upper crust suddenly discovered a desperate need for "Egyptian" furniture and decoration, often in a style that combined elements of Ramses II, Hammurabi, Montezuma, and Flo Ziegfield.[47]

As luck would have it, this occurred at the same moment when the world was being carried away with Henry Ford's automobile and the appeal of speed. There was a palpable public preoccupation with aerodynamics: automobiles and other vehicles were being redesigned to reduce wind resistance. More

Ottawa's Lindenlea. Housing for the masses? "After selecting their lots, homeowners could choose from five or six different house plans. Some owners even brought in their own plans … It certainly would have been less expensive to build totally standardized units, as the Europeans were doing at the time; however, while the designers of Lindenlea adopted certain Modernist tenets of building technology and standards, the aspects of individual identity and a picturesque setting remained fundamental principles."[48] The interiors, however, may have been less picturesque: built-in cupboards were still considered new and expensive. Lindenlea's kitchens had no cupboards and no counter space.

than a few "authorities" said that the "lines" of an object should be ideally contoured to synchronize with the air stream; in other words, objects should be "stream-lined."[49] The resulting amalgam of styles could have been the set of *The Ten Commandments* redesigned by Ettore Bugatti. This approach dominated most of the displays at the same 1925 Paris exhibit as Esprit Nouveau, namely the *Exposition Internationale des arts décoratifs & industriels*

This Montreal Art Deco creation became home to Pierre Elliott Trudeau after his toils at Ottawa's 24 Sussex Drive.

modernes. The style was named after that exhibit, Art Deco.

The contrast could not have been more total. Where Esprit Nouveau wanted squares, Art Deco wanted curves or zigzags; where Esprit Nouveau rejected all ornamentation, Art Deco indulged in motifs ranging back to the pharaohs. Ultimately, Art Deco failed: it was considered too luxurious. Art Deco would linger on the silver screen; but the Busby Berkley approach to homebuilding died with the world economy.

One remnant remained: the principle of streamlining, even when aerodynamics were irrelevant. Radios, toasters, and major appliances were streamlined, even though no one cared that if a stove were hurled through the air it should have minimal wind resistance. Small electrical appliances, whether streamlined or not, had made major inroads into the Canadian home by 1920; but aside from washing machines, the "big-ticket" electrical appliances, like stoves and refrigerators, faced consumer resistance. Gas stoves and ice still dominated the market.

Air-conditioning crept into industrial and commercial structures in the 1920s, but air-conditioned housing wasn't a priority. "Some day we hope all our public buildings, including our schools, city halls and even our legislative chambers, will be air-conditioned — and so help clear not only the atmospheric but also the mental fog so evident in these buildings today."[50]

Some structural changes in housebuilding were becoming the norm: more solid construction evolved. Somewhere in the western part of the continent, "balloon frame" construction became "platform frame." A two-storey house would no longer be built like a cardboard box, with two-storey studs tilted up into place on which the second floor would later be suspended; instead, storeys would be built one at a time, each with its own ceiling, which in turn would serve as the floor or "platform" for the next storey. The result was solid: you could slide these houses down hills, or tip them over, but they would not fall apart at the seams. Platform frame construction was also better adapted to prefabricated materials, including an innovation called "gyproc fireproof wallboard." This wallboard still looked primitive compared to plaster, and would take another twenty years

For a short time, there was a movement to extend the "streamlining" of your wringer-washer to the exterior of your house. Some designers attempted a half-hearted synthesis of streamlining and Heroic Modern: they would incorporate some curves, such as in this house (below) in Ottawa. This style became known as Art Moderne, but was not widespread because almost no one had any money for building. By World War II the style had disappeared, perhaps because the aerodynamics of a Canadian house were not a major selling point.

By 1925 less than 1 percent of Ontario homes had refrigerators, let alone other major appliances, despite the efforts of their manufacturers. In 1926, *Canadian Magazine* decried the situation: more appliances would allow "the emancipation of household slaves." "The electrically wise woman would impress her friends and neighbours and guarantee a higher social standing for her husband and family."[51]

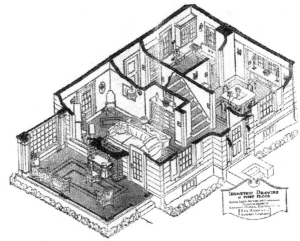

to catch on; when it finally did, it would turn home-building on its head.

But the greatest upheaval of all occurred on Black Friday, 1929. After the stock market crashed, U.S. President Herbert Hoover was told by conservative economists of the day that the resulting recession was the time to wrestle inflation to the ground and fight deficits. Hoover did so — and turned the recession into a worldwide Great Depression. Canada found itself with a 30 percent unemployment rate. In Charlie Farquharson's words: "Yer bizness cycle was in yer state of suspended constipation."[52] Saskatchewan's total provincial income dropped by over 90 percent; and the other western provinces were effectively bankrupt, though people wouldn't say so out loud.

The 1931 *Home Builders' Annual* (Toronto) included advice on "how an owner, faced with reduced earning power [could] save his home" by taking in tenants.[53] That practice turned into a national tidal wave. By 1931, over 160,000 Canadian families had to resort to "doubling up" in homes, to keep from sleeping in the street.[54] Residential construction dropped from $139 million in 1928 to $24 million in 1933.[55] In 1934, 72 percent of skilled construction tradesmen were unemployed. Real-estate prices dropped by 40 percent. Even the Montreal Board of Trade was recommending rent-to-income housing. The lieutenant-governor of Ontario, H.A. Bruce, had submitted a report on the deplorable housing conditions in Toronto. "This cancerous growth of slums eats at the very vitals of our nation."[56] "Diseases are being fed by the conditions under which we compel men and women to live."[57] As one Hamilton preacher put it (untheologically), "You don't have to be dead to go to hell."[58]

Platform frame construction spread in the 1920s under the name "western framing." It was apparently invented in 1904 by Vancouver's E.C. Mahony: he obtained a patent which strongly resembles this method, and the British Columbia Mills Company even sent trainloads of these houses across the prairies.[59] As Alaskans later discovered, in the earthquake of 1964 (above), platform frame houses refused to come unstuck.

So in 1935, the House of Commons established a Parliamentary Committee to think up a national strategy "in order to provide houses as may be necessary … having regard to the cost of such policy and the burden to be imposed upon the Treasury of Canada."[60] Otherwise, Canada would have a "national emergency" on its hands.[61] The result was the Dominion Housing Act to tinker with mortgages. "The bill had the unmistakeable [tone] … of the social engineer … The sum of human acts supposed

One 1931 advertisement wishfully listed this house as a "typical Canadian home." When the Great Depression decimated markets among the lower and middle classes, desperate builders prayed for rescue via contracts for customized houses for the rich. They had to maintain a high cash flow: unlike firms a generation later, firms in the twenties and thirties carried large semi-permanent crews on their payroll, instead of "contracting out" to a rotation of independent trades. For many firms, this practice proved suicidal.

by the model would lead to a given course of collective action. If only the parts were put together in a way which ensured that each part played its anticipated role, the national housing problem would be solved."[62] Lending institutions announced they had $75 million ready to lend on housing;[63] the problem, they said, was that they couldn't find reliable borrowers. Nonetheless, no one had illusions: "The Dominion Housing Act was seen as a quick, interim measure that would not involve the expense and delay of a more thorough approach which could be considered at leisure."[64] In non-bureaucratese, that means a quick fix.

Homebuilding meant jobs: "The federal government fell into the housing field accidentally in an endeavour to assist the country out of the difficulties of the hungry thirties."[65] But Ottawa had little business being in the housing field: constitutionally, this was a provincial responsibility. The only way Ottawa could move into this area after World War I was by invoking the War Measures Act. The provinces, however, were too broke to deal with the problem; so in 1935, some MPs proposed that Ottawa make direct grants to provinces to allow *them* to act on housing. Ottawa turned this down flat.[66] If the federal government moved, it would do so by *its* rules, and with *its* bureaucracy.

The federal official running the program was the minister of finance himself. He was empowered to do deals with financial institutions and with other governments (within limits) to help provide mort-

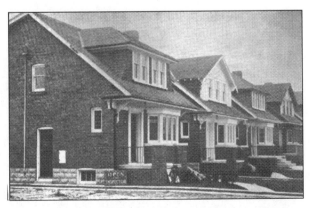

Firms that built houses "on spec" — without a predetermined client to commission the work — were unusual in the twenties, and almost extinct in the thirties. This 1931 project in Toronto indicates one of the rare exceptions.

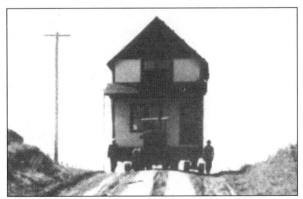

The crop failure of the prairie dust bowl, along with economic reversals, uprooted families — some more than others (Alberta, 1935).

gages. Ottawa's part of the loan would cover less than 20 percent of the house, the lender or another government would have to lend a further 60 percent, and the mortgage term would not exceed twenty years. Ottawa also insisted on its own system to enforce building standards. The Act also created the new Economic Council of Canada to advise on housing conditions.

The Council promptly fizzled — it did not get a proper head of steam for another thirty years — and the Act flopped as visibly as the Council. Lenders were so spooked by the Depression that they wouldn't lend even under improved circumstances. The Act's accounting was complicated and expensive to administer, and many areas of Canada had no system for appraisal or inspection of buildings. Where any of these requirements was missing, the Act's impact was eliminated; but in those magic locations where all the elements came together, the result was an oversupply of housing — which the locals couldn't afford anyway, driving real-estate values down even further.[67]

In just under three years, only 3,100 loans under the Act were made in the whole of Canada. In 1937, these loans affected less than 3 percent of all the housing units completed (48,600); only two Act-

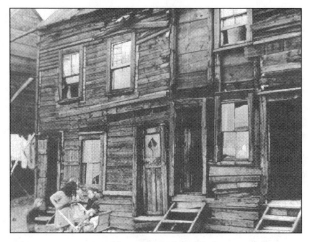

During the Depression, the Dominion of Newfoundland was so broke (notably here in St. John's) that it became the only independent country in world history to resume British colonial status voluntarily, so even the politicians were out of work. Eric Nicol said that, in the meantime, the only reason "the Depression did not affect Canada as badly as the United States was because there were fewer high buildings to jump off."[68]

assisted loans had been made in Saskatchewan, and not a single one in Alberta. In 1938, the legislation was scrapped and the government started over.

Between 1935 and 1938, the government had made another discovery: buildings fall apart, and sometimes need repairs. Ottawa could not claim entire credit for this revelation — Franklin Roosevelt had introduced a Modernization Credit Plan in 1934 to stimulate renovation under his New Deal's Federal Housing Act. Canada's National Employment Commission recommended the same in 1936 "as a method of absorbing the unemployed across the country."[69] "More living units could be obtained more rapidly by repairing existing houses up to reasonable standards than by any other means."[70] In 1937 Ottawa adopted the Home Improvement Loan and Guarantee Act. Owners could borrow up to $2,000 at reasonable rates, and lenders were protected from some losses on these loans. The situation was particularly tricky in rural areas: "Many rural properties were empty as a consequence of the migration from the land, yet other rural accommodation was grossly overcrowded as a consequence of sons, with their wives and children, returning to the parental farm after becoming unemployed in the city."[71] Ottawa killed its new renovation program within three years.

The federal government's second attempt at a National Housing Act (1938) was again under the minister of finance. To make housing more affordable, Ottawa's share of the loan was increased, and the limit on the loan was bumped to 90 percent. Lenders were encouraged to reach more localities. The government would help lenders if they incurred losses. Ottawa would support municipal low-rent housing projects and pay municipal property taxes (at varying percentages) on new housing during the first three years. However, that perk disappeared as early as 1940. Furthermore, several features required provincial cooperation, and five provinces (including Ontario) refused to play along. Of the $30 million earmarked for low-rent housing projects, not a single penny was spent — partly because certain events occurred in 1939 in Europe to change Ottawa's spending priorities.

At least the loans were more successful than under the old Dominion Housing Act.[72] In all, "the

effect of the Act ... was to provide a lever to reduce the interest rate which had been maintained through inertia, custom and lack of confidence in real estate."[73] In 1939, Ottawa floated another trial balloon — a Central Mortgage Bank, as a subsidiary of the Bank of Canada, to settle delinquent mortgages and encourage refinancing. "In return, the government hoped lending institutions would adjust mortgage interest rates down to 5 percent, write off all the arrears of interest in excess of two years, and adjust outstanding mortgages."[74] However, Ottawa never even opened the Mortgage Bank for business.

The federal government wasn't alone in trying new approaches to housing. Another was the cooperative movement. Although cooperatives *other* than in housing had had a sporadic existence in Canada since the 1790s, it was only in 1936 that cooperative housing got a boost. A group of miners in Antigonish, with advice from St. Francis Xavier University, built Tompkinsville, Nova Scotia.

How did generalized poverty affect global tastes in housing? Some people downplayed both the economic and the aesthetic changes of the day. "Toronto is famed the world over," said the Toronto Home Builders' Association, "for its many outstanding examples of domestic architecture [and] the thousands of attractive and well-built houses in the moderate priced class."[75] Others disagreed. Austerity gave Modernists a new argument. The old style of "decorated" housing and the newer Art Deco style would be simply "too expensive" for these lean and mean times. "We know now for a certainty that mankind cannot live the new, sanitary, open-minded, art-enriched life in ornamental, wasteful houses ... that is why we ask the architect to conceive the building first as a machine, not as a decorative shelter."[76] The problem was that the Modernists' creations weren't any cheaper. So, their argument changed: in times of austerity, we should at least try to *look* austere.

As Modernists overran Canadian architectural journals in the 1930s, they weren't content to eradicate only all present and future rivals, but those of the past as well. If any city on earth was "in need" of this architectural Final Solution, it was "surely" Toronto. "Toronto was composed of endless mongrel combinations of shooting roofs, gabbing gables and strutting bow windows that jostled each other on a twenty-five foot front"; this should move the viewer "almost to tears."[77] "We need a tonic. Some take it in moderation, others have been more reckless, while others again claim that it is more nauseating than castor oil. This medicine is called 'modernism.'"[78] Jacques Carlu, who was invited to design parts of Toronto's Eaton's store, told Torontonians that "against a solid, geometrical and logical background, architecture must rediscover its laws ... it must be the enemy of false decoration and of decoration for decoration's sake."[79] Editorialists agreed: "Why is Toronto so ugly? The explanation is a simple one. The city enjoyed one of its greatest periods of growth when architecture was at its worst ... Façades bulged with huge bay windows and ponderous cornices. Grotesque bumps and knobs, supposed to be ornamental no doubt, stuck out everywhere. Squat towers and turrets often gave the finishing touch of ugliness to the abortions."[80]

But all was not well in the Modernist camp. In Europe, Heroic Modernists discovered that their clean designs were being cluttered by the human beings who occupied them. Ignorant residents even decorated them with flowers at windows, or bright colours on the doors. The message went forth: don't let the public mess with your buildings. That seed fell on fertile Canadian ground, namely the Dominion Architectural Competition for Small House Design, launched in 1935 by the federal government, and a similar competition sponsored by the T. Eaton Company. Ottawa supported the Modernists by packing its jury. The winning designs were white cubes. The jury also undertook to eliminate local character in Canadian architecture: "The judges doubted whether there had emerged any great distinction between the regions in the form of plan [i.e., style]. It is quite possible that the designs contributed in any region could have been suitable and successful in any other region."[81] The white cube should satisfy *everybody.*

The jury's work went for naught — for the time being. Not a single builder could be found to construct any of these cubes; not a single buyer could be found to purchase or commission them; and not a single one was built. This was acknowledged as a flaw, not of the design but of the public; as Le Corbusier said, the public would need to be "re-

educated."[82] This would take time; but although war clouds were on the horizon, these would merely delay the inevitable. It was increasingly clear that the Dominion Architectural Competition had taught the Modernists in Canada one thing.

They now had Ottawa on their side.

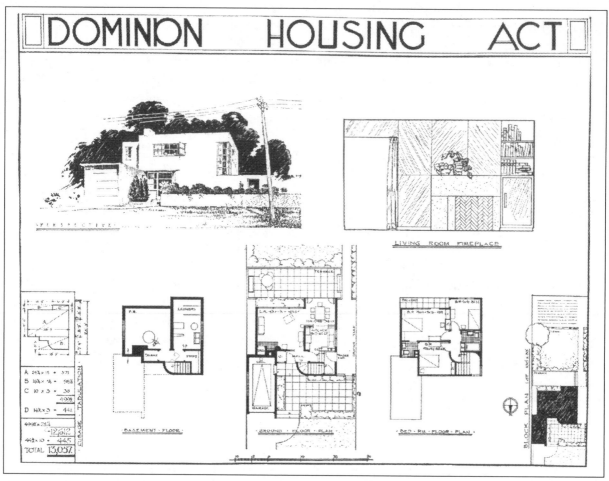

The jury of the 1935 Dominion Architectural Competition awarded first prize for this Toronto design. Such minor details as snow loads would not detract from the objective of bringing Modernism to Canada: "No reasonable objection can be found against a flat roof. Properly insulated it is perhaps the best roof for our climate."[83] The jury also repeated European warnings about people decorating their homes: "It takes very little alteration to spoil the layout and charm of these designs ... The designs illustrated should be taken as examples of good planning and good taste."[84] An almost identical plan won a comparable prize from the T. Eaton Company in 1936.

The Luftwaffe and Other Development Services

1939–1946

In which Canada contemplates putting all Canadians in prefabs, and architects speculate on the use of the Luftwaffe for urban renewal; building products are diverted to Mulberries and Gooseberries; the homebuilding industry gets organized, the federal government launches CMHC; and Canadians decide to make babies.

World War II was an improbable time to be preoccupied with housing, except for barracks. With the Wehrmacht goose-stepping down the Champs Elysées and Japanese Zeros sweeping across the western Pacific, Canadians had only one thought in mind: victory. We bought Victory Bonds, planted Victory gardens, built Victory Houses …

Gardens? Houses?

It's hard to picture Hermann Goering saying, "We're in trouble now, Adolf: they have carrots in Dartmouth, and better stairwells in Peterborough." However, these initiatives underline the intensity with which every aspect of daily life was conscripted. Matters were so desperate that in April 1941 Ottawa revived federal income tax as "a temporary war-time measure." Captains of industry, called "dollar-a-year men," streamed to Ottawa to ensure that this country functioned — not as an assemblage of several million scattered people, but as a single war machine. For the first (and perhaps last) time in our history, we were Canada Incorporated.

Dollar-a-year men concluded that if Johnny Canuck and Rosie the Riveter were to function at maximum output, they would need a proper roof over their heads; and since materials and personnel were scarce, Ottawa would no longer tolerate "inefficient" homebuilding. Government would first create a crown corporation, Wartime Housing Limited (WHL)[1] to break housing down into its components, redesign these components for mass production and assembly, and give the product a name to reverberate in the heart of every patriotic Canadian. Thus was born the Victory House.

WHL accumulated materials at discount prices through the Department of Munitions and Supply. It assembled land by expropriation or by using surplus federal property; it also made deals with municipalities, which had a surplus of land left over from the property-tax seizures of the Depression era. Sometimes WHL planned roads, sewers, etc. When the site was ready, WHL would put in its order — for 250 houses at a time in New Glasgow, 752 houses in North Vancouver, 300 in Richmond, and so on

The Victory House was not "designed" but engineered, from the inside out. There were only two models: a two-bed-room bungalow; and a four-bedroom, one-and-one-half-storey model. "Inefficient" dormers were scrapped. There was only enough porch to keep the owner out of the rain while fumbling for his keys, although a lattice was optional for the "Victory rose arbour." An entire functional house was shoehorned into as little as 770 sq. ft. It approached many of the Modern ideals, albeit with walls of clapboard more often than stucco, and a gable instead of a flat roof (to tuck in more space). It was a machine for living, with a hat.

across the country. The dimensions of these houses fit standard-size materials. A bungalow would measure 25 by 32 feet (7 m by 9.6 m), with one bathroom and a 55-square-foot kitchen, the size of many bathrooms today. Some had the luxury of a triple window in the living room — one of the few options available.

Building techniques were also revolutionized. Even if Rome wasn't built in a day, maybe the Victory House could be. WHL certainly tried. By 1946, Canadian houses still required over 2.6 person-years to be built, but over half of that was off-site, thanks to prefabrication.

The first casualty of the "house-in-a-day" drive was the horse: bulldozers now levelled sites. Coincidentally, the construction industry discovered new glue. This improved plywood and wood veneers. Laminated veneers had been around since 1500 BC; but aircraft engineers produced stronger varieties that could better distribute stress in airplanes. This gave builders the idea of using them in house construction. Special plywood sheets, called "the stressed

skin" in aircraft, could be adapted to walls and roofs, which were "tilted-up" while other work continued. The house became a "stationary assembly line."[2] Yet with all that engineering, there were still oddities in the Victory House.

For starters, it had no furnace. It did not even have a place to put one: instead of a basement there was a crawl space. The Victory House had to withstand Canadian winters with only a *single stove*. Did its planners expect all those Canadians listening to Lorne Green ("the Voice of Doom") on January evenings to wear four sets of woollies over their pyjamas? Also, Victory Houses lacked storage; so where would you put the garden furniture, or Aunt Myrtle's endless jars of pickled beets? The Victory House didn't even have room to store the preserves from your own Victory garden. "More than anyone else, anywhere, Canadians like to have a hole in the ground under their houses."[3] Surely, permanent houses in our climate should include furnaces, and basements to put them in?

There's the rub. WHL did not think it was

building permanent houses. The Victory House was expected to be disposable. WHL believed that as soon as the war ended, Canada would erect housing factories — like car assembly plants — spewing out prefabricated parts to be assembled like Meccano. Such synchronization presumed an industry of mega-companies instead of small-scale entrepreneurs. Victory Houses could then be trashed and replaced with a superabundance of *new* prefabs, bigger and shinier than their predecessors, bringing Henry Ford to housing. The government's urban utopia meant a "rationalized" industry of mega-builders (instead of family firms) working with prefabricated product, in a "non-fragmented market" (namely homogeneity of demand, to make mass production viable). This bureaucratic Holy Grail of housing coloured Ottawa's subsequent thinking for decades. Federal hostility to existing homebuilding could be traced to one of the highest mandarins in the country, Deputy Minister Clark of the Department of Finance, who proclaimed:

> The high cost of construction ... reflects an industry relatively little changed in form of organization and in technical processes from that which catered to our forefathers prior to the Industrial Revolution. During a period when machine production, standardization and technological advance have been revolutionizing every other important manufacturing process, the building of houses has remained a localized, handicraft process. [The] challenge [is] to make the housebuilding business as efficient as that rugged young interloper, the automobile industry.[4]

Part of this rationale was the credo of salvation via mass production, but the war added an extra incentive: with women now in factories — but without pay equity — any work moved from the building site to the factory could be shifted from higher-paid tradesmen (a male preserve) to lower-paid women. The men could then be handed Lee-Enfield rifles and shipped overseas to stop Nazis from destroying Europe.

Some architects looked at that destruction with mixed emotions. The *Journal* of the Royal Architectural Institute of Canada (RAIC) wanted Hitler to be defeated all right, but not before the Luftwaffe could rid the world of as much "hideous" Victorian architecture as possible. This would give European cities room to build Modern. "There is obviously no sense of remorse for the loss [by bombing] of Regent Street," said editor Eric Arthur in 1940. "We would gladly join with thousands and light a cracker and wave a flag over the ruins of the monstrosities ... we see no point in weeping over a ruin of the Albert Hall or the Albert Memorial, as yet unhappily spared."[5] Architects crowed that the Luftwaffe's efforts at reshaping British cities presented one of the greatest opportunities for urban planning since Nero. In the words of Toronto's John Layng,

> The sight of acres laid waste by bomb and fire [is something] in which Englishmen will find a tremendous creative stimulus ... Great gaping excavations torn by the determined and sadistic enemy can be much more a positive and creative inspiration for everybody than a street of our buildings ... The dead hulks that make up Yonge Street are much more pathetic than a bombed out area if only because more time must go by before anything intelligent is done about them.[6]

Could Nazi air power render the same service for Canada? The *Journal* of the RAIC noted that "the probability of an aircraft carrier ever standing off our coast may not be great, but ... not out of the realm of possibility."[7] However, if Nazis did not flatten Canadian cities before tea, Principal Cyril James of McGill reassured architects that they could do that themselves. In 1941, McGill became the first of several Canadian universities to adopt the curriculum that Mies had developed for the Illinois Institute of

The *Journal* of the RAIC singled out the *Tirpitz*, sister ship of the *Bismarck*, as the most likely candidate to help get rid of Victorian buildings in Canada: the *Tirpitz* had a catapult to launch planes, and a crane to fish them out of the water. "A German bomber pilot could lunch on his battleship at 1:00 pm and return for tea after bombing [Montreal or Toronto]."[8]

Technology in 1937. "You recognize," said James, "a comparative misfortune, in that none of the Canadian cities have yet been levelled by the war, but are eager, as soon as war has finished, to wipe out much that is unsatisfactory from one end of this Dominion to the other, in order that you may rebuild effectively the cities and communities of which you have long been dreaming."[9] Stephen Leacock responded sarcastically: "The bombing of the great European cities has brought out the fact that they needed bombing anyway … We certainly need bombing. Drop some more."[10] If the purpose of this exercise was to expedite slum clearance, he added: "To shovel up the slums, to shovel up half the city and throw it away, that is the word of the day in every great North American city. The biggest man is the man who will throw it furthest. Later he will

have a statue with a latin motto on the base to mean 'knock it all down.' "[11]

Housing conditions in Canada were indeed a problem. In the early forties barely three out of every five dwellings had piped running water; and barely half had inside flush toilets. Only one house in five had a refrigerator; and in a large percentage of houses, the stove was also the dwelling's only source of heat. Ninety-three percent of homes still relied on coal, coke, or wood for fuel. In places like rural Manitoba, over 94 percent of homes had to rely on outside privies; over 93 percent had neither bath nor shower; 96 percent used wood as fuel; over 90 percent relied on kerosene or gas lighting; and aside from cellars, 73 percent had no refrigeration of any kind — not even ice.

If mass production could promise "a chicken in every pot and a Ford in every garage,"[12] what about housing? In theory, the government's first step would be to drive out small builders and invite giants to take over. That should have been easy: there had been serious attrition among builders during the Depression, and those still in business were barely hanging on. A 1943 article in *Canadian Business* said the industry was composed of "perhaps 20,000 or 30,000 little contractors — little men who like to work for themselves, who like building and who have sufficient capital or can borrow it to build maybe one or two houses or an apartment house without going broke."[13] Large builders[14] amounted to only 10 percent of the market. While profits were reasonable,[15] they did not spawn privately owned giants. Only WHL came close: its production averaged 12 percent of Canada's total of 42,800 new units per year in 1944, and over the five years of WHL's existence, it created 25,751 houses. The remaining 20,000–30,000 "little men" either hired out their services to WHL to make ends meet, or chased a market which, excluding WHL's share, was 9 percent *smaller* than it had been during the Depression. Although war had returned Canada to full employment and unleashed pent-up demand for housing, builders had trouble responding. Government blamed the builders, and builders — when asked — blamed the government. Be that as it may, Ottawa concluded that almost all of Canada's private homebuilders were obsolete, and therefore expendable.

But factory-built cities could not be achieved merely by overturning the industry: Canadians' attitudes about their homes would have to be changed. Factory production presupposes a standardized product. If Ford said "you can have a Model-T in any colour as long as it's black,"[16] wouldn't mass-produced suburbs also have to be homogeneous? This would mean re-inventing both the Canadian builder and the Canadian consumer.

The builders defied orthodox economics: how could a bunch of "the boys" on a work site compete against a house factory? But statistics kept supporting small builders. The dictum "small is beautiful" — thanks to knowledge of the market and hands-on control — didn't appear in management texts until thirty years later. In due course, the construction industry would help to reform conventional wisdom about economies of scale; but meanwhile, the war that builders had on their hands was not merely with the enemy across the pond, but also with their own government. Ottawa's policy hit a nerve: Canadian homebuilding had tradition; it was not merely a business, but a craft.

The very word "craft" implies a heritage of both skill and independence beyond that of a normal employee, whom the common law describes as being in a "master-servant relationship." That prospect was anathema to the entrepreneurial aspirations of the builders. Ever since Champlain landed with his duly recognized carpenters, stonemasons, and locksmiths in 1604, the building occupations have guarded their status; and this insistence on self-respect had become all the more crucial in the 1940s, as builders were threatened with the prospect of becoming nothing more than the hands and tools of housing programs run by governments or mega-companies. That position, however, had a corollary: shoddy workmanship or "jerry-building" was not only a bad reflection on the business but an insult to this craft. Although builders welcomed most factory innovations, some new techniques represented corner-cutting at the expense of quality. WHL's omission of furnaces gave them no solace. Despite learned predictions that homebuilders were lemmings on their way to the cliff, the industry refused to jump. This came as an annoyance to many officials and consultants.

Would Canadian consumers be equally uncoop-

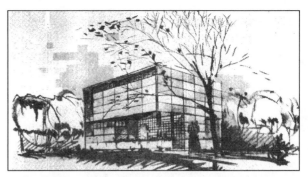

In 1943, this assembly-line "house of the future" was proposed for all Canadians. According to the *Journal* of the RAIC in 1943, "The ideal of the complete prefabrication of houses [would be] brought substantially nearer realization" if Canadian housing committed itself to the material of the future: plastic. This would "hold out the promise of higher standards of living in respect of cleanliness, colour, weather resistance, insulation and flexibility of design."[17] There was no need to worry about insulation or fire resistance: the house could be built of a plasticized combination of urea formaldehyde and asbestos, which would mean that: "Improved standards of health and environmental cleanliness are possible."[18]

erative? "Most people have neither imagination nor individuality," Richard Bolton reassured the RAIC. "They would fit into one of a small number of good house plans just as they fit into one of the standard plans for life insurance."[19] But homebuyers kept insisting that *their* house not be identical to their neighbour's — as if Model-Ts came in different colours. This idiosyncrasy barred a "rationalized" housing policy. For the next fifty years, variety would be blamed for retarding the "right" kind of housing: "The more the industry is dominated by small firms, the less likely its members will search for and adopt changes enhancing their efficiency ... the new single-family housing market is fragmented ... Demand is heterogeneous since comparatively few buyers are willing to buy the exact same house ... thus retarding the introduction and adoption of change in the single-family homebuilding industry."[20] Bureaucrats and architects were complaining that the problem with suburbs was not that they were too monotonous, but that they were *not repetitive enough*.

In Utopia, every Canadian would be offered identical houses with "options" — like a Volkswagen. That is how Victory Houses worked: the "Victory rose arbour" was an option; so was a triple window in

the living room. Although Canadians were known to value distinctiveness (even Model-Ts were produced in colours for the Canadian market), housebuilding factories might have to be forced upon them for their own good. The government pondered mandating WHL to become *the* giant builder of factory-produced, post-war homes: it could become for housing what General Motors was to cars — or, more accurately, what Canada Post was to message delivery. The RAIC agreed: a "Building Authority" should pre-empt a "return to the pre-war scramble, profiteering, and unbalanced development."[21] The authority's executive should consist of "leaders" in various disciplines — beginning with architects.

It is not clear whether that prospect appealed to realtors — but they had their minds on other things, as they geared up to found a Canadian Association of Real Estate Boards on March 2, 1943, under the leadership of Hamilton's Charles Purnell (the organization later became the Canadian Real Estate Association).[22] On the other hand, the prospect of a

"building authority" scared the daylights out of builders. It would have wiped many off the map and reduced the rest to job-lot suppliers instead of independent craftsmen. But their concern was not merely self-serving: they were not prepared to bet on the quality of workmanship if hands-on aspects of construction were obliterated by a mega-corporation. "There is no need for any government body to create or maintain a Construction Company to build such houses," said Montreal builder Jack Price.[24]

Builders also had more immediate problems, such as trying to build with no work force and no materials. World War II solved unemployment with a vengeance: instead of too many people chasing too few jobs, the challenge was now for employers to obtain *any* personnel. Ottawa's National Selective Service agency decided where 100 percent of the population should be employed. In some lines of work, personnel disappeared. If you wanted your grass cut, you had to do it yourself or, as some Esso refineries did, buy sheep.[25] Even specialized trades were hit. If a bricklayer was assigned to a munitions plant, a prospective employer would have to fight to have him "released"; releasing convicted felons involved less paperwork. Although Prime Minister Mackenzie King said, "conscription if necessary, but not necessarily conscription," this sounded hollow to some entrepreneurs: the entire working population seemed conscripted already.

J.L. "Jack" Price: "Housing conditions are simply deplorable. In Montreal some people are living in stores, warehouses, even stables, without fresh air, sunlight, sanitation; in fact, all the things necessary to make the buildings at all livable are absolutely lacking. [There is] a dire need of some comprehensive programme."[23]

Hamilton's Charles Purnell, first president of the Canadian Association of Real Estate Boards. The largest item on the realtors' agenda was the concern that wartime rent controls would become permanent.

Frank Nicolls, Canada's first director of housing (1935) and an active supporter of the housing industry, was credited with "originating" the National Building Code in 1937. The Code came out in 1941 as 422 pages of "model" recommendations (price: $1.00). Architect J.S. Mathers said, "Whether or not it is ever adopted by municipalities, it will remain a monument to the efforts of those who prepared it and is well worth the price asked for it,"[26] but he warned RAIC that he doubted whether all builders could understand the Code: "We had hoped that the National Code would have been phrased in simpler and more direct English so as to be unmistakably clear to anyone with an eighth-grade education."[27]

Obtaining materials was no easier. For each major industry, the federal government appointed controllers to supervise supply — and "control" they did. There was a controller of lumber, a controller of construction, etc., all reporting to C.D. Howe; and C.D. Howe, the so-called Minister of Everything, reputedly reported only to God. Entire forests of lumber, for example, became munitions packing crates. Even sawdust was enlisted in the war effort: if naval losses to U-boats continued to mount, Canada had a contingency plan for giant unsinkable ships built of sawdust and ice — almost the only materials still in substantial supply.

By the middle of the war, the life of the typical homebuilder was extremely complicated. When American builders formed an association in 1942, Canadians started doing likewise. Since local associations now existed in five cities (Toronto, Winnipeg, Victoria, Hamilton, and Ottawa),[28] builders decided to launch the next logical step: a Canada-wide organization. Kenneth Green of Ottawa was caretaker head until incorporation, then passed the reins to Montreal's Jack Price. The founders came primarily from Montreal,[29] Toronto,[30] Ottawa,[31] and Hamilton.[32] There were also representatives from Vancouver,[33] Kitchener,[34] St. Catharines,[35] and London.[36] This multi-city representation should not give the impression of a powerhouse. The initiative was started on a shoestring: after a full year of existence, the association representing one of the largest industries in Canada had amassed total assets of $240.80.

Nonetheless, when the National House Builders' Association (NHBA) came into existence on February 8, 1943, its ambitious goals were to improve cooperation,[37] quality,[38] standard-setting,[39] information,[40] and government liaison.[41] NHBA's mandate emphasized "legislation affecting homebuilding" — which sounded odd. On one hand, Canada had a plethora of municipal building codes; but beyond that, there was no system of guarantees; there were no formal standards of workmanship; there was no legislation for apprenticeship, licensing, or the like. Although civil and common law alluded to guarantees against "latent defects" in houses, the market was still dominated by *caveat emptor*.[42] Homebuilders, however, had come to the same conclusion as Pogo: "We have met the enemy, and he is us."[43]

A minority of incompetent builders who reflected unfavourably on the industry might also provoke heavy-handed government controls on everyone. This led to only one conclusion: the industry would have to declare its own war on "jerry builders." NHBA would have a Disciplinary Committee to enforce "standards of practice" and "to censure, fine and expel" members. The first general meeting even resolved that the housebuilding business should require a licence and "that investigation should be made as to [builders'] honesty and ability before licences were granted."[44] It called for "a Seal for

Quality-Built Homes and a Code of Ethics."[45] Vice President Norman Long placed this initiative in an ideological perspective:

> Between Capitalism, as represented by unrestricted free enterprise on the one hand, and Socialism on the other, government supervision over business is inevitable ... [builders should form] a strong national organization and use this as a means of improving housing standards. Licensing of builders will eliminate the "jerry builder," and protect the public. It will assist the industry in efficient planning and control within the industry that will be of great public benefit and lessen the necessity of government controls.[46]

But if the builders' only goal were to pre-empt government intervention, they could have done so without a charter like that of a College of Physicians and Surgeons. That wasn't good enough. In a "profession" a member is judged by his peers, and the profession sets standards governing admission: NHBA wanted consumer protection for housing via supervision by expert builders, which they believed would reputedly serve the public better than supervision by a bureaucratic bean-counter who didn't know the business end of a hammer.

NHBA then called on the provinces to impose licensing legislation on homebuilders: "The Act should be written so that licenses could be suspended or cancelled for cause, and should be renewed annually."[47] NHBA's draft model laws said eligible builders would either have to be in the industry for five years or write exams;[48] it also contained a kind of disbarment clause for shoddy homebuilders. This so impressed other industries that the spokesman for the plumbers called the homebuilders "very sane."[49]

At the major policy meeting of March 31, 1944, all but eight of the ninety-three participants came from Montreal, Toronto, or Ottawa (and there was no one from east of Arvida or west of Kitchener); but the president bravely admired "the splendid attendance."[50]

Despite the lofty philosophical objectives, builders found themselves preoccupied with more immediate questions: What style of houses should be built? Where would materials come from? Where was the money? How should they respond to Modern? Architects were linking Modern to patriotism: "The glamorous warehouse-cube style was well suited to post-Depression sobriety, ... small budgets and limited resources — all you needed was enough white paint. But it was more than a question of economics ... Since neoclassicism was favoured by dictators — by Hitler and Mussolini, and, as it turned out, by Stalin — the austere architecture of the Modernists came, by default, to represent anti-fascism and anti-totalitarianism."[51] But if that were so, why weren't new streets near munitions plants lined with prefabricated white-cubicle "dream-houses" as described in the journals? In the writings of the architectural critics, the overriding reason was the Philistinism of builders — assuming they had any reason at all.

The builders replied in the person of Charles Dolphin at NHBA's inaugural meeting: "Dreamhouses are receiving so much publicity at the present time ... [but my] experience has been that customers want houses built of much the same material as has been used in the past. Brick and stone walls are still in demand; windows of the same type and size, as they used to be in homes, are still in demand."[52]

It was simple: builders might have built Bauhaus-style houses if they had seen a market; but they didn't. Mr. & Mrs. Canadian still wanted brick and stone and all those "dismal" signs of cosiness. From this point onward, the gap between architectural theory and Canadian homebuilding practice became almost unbridgeable. When that gap emerged in the 1930s, it could still be blamed on money; but from 1944 onward, it was philosophical. Decades would elapse before any book of architecture in Canada would deign to illustrate builders' homes, and builders refused to build Modernist architects' versions of homes for the general public, unless squeezed by the government. No other single issue so determined the shape of the suburbs to come.

Dolphin also expressed the builders' opinion about redesigning homes as "machines for living": "Labour-saving devices will still be welcome, and as

these become perfected, they will be acceptable; but they would not materially affect the design or the construction of the home itself."[53] The "machine for living" could do its ticking elsewhere.

But bigger things were also ticking, as the world held its breath for an Allied invasion of France. The secret plans for the landing in Normandy called for an instant beachhead/port complex called "Mulberries and Gooseberries" to become — overnight — the largest port in the world. Canadian builders were hardly privy to what Eisenhower had up his sleeve, but they could guess. They anticipated that D-Day, and the drain on building supplies, would occur earlier than it did. On March 8, 1944, almost three months before D-Day, lumberman Archie Streatfield told a private meeting of NHBA directors that "the demands that would be made by the Army requirements might be so great, after the landing is made in Western Europe this spring, that very little could be had for local use."[54] Builders' concerns were heightened when the controller of construction announced he might shut down construction altogether. As Canada approached the fateful date of June 6, 1944, supplies for the home front evaporated. Canada was short 12 million bricks, and NHBA's A.J. Hendriks predicted that the country would have none at all by June 1; lumber would not be far behind.[55] The crisis in personnel reached similar proportions: by May 18th, Toronto's Harry Long told NHBA that local builders and municipal officials had reached a common prognosis: "Within a very short time we will be out of business."[56]

Bureaucratic snafus added insult to injury. One complex of military housing in St. John's, Newfoundland, was discovered to have the wrong water connections — whereupon a review of the blueprints disclosed that it was supposed to have been built in Saint John, N.B. More infuriating, for builders facing possible bankruptcy, was the prospect of being victimized by government. The result was verbal war. In the words of Archie Streatfield, "There are restrictions as far as western lumber is concerned. Certain types of lumber cannot be shipped east of the Manitoba border. There are two or three million feet of lumber piling up in the west!"[57] Exasperated builders suspected that supplies were hoarded by the government for WHL, its pet housing enterprise.

J.A. Clifton said, "Material in warehouses *for three months* cannot be sold for construction but is waiting to be released to Wartime Housing Ltd.!"[58]

The government's reply showed that the best defence is a good offense. The controller of construction "blamed the Builders for the position they are in at the present time. They have never given the government any figures of what they could do or expected to do; and the government feels that if they do not want to help themselves, there is no reason why it should worry about them."[59]

The builders responded with a lobbying campaign that allowed them to squeak by; but their suspicions about WHL turned into outright hostility. They targeted WHL's two weak spots: its cut-corners workmanship, and the absence of furnaces and basements. Jack Price led the charge: "For people in the lowest income brackets; regardless of how these individual houses, duplexes or apartments are financed — they must be substantially built with modern conveniences ... The fact that these houses may have to be built at public expense does not change the need for good workmanship and careful planning."[60] His Ontario vice president, Norman Long, concurred:

> Toronto ... is considering 250 houses ... on property with an assessed value of $187,000 to be turned over to Wartime Housing Ltd. for $250, without basements, and heated by stoves ... Everyone is opposed to this *type* of construction, but does not wish it to appear that we were objecting to the city arranging for accommodation for enlisted men or dependents. We are opposed to this *type* of house ... we can well afford to build better houses, with proper basements, heating facilities, etc.[61]

Finally, Price decided to hit where it hurt, by attacking WHL's patriotism: "$1,600,000 has been spent on temporary wartime housing which will eventually be slum areas, and we must prevent the same thing happening again ... We do not want to ask any returned soldier to go into such houses as they are now proposing!"[62]

Private housing didn't look very different from WHL — that was all anyone could afford, or find materials for; but builders were convinced that their houses were of better quality and equally convinced that, regardless of bureaucratic theories, independent firms could outperform a government housebuilder or even mega-companies. They were in for a fight. The dollar-a-year men remembered that, after World War I, Canada suffered a severe depression; to avoid the same fate, several called for a national post-war homebuilding campaign to show gratitude to our returning forces, revitalize cities, and boost the economy. But how could we justify all this homebuilding if nobody had money to buy? Most Canadians had lost their savings in the Depression; and no one made decent money in the armed services — at least not honestly. One option was socialized housing, namely a giant state-owned construction firm creating state-owned rental houses, resembling what the up-and-coming Labour Party was urging in the U.K.

The choice was reputedly between "public housing" and "subsidized housing." The former meant the Crown was builder and landlord; NHBA preferred "subsidized housing," meaning the private sector would be builder and landlord, but with public-sector help in cash and policies. In July 1944, NHBA called for a seven-point national program focusing on adequate wages,[63] subsidization of the disfavoured,[64] accessibility of home ownership,[65] professional housing authorities,[66] improvement over WHL standards,[67] availability of staff and materials,[68] and priority of low-cost construction.[69]

The problem with that shopping list was that its very first item — wages — called on builders to put their money where their mouth was, and they found themselves in the bizarre position of proclaiming that even after galloping pay increases, wages still had not increased *enough*. Jack Price told the membership that "most of the increased cost of living … has been caused by increased labour rates and it seems unlikely that there will be any decrease in those rates in the near future, or even after the War … Costs may possibly advance, as there are still people with incomes that might have to be *increased* if they are to take part in maintaining the nation's purchasing power, to keep our national income at something like the present high level."[70] If national wage levels were to be

kept buoyant, everyone would have to play their part, including the builders.

That brought up the ticklish question of unionization. Parts of the construction industry, both before and after World War II, witnessed some of the worst labour disputes in Canada, with both unions and management reputedly using baseball bats for purposes never foreseen by Cooperstown. But that was not the mood among homebuilders in 1944. NHBA director Harry Long said, "Unionization of labour … will help to stop low wages. The day has come when the builders should recognize union labour and the industry as a whole would be better off. Organized labour would help to bridge the high and low periods."[71] Builder Archie Jennings agreed, "for the good of the builders."[72] NHBA unanimously resolved to send a delegation "to meet the representatives of labour with a view to considering their proposal as to the unionization of the industry for their protection as well as for the protection of the builders."[73] This love-in is not as surprising as it appears. The builders had specific trades in mind — craft unions with a guild tradition with which the builders could empathize: these were heirs to the ancient practice of training "apprentices" who graduated to "journeymen" and ultimately to "masters." The builders and unions found a common cause in the overall professionalization of the industry and creation of a decent national wage policy, although the idea of a grand builder-labour alliance was short-lived.

The second point on NHBA's seven-point agenda was subsidization: housing for the disfavoured was expected to be superior to WHL's, with furnace and basement — but the public's financial commitment would need to be scaled up accordingly. In the words of Jack Price, "The building of modern homes to rent at approximately $15 a month would probably call for a public subsidy, if these houses are to be built by private enterprise."[74] NHBA had resolved, however, "that *public* housing is unnecessary. If people cannot pay an economic rent, the federal government should *subsidize* low rental accommodation for tenants. The municipalities should not be expected to place this burden on real property [taxes] in the community."[75]

Wouldn't this cause a haemorrhage to the national

treasury? That raised NHBA's third concern: affordability — which prompted questions about design, construction, and financing. The builders' survival depended on whether the private sector could produce better-quality houses to compete with WHL's; if not, the government would launch its homebuilding giant. Jack Price summarized the situation: "We must prepare now for … the needs of our communities after the war … If this is not done and if we do not have a comprehensive programme ready we can be sure that some government agency will carry out the whole thing with prefabricated houses or construction programmes similar to Wartime Housing … and will make the lot of the independent house builders even worse than before."[76] NHBA's response was therefore to plan "demonstration houses" in Canadian cities, starting in Toronto. "The houses will be permanent, modern and attractive, will comply with building bylaws, and it is expected will be available to the public … on carrying charges that will compare with the proposed rental for the WHL temporary dwellings."[77] Their price would be $3,800 plus land, which, leaving aside the land, was less than two and a half times the average Canadian urban family's annual income of $1,680. One would be built in east-end Toronto for $5,500, and one in the west end for $4,200 (both included land). They would be opened to the public, then raffled off with the proceeds to War Relief.

Once builders reduced expenses on construction, the next challenge was to reduce costs on the non-structural side. NHBA called for a waiver of sales tax on construction materials[78] and set up a task force to work on income tax measures "designed to help the construction industry in a practical manner."[79] The most promising avenue for cost-cutting, however, was financing. The usual down payment was a minimum of 10 percent or $400. NHBA's Harry Salter commented that "most of the people cannot pay the 10 percent downpayment. If the public cannot pay, they should be able to buy on the lease-purchase plan,"[80] meaning rent-to-buy. A.C. Jennings added that $200 would be sufficient; finally, NHBA suggested abolishing down payments altogether: "Low-cost similar houses will also be made available with no down payment under a lease option plan, under which monthly payments will provide a sufficient amount to accumulate an equity after a period of years, which will substitute for the down payment required."[81] The mechanics were suggested by W.H. Kitchen, who recommended that the federal government loan 90 percent, and that the "city take the responsibility of collecting [the other 10 percent]. They could appropriate so much money to cover the ten percent, which will be loaned to the purchaser. Each person buying a house would have to agree that until the ten percent is paid, twenty-five percent of their wages earned would have to go in the payment of that home."[82] Norman Long suggested that mortgage rates run at 4.5 percent with thirty years' amortization. The end result, in the words of builder W.H. Rogers, would be the following: "A man should pay for shelter only one quarter of his monthly earnings. If the mortgage requirements were amended to a reasonable point, practically every wage earner could own a home."[83]

As it turned out, Ottawa was also thinking about financing, though in secret. One official, invited to travel to an NHBA meeting, did so only to announce that he wouldn't tell the audience anything.[84] In due course, Prime Minister Mackenzie King's Advisory Committee on Reconstruction[85] called for homebuilding to almost double, from its 1944 level of 42,800 units per year to 70,000 units per year for the decade after the war. As it turned out, 320,000 houses were completed within four years. In 1948 alone, 83,000 units were built, more than double the output of 1945, and three-quarters of these units were single, detached homes.

The Committee's report repeated the call for houses "which will actually rent at $12 a month or lower,"[86] and repeated that the main obstacle to lower cost was the non-factory scale of the builders. It recommended replacing the existing industry with house factories: "The central postwar aim [was] to create a mass-production housing industry out of the comparatively few hammer-and-nails housebuilding firms that had survived the war."[87] The report laid the groundwork for a new National Housing Act, the brainchild of Deputy Minister Clark at Finance, to address housing, urban planning, and municipal finance. Clark's entourage called it so boring that Clark took it to his cottage to "touch it up a little." He produced a two-page charter of the aspirations of

"educated thinking" on the subject of housing: market economics, technology, design, training, planning, etc. On one hand, it stood as a challenge to the decision-makers; on the other hand, in the admiring words of one experienced bureaucrat, "the words have an impeccable vagueness."[88]

Its financial suggestions were less vague. The economists of the federal government had fallen in love with John Maynard Keynes, the guru of mid-twentieth-century economic strategy. Keynes had argued, among other things, that governments should use certain industries tactically to fine-tune the economy. From 1944 onward, Ottawa concluded that the housing industry could be an essential tool of overall national policy. When the economy needed heating up, the feds could stimulate housing; when spending needed to be reined in, the housing industry could be targeted first. What made housing an ideal vehicle was that it was so amazingly easy to manipulate. (The slightest tinkering with Bank of Canada interest rates can have gigantic effects on homebuying and hence on the availability of cash: a shift of only a quarter of a percentage point affects millions of Canadian mortgages; that, in turn, controls how much cash is left over for consumer spending after the monthly mortgage payment.) If computer games had existed for post-war economic bureaucrats, the housing industry would have been one of their favourite joysticks.

No one told the industry this, at least not initially. Paradoxically, the builders themselves were making speeches on the importance that the industry should have in post-war economics. Little did they know how much the government would agree with them. The stimulative aspects of the new Act were welcomed. The new Act also took a page out of the book of its American counterparts: it provided subsidies for slum clearance. This would plant the seed for "urban renewal" in Canada. However, there was no stampede toward demolition anticipated at that time: on the contrary, it was generally expected that the demand for housing would so exceed supply that Canada would not choose to lose its tenements. The issue of urban renewal, however, would return to haunt downtowns across the country.

When the war ended in mid-1945, public policy turned to strategies to deal with returning veterans, war brides, and, eventually, refugees. Those bureaucrats who had held their breath in anticipation of giant house factories were disappointed, and continued to be so for decades after; but other wartime efforts produced pleasant surprises. The Victory House, which was supposed to be temporary, was anything but. Instead of carting these houses away in dumpsters, countless veterans upgraded them, put "holes" (basements) under them, installed furnaces, and made them into durable components of the urban landscape. Although some pundits would later

ARE YOU WELCOMING A **War Bride** TO YOUR HOME?

WITH our housing problem, it's going to be quite a job to house our war brides — some of them from overseas. One way adopted by many people is to add a wing to the house or convert part of it into a separate apartment.

If you are making such arrangements — or if you are planning to do a part to ease the housing shortage and add to your income by answering part of your house — consider your interior decorating schemes from the floor up. Start with Linoleum. It will give you charming effects, long life, economy of upkeep — and it will save housework because it is so easy to keep clean. Another advantage — and a big one — is that it is so resilient which makes it easy to walk on and reduces the noise of passing feet.

Ask your dealer to show you the wide and charming range of colours and effects in Dominion Battleship Linoleum, Marboleum and Marboleum Tile.

DOMINION OILCLOTH & LINOLEUM Company Limited, Montreal

DOMINION *Battleship* ✦ *Marboleum* **LINOLEUM**

The 1944 National Housing Act, said one bureaucrat, "was a pretty unromantic document with which to greet the returning warrior heroes expecting to make their homes in a new kind of world."[89] Nonetheless, it reduced builders' risks by guaranteeing that certain unsold homes would be bought back by the government; it opened the door to life insurance companies to invest in construction, and guaranteed part of their investment; it expanded the system of joint loans and guarantees. Although Canada had not reached the point of *no* down payments suggested by the builders, the groundwork was nevertheless being laid for the post-war boom.

revive the notion of the disposable building, the Victory House demonstrated that even in a throw-away society, there were limits. Canada had obviously learned a lesson in 1917, when Ottawa introduced income tax for the first time: never jump to conclusions when the government calls something "temporary."

This was especially true of "temporary" bureaucracies. According to Ottawa, the mere fact that the war was over was no reason to do away with wartime supply controls — and the fine bureaucrats who administered them. The Department of Munitions and Supply, which kept an iron grip on every feature of homebuilding, was renamed the Department of Reconstruction and Supply — with its web of controls and controllers largely intact. Several reasons were advanced. The ongoing powers of these civil servants would be necessary to fight *inflation*. If not, they had to fight *deflation*. They would undertake to solve *shortages;* if not, they would allocate *oversupply.* There was one constant: C.D. Howe, still the Minister of Everything, announced that "housing is a number one emergency," and hence the services of these mandarins would be desperately needed. As the French statesman Clémenceau once said, "There is no passion like a functionary's for his function."[90]

But did the profusion of bureaucrats do any good? There were chronic shortages of cement, gyproc, lime, and brick. "I am right next door to the largest lumber mill in the world," said builder D. Lightbody of New Westminster, "and I am unable to get the lumber necessary for my construction. There are huge piles in the yards but I am sure that price plays a large part in the release of lumber."[91] People had no idea what might happen to the price of a house — or its component parts — if the wartime controls came off. One contractor in Regina announced that his company would have to refuse to build a house for anyone unless the customer could supply his own materials. Paradoxically, few Canadians seemed to notice that while bureaucrats wrung their hands over the shortage of supplies, which left veterans' families living in radio schools and airport terminals, "as much as fifty percent of Canadian lumber was being exported, mainly to the U.S.A."[92]

Government economists still argued that without direct controls, the Canadian dollar would go the way of the Deutschmark after World War I: straight through the floor. Pent-up demand was so great that civil servants lay awake nights with visions of hyper-inflation — Canadians using wheelbarrows of money to buy cups of coffee. Alternatively, other theorists believed that Canada could return to the Great Depression if all those veterans were unceremoniously dumped on the job market, since that had also happened after World War I. Ottawa thought housing was not just about floors and roofs; it was not even about solving what C.D. Howe called a "national emergency" in shelter. It had *primarily* become a question of managing mind-boggling volumes of money and mortgages. The total amount of supplies, labour, mortgages, and down payments required to meet the backlog was now so large that it could have ripple effects throughout the economy and Canada's financial institutions. What the government wanted was not expertise on housing but on mortgage administration: thus was born Central Mortgage and Housing Corporation (now Canada Mortgage and Housing Corporation), on January 1, 1946. At its head, the government placed (a) one of Canada's foremost experts on mortgage financing, and (b) an army general. That said it all.

CMHC's president was mortgage wizard David Mansur, described by his own staff as having "the unmistakable air of the paramount government official who had direct access to the Delphic Oracle. It was a period when the concept of the gross national product had just come into fashion, and we all sat and listened in awe to Mansur's beautifully constructed paragraphs, his precise vocabulary, and his esoteric reference to this new thing, the GNP."[93] Mansur would be joined by General Young — along with Canada's leading economist on the subject of housing, Dr. O.J. Firestone, whose habit was "nodding his bald head sagely and smiling gently in approval [of Mansur], as if to indicate that he also had private access to the oracle."[94] Another mortgage expert hired was Bert Woodard; the combination of his Yorkshire accent, staccato delivery, and the fact that he never removed his pipe from his mouth made him incomprehensible;[95] that is perhaps the reason that he later sat down to *write* the definitive text on mortgage financing.[96]

The end of World War II gave rise to the fifteen-

year fertility rite later labelled "the baby-boom." However, the shelter to which the veterans returned was seldom conducive to their amorous inclinations. "Great numbers of returning veterans had started their married lives in army huts that had been moved onto university campuses. Other temporary wartime buildings had become the rather pitiful refuges for families on welfare who had nowhere else to go in the dislocations of the time; with the screens made of blankets, the interiors of warehouses and drill-halls were divided into family spaces."[97] Saskatoon housed its university students in the airport; in Calgary, families were lodged in the Wireless School. That situation went on interminably. Even in 1948, NHBA officials complained that Edmonton had one hundred families of veterans "cooped up in army huts"; "Regina has had temporary houses without running water and heating facilities for about three years."[98]

It was against this backdrop that Canada launched a building spree unprecedented in its history. The fruit of Canadian loins would be housed in suburban tracts that would invade the countryside as aggressively as any military operation.

American texts declare that the U.S.A. invented the "suburb" in 1869.[99] Actually, John Wyclif had referred to "suburbs" in the fourteenth century. Subsequently, they were called "suburblis" or even "suburbles." But by whatever name, in 1946 Canada, "the burbs" had arrived.

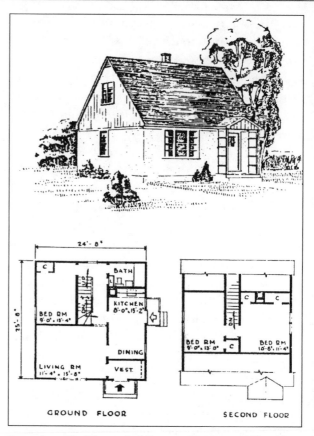

It was hoped, at the end of the war, that houses like this one would start to fill Canada's backlogged need for 150,000 housing units.

Canada Does the Wreggle's Wriggle
1946—1954

In which the Messiah comes to Canada; nails go into private hands; national fibre comes in quotas; urban planners use their sandbox; CMHC dribbles; and Canadian housing fights communism.

Just because Canada invented Pablum,[1] must our country be forever equated with blandness? And what about our suburbs: did they (do they) have to be colourless? Toronto's Norman Breakey didn't think so. His solution was "a paintbrush on wheels."[2] His contribution to civilization can be understood by noting how people painted before his invention: "Take a paintbrush in your right hand, or your left hand if you are left-handed, or both hands if it is a big brush. Dip the brush into a can of paint and raise it above the head ... Dab it on the ceiling, repeat the process hundreds of times. Then — take a bath."[3] Breakey's paint roller changed all that, along with a complementary invention of the era, drywall. By the 1950s builders had generally stopped finishing rooms in plaster. Workmen would materialize on a job site with prefabricated walls and seal them together with incredible speed. Some jerry-builders were so carried away that they even used drywall as a subfloor. That was a bad idea. One tenant of a Montreal walk-up, whose bathtub overflowed, discovered that drywall weakens when wet, and narrowly avoided having her bathtub fall into her downstairs neighbour's apartment.

Architectural journals of the era, however, were less interested in such niceties than in advancing the Modernist crusade:

> [The architect] must not abdicate his proud position but rather by his own aggressive and well-considered acts brave the anger of all stupid and self-seeking opposition ... [He is] the apostle of good living and the enemy of all mean, shoddy building ... He has been and will be always the agent by which a civilized way of life is established in any generation and upon his performance depends the glory of his age. He cannot and he dare not prostitute his art, for on him depends a future world, a world which may at last give place to order, and to beauty.[4]

Order and beauty were defined: "Prior to the recent war, domestic architecture was in a rather sorry state. The architectural styles ran the gamut ...

the three popular styles were Tudor, Cape Cod and Georgian ... that confronted the young and enthusiastic architect, aspiring to persuade an unappreciative public to build in a more *logical way*."[5] This meant the obliteration of traditional variations: "House design [has been] largely an exercise in archaeology, and its criteria are those of this or that period in architectural history, rather than its ability to satisfy *modern* living ... Against this sort of thing, architects today are setting their wills and energy. The day of archaeological eclectism [*sic*] is fast drawing to a close."[6]

But resistance continued not only among builders, but in the financial establishment. The Royal Bank said, "People do not want radical ideas in housing. They have no desire for sliding walls and rooms which can be extended by the mere pulling of a zipper."[7] *Interiors* magazine warned its Canadian readers: "The most vivid type of modern architecture today is what we have come to call California Modern. It features large expanses of natural redwood, plate glass, and deeply underslung furniture

and was designed, largely by foreign-born architects, specifically for the California climate. Designers in New England and Eastern Canada should regard it with considerable caution. It looks awfully bleak in a blizzard."

But architects were undeterred and, more importantly, so was CMHC. The new institution immediately dictated designs — all of which were variations on the same theme. "At all costs," CMHC added, "avoid applied decoration: you date your house, and from that moment obsolescence becomes effective."[8] CMHC was ready to eradicate all existing regional styles: CMHC's selected "Maritime Region" house looked like a Toronto bungalow — because it actually *was* a Toronto bungalow.[9] CMHC made no apologies and repeated *verbatim* the opinion of the 1936 Dominion Housing Competition: "The designs contributed in any region could have been suitable and successful in any other region."[10] Lest Canada miss the message, CMHC flooded the country with pamphlets advocating its own designs.[11] The impact was predictable. "Quite aside

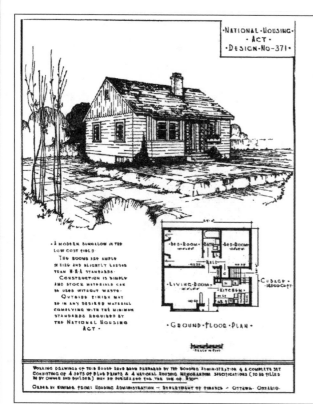
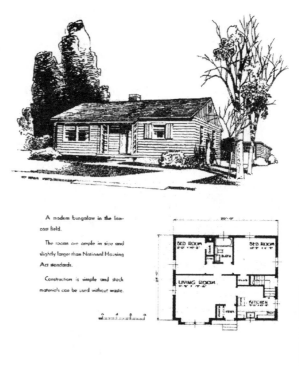

CMHC's recommended houses were a compromise between WHL and Modern, namely wartime housing with a flatter roof. The 1938 version (left) became the 1946 version (right), but these houses were identical in almost every other way. Post-war houses looked like Victory Houses that had been sat on.

from the effects of saturation distribution on the desires of consumers, the corporation held the power to approve designs before it loaned money ... Its own designs were more easily and quickly approved."12

The federal think tank producing many of these designs was led by architects Frank Nicolls (until 1946) and Sam Gitterman. They were aware of the cries that the corporation was contributing to Gross National Monotony, so they attempted a solution. They would produce special recommendations incorporating "regional" architecture, starting with British Columbia. B.C. was an ideal launching point, since its unique climate demands many distinct architectural features anyway. However, the feedback from B.C. was almost non-existent, so CMHC lost interest in that approach.

Nicolls and Gitterman were no newcomers. When that duo joined the Dominion Housing Administration in 1935, neither could have predicted that within twenty years, they would occupy a most paradoxical position: thanks to CMHC publications, they had become the most extensively imitated architects in Canada (far beyond the Heroic Modernists); but although they enjoyed the respect of officials and industry, they were virtually unknown to the occupants of the houses they had designed. To paraphrase Winston Churchill, never did so many live in so much, known to so few.

Universities were on a different tack. The standardization of "correct" design, according to some professors, reinforced the drift of architecture students toward rote: "Sometimes [a student] will carry on for two or three years with all the symptoms of a subhuman intelligence yet evincing just enough low cunning in examination work to prevent an enforced departure for pastures new."13 The most telling barometer of the architecture schools, however, was the opinion of Harvard professor Joseph Hudnut. At first, he warned RAIC about machines for living and other Le Corbusier ideas:

> I am aware of new techniques of planning and the surprising gadgets with which our houses are to be threaded. I perceive also the aesthetic modes ... [namely] the perforated box, the glorified woodshed, the house built on a shelf ... [They] have left unexhibited that *idea* which is the essential substance of a house. My impression is obviously shared by a very wide public ... I am even less persuaded by ... those who have created a vegetable humanity to be preserved or cooled or propagated in boxes ... My requirements are somewhat more subtle than those of a ripe tomato or a caged hippopotamus. Now I do *not* advocate a return to the Cape

Contrary to conventional wisdom in architecture schools, gigantic numbers of suburban houses were indeed inspired by professional architects — at the federal government and CMHC. Sam Gitterman (above) was a leading force from 1935 onward, as was Frank Nicolls. Their widely distributed designs, however, were often reinterpreted by the builders — then reviewed again by the lenders. NHBA president Les Wade later reflected (1957): "A builder finds that forward-thinking design is not accepted very readily by many of our lending institutions. In fact, our experience has [often] ... been 'thumbs down' completely."14

Cod cottage, still less a return to that harlequinade of Colonial, Regency, French Provincial, Tudor, and Small Italian Villa, the relics and types of our ancestors' inexhaustible inventiveness which adds such dreary variety to our suburban landscapes. That adventure is at an end ... [The future owner] shall be a *modern* owner, a *post-modern* owner. Free from all sentimentality ... his habits of thought shall be those most serviceable to a collective-industrial scheme of life ... Even so, he will claim for himself some inner experience ... discoverable in the home.[15]

Hudnut admitted, however, that he was fighting a losing battle: "I tell my students that there were noble buildings before the invention of plywood. They listen indulgently but they do not believe me."[16] Hudnut finally succumbed. By 1949 he told the University of Toronto:

Le Corbusier stands first among living architects. First? I am tempted to say that he stands alone, Messiah and author of a new Bible of Design ... The buildings which will exhibit his creed are, for the most part, still on paper — or in the minds of the thousand students of architecture to whom he is prophet and missionary. The American people resisted ... [but] we ought to think of Le Corbusier as a poet ... Our young architects look up from their drafting boards to catch, through a torrent of images and through the sketches that sprawl across his pages pregnant with ideas, glimpses of a new and radiant universe.[17]

CMHC would have liked to be part of that universe, but its own head of research, Humphrey Carver, had doubts about its ability: "It took a long time for the Ottawa establishment to comprehend that housing is a human and a social subject and not just a matter of money and physical materials ... [Furthermore] the environmental quality of the product was not considered important and, looking around me at these meetings, I could not feel that anyone present was very qualified to judge such matters."[18] Instead of a "great creative national enterprise"[19] there was "a sense of futility in the scattering of bungalows upon the reluctant suburbs."[20] CMHC set up a policy task force, but it "fizzled."[21] CMHC couldn't even get the members into gear: Robert Legget "was busy elsewhere" setting up a Division of Building Research for the National Research Council, and O.J. Firestone indicated "he was 'slumming' and must hurry away to higher things."[22]

But, in the late forties, Canada needed help: only 61 percent of homes had running water and barely half had an inside flush toilet. The figures were worse among rural dwellings, which represented half the housing stock: there, only one in five houses had a refrigerator.

Canada needed a massive building program. Aside from the demand from consumers, many municipalities felt starved: they were sitting with development lots that had been laid out in the Roaring Twenties, but which had been seized for taxes after the Crash. Around Montreal, there were fire hydrants sitting in the middle of farmers' fields, and used from time to time to water the vegetables. When the building boom finally arrived, "the new house fashion was the single-level bungalow, which typically had less than 1,000 square feet of living space, a small (55-square-foot) kitchen with a linoleum countertop containing a single sink, with one bathroom with a little medicine cabinet on the wall as a major storage area."[23]

One unmourned casualty of all these new bathrooms would be the privy, complete with crescent moon carved in the door. That carving, in any event, did not enjoy the venerability of age: this "tradition" was invented only in World War II with the popularization of "Lil' Abner."[24] Privies (with crescent moon or not) would quickly disappear: by 1967, when St. Paul, Alberta, undertook a collective privy-burning as a Centennial Project, it could say that it was doing so not only for itself, but symbolically for the whole

country. "They have held up their ends," the local minister eulogized, but few tears were shed.

The post-war transformation in housing technology was not yet complete. Roofs were still not prefabricated. Insulation, by today's standards, was miserable. "Stressed skin" sheathing and subroofs existed but were not yet standard. Boards were still used in walls instead of plywood. Even the windows and cabinetry were still hand-built. Nonetheless the Canadian house was changing: dirt-floor cellars were replaced by concrete-floored, full basements, even among WHL's "temporary" houses, now equipped with furnaces. Thanks to backhoes, which replaced bulldozers for excavation, and prefab foundation forms, basement construction-time dropped by 65 percent. Forced-air furnaces blew onto the market. Pressed-steel bathtubs replaced cast-iron ones. In Nova Scotia, seaweed insulation disappeared — despite a last-minute attempt to revolutionize its production and performance. Asphalt shingles replaced wood and asbestos-cement shingles. Clapboard was still the rage in Atlantic Canada; brick was preferred in Quebec and Ontario; and western Canada continued its love affair with stucco; but a remarkable new material was being marketed. It was called "aluminium." If you no longer needed it for your bomber, you might try it on your bungalow. Fleet Aircraft sold aluminum windows within a year of the war's end, and Fairchild Aircraft and Alcan built houses with "aluminium siding" in Montreal at the same time.

But not all construction practices were commendable. To the expression "jerry-builder" was added "mushroom builder." Colonel Akins, speaking for Manitoba homebuilders, accused them of profiteering.[25] Builders also accused incompetent newcomers of wasting scarce manpower and materials. "If the supplies can be channelled to the experienced builders," said Robert Rae, "more construction would result."[26] "During the present emergency," added builder Dean Buzzelle, "many inexperienced people have started to build houses and have been one of the causes of the present confusion."[27] There was indeed confusion. Although the Ontario Ministry of Housing exhorted the industry to think "forty or fifty years" ahead,[28] access to materials made business a week-to-week affair. Wartime controls had

evolved into "priorities": an entrepreneur with a "priority" could get supplies unavailable to anyone else. For some builders, it seemed as if the war had never ended.

"Inadequate supply of materials," said NHBA, "has caused grievous delay."[29] No one disputed the "priorities" for veterans' housing, but builders argued that other housing should come next. If there was a supply crisis, why should non-residential construction scramble for the same materials? What was the priority system supposed to accomplish anyway?

Even though half of Canada's lumber was going to the U.S., no one seemed to notice: Canadians were too busy denouncing each other for the supply crisis. Although the officials said that their controls were an essential buffer against inflation, was government *contributing* to — more than solving — inflation? "Wartime Housing Ltd.," said NHBA's then president George Prudham, "has placed orders for carloads of lumber in British Columbia at $6.50 per thousand over the current list, and *this* is being used by the B.C. mills as an excuse for raising the price of lumber."[30]

Then came nails. In cryptic bureaucratese, the steel controller announced: "The ex-quota of nails will be handled by Central Mortgage and Housing Corporation."[31] This gave CMHC a monopoly on the 400,000 kegs of nails used by Canadian builders each year. In today's parlance, CMHC would be "Nails Canada." NHBA and the nail producers objected. Finally, nails went back into private hands.

Matters became even more unstuck with bathtubs. When the industry reported shortages, the government banned imports. Negotiations finally permitted the import of 10,000 bathtubs — but no sinks.

All this was done in the name of fighting inflation. Manitoba's minister of housing reflected the conventional wisdom: "When you start out to build more houses ... [and] supplies remain short, we might further inflate prices. Inflation will eventually price houses off the market."[32] CMHC's Mansur denounced "easy money" (low down payments and low interest) and accused the U.S.A.'s "GI loans of being definitely inflationary";[33] but he hedged his bets and also warned about *deflation*. "There is no sign of a depression at the present time, but the pre-

sent very great demand cannot continue forever and we must look forward to the time when fewer houses will be required."[34]

This thoroughly confused Canadians. Alberta MLA Rose Wilkinson, one of the rare female politicians of her time, warned CMHC against a self-fulfilling prophecy: "We should not waste time thinking about a depression: that helps to bring it on."[35] She favoured a bullish approach in pursuit of "national fibre": "Since 1930, we have been short of homes … in Calgary, one-third of the homes are owned, two-thirds are rented. This is a very undesirable condition. The home is the basis of family development. National fibre depends upon the home atmosphere … If we had better homes, we would need fewer institutions, particularly of the corrective variety!"[36]

CMHC finally responded with a clearly expansionist policy. Mortgage loans became available at 2.5 percent interest, over as much as fifty years. CMHC also tried the cutting edge of new technology, with this new creature called "the aluminum window." CMHC astonished observers when it announced

purchase of "22,000 windows of aluminum construction at the same price as wooden sash"[37] — but conversion of war factories had made aluminum *easier* to find than wood.

CMHC's attitude to builders was pragmatic. It inherited the government's belief that the nicest thing to do to builders was to wipe them out and start over with mega-companies; but in the meantime, CMHC would make the best of a bad situation. "It was the task of CMHC," said staff, "to develop the Canadian housing industry, practically from scratch, sow the seed and cultivate the crop."[38] But the builders refused to behave like vegetables: they complained to CMHC that with regional disparities, western freight rates, incompetent appraisals, poor consultation, and appropriation of low-cost housing by ineligible tenants, Canada's construction program was "a mess."[39]

The builders also stepped up their own campaign to improve quality. They wanted to *license* qualified homebuilders and almost persuaded Alberta to legislate accordingly.[40] They hired one of the most notable lobbyists in Toronto to pressure Ontario to do likewise. They also called on CMHC to increase

CMHC president David Mansur (centre), with honour guard carrying two-by-fours. With the builders, Mansur hammered together a program called "integrated housing": CMHC would buy back from builders unsold houses that met CMHC specifications. This took some of the risk out of construction, and builders loved it. Mansur told them: "The integrated housing plan is a good vehicle; in fact, I can *say* it is really a grand scheme because *I* did not have any part in originating the plan."[41]

inspections of builders, and particularly to watch for possible hoarding of materials. Finally, they proposed a warranty system: "The plan calls for an unsatisfied judgment or assurance fund for the protection of the home purchaser, such fund to be established by collecting a yearly fee [from builders]."[42] However, despite top billing on the builders' agenda, these plans took years — in some cases decades — to materialize.

The future of low-cost housing remained in limbo. The two major political parties reversed roles: the Liberals denounced subsidized housing, while the Conservatives had no such inhibitions. Paradoxically, the federal (Liberal) government was *already* subsidizing housing: as NHBA's George Prudham argued, "The cost to the taxpayer for each Wartime Housing unit is about $3,000";[43] and "wherever a municipality enters into a contract for low rental housing, the municipality is called upon to put up the equivalent of $600 per unit to cover land and services."[44] The builders again claimed they could build "a better standard of housing at lower cost than government agencies,"[45] but that it was impossible to compete with "government housing which bears heavy subsidies, namely interest rates of two and a half percent, amortization of fifty years, and tax rates of about one-third the normal rate."[46] Government-built units were then supposed to rent at between $27.00 and $37.50 per month.

Some observers didn't like the aesthetics of proposed public housing either. Alberta housing minister A.J. Hook gave his prediction: "Alberta did not like to see the government in the house-building industry or owning homes. Row after row of similar houses creates a drab effect. We like individuality!"[47]

That didn't bother CMHC. After taking over WHL, it launched a veterans' rental housing program composed of another 25,000 standardized houses over three years. By 1949, CMHC was landlord to over 40,000 families. Remarkably, while CMHC was promoting government-built public housing, it was simultaneously unloading its WHL units. "We are at a loss," said NHBA, "to understand the government's claim that additional rental housing must be provided while simultaneously government rental units already acquired are being sold ... in competition with the private house-building indus-

try." If there was a low-rent housing crisis, why wasn't government keeping the stock it already had? To add to the confusion, in October 1947, Louis St. Laurent (heir apparent to Mackenzie King) announced: "No government of which I am a part will ever pass legislation for subsidized housing."[48] St. Laurent then promptly reversed himself.

Once "subsidized housing" was politically correct, what should it look like? Canada was influenced by a flood of American literature saying the first step would be to flatten existing neighbourhoods. By 1949, Americans had given this process the statutory label of "Urban Renewal."[49] "Blighted" areas of cities would be amputated, like gangrenous limbs, and from the rubble would emerge a new order modelled on Corbu's "Shining City." Slum-dwellers' new homes would need subsidization; but federal politicians were hesitating to move in that direction. Toronto therefore took the lead. It installed the first municipal housing authority in Canada — in a Gerrard Street funeral parlour.

The reluctance to *pay* for the shining city in the slums was reputedly based on a high moral imperative: governments didn't want "to give the poor more than they deserved ... That public housing should not have 'frills' was almost taken for granted. No one stopped to consider that attractive urban architecture benefits everyone if it benefits anyone. Few people realize this even today."[50] NHBA and others warned that the projects would merely replace horizontal slums with *vertical* ones. Since when were highrises appropriate for low-income families? In the words of one American expert, "Toddlers trembling on the brink of toilet training cannot reach high-up apartments in time to avoid disaster."[51]

While Canada pondered highrises, new-style housing in the suburbs was going full tilt. Even the streets differed from anything seen before. A seed had been planted in the early war years: although Victory Houses were Spartan, the layout for these sternly rationalist subdivisions became whimsical. Streets curved; they meandered; they looped; in some cases, they disappeared altogether, and houses faced onto what would be shaded walkways — if the trees ever grew. Even the nomenclature changed: it was *passé* to call the thoroughfare a "street." It was now a "drive," "terrace," "path," "court," "gate," "circle," or

"crescent." Some of these plans, like the earlier revolutionary plan for the Town of Mt. Royal near Montreal (1917) and the Churchill Park area in St. John's (nicknamed "the New Jerusalem"), were the legacy of Thomas Adams and the Garden City planners, who believed that if roads dog-legged and houses clustered in a certain way, we could transpose the charm of the Cotswolds into suburban Moncton or Saskatoon. More often, however, the planners were not the decisive factor, because Canada had almost none to speak of. Adams's Town Planning Institute had gone dormant in 1932 — and there was not one planning school in the country.

Yet curves became even more noticeable after the war! Who was responsible if not planners? The edict came straight from CMHC president Mansur. He had a loathing for adolescents with raccoon coats and porkpie hats, and rumble-seated jalopies being driven at speeds unthinkable in polite society. Mansur issued his edict "so that hot-rods driving too fast for safety would be immediately identified by their squealing tires."[52] With CMHC's scientific precision, this principle became known as "the Squeal Factor."[53] CMHC's George Wregglesworth was assigned to plot the resulting curved roadways on maps, so CMHC staff named them "Wreggle's Wriggles."[54] The Wreggle's Wriggle is a fundamental feature of Canadian suburbs to this day.

Architecture schools, for their part, deplored the notion (somewhat incorrect) that so few suburban developments were architect-inspired. CMHC's top researcher, however, put a different spin on that issue. He believed CMHC's "straightforward, small-house designs [could] create places of great beauty by grouping and clustering and arranging landscape."[55] "The art of the suburbs," he said, "is closer to landscape design than to architecture. So I used to chide Canadian architects who thought that their great gift to Canada would be some unique and original house design, remarkable in being different than everything around it … [Layout] had been a geometrical exercise that had never seemed to call for much imagination until Harold Spence-Sales demonstrated that to design the basic unit of a community is a social art and a landscape art."[56] Spence-Sales founded the first planning course in Canada at McGill in 1947–48. At the time, he didn't bother with details like a curriculum. Instead, he outlined proposals for subdivisions on a sand table, a sandbox on stilts, like those used by military tacticians to display troop movements. It is in this sandbox that Canada's home-grown planning profession was born.

For the time being, however, most of those few professional planners in Canada were imports. Some from Labourite Britain were automatically suspect among developers, and architect Peter Caspari decried the "possibly well-meaning but certainly ill-informed U.K. town planners operating in Canada."[57] One CMHC staffer later complained that "the growing tendency to higher density was the direct result of some of the attitudes from the planners and architects that had brought their experiences of planning from elsewhere. According to some of the planners, the concept of a single-family dwelling just didn't make sense."[58] Worse, the era's most illustrious planner, Toronto's Hans Blumenfeld (who coined the phrase "suburban sprawl"),[59] had worked in Stalin's U.S.S.R., had his passport lifted by U.S. authorities, and was overheard saying nice things about East Germany. There would be rough times ahead.

This tension stemmed from an event that shaped the public psyche — when Igor Gouzenko, a frustrated Soviet cypher clerk, left his embassy in Ottawa on September 5, 1945, and spirited an armload of incriminating documents to his Somerset Street apartment. Until then, people still had warm feelings about our World War II ally "Uncle Joe" Stalin. Gouzenko exposed not only Stalin's ongoing designs upon the rest of the world, but also his spy network to implement them. Ottawa thought poor Gouzenko had lost his senses, and dispatched Mounties to watch his home in case of suicide. Not until July 1946 did Canada fully believe Gouzenko's evidence. Ottawa reacted with consternation, Washington with hysteria. The Cold War was on. If World War I started in Sarajevo, the Cold War started on Somerset Street.

Nothing Stalin subsequently did reassured the Western world in the least. Mounting fear triggered a watered-down Canadian McCarthyism, which seeped into every aspect of life, including homebuilding. The watchword was "vigilance" toward any "softness" on communism. People shook their heads

over how muddle-headed our other wartime ally, Great Britain, had become: Clement Attlee's Labour government wanted to build, own, and lease entire "new towns." A spokesman for American builders came north to warn his Canadian colleagues of this slippery slope to socialism.

> You must justify yourselves as builders and as citizens of the great free world through guarding against socialization of your industry ... [You must] compare the gradual inroad of socialized housing in England which, after three years, has supplanted private enterprise in the house building industry. The basic object of the [U.S.] builders is resistance to socialization. Canadian builders must also get behind your local and national organizations to preserve free enterprise in housing.[60]

Boxes of warning leaflets were imported from south of the border.

But despite "the Reds under the beds," Canadian builders' campaigns did not sway perceptibly from their traditional emphasis on affordability and availability of supplies. NHBA president (and eventual federal minister) George Prudham believed if builders could *deliver* affordable housing, the rhetoric would be moot: "If we accept the challenge and build houses the average man can buy, we don't have to fear socialism or government intervention. I feel we have an obligation to look after the little man. If *we* don't look after him, the government will."[61]

The Cold War had more tangible results when it turned into the Korean War in 1950. That event sucked almost everything metallic off the market. Hot water tanks were the first to go. The responsible federal minister predicted that shortages would get worse: "You builders have been finding it increasingly difficult to obtain furnaces, hardware, nails, copper, zinc, and other necessary items ... Moreover, Mr. Howe has warned that steel will be in even shorter supply as the National Defence program moves into high gear."[62] Shortages provided the excuse for the government's first major retreat from its commitment

to affordability. The minister responsible for housing was Robert Winters, who in the next decade came within a hair of becoming prime minister (only to be upstaged by a young intellectual named Pierre Trudeau). As the 1951 strategist of housing policy, Winters explained that since builders wouldn't be allowed enough building supplies to satisfy the public *anyway*, the government might as well *suppress* demand (by jacking up costs) to fit what could be built with the leftovers. So the government doubled NHA (National Housing Act) down payments and reduced amounts available for loans. Winters explained:

> The small, so-called wooden house requires approximately two and a half tons of steel for water pipe, soil pipe, nails, plumbing fixtures, furnaces, hardware and other manufactured products ... The difficulties of the moment are physical rather than financial. They result from lack of materials — not lack of money for lending purposes. [We must] relieve the pressures which attractive financial terms will place upon the physical limitations ... The danger [is] if the amount of residential construction gets beyond the capacity of the housebuilding industry.[63]

New institutional loans for construction promptly plummeted from $310 to $237 million. Builders were beside themselves. New NHBA president F.A. (Phil) Mager replied with the rhetoric of the day:

> The greatest bulwark we can erect against the inroads of Communism will be to extend the facilities of homeownership to an ever *widening* segment of our population. It is alarming, therefore, that mortgage finance under the National Housing Act has been curtailed ... If we accept the family as the basic social unit in our democracy, the house as the ideal form of accommodation

for that family, and home ownership as the hallmark of a good citizen, then we should put no barrier in the way of the family of modest means from owning the house it occupies![64]

Homeownership, added NHBA's Hamilton Local, makes a "country better equipped mentally and physically to undertake a rapidly expanding defence effort. Accordingly, we view with alarm the fact that mortgage financing is now so regulated that only the upper-bracket wage earners are able to purchase houses."[65]

NHBA also told the Ontario government (and anyone else who would listen) that "this tradition [of home ownership] should be encouraged and fostered as a principal weapon against the encroachment of those elements which have as their purpose the destruction of our democratic way of life."[66]

The doubling of down payments was also opposed by the Progressive Conservatives. Young housing-critic George Hees insisted on "a flat ten percent downpayment on houses, and that a family home should be purchasable by workers earning as little as $53 a week."[67] (By 1954, the average weekly wage was $62.) The Tories also stood for improving municipal infrastructure: "One of the root causes of inadequate housing is the difficulty encountered by municipalities in meeting the costs of essential services necessary for any housing project. This problem must be faced, not by the municipalities alone, but in cooperation with the provincial and federal authorities."[68]

But Winters replied that if builders didn't calm down about the status quo, he could introduce something worse. The government could appropriate all materials and ignore both builders and homebuyers: "The government could have stood by and let the housing industry grind almost to a stop." "Another alternative," he said, "would have been to leave the financial terms of the National Housing Act unchanged and to attempt a system of 'priorities'"[69] as existed in WW II. That didn't mean he wouldn't do that anyway: "Despite all the attendant difficulties, the time *may* come when priorities [namely wartime controls] and allocations to housing of vari-

ous types will be necessary."[70] In short, the Canadian housing industry should swallow the assault on affordability, because the *next* time the government might assault the industry's supply base. The typical response was epitomized by Saskatoon builder T.M. Ball's sarcastic letter to CMHC:

> If it is the policy of CMHC to further curtail housebuilding you would be doing the housebuilding contractors, as well as the nation, a service in saying so ... In the event of the government not desiring an increase in housebuilding, possibly you would suggest *what defense work you would like this organization to undertake.* I wish to continue to be of *some* use to the nation at this time.[71]

Cold War rhetoric also had physical results for home design. In 1951, NHBA president Mager reported that "the threat of war demands that we give consideration to ... the protection of the individual family, by provision of low-cost individual family [bomb] shelters."[72] NHBA resolved "to form local committees on family air-raid shelters to study how the best type of family shelter at the lowest possible price can be made available to the Canadian people ... to mitigate the effects of enemy action and to speed public recovery after such action."[73] But W.H. Kirkpatrick of the National Concrete Products Association told builders: "It depends in large part on the type of home in which Canadians live whether or not they will survive an atomic bomb attack." If Canadians made sure to buy his product, "Homes of lightweight reinforced concrete block or pre-cast lightweight concrete [will survive] a (thirty-five-kiloton test) explosion with no more than *minor* structural damage ... The greatest safety [is] in homes built with basements or other types of survival shelters. The cost of adding masonry survival shelters to existing homes is negligible."[74] He advised that, by contrast, if a nuclear bomb dropped within 4,700 feet of the buildings of his competitors, such as a frame house, the home would be "almost a complete loss."[75] So would a two-storey, brick-and-cinder

block home — "The second floor [will be wiped] away and the first floor [will collapse] into the basement" — hence the importance of his product for the discriminating consumer.

Officials pondered building a bomb shelter for the prime minister in Carp, Ontario; it was completed during Diefenbaker's term, and was promptly nicknamed the Diefenbunker. However, shelters were hardly the first invitation for Canadians to go underground. At some indeterminate moment in the previous decade or two, Canadians stopped having "cellars" and started having "basements." At first, the difference was merely terminological; however, times were changing: the space for turnips and pickled beets was becoming space for people. Dirt floors were disappearing, concrete blocks were making way for poured concrete foundations, and by the 1950s the "basement" was even dry enough to build a "rec room." But there was no guarantee of absolute dryness in a basement; dampness remains the most common construction problem to this day. An increasing number of blueprints from the 1950s therefore displayed an alternative means of dealing with family situations above ground: the "family room" or "den."

American texts, of course, say the den was invented in the U.S.A.: the room for children "was first called the don't-say-no-room, then the multi-purpose room, but when a 1947 *Parents' Magazine* model-house plan used the term *family room*, it was adopted generally."[77] *Den* was almost synonymous, except that it may have been smaller. The migration of young baby-boomers to this room was, according to some parents, a reflection of the *Oxford Universal Dictionary's* definition of *den* as "the lair or habitation of a wild beast." *Oxford* indicates, however, that by 1837 the definition also meant "a room unfit for human habitation," which is what many parents thought after their baby-boomers had finished with it. However, this room was becoming a focus for family activity by default: although the term *parlour* had been mostly replaced by *living-room*, that did not mean that any "living" necessarily went on there — particularly if it didn't include the house's only television set. Since magazines predicted that lifestyles in the 1950s would be more "casual," this automatically discarded the house's front room (used as a sitting room for weddings and funerals), which was being reduced to "an infrequently visited religious shrine."[78] There would need to be a decent hallway to *the den* where real family living would take place, along with access to the backyard with its ultimate shrine to "casual" entertainment, the barbecue. *Oxford* also records that in 1952, a new word entered the English language: *split-level*.[79] In short order, the media reported that "Canada has gone split-level mad, provided [you] know what split-level means."[80] CMHC knew what it meant, and "encouraged [it] through favourable appraisals."[81] Designs usually permitted direct access from the family room to the great outdoors.

A preoccupation with backyards was not this era's only contribution to embryonic environmentalism. Some developers discovered that subdivisions were not necessarily *supposed* to look defoliated — and that consumers agreed. This surprised some builders who never expected streets to contain the trees they were named after. For example, Halifax's Clayton Developments "didn't want any trees cut, but all the builders weren't used to this method.

H-BOMB SHELTER

For Canadians truly serious about megatonnage, a 1955 issue of *National Builder* illustrated an H-bomb shelter displayed in front of Toronto City Hall — although the small print said, "The shelter is not designed to withstand a direct hit."[76]

DOMINION *inlaid* LINOLEUM

. . . the <u>Trend</u> Flooring . . .

. . . chosen by the architects of Canada's "Trend" Houses!

Marboleum

Battleship

Jaspe

Handicraft

In Tiles

and

By-the-yard

If you put tile flooring and either weldwood or knotty pine in your rec room, you might even consign your teenagers to it, along with their infernal new preoccupation, Hi-Fidelity. One report in *National Builder* discussed the advantages of "music conditioning" homes: the home of the future would have a centrally controlled radio/phonograph with speakers built in throughout the house.[82]

They wanted to cut the trees so they could store their bricks, roofing shingles and lumber. Clayton told them that they couldn't do this, but after they saw that the houses sold even though they didn't cut the trees, the attitudes changed."[83] On another environmental front, NHBA invoked the war (and shortages of supplies) that called for an all-out attack on waste: no more bits left at construction sites! "We are certain [that waste reduction] could achieve amazing results in our own industry … We are all agreed that these savings could easily run to twenty percent; if *all* obstructions are removed they could reach thirty percent or even forty percent." It would take decades for this idea to catch on.

Another idea that was not catching on as quickly as officials expected was prefabricated housing. Although 1953 marked the founding of what is now the Canadian Manufactured Housing Institute (CMHI), Canada had still not identified the right equilibrium between factory-built and site-built housing. There were five possible strategies to choose from:

1. Canada could follow the pundits' advice and build assembly-line houses that resembled nothing previously seen. Thomas Edison had proposed a cast-concrete manufactured house in 1908; Buckminster Fuller had proposed his Dymaxion House in the late 1930s, on the model of a truncated grain silo; Walter Gropius threw not only his moral support but also his considerable salary into the General Panel Corporation. All of these schemes, however, encountered a lukewarm response from consumers.

2. Another strategy would be to promote factory-built housing, but to make it look conventional instead of like Martian cubes. Halliday Homes, a company that dated from 1888, was one of several builders experienced with "modular" houses (called "breakdown" houses in the Maritimes), but they got a half-hearted reception from conservative municipal governments.

3. Factories could focus on prefabricating building components — roof trusses, windows, cabinets — for use in conventionally built houses (again if municipal reluctance could be overcome).

Ground-floor plan only.

In 1952, *Star Weekly*, Canada's largest weekend magazine of the era, described these three designs as "dream houses."

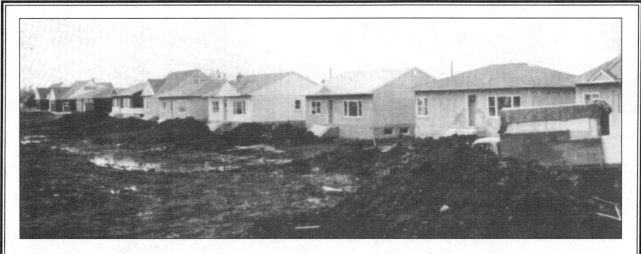

Homebuilding had reached the billion-dollar mark in 1951, and this frenetic pace (such as here in Edmonton) would continue until the 1970s.

4. The emphasis could be on meeting the growing demand for "mobile homes" (this was the original inclination of CMHI).

5. Factories could do a combination of these measures, depending on the direction of the market.

Ultimately, it was the last option which proved the most successful — but not before Canadian companies overcame a variety of challenges. Although mass production promised economies of scale, firms had to compensate for the extra labour involved in loading and unloading the modules, the extra risk of damage in transit, and, most problematically, the difficulty in keeping a constant flow on the assembly line when the market fluctuated at the bat of an eyelash. The entrepreneurs who would cope with those conditions could not be "religious zealots," as one developer called the advocates of manufactured housing,[84] but had to be flexible and resourceful. Like other housing-related organizations, CMHI had modest beginnings, as the Canadian Trailer Coach Association,[85] reflecting its original focus on mobile homes. These "trailers" grew in sophistication (particularly after the introduction of Canadian Standards Association rules),[86] but true diversification into all aspects of manufactured housing would not become a reality until two decades later.

Among existing homes, new approaches were also being devised. In 1951, Canadian realtors introduced a cooperative system to share information about homes for sale. They called it, logically, the Co-op system, or Photo Co-op since realtors exchanged pictures. A decade later (in 1962) this became the Multiple Listing Service (MLS) by which some 90 percent of owner-occupied homes are sold today.

Changes were also occurring at CMHC. The departure of David Mansur marked the end of an era. His parting gift was a new National Housing Act (1954), which eliminated federal contributions to loans but opened a loan-insurance system allowing *banks* to participate fully in housing. Until then, if you wanted money for a house, you borrowed from your life insurance company. NHBA was gratified: "We have won a great victory," said president Gordon Shipp. "Not only does the new act permit the chartered banks to lend on real estate for the first time in their history, but it reduces down payments from twenty percent to ten percent on the first $8,000 of lending value, and extends the amortization period from twenty to twenty-five years." Shipp concluded: "This measure is designed to ensure a high level of house building for years to come ... Each one of these points [was] consistently fought for by [the builders'] association."

A pattern had now emerged for mortgage financing. There were two basic kinds of mortgage: a "conventional" loan or a "high-ratio" loan. A conventional loan came from financial institutions, which were usually told by their own legislation how much they could lend on a home mortgage. Banks, for example, were governed by the Bank Act (and still are); this

statute dictated the maximum loan which the bank could make in relation to the appraised value of the property.

If the homebuyer could afford only a small down payment and hence needed a bigger loan, he would have to give up on the idea of a conventional mortgage, and seek a high-ratio mortgage instead. The lender would insist that someone guarantee the loan, in view of the greater risk. In NHA loans, CMHC insured the loan; so if the borrower defaulted, CMHC would pay off the lender, then settle its own accounts with the delinquent borrower. In later years, private companies also became mortgage insurers — for a price. Over the following decades, every change in legislation concerning borrowing limits — whether for conventional mortgages or high-ratio, insured mortgages — would have a significant impact on Canadian homebuyers.

Mansur had another parting gift: CMHC fulfilled every bureaucrat's dream of relocating into posh new headquarters — complete with a basketball court. When moving from #4 Temporary Building on Parliament Hill, Mansur "chose a building site two *miles* away from Parliament Hill; it was a deliberate move to express the independence of CMHC as a corporate institution."[87] Unfortunately, the visual effect, according to CMHC staff, looked "not unlike a glorified Howard Johnson's highway restaurant."[88]

According to one CMHC staffer, "Even the architectural style of [CMHC's] new head office was a departure from the conventions of Canada's federal government buildings. It was designed in red brick American Colonial style because Mansur wanted the building to look like the head office of an insurance company."[89]

Where the Wildebeests Roam
1954–1960

In which a fool and his money are soon with a consultant; municipalities lose their fiefdoms; a house is built with vials of embalming fluid; you are what you eat; and Canadian homebuilding encounters the principles of good breeding.

I'm a G-nu, I'm a G-nu
The g-nicest work of g-nature in the zoo!

Flanders and Swann, "The Gnu"[1]

What housing expert would fill David Mansur's shoes? None. Ottawa picked a fisheries official. Stewart Bates "loved going out on the trawlers, exchanging yarns ... with a nip of scotch in his hand."[2] There were no fish at CMHC, where he would "suffer dreadful frustrations."[3] But Bates had a psychological lifeboat, of sorts. He decked out his office with hi-fi equipment; in times of stress, he would retreat to it with hapless senior staff and play "The Gnu" song to them.[4]

Yet Bates largely succeeded where WHL had failed. Although the dollar-a-year men's dream of a housing oligopoly never materialized to produce the desired concentration of power, CMHC's combination of strategy and muscle would eventually give Bates an even tighter grip on the industry than WHL ever anticipated. One of Bates's first moves curried favour with the architects. He shuffled CMHC's chief architect Sam Gitterman, "the acknowledged master"[5] of small-house design: "The new impresario needed to find a new star, a Nureyev for his 'corps de ballet.'"[6] Bates hired Ian Maclennan, who built cor-

rect Modern buildings — in New York and Caracas. "Up to that time the engineers had been the predominant professionals at CMHC; the architectural influence then became dominant."[7] CMHC staff expressed some "doubts about [Maclennan's] knowledge of housing,"[8] but the architects' institute promptly rewarded Bates with an Honorary Fellowship.

"Urban renewal," on the other hand, gave Bates good reason to play "The Gnu" song. Instead of a noble "rediscovery of the good things already built in the older areas of cities ... to revitalize them rather than to erase them with a bulldozer ... urban renewal came to have a pejorative meaning because of the failure of our legislation to provide sufficient funds for the conservation part."[9] But Bates almost had to be restrained from attacking slums with his bare hands. He admonished his staff not to have "an antiseptic, namby-pamby attitude [that is] colourless and dead. Urban renewal isn't something to be discussed so politely. Life cannot be understood by staying home and drinking tea!"[10] It was time, he exclaimed,

for CMHC to take on the "rogues, vagabonds, sorcerers, the pimps, the bawds, and the perverts!"[11] Urban renewal didn't. "The long series of urban renewal studies eventually deteriorated into a routine exercise, going through the prescribed motions of what McGill's Harold Spence-Sales called a 'vermin count.'"[12]

But in its early days, urban renewal was alive. One controversy occurred in Montreal: in 1952, the Dozois Plan (later known as Habitations Jeanne-Mance) was approved. It was classic in its day: slums would be demolished and the occupants moved into government highrises. Quebec's wing of NHBA, represented by Maurice Joubert, attacked (a) the displacement, (b) putting families in highrises, and (c) the cost. This hit a responsive chord with crusading young Mayor Jean Drapeau, who supported renovation and lowrise infill as the proper ways to rebuild slums. He told NHBA, "It is useless to replace slums with barracks in the short term, when it is possible to provide to all a true home, within the context of a comprehensive plan."[13] Drapeau's objections to the Dozois Plan put him on a collision course with Premier Maurice Duplessis, whose political machine ousted Drapeau in 1957; when Drapeau regained power after Duplessis's death, he resolved never to explain his views on planning again.[14]

The problems with urban renewal were pale by comparison with the continuing war between the government and the builders. By 1955 CMHC questioned whether to do business with NHBA at all. CMHC let it be known that it would rather deal with a new organization where homebuilders would be offset by architects, lumbermen, and suppliers. With any luck, the interests of these groups could be diluted and moulded into *common* stances easier for CMHC to deal with. CMHC even coined a name — the National Housing Council — and Stewart Bates promised a government grant of "approximately $80,000 for the operation."[15] When the lumbermen seemed to find this idea attractive, the builders reminded them that NHBA already had within its ranks four semi-autonomous "institutes" to represent related interests (locals, developers, prefabricators, and suppliers): so why couldn't a National Housing Council be accommodated within NHBA instead of vice versa?[16] The builders wouldn't openly announce

that they smelled an end run; but NHBA was nervous, and dispatched the methodical administrator of its Ottawa local, Colonel Boss, to keep an eye on CMHC and the government.

Boss was kept busy. CMHC told a Royal Commission in 1956 precisely what it thought of the builders: their reluctance to embrace Modern, among other things, demonstrated that their philistinism was exceeded only by their backwardness. "Unlike many of the leading industries, the housing industry has not applied itself to the stimulation of new markets by a progressive concern for excellent design. It has been too willing to settle for conformity with minimum standards and poorly executed architectural conventions and styles."[17]

In response, NHBA decided to crank up its Liaison Committee with Ottawa, despite bickering over which lucky members would be sent to argue with CMHC. Another NHBA committee, ponderously named the Institute for Housing Stabilization, was told to "plan [for] ... constant contact with Members of Parliament and other government officials to keep our problems to the fore, and take necessary action to obtain information."[18] Instead of CMHC's proposed $80,000, NHBA's war chest was $25,000.

The urgency was obvious. Virtually every meeting with CMHC turned into a row over its housing standards. In the words of CMHC's chief engineer, "There were five inspections during construction; they had all kinds of terrible battles ... Basically, [CMHC] told these guys to do it our way or not at all."[19] The builders routinely published their own lengthy lists (in their publication *National Builder)* of "ill-conceived" CMHC standards and designs. Roof trusses were a case in point. In 1933, a new design featuring metallic connectors had been pioneered (oddly enough, by the U.S. Forest Products Lab), but even after two decades, as CMHC's own report later said, "CMHC's Building Standards ... required roof trusses to be designed by conventional engineering methods that generally resulted in uneconomical trusses."[20] Builders said CMHC's techniques were generally redundant, costly, and overbuilt; and NHBA hired its own engineer to prove it. So CMHC publications promptly accused the builders of resisting progress CMHC-style, with

techniques that were redundant, costly, and over-built. There were further accusations of "outdated and unfair" CMHC appraisal practices: Toronto's Rex Heslop reported that "he had four different valuations [from CMHC] on one house in a single month."[21] So CMHC refused in 1955 to deliver its appraisal forms to NHBA at all. NHBA responded by accusing CMHC inspectors of haunting job sites, alarming prospective buyers with tales of supposed flaws.

The tug-of-war between CMHC and the builders was more than an exercise in kicking each other's puppy. It was about power and the growing ability of this government agency to control almost every aspect of the building process, either directly or indirectly. The only significant area in which the builders had a free hand was in the market for relatively expensive houses, where well-heeled buyers did not need CMHC-insured mortages; but as soon as the builders' sights turned to buyers who needed higher-ratio loans — namely the majority of Canadians — they entered the universe of CMHC rules and regulations. The builders cried manipulation — and sought ways of responding in kind at the highest levels of CMHC itself. Paradoxically, although CMHC had attempted an end run around the association, it later complained that it didn't get *enough* input from NHBA — so NHBA offered to nominate a retired builder to CMHC's board. NHBA did so nervously, with concerns of being co-opted. It needn't have worried. When Robert Winters heard about the offer, he declared that *he*, as minister of public works, named directors of CMHC, and that NHBA wouldn't be represented on *his* board unless Parliament amended CMHC's Act.[22] Winters promptly named two new CMHC directors: a labour leader and a social worker. Winters's successor, Howard Green (in the Diefenbaker government), rebuffed NHBA as well: "*I* am authorized ... to appoint directors to the board. In exercising this authority, I must, of course, ensure that none of its members are directly representative of any of the diverse interests that operate within the housing field."[23] NHBA replied that ignorance was bureaucratic bliss: "Since the present CMHC directors other than the appointees representing government and CMHC itself have no experience in residential construction, there is little chance of housing policies originating from any source but the *administrators* of those policies. In other words, the directors appointed to represent the public interest are rubber stamps."[24]

CMHC had other instruments of influence. In April 1956, it created the Canadian Housing Design Council at a meeting hosted by CMHC to bring together builders, architects, and consumers; but the framework and agenda were not designed by the participants, but by CMHC's own "small nucleus group."[25] It took four years to invite the builders to take part formally. Gordon Shipp reported back to NHBA on the council's view of correctness: "Are there no false gables? ... Is there honest, simple use of materials? ... Are the colours restrained? ... Is the roof simple?"[26] Shipp deduced that "the committee is composed of very intelligent and capable persons, but architects predominate."[27] In due course, the council issued awards for architecturally correct design — but not for liveability or saleability. At the risk of offending other staffers at CMHC, the council dismissed the enormously popular split-level design as "a bungalow with a broken back."[28] Shipp replied: "Builders build homes that the public will buy, and cannot afford to build homes merely to win awards."[29]

CMHC used sticks as well as carrots. In 1954, banks entered the home mortgage business, but CMHC would do house inspections before release of funds:

> Not only did this measure increase the staff of CMHC but it tended to establish in Canada a centralized inspectorate that came to dominate the whole building field from construction planning to planning in general. It led increasingly to the subservience of municipal and provincial planners to those who were in specialized positions backed by the source of the funds, in Ottawa. A planner ... in Alberta remarked that CMHC officials treated the provincial officials "like kids, as if we knew nothing."[30]

1

2

3

4

6

5

CMHC had ways of hand-picking sympathizers for positions of influence. It created a new Canadian Housing Design Council, which would launch still another awards program. The council's first national awards were presented in April 1957 for houses in Victoria (1, 2), and Don Mills (3, 4). Council member Allan Jarvis, head of the National Gallery in Ottawa, conveniently repeated the Modernist view that the council came "a million houses too late." NHBA joined the jury despite suspicions that it was stacked with Modernists, and finally lodged a formal objection to "a strong bias towards *one* type of architecture." The council's first jury picked these houses from among builders' houses presented to it, but complained of "lack of variety." By 1960, the council found designs from Kelowna, B.C. (5), and Woodbridge, Ont. (6), more to its liking.

In 1957 the Winnipeg Home Builders' Association built the "House in a Day" in 19 hours 10 minutes. Furniture was moved in by noon the following day. It used many prefabricated components, but not as many as the experimental house built by Cerametal Industries — of porcelain enamelled steel panels — in Oakville in 1960 (below). This exercise in "hyperbolic parabaloids" was predicted to be the "forerunner of a new type of house." [13]

Best Selling CMHC Design

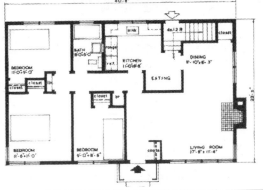

CMHC not only promoted its own preferred styles and methods of construction, but also restricted alternatives by controlling which buildings could obtain mortgage financing. This "Design #215," from Toronto, was CMHC's most popular model in 1955: it covered 919 sq. ft.

With all this bureaucratic coming and going, was the Canadian home actually changing? The answer is yes. Power tools, including paint sprayers, were taking over the job site, despite the inconvenience of lugging portable generators to the middle of a field. Workmen's time could be used more efficiently, instead of the previous condition where "much of the life of the construction worker was traditionally that of a pack horse."[32] Furthermore, when builders reversed the direction which warm air took in a house,[33] heating became more efficient. Electric baseboard heating was also starting to creep in. After disputes with CMHC were resolved, roofs were installed more efficiently, with the help of new prefab trusses introduced by Johnson-Crooks Construction of Kitimat and Prefabricated Buildings of Saskatoon. Standard-sized manufactured windows now came from factories instead of being assembled on site; the same was true of cabinetry. Last but not least, new sliding mirror doors on their medicine cabinets now

allowed Canadians a better view of their pained expressions in the morning.

Then there was this newfangled idea called "market analysis": CMHC and the Dominion Bureau of Statistics were now producing solid information on who was buying houses. Men in white coats and horn-rimmed glasses could stand in front of blackboards and tell us more about ourselves than we had ever thought possible. As of 1956, the average National Housing Act homebuyer earned $5,312 a year, was 33.9 years old, male, with 2.5 dependents. His house cost a total of $13,163, representing $11,667 for construction, $2,041 for land, and $455 for other items. He made a down payment of $3,811, and assumed an NHA mortgage of $10,352. On this he would pay $81 every month for the next twenty-five years. His house would be 1,138 square feet; his lot would have 60 feet of frontage. The behaviour of Mr. Suburban could be dissected, down to the colour of his Argyle socks.

The statistics risked making Canada smug. Key economic factors in most sectors — from financial to population figures — were increasing at a rate that far outstripped the U.S.

Economic Growth 1945–52	Canada	U.S.A.
Gross national expenditure	94%	62%
Private investment	467%	263%
Population	19%	12%
Industrial production	24%	8%

Canada's housing accomplishments were hailed as a particular triumph. During World War II, Canada was expected to need 700,000 housing starts in the post-war decade; in fact, 885,601 units were built.

Yet this wasn't the whole picture. A 1955 Gallup Poll said that despite the construction boom, Canadians were not much happier with their housing than before:

Opinions	1946	1955
Housing fully satisfactory	42%	38%
Housing fairly satisfactory	38%	45%
Housing not satisfactory	20%	17%

In short, the country appeared to be on a treadmill: supplies of decent housing just could not keep up

with the demand. Canada was also losing some 8,000 housing units per year to demolition. Almost no one wept: as of 1955 Canada had some 350,000 units predating 1880 (and over 500,000 units built between 1880 and 1905). The prevalent view was that cities would be better if these were obliterated — although only Modernists claimed to know what would replace them, and no one knew who would pay.

Three factors explained the treadmill effect.

First, the scale of the population explosion caught almost all planners and pundits by surprise. Between the baby-boom and high immigration, galloping homebuilding was outdistanced by even faster family formation. By 1952, post-war housing was lagging behind production of post-war families by a total of 37,000 homes.

Secondly, the target market for NHA loans had shifted away from lower-income groups in favour of middle-income earners and higher. In 1948, only 6.9 percent of NHA loans were made to people earning over $5,000 per year; by 1955, that figure had reached 53 percent. This discrepancy cannot be explained by inflation alone: Ottawa's new National Housing Act in 1954 "abandoned the principle of federal support for housing ... of all middle and lower income groups, which had been inherent in the NHA up to this time."[34]

Lastly, a third of Ottawa's housing money simply failed to reach its destination: "Of the $480 million aggregate appropriation under the Act, the [actual] commitments were in the region of $333 million."[35]

There were other glitches. By 1956, the homebuilding industry was witnessing another supply crisis; but this time no war was to blame. The missing material was glass, which had to be ordered "months or even a year in advance." "The architectural trend to use more and more glass in all types of construction, coupled with the history-making demands of the automotive industry ... taxed the capacity of all glass manufacturers." Not all Canadians were deterred: George Plumb of Duncan, B.C., built his entire house of glass — 180,000 bottles. David Brown of Boswell, B.C., would not be outdone; he built his home with empty embalming-fluid vials. Those concerned about glass shortages took solace from a CMHC expert who told NHBA that future houses would be "constructed in a sheath of plastic ... ready in forty-eight hours [with] a couple a trucks arriving with chemicals which they pour into pre-set forms to construct plastic walls which are bonded with an adhesive."

Glass shortages weren't the only problem that cars created for subdivision planners. Anxiety was expressed over the 1950s monster automobiles: the developers wanted to keep typical road widths at 22 feet, but "the length of today's cars would make 26 feet almost mandatory!"[36]

Development was proceeding so quickly that municipalities were simply unable to cope. How could street, sewer, and highway construction keep pace? And at what cost? Would property taxes spiral?

Builders argued that some public expenditures should "naturally" be covered by the local property tax system, and others should be paid by sales and income taxes. According to the "User Pay" philosophy, local roads and sewers should be funded by property owners; but since not all property owners use hospitals, universities, welfare, and schools, the latter should be covered by provinces and their (larger) tax base. However, governments moved in the opposite direction: municipalities were squeezed as senior governments appropriated the lion's share of taxes. In Alberta, for example, the federal share of taxes moved from 40 percent in 1930 to 71 percent in 1955; the municipal share dropped from 40 percent to 12 percent.

Schools were a fiscal time bomb. Although traditionally financed by local property taxes, wouldn't the baby-boom cause these taxes to spiral, raising housing costs? If hospitals and universities were subsidized by the provinces, why was school funding still siphoned out of local taxes? NHBA's Norman Long said, "Either the urban municipalities get additional sources of revenue assigned to them, or in the alternative, the provincial government must take over the full cost of education and social services."[37] "Real estate," NHBA told Ontario, "is carrying too great a proportion of the taxation structure of our economy ... Where a would-be homeowner has the ability to pay the ordinary mortgage carrying charges, he is reluctant to shoulder an almost impossible added burden by way of inflated municipal charges."[38] This initiative went nowhere with provincial governments.

By 1955, opinion on municipal planning was even more divided than on municipal taxes. Some builders exhibited an ideological objection to municipal intervention in real estate; others said town planning could be useful if done intelligently, but that the municipalities were failing to do so: "Decisions are made from hearsay and textbooks."[39] Still other builders argued that the planning process would be fine if all competitors were on a level playing field, but "special interests get the council to change the work of the planning board."[40] Then there were the more traditional objections:

> Developers face a chaotic bureaucracy and can become lost in a jungle of red tape. In the case of one project, forty-three acres in area, eleven pounds of paper was necessary before approval was granted. In the case of a second project, two hundred acres in area, nineteen pounds of paper was necessary. In the case of a North York subdivision, after its plan was approved by eleven different departments, and registered, and contracts for services awarded, [development] was held up by Metro engineers who did not like what North York engineers had okayed.[41]

As one developer said, "The Metro [Toronto] engineer doesn't trust the municipal engineer and the municipal engineer doesn't trust the developer's consulting engineer!"[42]

Furthermore, developers protested that when required by municipalities to dedicate 5 percent of their subdivision to public use, the "green intent" was being subverted: municipalities were selling off this land, turning the 5 percent allocation into a supplementary tax. Worse still, the land was being sold to competitors. Some developers approved the 5 percent dedication if it would indeed turn Canadian cities into the promised environmental paradise; W.L. Pope said: "Why shouldn't municipalities earmark the five percent of the cost of raw land received from subdividers to purchase golf clubs and other

green belt areas coming on the market? At present this money goes into a general fund!"[43] If municipalities had maintained this commitment to open space, the cumulative effect would have been greener cities today.

NHBA's Project Builders & Land Developers Institute (later known as the Urban Development Institute)[44] therefore asked an expert to develop a strategy. It heard the results on July 5, 1955, in a room at the Ontario Association of Architects[45] — a nicer venue than the NHBA strategy room over a drugstore in Toronto's Applewood Acres shopping centre. The consultant recommended that

- Developers attack the 5 percent land dedication (for green space) on ideological grounds: call it "*expropriation without compensation* which should be stopped!"[46]
- Developers attack urban planning itself on ideological grounds: say that the powers "now exercised by the municipalities against land development infringe individual *property rights!*"[47]
- Developers attack on another front: "The trend towards an increasingly high level of *municipal services* should be arrested!"[48] Although developers had lobbied for "uniformity of services" among municipalities at a median quality and cost, the consultant told them to keep quiet on that point.

This adversarial approach would challenge the very legitimacy of governmental intervention in homebuilding. The developers took this advice seriously — in view of who the consultant was: David Mansur, past president of CMHC.

Mansur, once described by Robert Winters as a "loyal, devoted, diligent and brilliant public servant,"[49] demonstrated his experience with the workings of bureaucratic minds by offering further advice. Having defined policy objectives, Mansur moved to tactics:

- Never let officials know where developers are coming from: that means *never take an overt position.* "Taking any action that would make [government officials] close their ranks and unite in self defence would be a mistake."[50]
- It is pointless to expect governments to *read* care-

fully prepared briefs anyway. "Briefs submitted to governmental bodies are useless."[51]

- Officials should be *played off* against one another, for example by capitalizing on jealousies. Metro Toronto would be easy: "The greatest asset the group [of developers] has is in the differences that prevail between the three levels of government." To keep planners from knowing what was coming, developers should never disclose more than dribs and drabs: "The group … should [push] its overall program bit by bit."[52]

- Finally, *back-room* liaison is far preferable to public overtures: "Individual pressures, developed by members of the group at various levels of government, would be dealing with the various problems."[53]

Although Mansur went on to be chairman of this developers' group,[54] most developers felt uncomfortable with his advice. They didn't like becoming chummy with officials, or concealing their policies from public view; so they chose precisely the opposite course of action. They decided on a public position to be presented forthrightly, though *not* personally, but by a lawyer. The problem was that the developers were not too enthused about lawyers either. So they amended their resolution to specify representation not just by a lawyer, but by a *competent* lawyer.

The developers also rejected Mansur's advice about abandoning standardized services. In fact, they later hired their own consulting engineers to devise cheaper standardized services, like sidewalks only on "major arteries." Cost-cutting ideas covered everything from water mains to storm sewers: but some developers already sensed the writing on the wall. The rising cost of utilities, prophesied James Kelley,[55] would eventually "squeeze frontages to a minimum."

Mansur was not the only retired government official to dispense advice to developers. Frank Nicolls, first administrator of the Dominion and National Housing Acts, developed NHBA's tax position: he wanted Canadians to be able to claim their mortgage interest as a tax deduction. This measure would have lowered almost every Canadian homeowner's income tax bill substantially. In view of tax deductibility of mortgage interest in the U.S.A. and U.K., builders launched a "campaign for income tax exemptions for mortgage interest payments." That issue would linger, on and off, for another thirty years.

NHBA also undertook a campaign for "equalizing the present excessive school taxes" and "removal of some of the hidden taxes" in housing. Nicolls and the builders had developed a cordial relationship over many years, and NHBA acknowledged his "notable contributions to organized homebuilding" in 1955, when he was made an honorary life member. Nicolls's biggest help, however, was on the subject of codes.

Municipalities were accused of jiggling building codes and fire codes. These are the safety standards for structures — the kind of regulation that goes back to Babylon's Hammurabi. There is a story of Christopher Wren's supposed confrontation with the municipal council of Windsor, England. The council insisted on a supporting column that Wren swore was unnecessary; he finally acquiesced and installed a column that stopped one inch short of the ceiling. This municipal building still stands.

In Canada, setting construction standards was the preserve of municipal sovereignty, guarded with the passion of Third World principalities. Although the federal government (with Nicolls's help) had started its National Building Code back in 1937, constitutionally it could not apply it to most buildings. Provinces, for their part, provided no guidance. That left municipalities in control of codes within their borders, and although these codes broadly followed the National Building Code, local councils reserved the right to add their own wrinkles.

The typical council had no idea what it was doing. Robert Winters denounced "wasteful municipal plumbing and electrical codes."[56] "Municipal rulemakers," added the builders, are "decades behind the times … with no efficient mechanism for updating." The plethora of conflicting rules varied every few miles, and drove large builders crazy. Cynics believed this Balkanization was deliberate: it was as close as a municipality could get to a "non-tariff barrier" — freezing outsiders out of the local construction market. The local building code could be written so incomprehensibly that only a local builder (preferably a chum of city hall) could figure it out. Halliday Homes was one example: it wanted to apply World War II aircraft construction, "stressed-skin"

panels, to home construction. It was "blocked outright by local codes ('where are the studs?')."[57] Eastern Woodworkers of New Glasgow introduced McGregor Houses with stressed-skin walls by resorting to subterfuge, placing studs where these were not needed, to appease the local building inspectors. Canadian builders were repeating Wren's experience in Windsor. "The same firms also tried prefab walls [complete with wiring and plumbing]"; but out of disgust and frustration with the local codes, "all backed away by the mid- or late 1950s, to the rudimentary ... approaches."[58] Canadian Comstock was "the first in North America [1946] to introduce 'utility' core units: eating/bath/kitchen cores in a one-box unit ... [and] unit-built bathrooms to be moved in like wall panels ... [but] municipal codes and requirements for on-site piece-by-piece inspections, and installation by *local* trades, forestalled the innovators." Kernohan Lumber even tried a revolutionary "whole-house box modular system" introduced in London; but "Kernohan's efforts to gain municipal acceptance in other towns, within a radius of up to 300 kilometres were blocked. Even where allowed in, the local plumbers and electricians [required by municipal regulation to hook up these units] took their time, thus erasing many of the cost advantages."[59] A similar fate awaited two-unit modular houses built by West Coast Trailer in British Columbia. Not surprisingly, "the [builders'] association became a vocal advocate of the adoption of the National Building Code,"[60] and resolved to "urge the federal government to expedite the work on the production of a uniform residential building code."[61] This work was carried on by experts at the National Research Council (NRC).

The code was not perfect: as builder A.L. Wright said, "To get all the nuisances written out of the code would be a wonderful achievement."[62] Nevertheless, NHBA was happy to work with the NRC to arm-twist municipalities and provinces into standardizing their codes on the national model. By the late 1950s, the effort was working. NHBA's liaison person with NRC said proudly in 1958, "We are at least ten years ahead of the U.S. in the matter of building codes, chiefly because we have a National Building Code."[63] The U.S. did not speak with the same pride: a builders' representative from Washington told

NHBA that their own "research house" would be built at Michigan State College and "ignore existing building codes."[64]

The working relationship between NHBA and NRC grew very close. The Building Research Division of NRC applied to join NHBA — which altered its by-laws to treat NRC as a homebuilder. NRC enlisted its researchers in NHBA, and NHBA routinely appealed CMHC construction standards to NRC — with considerable success. NRC owed the builders for their energetic lobbying in favour of NRC's National Building Code, and wrote to NHBA saying how "heartened" it was by this ongoing support. The organizations routinely exchanged laudatory letters, suitable for framing.

Yet by 1955 developers deduced they had a major image problem in other circles. NHBA had assumed that the public distinguished between *land development* and *land speculation* — speculators and developers were regularly at each other's throats. Developers prepare sites for construction; speculators trade in real estate; and developers must *buy* real estate (often from speculators) to have sites ready to build on. Unless a developer got into land speculation, too, he was not usually enamoured of his "suppliers." NHBA director R.K. Fraser described land speculation as one of the "crying problems of the industry."[65] In 1956, A.W. Farlinger told fellow developers that "the time has come to tell [our] story ... Land developers are not receiving due recognition in public regard. They are being confused with speculators! Land developers [on the contrary] are in a legitimate business!"[66] Fortunately, the business community knew its friends: "The *Globe and Mail* has recently launched a real-estate section, and no doubt could be counted upon for cooperation."[67]

Some things, nonetheless, would best be kept from the public. In 1955 *National Builder* reported Canada's first subdivision for nudists, covering eight acres south of Vancouver. There were no photos. Readers were reassured, however, that "the area is to be surrounded by bushy douglas firs, and each house will be well protected by shrubs and trees."[68]

As the suburbs took shape, CMHC's Stewart Bates worried that urban sprawl would leave Canadians with no time to eat, sleep, or work; they would just *drive*. In the late 1950s, Bates broached the idea

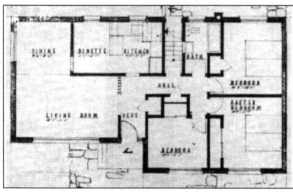

CMHC identified this 1956 house in Scarborough Township as "Canada's millionth house since World War II." To some eyes, it may have looked naked without its obligatory TV aerial.

of dramatically shifting urban growth from the handful of top metropolitan centres into smaller areas and perhaps into new cities altogether. "Do we let new subdivisions fasten onto present agglomerations? We'll pay a heavy price if we do. If, for instance, we allow Toronto to become another Los Angeles, mobility will become impossible … Then where is our economic prosperity? And Toronto *will* become another Los Angeles unless we do something about it soon."[69] Some would argue that this prediction has come true.

The public taste for prophecy generally had reached biblical proportions. Even David Sarnoff, the National Broadcasting Corporation mogul who helped bring radio and TV into North American homes, got into the act: he predicted that by 1990 every home would have its own nuclear reactor in the basement.[70]

A Chicago expert told Ontario real-estate agents that he was "alarmed at the number of apartment houses being constructed in outlying districts" (like suburban Toronto). "Except for the higher income group, the apartment house is becoming obsolete."[71] In 1957, heating contractors were told that "one out of every five homes built in 1957 will have design features requiring the use of two or more furnaces, air conditioning plants, or zone systems of temperature control."[72] Even more elaborate predictions came from the Building Research Institute in Washington, which declared in 1957 "that 'the hammer-and-saw contractor' will disappear from the scene."[73] Some of their other prophecies were accurate, such as the assertion that "the industry will shoot for 2,000 square feet of living space for the *middle* income market." Other predictions were more problematic:

- There would be *annual model changes* in houses, as in cars: "Yearly changes in the model of house will tend to make older houses obsolete more quickly than today."
- "Sources of energy will increase and *more* energy will be used."
- "Quite possibly, the most advanced forms of structure will resemble the pioneer Monsanto *plastic* House of Tomorrow."
- "The entire kitchen, including automatic laundry, will be installed in the home as a *complete unit* produced by one manufacturer."
- "Houses will be built so that they can be *added to*

Some builders were anxious to try "avant-garde" colours. NHBA president Gordon Shipp built a display house in Toronto, modestly entitled "Home for All America" by a U.S. magazine, in mauve and purple. The house had other new features, including extensive use of folding doors and horizontal sliding windows. It even had a controversial *inside* bathroom. It took a full-scale battle with CMHC to make such windowless bathrooms legal on NHA-supported projects.

or subtracted from according to the owner's living requirements, and ultimately sold second-hand to another homeowner for use *somewhere else.*[74]

While these prognostications might have made builders dizzy, at least they weren't getting ulcers. In 1957 a Canadian Restaurant Association poll concluded that builders ate more sensibly than people in other occupations.[75] Only 16 percent reported stomach trouble, thanks partly to the fact that only 24 percent did business over lunch. Other occupations, notably advertising and public relations, reported a 79 percent rate of stomach ailments, since 63 percent conducted business over meals. In contrast, Canadians could sleep better at night, knowing that their homes were probably built by a digestively contented builder.

Some of the "new" colours appearing in houses might have unsettled the calmest stomachs. Turquoise shutters, purple bathroom tiles, and a host of other unconventional colours exploded across the suburbs. *National Builder* cribbed from the American *Perfect Home* and issued this advice:

> Green tends to make houses blend into their environment and to set them back on their lots. It's a good colour to use if you feel your houses look a bit too close to the street … Red is active and forceful (the decorators say). Yellow and orange show independence. Decorators consider that most of the blues and greens are retiring tones, friendly and quiet. Decide which exterior feature you want to make a focal point and paint it a colour that contrasts … By reversing this principle, you can de-emphasize other parts of the house that you do NOT want to stand out … Use light-coloured paint to make a small house look larger. Try a dark colour to reduce the appearance of a house that's too large for its setting. If you feel that a house looks too high, you can shorten it very effectively by giving it a

Training program, 1955. These student painters get blackboard instruction on how to use their brushes.

> dark roof and putting shutters on just the upstairs windows. If it looks too low, paint it a light colour and the roof an even lighter one.[76]

But NHBA also had other things on its mind. It was busy engaging in that one activity more Canadian than maple syrup — its own miniature constitutional crisis:

- Montreal's position was "still shrouded in some mystery";[77] in fact the whole Quebec wing said it didn't feel *part* of the national family, and wanted to negotiate a new agreement — whereupon British Columbia wanted the same.
- The agenda and economic perspectives were allegedly dominated by Toronto. Torontonians replied this was natural, because so much of the constituency was in Toronto.
- Easterners wanted the West to adopt a more user-pay approach.
- Westerners wanted freight rates placed higher on the agenda.
- NBHA's president, William Grisenthwaite, warned that unless a new agreement was hammered out, it meant constitutional death.[78]

Rolling the dice worked for him: a last-minute deal produced a new organizational framework. That, however, was only part of the issue. Another problem had almost as much importance as The Constitution: it was The Deficit.

NHBA was broke. This proved embarrassing. When Toronto mega-developer Rex Heslop was overheard telling a builder to withhold his membership until NHBA knew where it was going, directors reprimanded him for treason. The directors also had to scrounge sheepishly for a bail-out — which was volunteered by none other than Rex Heslop. Heslop promptly sought election to the presidency of NHBA — and was just as promptly defeated.

But other developers were distancing themselves from ordinary homebuilders. NHBA's committee for developers politely seceded in 1957 and called itself the Urban Development Institute (UDI). Its first president, Bill Thompson, offered a "co-operative arrangement" under the same roof with NHBA; but if NHBA didn't like it, UDI would walk. Ultimately, Thompson reported that "while some UDI members wanted to detach themselves from NHBA, I am happy to report that the *mature* judgment of the group favours remaining part of NHBA."[79] However, that wouldn't last forever.

Nor would the building boom. As 1956 wore on it looked as if many developers wouldn't be in business long. Inflation had been running at about 1.5 percent; moving into 1957, it jumped to a staggering 3.2 percent. This is where homebuilding ran into James E. Coyne. After seventeen years with the Bank of Canada, Coyne had been elevated to governor in 1955. His crusade against inflation invoked Robert Winters's old argument, namely that he *might as well* raise interest rates since the builders wouldn't have enough material to build what buyers wanted *anyway.* "It may well be that the supply of construction materials and labour cannot expand enough to make [market] intentions possible of realization. To expand the money supply so that all those intending to construct new buildings this year … had easy access to borrowed funds at low interest rates would aggravate inflationary pressures without adding to the physical resources required to carry out such programs."[80] He promptly rammed bank and mortgage rates upwards.

Almost nothing affects homebuying more than interest rates. How much of a Canadian's income gets gobbled up by loan payments has even earned a phrase — the Gross Debt Service ratio. Since Canadians have so much of their money tied up in mortgages, the slightest hiccup in interest rates can produce a disproportionate effect on how much cash is left in circulation. A change in monetary policy, namely the supply of money at a given interest rate, has ten times as much impact on housing starts as a change in tax policy.[81] To Ottawa, the Bank of Canada rate was another way to use the homebuilding industry as a joystick to affect national spending. "It provides one of the major arteries, if not the major one, by which monetary policy is transmitted to the economy."[82]

CMHC followed Coyne's lead and discontinued its loans to various land assemblies. Worse, banks — which had just recently been enticed into home lending, and which (by law) weren't allowed to charge more than 6 percent on mortgages — immediately withdrew from mortgage lending. This withdrawal, said Vancouver's Robert Nelson, "lowered the boom" on the housebuilding industry.[83] Builders in the West, for example, estimated that 50 percent of bank loans were drying up. One Calgary builder had ninety purchasers who couldn't get loans.

Hardly a day went by without virulent attacks on high interest rates by the Progressive Conservatives. Liberals defended the interest rates and argued that short-term pain was necessary for long-term gain. One builder suggested the culprit was the Trans-Canada Pipeline, because the tight money "has come about through inflation and the need of men for the pipeline."[84] Others, however, were more preoccupied with effects than causes: in the words of Calgary's Norman Trouth, "If a housebuilder cannot get mortgage money, he is absolutely done."[85]

From Winnipeg came word that most lending institutions, both banks and insurance companies, "are welshing on verbal commitments given to builders earlier this year."[86] Western builders like Calgary's Les Wade assumed eastern counterparts were in the same boat. "Down East, no mortgage funds or finance are available; it's getting tough."[87] The view in NHBA's strategy room, over the drugstore at Applewood Acres Shopping Centre, was different: several NHBA heavies (who chose not to be named in NBHA's minutes) expressed unabashed disinterest over the demise of their colleagues. Calgary's description of mortgage problems was dismissed as "garbled."[88] In any event, said one director, the bankruptcy of the smaller builders "is a healthy weeding

out."[89] Said another, "The government has done the industry a kindness by preventing over-building. To make any effort to go to Ottawa to oppose this thing would not be in the best interests of the Association."[90] Another builder's opinion was read at the meeting: "I cannot agree … [to] trying to force the banks to extend further loans beyond their judgment … This could easily [be] to the detriment of the industry at a later date."[91]

Some builders disagreed. Harvey White argued that if "any local association is adversely affected [by tight money], NHBA is duty-bound to act on its behalf."[92] Alfred Miller called for a lobby to reduce NHA down payments. NHBA's management committee turned them down flat: "It would be illogical to apply for such action at the present time, since the proposal [if accepted] would restrict production by spreading available mortgage funds over fewer houses."[93] NHBA's thinking on low down payments and affordability was undergoing a 180-degree shift. If the total money in circulation was *finite*, then you could expect

- Large loans on few houses, or
- Small loans on many houses.

By that reasoning, houses with low down payments, notably for low-income Canadians, would gobble up all the loan money and leave no loan money for the rest of the market, notably the middle class. On that premise, the management committee specifically repudiated low down payments for cash-strapped Canadians.

When western builders got wind of this flip-flop, they were livid. Until then, interregional relations had been cordial: for example, eastern builders insisted on conventions out West; western builders in the East. This mutual admiration was about to be sorely tested. Westerners (led by Calgary) accused NHBA leadership of an economic view that extended no further than Toronto. The Torontonians denied any breach of solidarity, and claimed that they were as concerned about tight money in Toronto as in Calgary. After much coming and going, NHBA produced a Canadian solution: its press releases briefly mentioned easing tight money — then promptly changed the subject and gushed about wintertime building.

The federal government tried to rid itself of the tight-money zealots, but it took years. When John Diefenbaker took power (1957), he was convinced that the tight-money fans in the governmental apparatus were conspiring against him. He asked Coyne to change his policies (Coyne refused), then asked him to step down (Coyne refused again), and finally drafted a special Act of Parliament to fire him (Coyne quit before final passage). NHBA took the reverse course to Diefenbaker's. After the blowup with Calgary, the leadership dropped any pretense about its policy on tight money. When director H.S. Muroff suggested NHBA lobby "to reduce down payments to say $500 per house, and increase the amortization period to forty years,"[94] economic research chairman Regner Blok-Anderson stopped him cold: "The government and lending institutions have done a terrific job … If down payments are dropped, loans will have to be bigger, so there might be fewer of them. If the amortization period were to

The Diefenbaker government launched a slogan, "Why wait for spring? Do it now!" Winter building was also an industry priority — but Canada's climate is seldom nice to houses.

be increased, it would be that much longer before the lending institutions recovered their principal for re-investment in mortgages ... Who are we to make recommendations with respect to how lending institutions should make up their investment portfolios?"[95] The board, while not describing the tight-money establishment as "terrific," agreed: "The situation was well in hand."[96] Affordable financing was a dead issue.

But some builders wanted to hedge their bets by creating new sources of cheaper capital. NHBA toyed with a national "special mortgage fund" composed of "national housing bonds," namely a kind of savings bond to raise money for mortgages. Eugene Chalifour also organized a lobby to reduce mortgage insurance. Between 1935 and 1958, defaults were at a rate of only $1 of loss for $10,000 of loan — one one-hundredth of one percent, one claim per province per year; so Chalifour labelled a 2 percent charge for insurance "exorbitant."[97] The minister of public works replied flatly that circumstances do not "warrant reduction in the insurance fee at this time ... [but] I am, however, grateful to Mr. Chalifour for his suggestions." Indeed.

Then in 1958, various builders and CMHC revived the notion of lease-purchase agreements, where renters would be able to use their rent as part payment on the eventual purchase of the home they were occupying. In the words of Rex Heslop, "The main object is to provide rental housing with a subsidy. My own idea is that if rental houses can be sold at the end of five years, builders would be more inclined to provide rental housing."[98] Builder J.S.L. King had embarked on the first project of this kind in Oshawa with a total of 198 units. However, that idea, too, died for lack of interest.

One promising area for joint action between industry and government was experimental housing. NHBA's George Hipel built a "Budget Research House" with a typical mortgage loan. Colleague Bill McCance explained: "Our object in erecting the house was to demonstrate that, technically, a low-cost house could be built and purchased by persons earning less than $3,000 a year. This, we have succeeded in doing." Demonstration houses were built in Dartmouth and Hespeler (now Cambridge).

NHBA president Maurice Joubert also insisted

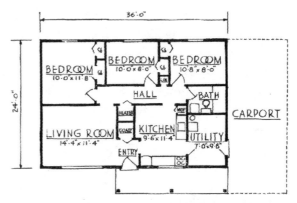

As NHBA's priorities shifted toward research, it experimented with an $8,000 "Budget Research House" for families earning under $3,000 a year. This Mark I model, built in Dartmouth, N.S., and Hespeler (Cambridge), Ont., was intended to disprove the reliability of certain CMHC standards.[99] It included an interior bathroom (with fan instead of a window); it introduced more economical techniques for plywood sheathing, foundations, joists, and rafters; and it launched a series of further experiments that were as deliberately unconventional in their construction as they were deliberately conventional in their appearance.

that "attention should be paid to consumer research as well as to scientific research ... We cannot claim leadership of the industry, if we don't show evidence of leadership that will substantiate our claim." Concern for consumers had taken many forms. Over the years, Hamilton's William Grisenthwaite Construction had led the calls for home warranties: Grisenthwaite's own guarantee looked like a cross between a bank note and a Ph.D. diploma. The Victoria NHBA chapter's war against "shyster contractors" led to the trial of two fraudulent "home repairmen." NHBA told locals: "The Victoria Home Builders' Association's action in this matter sets a fine example. When something happens like this in your

community, take the initiative. Offer your help to the victims. Cast your organization in the role of protector."[100] But was this enough? For fifteen years the industry had hired lobbyists to press for laws *licensing* "correct" builders and barring others who could rip-off consumers. This position was reiterated in 1957 by Harry J. Long, whom NHBA had slated for an honorary life membership: "It seems clear that apart from such public education, the only tangible step that can be taken by the industry to protect itself from the encroachment of part-time amateurs and thugs is through legislation."[101]

That all changed. This transformation in NHBA policy was signalled not only by what was said, but also by the way builders blasted each other. The Toronto Metropolitan Home Builders dismissed Long's views as "a snare and a delusion."[102] They agreed instead with an American spokesman who gave Canadian builders this lesson in ideology: "The law has failed to keep out all unethical builders, and has interjected another governmental agency into the business, which already has too many. It has also

The Royal Architectural Institute of Canada labelled this 1960 Don Mills complex as both "excellent" and "distinct,"[103] although it did not specify what it was "distinct" from.

encouraged homeowners to find fault with their homes … *I* advise those who are thinking of promoting a builders' licensing law to stay away from it as long as they can."[104] When the subject returned to the board of NHBA, some were "in favour of licensing, but the general attitude was one of opposition. It was agreed to drop this matter entirely,"[105] ending an initiative which had been launched at NHBA's inception.

The plethora of newer ideas, however, left NHBA not enlightened, but confused. When NHBA called on Diefenbaker to set up a federal ministry of housing, some cynics believed this would be required if only to keep track of all the suggestions floating around. The multiplicity of official statements became so bewildering that NHBA president Joubert called for a Golden Book to codify NHBA's own opinions, including

- Is (home ownership) "the most satisfactory" way of obtaining shelter?
- What is the Association's stand on rentals, subsidized and otherwise?
- What says NHBA on slum clearance and redevelopment?
- What is NHBA's relationship with consumers?
- What are the policies on home financing and services?

Joubert worried that homebuilders were developing collective amnesia. He was right. Each of these questions had spawned mountains of documents — which NHBA was losing track of. The Golden Book idea was ironic, because by the late 1950s NHBA equivocated on almost all the major points for which it had been founded in 1943:

- It couldn't agree on whether mortgage rates should go up or down.
- The group that explored ways to reduce legal costs on home acquisition was disbanded by the board.
- R.K. Fraser's committee to establish a mortgage corporation petered out.
- NHBA's education committee was dissolved in 1959.
- The licensing idea was killed.

Historical dates may now be listed as BC (Before Christ), AD (Anno Domini) and BPC (Before Political Correctness). A generation ago, sales staff assumed that Canadians could be sold on the sex appeal of almost anything, including construction materials and — in the case below — sewer pipe. Left: heating systems were promoted (1965) with the help of the hot-water heat bunny.

We Still Say...

Kitchens are for cooking, Sheila!

But roots from your favorite shade tree plugged the house drains tight,...so it's bath in the kitchen tonight! Filling that tub was just the beginning of your problem. With the drain line being dug up, a costly proposition, it's out the back door and down the back steps for that tub of water! If your builder had used Plain End Vitrified Clay Pipe, Fittings and Root-Proof Couplings you'd have been sure of trouble-free house drains, forever. They're root-proof, by actual test.

Plain End Pipe from 4" to 27"

NATIONAL SEWER PIPE

LIMITED

NHBA priorities had shifted, particularly in the direction of public relations. In 1959, NHBA succeeded in persuading newspapers to publish articles on housing, whose legacy is the Homes section of many Canadian newspapers today. In short order, fifty-two newspapers were running these articles, from Toronto's *Globe and Mail* to Stettler's *Independent*.

Marketing had become such a hot topic that builders were seriously pondering the prospect of tying up substantial capital in "model homes." The 1950s were also the heyday of beauty pageants — and the housing industry refused to be left out of the sash-and-tiara business. Along with National Home Week, therefore, came Miss National Home Week. NHBA's president posed with Miss Electricity, although the result was less than charismatic. The beauty pageant idea was short-lived: NHBA's PR director Isobel Temple suggested that "instead of picking a Miss National Home Week for promotional purposes, a Mr. and Mrs. Canadian Homeowner" might be more appropriate. The board agreed that whatever else might etch *houses* on Canadian brains, nubile bathing beauties weren't it.

NHBA's emphasis on research, however, had more lasting results. On the technical front, NHBA launched its Mark series of experimental homes and, in what *National Builder* called a "triumph," snatched CMHC's longtime expert Sam Gitterman to run it. Meanwhile, NHBA president Joubert was looking for a grand slam to respond to different priorities simultaneously. He wanted an Act of Parliament to provide NHBA with funding, encour-

age research, and promote evolutionary development in housing:

> Every time a mortgage on a new house is written, or an existing house with a mortgage changes hands, a small transfer fee would be charged [and] diverted to NHBA for research purposes. There is precedent ... accepted by the federal government in keeping track of pedigree livestock ... Just as the livestock transfer fee is spent to improve the breed of horses, cattle or household pets, so the house transfer fee would be spent to improve the breed of Canadian housing.[106]

Joubert's livestock idea had further embellishments: "The pedigree house would have a registry number like the one on a motor car. The owner would have a certificate as to who built the house, who financed it, and what kind of materials and equipment went into its construction, giving the property a tangible value."[107] The entire package would be called the Pedigree House Plan.

By the end of the 1950s, Canadian homebuilding was, compared with the previous decade, a horse of a different colour. However, a number of its new aspirations (like the Pedigree House Plan) were blue-ribbon ideas which, in retrospect, never got out of the starting gate.

Revenge of the Cliff-Dwellers
1960—1969

In which architects meet Lego® and the talking brick; Toronto gets slabbed; the North collects honeybags; buildings get brutal; builders contemplate the teacup; and the whole country goes city-happy.

> Little boxes on the hillside
> Little boxes made of ticky-tacky
> Little boxes on the hillside
> Little boxes all the same
>
> Malvina Reynolds, 1962[1]

> If you're going to live in the city, you're going to have to live in an apartment.
>
> J.R. Nicholson, minister responsible for CMHC, 1967[2]

As the world's second-largest country (in area), Canada is an improbable place for sardine-can population densities; yet locations like Vancouver's west end have among the highest densities in the world. In the "go-go" sixties, not only was "tract housing" getting denser, but apartment construction was on a dramatic upswing.

Admittedly, multi-family dwellings have been popular in Canada since time immemorial. Some were being built in ancient British Columbia at the same time as those in ancient Mesopotamia. Apartment construction even retained some primeval practices that disappeared from other forms of home-building. Cornerstone-laying ceremonies — the descendants of prehistoric sacrificial rituals for con-struction[3] — are one example. To invite women to a cornerstone ceremony was, in a previous age, a breach of etiquette: women had been the sacrifice.

Apartments have played a particularly important role in Canadian downtowns since New France. To this day, Montreal is the "apartment capital of Canada,"[4] and some 50 percent of Quebec households live in apartments, compared to less than 10 percent in Newfoundland. Toronto (1990) has some 350 buildings of over 200 units;[5] but it was not always thus. The "golden era" of apartment development was the 1960s.[6] Prior to that, apartment construction had puttered along over the decades, accelerating in World War II when it represented "about one-third of all housing starts during these years.

Many of these multiple units were in fact triplexes, double duplexes, and other small buildings in Quebec."[7] By 1949, construction had dropped back to 11,000 apartment units per year, mostly in Quebec. These didn't even have heat: they were called "cold flats" (logically enough) for which the tenant had to provide his own electric space-heater called (equally logically) a "Quebec heater."[8]

The walk-up business spread in the 1950s. Not all experiences were happy: "In Montreal, CMHC financed the construction of thousands of mostly walk-up units and backed some builders with no housing experience. Ultimately, many of these units reverted to CMHC when their owners defaulted."[9] Then the breakthrough happened: in short order, apartment construction "changed in production process and end-product perhaps more than the single-family house has in an entire century."[10]

By 1961, over two-thirds of all housing starts in Metro Toronto were apartments — triple the rate of a decade earlier. Between 1965 and 1969, Cadillac Fairview alone added over 1,500 new apartment units to its portfolio each year.

The apartment boom was the result of three major factors: support from governments, cooperation from lenders, and technology. Municipal officials loved the move toward a "skyline": many lay awake nights with visions of Manhattan dancing in their heads. Highrises "put a city distinctively on the map" (regardless of whether all other municipalities were doing likewise) to a more visible extent than the "bungs in the burbs." The country was awash in "mind-boggling prognostications"[11] about Canada's urban future. CMHC, for its part, "was moving rental properties through the insurance underwriting process on an assembly line basis"[12] — which suited lenders who favoured highrises because of "ease of administration, large-scale operation, and central siting in city cores."[13]

But the biggest factor was technological: it was the "Toronto slab." This Canadian invention, also called the "flying form" method, had a greater impact on the changing face of cities than anything else. For centuries, apartment construction had been like single-family homebuilding, just bigger. Construction methods started changing in the 1950s: apartments were using more concrete (which

By the 1960s, the vision of Jeannette Macdonald and Nelson Eddy in their archetypal log cabin had given way to concrete "hives," which were heralded as the inexorable future of Canadian city-dwellers. Pierre Berton's definition of a Canadian as a person who could make love in a canoe was fast fading into wishful nostalgia.

homebuyers never cared for), but it still took three storeys of shoring to produce a single storey of construction per week. Builders tried motorized buggies to replace wheelbarrows, conveyer belts for concrete, and new shoring systems, among many efforts, but workmen still had to scramble through scaffolding like spiders.

Then Robert Campeau substituted twenty-storey European cranes, followed by cranes that could climb the building as it grew. Climbing cranes eliminated wheelbarrows, buggies, and conveyer belts. A standard floor slab was then developed for hoisting by a special "highrise hoist tower" — also invented in Canada. Mix them all together and you had a "Toronto slab" highrise.

But Scandinavians were also pushing new technology, which they insisted was as superior for the structure of the building as teak furniture was for the interior decor. Their system was to mass-produce pre-cast stairs, elevator shafts, landings, balconies, and plumbing wall units plus partitions.[14] Concrete

floor slabs were cast on the ground and then lifted on hydraulic jacks into position. The end result would be an apartment that was a cross between an IKEA furniture kit and concrete Meccano.

The proponents of this method were Sweden's Jespersen and Skarne, Denmark's Larsen and Nielsen, and England's Wates Limited. Jespersen set up a facility in Markham, filled with prefab bric-a-brac ready for assembly. Wates persuaded a series of Toronto firms (Belmont, Cadillac, Greenwin, Heathcliffe, and Meridian) to form Modular Precast Concrete Structures to do likewise. So what was Canada waiting for? Conventional wisdom was that the Europeans *had* to have a better system because: (a) they said they could save 10 to 12 percent on apartment costs, (b) this was a step closer to the architectural/governmental dream of total prefabrication; and (c) this was an import, whereas the Toronto slab was, well, *domestic*.

Shelter Corporation's Graham Lount, in Winnipeg, was one of the first to experiment with the Europeans' system — and the first to get cold feet. The Europeans' cause was not helped when one of their buildings, at Ronan Point in England, inconveniently collapsed. It was a British adaptation of the Danish Larsen and Nielsen system; but when a gas explosion occurred on an upper floor, an entire corner room section, eighteen storeys up, decided to migrate to the edge of the building and fall over. This technology's cost factor was even more embarrassing: during the hysterical building frenzy of 1966–71, the Toronto slab rose 13 percent in cost whereas the European system rose 22 percent for 1968–71 alone. Jespersen claimed that its system was not to blame, because the "the plant was running at only half capacity [so] the structures yielded somewhat higher costs than normal."[16] But despite the company's protestations, the plant closed and the "distinctly unprofitable" Modular Precast venture followed suit.[17]

And what happened to the Toronto slab? It was recognized as "the most efficient construction technique" — and it now dominates the North American highrise industry.[18]

What other kinds of construction were sprawling across the landscape? The 1960s home (when it wasn't an apartment) was bigger than its 1950s predecessor: it was typically 1,100 to 1,300 square feet. These houses were "cottages" (an ironic euphemism for two-storey homes), the now perennial "bungs," and a

The impact of Toronto-slab ("flying form") apartment building on productivity was dramatic: in barely 15 years, the number of person-hours to build a unit had been slashed from 2,000 to 1,000.[15]

growing proliferation of "splits" (the split-level species having evolved into side-splits, back-splits and other "splits"). Although western Canada still loved stucco, prefinished aluminum and hardboard (masonite) siding was taking the rest of the country by storm. Traditional plaster walls and hardwood floors were making way for drywall and broadloom. Kitchens were larger, and usually featured eating areas. Counters had grown to 15 square feet or more; and, as in the film *The Graduate*, there was one key buzzword: "Plastics!"

The 1960s even witnessed the spread of the housing boom into the North. Below the treeline, the log cabin had replaced native housing over the past century; but even after World War II, homes were built with whatever bric-a-brac was available or could be dragged across Great Slave Lake by cat-train in winter. The main street of Old Town in Yellowknife is still aptly named Ragged Ass Road (with perhaps the most frequently pilfered street sign in Canada, ahead of its nearby competitor, Lois Lane). North of the treeline, conditions were even more primitive; and in the late 1950s Ottawa felt that Canada's image was being tarnished when Canadians, such as Inuit in the Keewatin, were still inconveniently starving to death.

The government therefore embarked on a program of centralization of populations: communities would be built complete with schools, services, and houses called "matchboxes" in honour of their shape, solidity, and uncanny ability to go up in smoke. In short order, however, the North would become the testing ground for a plethora of unconventional housing ideas coming off CMHC's drawing boards: there were dome houses, houses with unusual room layouts called "inverted basements," and various other experiments that Inuit were expected to live in or with.

As communities became established, so did the need for local administration and utilities. Water delivery and sewage, for example, were problems on permafrost — an environment where the ground is

In 1961, some builders predicted that houses perched in mid-air would be the future answer to high excavation costs. This model, by Henry Switzer, in West Vancouver was finished in pink stucco.

The solid stainless-steel house, tested in Woodbridge, Ont., by architect Thomas Ibronyi, was touted as the future housing for the Arctic.

frozen solid, year-round. Inuvik had "utilidors," namely above-ground hookups, but other communities devised a simpler approach. Clearly, privies were out of the question: no one wants to get lost in a blizzard or attacked by a polar bear when responding to nature's call. The solution? Install toilet seats over garbage pails (or their equivalent) lined with green garbage bags. The device is called a honeybucket. When full, the "honeybag" is placed outside for municipal pickup, like garbage bags in southern Canada. Another approach was also developed: a truck delivers clean water to a storage tank in each home; that truck is painted white. Another truck carts "used" water away; it is painted brown.

However, refuse pickup was almost all that NWT municipal governments were allowed to govern. They were officially named "hamlets," lest anyone get the notion that these localities were entitled to the same democratic system as "villages" in the south. Locally elected councillors could not even enact a zoning by-law. All power over their day-to-day lives ultimately rested with appointees at the Department of Indian and Northern Affairs; and since almost 100 percent of the housing was technically "public housing," Inuit got to learn about bureaucracy in a hurry. At both a legal and administrative level, the housing system bore an uncanny resemblance to its counterpart in Siberia. Eventually, Inuit felt compelled to use the land-claims process to negotiate democratic municipal practices to correspond more closely to those elsewhere, even though the topic had nothing to do with any claim for land. This demand was made over the heated objections of Ottawa mandarins who argued that zoning by-laws "might be used by locals for purposes contrary to the overall interests of Canada,"[19] which only those mandarins could grasp.

But sometimes even essential services broke down. One winter in Eskimo Point (now called Arviat), the community found itself without power (or heat) from both the primary and backup generator systems. This lasted for three weeks thanks to a blizzard. Some people bundled up, some bought Coleman stoves, and some built igloos in the front yard. (Ancient housing traditions remain useful in the North, regardless of how many northerners lie awake nights dreaming of toilets that flush.)

Despite all the changes in housing throughout Canada, there was little overt change in *how* buildings were generally produced. Where were the assembly lines for housing that were supposed to replace conventional builders? They turned up at a nuclear weapons base.

Canada's first Bomarc missile base was at La Macaza, Quebec, a place the National Building Code had not yet reached. Housing was built by none other than A.V. Roe Ltd. (Avro), designer of the ill-starred Avro Arrow. Avro undertook to produce state-of-the-art manufactured houses, but ran into so many "piecemeal municipal code wrangles"[20] that it gave up. In a parting shot, Avro announced that it had *never* seen red tape like this. This, coming from the producer of the Arrow ...

But another innovation had more success. New designs in aluminum windows were rapidly eliminating the traditional annual ceremony of installing storm windows. Double-glazing also allowed for better energy conservation. These windows had existed since the 1940s, but the plastics revolution now made them affordable.[21] Canadians also learned the advantages of a peculiar product called weatherstripping, and fell in love with horizontal slider windows — although water and condensation problems would later haunt many buyers.[22]

Giant windows had been a preoccupation of home designers for a decade: the resulting profile, nicknamed "Contempo" architecture, evoked the California lifestyle — where large glass surfaces would remind occupants of the great outdoors and their barbecues. Textbooks insist that the Heroic Modernists invented this ubiquitous asymmetrical bung, with its picture window the size of P.E.I., carport, open-concept living room, and cathedral ceiling. This bung was attributed to Gropius and his friends, who "softened the monochromatic Bauhaus-derivative Cubist compositions and enlivened the [Mies] steel-and-glass models."[23]

Meanwhile, the new version of Modernism sweeping the architecture journals was a variant called Brutalism.[24] Brutalism would "realize the true potential of the machine ethic ... utilizing machine-produced materials in their natural or 'as found' condition."[25] The invention of Brutalism was also attributed to the Heroic Modernists. The fact that most of

them were now dead was irrelevant. For example, this style owes its name to Le Corbusier, who

> used *béton brut*, a concrete whose naturally textured surface is left as found after the wooden formwork is removed. If the resulting surface is rough, uneven or oddly textured, so be it ... Also characteristic of the style was the exposure of the mechanical systems to public view. Visible heating ducts, plumbing pipes and electrical conduits along walls and ceilings of the interiors combined with the stark use of new material [this later evolved into what architects called "Decorative High-Tech"].[26]

The American architectural leader Louis Kahn loved concrete, but was also conversational with other materials: "You say to brick 'What do you want, brick?' and brick says to you 'I like an arch.' And you say to brick 'Look, I want one, too, but arches are expensive and I can use a concrete lintel ... what do you think of that, brick?' Brick says, 'I like an arch.'"[27] "What Kahn meant," another expert explained, "was that ... even the lowliest material should be used for what it does best ... 'What does the building want to be?' he would enquire ... What marked his work more and more were massive walls and the honest beauty of materials like poured concrete ... Kahn was one of our great architects, even if some of his monolithic buildings are hard to love."[28]

But Brutalism was loved by town councils, and countless municipalities invoked the Centennial as a reason to destroy century-old buildings and replace them with new city halls, as a tribute to their respect for a hundred years of history. North Bay's Brutalist council chamber, for example, is referred to affectionately by locals as "the toilet."

Raw concrete apartment buildings abounded and the occasional Brutalist house was built; but the style was largely resisted by homebuilders and their clientele. As author Tom Wolfe later wrote,

[Consumers] bought houses with pitched roofs and shingles and clapboard siding ... with gaslight-style front porch lamps and mail boxes set up on lengths of stiffened chain which seemed to defy gravity — the more cute and antiquey touches, the better — and they loaded these houses with "drapes" such as baffled all description and wall-to-wall carpet you could lose a shoe in, and they put barbecue pits and fish

"Brutalist buildings tended to appear massive and visually ponderous ... [with] rugged looking walls."[29] The ideal materials for these top-heavy "exercises in mass," like this Ottawa complex, were concrete, concrete, and more concrete.

ponds with concrete cherubs urinating into them on the lawn out back, and they parked the Buick Electras out front and had Evinrude cruisers up on tow trailers in the carport just beyond the breezeway.[30]

This brought tears to the eyes of the aesthetic establishment; but if North Americans persisted in being hopelessly retrograde in selecting home exteriors, perhaps they could be influenced on interiors. "Every Sunday in its design section," said Wolfe,

the *New York Times Magazine* ran a picture of the same sort of apartment. I began to think of it as *that apartment.* The walls were always pure white and free of mouldings, casings, baseboards and all the rest. In the living room there were about 17,000 watts' worth of R-40 spotlights encased in white canisters suspended from the ceiling in what is known as track lighting. There was always a set of bentwood chairs

blessed by Le Corbusier, which no one ever sat in because they caught you in the small of the back like a karate chop. The dining-room table was a smooth slab of blond wood (no ogee edges, no beading on the legs), around which was a set of the S-shaped tubular steel, caned-

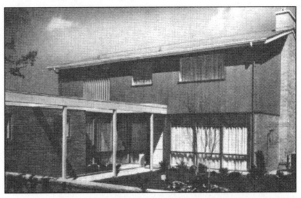

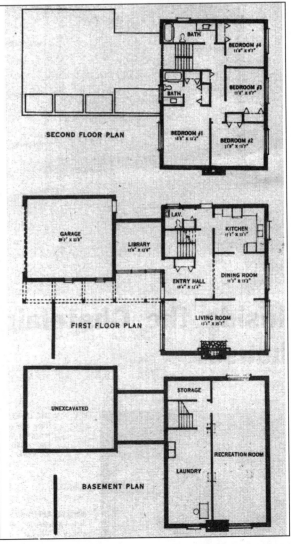

Chatelaine magazine's Home '61 in Montreal (above) cost $15,195 for 1,360 sq. ft. not including the Studebaker. Its Home '62 in Toronto (right) was welcomed as a "happy example of ... the comeback of the two-storey house."[31]

bottomed chairs that Mies van der Rohe had designed — the second most famous chair designed in the 20th century, his own Barcelona chair being first, but also one of the five most disastrously designed, so that by the time the main course arrived, at least one guest had pitched face forward into the lobster bisque. Somewhere nearby was a palm or a dracena fragrans or some other huge tropical plant, because all the furniture was so mean and clean and bare and spare that without some prodigious piece of frondose Victoriana from the nursery the place looked absolutely empty. The photographer always managed to place the plant in the foreground, so that the stark scene beyond one peered at through an arabesque of equatorial greenery; and *that apartment* is still with us, every Sunday.[32]

But Canada was about to see a different vision of the apartment of the future. As Canada prepared for its centennial, a remarkable thing occurred: national self-deprecation made way, temporarily, for public optimism. Canadians seemed to share a broadly based conviction that we had come of age as a nation, that we were on the verge of magical things, and that the most magical place of all would be our national showcase, Expo 67. It would be the world's window on the future; and in a world increasingly urbanized, Expo would also have to portray the future of the city. A display was needed to show us what we would be living in some years hence. CMHC discovered recent McGill architecture graduate Moshe Safdie. He hadn't built anything significant, but that was irrelevant: work from his drafting table dazzled CMHC. The project was given the appropriate name of Habitat, and public authorities undertook to build this prototype of future Canadian cities.

Safdie may have been inexperienced, but his architectural correctness was impeccable. His material was concrete, of course. He would quote Piet Hein:

Moshe Safdie's Habitat. Safdie had been playing with Lego.[33] He hit on the idea of substituting life-size concrete apartments for the Lego bricks. "If this is built," said CMHC's Ian Mclennan, "it will set housing in Canada 15 to 20 years ahead."[34]

There is one art, no more, no less;
To do all things with artlessness.[35]

In his love of mass production he also liked quoting Buckminster Fuller's line that just as time "enables us to appraise da Vinci as the greatest artist of the Middle Ages [*sic*], [Henry] Ford will undoubtedly be acclaimed ... as certainly the greatest artist of the 20th century."[36] Last but not least, Safdie saw himself as the defender of the Modernist faith:

[Man originally] was very influenced by the materials. If he had mud he used it in a way that was true to the nature of mud, if he had stone he used it according to the nature of stone. He didn't try to make the stone look like mud or like wood ... I believe that the expression of truth, calling an arch an arch, makes an architecture of growth, one that is open-ended; the architecture of pretense, of defiance of physical truth, is an architecture that is retrograde ... So, I basically disagree with [the architectural expert] who says everything is possible in architecture today ... I absolutely disagree with him. We have very few alternatives to the right solution ... A solution is a process of moving toward the truth.[37]

Didn't Habitat's move toward the truth have a doctrinal weak spot, namely "busyness"? No, said CMHC's architects; they knew this for certain, because they thought the *idea* for Habitat was invented by the Heroic Modernists. "Safdie's idea has to be considered alongside Le Corbusier's Unité d'habitation," wrote one CMHC official:

Le Corbusier's idea was to encase the whole life of a village-size community within a single great concrete hive and lift the structure off the ground on vertical supports ...

This is a thrilling and lyrical image ... The wonderful geometrical intricacy of Safdie's design lacks the gentle humanity and sculptural simplicity of what Le Corbusier ... showed us; but in spite of these points of criticism, Habitat has to be acknowledged in history.[38]

In due course, public authorities also had to acknowledge details, like whether Habitat was buildable. No one would set up the concrete cubicle factory that Safdie wanted, so the project had to be redesigned, and per-unit costs spiralled. Worse, the project was late — and if an exhibit wasn't ready on time, it was supposed to be "bulldozed into the St. Lawrence."[39] Montreal mayor Drapeau visited the site, and observed that there wasn't even time to bulldoze it; so with characteristic flourish, he "decided to announce that Habitat '67 had been left voluntarily unfinished so that visitors could see how it was built."[40]

The next problem was getting anyone to live there. CMHC had furnished a luxury suite for its own senior staff during Expo, but subsequently discovered that the units were ferociously difficult to dispose of. Both builders and the plebs were clearly unprepared for such a housing concept, in such a windswept, isolated location, at such a cost. Ultimately, the notion that Canadians would live in Habitat-type cities joined the ranks of prophecies that failed to materialize.

CMHC was getting used to disappointments. At the end of the 1950s the banks had walked out of home mortgages because of low returns: they were supposed to make 5,000 NHA loans in 1960, but by the end of the first quarter, CMHC had counted only eighteen.[41] NHBA was complaining of a 40 percent crash in housing starts and called for a Royal Commission;[42] it tried to recruit CMHC support, but Les Wade reported to the board that "the reception given to the NHBA delegation was very poor."[43]

CMHC couldn't even earn affection when it dished out money. It was busy making direct loans to builders — which the builders' association protested on two grounds:

- The government should set up a system allowing private lenders to fill the bill, and
- "No private mortgage company would grant loans to the inexperienced and incapable, in the manner that was done by CMHC."[44]

CMHC was accused of a "lack of real planning."[45] Furthermore, "due to the very low pay … it is not possible to obtain or hold qualified people."[46] Later reports done for CMHC itself and the Economic Council of Canada agreed that CMHC was part of the problem instead of the solution: "Between 1957 and 1973 [there were] nine major changes in CMHC's direct lending. Between 1957 and 1960, CMHC loans contributed in a major way to instability in total housing starts … from 1960 to 1967, CMHC lending made [only] a modest contribution to instability."[47] This instability caused higher prices because "the greater risk of unemployment must be compensated by higher wages; the risk of slack demand means profits must be higher in favourable times; and market fluctuations promote turnover of both labour and entrepreneurs, which inhibit the improvement of skills in the homebuilding industry."[48] Trade magazines agreed with this diagnosis, whereupon CMHC leaned on NHBA to shut the journalists up. NHBA disclaimed any responsibility for editorial content in construction magazines, but CMHC replied that unless NHBA straightened out the media, NHBA "was not enhancing [its] position with the government."[49]

Crossed signals were a fact of life. When the real-estate industry lobbied for a better system to finance the purchase of older houses, the minister of public works replied that the same effect could be reached by decreasing down payments[50] — although that prospect had already been vetoed by the minister of finance.[51] Other Diefenbaker government policies cancelled each other out: interest rates were boosted from 6 to 6.75 percent to attract banks into home mortgages … but banks were then barred by glitches in the Bank Act.[52] Next, when the government tried to make housing more affordable by extending repayment terms (from thirty to thirty-five years) and the level of financing, the savings were nullified by the increased interest. Ottawa also tried to increase housing via urban renewal … but bulldozed as many low-income units as it built. Urban renewal went from bad to worse: although governments knew that repairs often did the job "more cheaply than new housing, existing legislation didn't allow it — so cities chose to wait for severe blight to set in and then apply for total clearance."[53]

Where was NHBA during these momentous times? It was settling into the comfortable mould of a two-issue non-governmental organization (NGO) with a pair of exclusive preoccupations: the development of technology and the financing of homebuilders. NHBA's technological initiatives, in its Mark program, were wide-ranging and even adventurous. For example, the Mark III was "too radical to obtain a building permit in any Canadian city,"[54] so it was built at the Rockliffe Air Base near Ottawa in 1961. The experimental sealants on the roof failed, so it was replaced with another design, which was equally experimental. Much of the plumbing was plastic, the foundation was made mostly of treated wood, and the toilets recycled water to "eliminate the need for municipal sewer services."[55] The foundation got an unexpected test within the first month, when a freak January thaw caused such soil displacement that any concrete foundation would have cracked; but the treated wood bowed without breaking, so jacks were simply brought into the house to bounce the walls

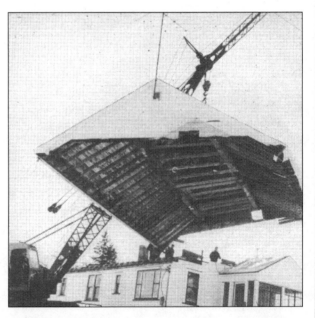

In 1962, NHBA tried to launch a renovators' committee but it was premature. Some ideas about home repair, at the time, were a bit drastic.

NHBA's Mark houses tested the outer limits of housing technology. The Mark II (above), built in Calgary by Les Wade, experimented with new plywood and floors. The Mark III (top right) in Ottawa included a revolutionary all-plastic plumbing system and its own self-contained sewage system. The Mark IV (right), also in Ottawa, had Canada's first all-wood foundation; it also tested an asphalt roof, a plastic roof, and exterior walls finished with both a kind of paper and a plywood veneer.

back into position again. The Mark IV was built next to the Mark III, with the first all-wood basement in Canada, and again with "recirculating plumbing." A revolutionary asphalt roof failed and had to be replaced. An experimental plywood exterior also failed, but was successfully replaced with an equally experimental coloured plywood. The Mark V project was a matched pair of houses, using two completely different construction techniques to produce identical results: this was a test on how to cut costs "within the realm of existing building regulations." The Mark VI was built in Kitchener in 1968. It experimented with new forms of concrete basements, new garage design, instant bathrooms, steel studs, and massive use of vinyl. Plastic pipe was generally ruled a success.

Consumers, for their part, were adding their own flourishes. Architects urged builders to try to discourage some of the decor that was winding up on the front door. For example, in 1961, Montreal architect André Blouin advised builders to "banish the herons, pelicans and aluminum birds from the entrance door. The door is the sign of the owner; let us leave the moon above and let us not put its quarters on the doors."[56]

There was disagreement as to whether a comparable level of experimentation could be seen in the architecture schools. There was certainly no shortage of theorizing: "What the 1960s produced, curiously enough, was a larger proliferation of dialogue and a smaller collection of corresponding buildings than any period in history."[57] That dialogue, however, took place within the narrow confines of Modernist doctrine. In the words of one planner, "The professor viewed the project as to how closely it conformed to the vision of the Masters — Mies, Corbu, Wright, etc."[58] Dissenting views were, according to a later architectural writer, "suppressed with the same puritanical vigilance that the Moral Majority might reserve for pornography."[59]

Much of the task of bringing technological innovation to single-family homes therefore rested with

Find the house in this picture. Some Canadians, including these residents of Harbour Grace, Nfld., believed that the customary bungalow of the era needed a little livening up.

the builders, with the support of officials in a variety of agencies like CMHC and NRC. Technology, however, was hardly the only issue on NHBA's agenda. During the 1960s, discussion of mortgages would outweigh all other NHBA substantive issues (together) four to one. Like many other NGOs, it spent countless hours arguing over its last (or next) convention, dues, and voting procedures — and its two courtesy calls to the Honolulu Home Builders' Association.

Some builders began to wonder whether NHBA's Toronto headquarters were the best place from which to lobby Parliament Hill and CMHC, on mortgages or any other major issue. Torontonians on staff replied that Toronto was much cheaper than Ottawa.[60] The question was referred to NHBA director (and future president) Ernie Alexander, of Barrie, who assured the board that NHBA was as effective as if it had "a corner right in the PM's office."[61] He resolved the issue in favour of the budding world-class city: "The place

for a cup is in the centre of the saucer, not out at the rim."[62]

The main question on NHBA's plate (or saucer) was money. If builders could not get "bridge financing" to carry them through to the sale of their houses, they could not build. Every time the government loosened or tightened the money tap, housing starts spiralled or plummeted. This was getting so unnerving that even the Economic Council of Canada eventually objected. There was no question who was responsible for whether homebuying was a buyer's or seller's market: it was the Bank of Canada.[63] NHBA tried almost everything to get around the problem. It suggested a Mortgage Exchange. It lobbied to allow pension plans to invest in the mortgage market. However, the government finally gave NHBA a different opportunity.

As Diefenbaker's troubles deepened, he resorted to that consummately Canadian technique of making public announcements without actually doing anything: he launched Royal Commissions. One was

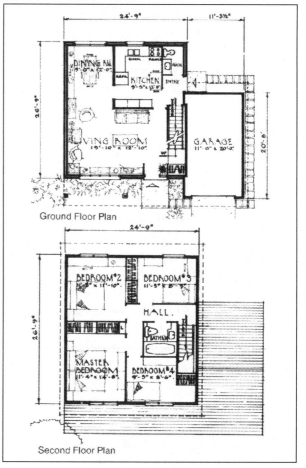

Ground Floor Plan

NHBA built two identical Mark V houses in Kanata, Ont. (one shown above) to provide evidence on how to cut costs. The Mark VI (below, floor plans to right) in Kitchener boasted a pre-cast basement, steel joists, and steel studs.

Second Floor Plan

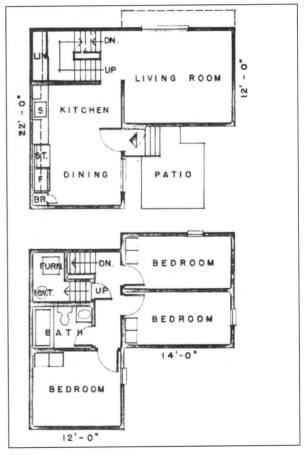

The Mark VII in Vancouver (above) experimented with new cladding, a new kind of basement, and novel plumbing and wiring systems. The Mark VIII in Winnipeg (right) was an attempt at affordable "infill" housing in an existing neighbourhood; although many features proved successful, the shoehorning of four houses on one lot caused claustrophobia.

the Porter Commission on Banking and Finance. NHBA jumped in with both feet; and to its astonishment, most of its proposals were accepted. The Commission agreed that

- Banks should be brought back into the mortgage business by making interest rates more attractive.
- The government (via CMHC) should withdraw from direct lending, and confine itself to *insuring* mortgages.
- The Bank Act should allow banks to invest in conventional as well as insured mortgages — including second mortgages.
- The limit on the value of a house which could be mortgaged should be raised to 75 percent.

But just because government-assembled experts spoke, that didn't mean government would listen: there would have to be review committees — and committees to review the reviews. In the meantime, the money situation worsened: one major lender (Atlantic Acceptance) collapsed, not only leaving clients in limbo but also spooking other lenders. To make matters worse, the White House then told American investors to keep their money at home. Financing appeared to be drying up altogether. In 1966, NHBA president Charles Campbell expressed his bewilderment:

> Last year ... mortgage companies were chasing the builders to take mortgage commitments because they had so much in mortgage funds they didn't know what to do with them. Then came the fiasco of the Atlantic Acceptance failure and suddenly nobody had any mortgage funds ... Commitments which had been made and were being counted on by the builders were withdrawn. It seems to me to be utterly ridiculous when multi-million dollar corporations who are used to lending vast amounts of money in the mortgage market, and pushing mortgage money out like crazy one day, should the next day find themselves

without a cent to their name. However, the Atlantic Acceptance fiasco was only the beginning of the mortgage problem. Along came Mr. [Lyndon] Johnson with this edict to the American investors that they were to restrict the capital outflow from the United States into foreign countries and this time he included Canada ... On top of this, municipalities across the country were beginning to feel the strain of inadequate servicing and went to the money market for long-term financing for major municipal projects, again increasing the strain. At this time, Mr. Pearson made his now famous request for the construction industry to slow down and the federal government would defer as much of its work as possible. It wasn't too long after that that they announced the beginning of the causeway from the mainland to Prince Edward Island at an expenditure of several hundred million dollars ... The continued shortage of money drove the asking price of mortgages in the conventional field from an interest rate of 6 3/4 percent to a high of 7 3/4 percent at the end of the year. [We hope] ... that the Bank Act will be one of the first pieces of legislation to be placed before Parliament [to allow banks to enter the mortgage market] in January. It has been promised and promised until we are sick of promises. Action is long overdue. The government should listen to its own program — "DO IT NOW."[64]

In 1966, Ottawa finally agreed to allow banks to put 10 percent of their loans in home mortgages. It also agreed with NHBA that CMHC should be allowed to insure loans for *existing* housing (conditional on a $1,000 minimum on renovation invest-

ment). But by then, interest rates had risen and inflation also added to the problem of affordability: "Tied in with this problem of the shortage of mortgage money," said Campbell, "is the spectre of inflation. Over a period of thirty months, we have had an increase of 23 percent in the cost of construction materials."[65] That wasn't the worst: between 1949 and 1966, the typical Canadian homebuyer had witnessed an increase in his financing costs of 45 percent; construction costs had gone up by 100 percent; but the cost of the serviced lot underneath had increased by 350 percent. Even public utilities came precariously close to "gouging": builders "wanted to put wiring underground in 1960; Hydro charged them $125 per front foot (the width of the lot); within four years this was raised to $1,000 per front foot."[66]

Some observers believed that builders were so inefficient with their arithmetic that they might never notice. During the proceedings of the Newfoundland Royal Commission on Housing in the mid-1960s, "one of the Commissioners asked one builder how he kept track of his costs … He had a nail on the wall for each house he was building. When he got an invoice he stuck the invoice on the appropriate nail. When the builder was finished the house, he took all the invoices for that house off the nail, added them up, put on his own profits and that was his final price. That's how the industry seemed to have operated." According to one CMHC official, "It was the best example of cost accounting that the Commission had ever seen at the time."[67]

The upward pressures on costs triggered a national preoccupation with "buying a home now while you still can": the Canadian home was being perceived as a "hedge against inflation." Although people had long known that their house was usually their biggest investment, it was not until the 1960s that "playing the housing market" made a large dent in the collective psyche. Canadians suddenly realized that negotiating a good deal on your house was one of the few ways of making money without being gouged by the taxman. Countless taxpayers started speculating on their own homes. At first, many builders did not even realize what a potent selling point had just come within their grasp, during a time of conspicuous inflation. Others had to fill them in.

"The best defense against inflation is the purchase of a home," said Lloyd Gunby in 1968[68] — confiding his off-the-record opinion to a group of homebuilders. The builders had made a discovery akin to Henry Kissinger's, when he reputedly said, "This is not only our policy: it has the added advantage of being the truth."

Studying this whole "housing question" was acquiring the status of a national sport. Would there be as many housing researchers as there were housing starts? Aside from the Canadian Housing Design Council (1956), the Canadian Council on Urban and Regional Research was launched in 1962. In 1967 these organizations were joined by the Canadian Association of Housing and Renewal Officials. These various organizations all added to the research and discussion going on at CMHC, NHBA, the Community Planning Association of Canada, and other organizations. Some research projects worked better than others. For instance, CMHC hired a social scientist in the Maritimes "to search for explanations of [public housing] discontent in the taverns in the town where the phlegmatic maritimer is most articulate and lucid."[69] The tavern-hopper's results were not only "irrelevant" but "confused."

CMHC itself was thrown into confusion by the sudden death of Stewart Bates in 1964; he was replaced by staffer Herb Hignett. The previous year, when NHBA's chief officer, John Caulfield Smith, resigned and was replaced by Bernie Bernard, NHBA went through its own transitional pains: at one point, it totally forgot that it had a policy (dating back to the late 1950s) calling for a federal department of housing and/or urban affairs.

Even more amnesia reigned on the touchy issue of consumer protection: NHBA's plan for licensing builders had been reversed in the late 1950s on the insistence of Toronto builders, but as long as there were jerry-builders, some people still argued that the industry was working under a cloud. In 1961 builders from most of Ontario supported "certifying individuals rather than corporations … [and] legislation [that] would not permit a corporation to build homes unless it employed a registered builder;"[70] but they were told that "the Toronto Association will not have any form of registration except on a voluntary basis; in other words, no compulsory registration."[71]

The other builders were cowed: "Until things are ironed out entirely, we will not do anything."[72] In 1961 the longtime champion of builder licensing, Graham Lount of Winnipeg's Shelter Corporation (president-elect of NHBA), warned the industry that unless it got stricter with its own members, government would do so for it: "Why do municipalities feel it is essential that they be in a position to license contractors? ... *We say* that we are best qualified to determine a man's ability. This, of course, is something we have to prove."[73] However, Lount's appeal fell on deaf ears, except in Quebec, where builders had been insisting (since the 1940s) that a licensing system be introduced. Every year they reported that the relevant legislation was imminent, but by the end of the decade, the Quebec provincial association was still reviewing the proposed bill[74] (it was enacted in the 1970s). Toronto dismissed it all: "We are completely against licensing. We feel the government will administer it ... Toronto refuses to go along with the proposal." The board of NHBA resolved "not to pursue [even a voluntary] registered builder program at the present time."[75]

Another Lount pet project was to assure that builders were organized not only nationally and locally, but also provincially. Ontario was the first to respond, in 1962, and other provinces soon followed suit. One CMHC official offered this rationale for the founding of the Newfoundland and Labrador Home Builders' Association: "One of the ways the CMHC helped to create the industry was to get the builders mad enough [over regulations] so that a number of the builders got together to form the Home Builders Association as a united front in arguing with CMHC."[76]

Lount also hoped to persuade his colleagues of the importance of education and training, and to reverse the decision (from the late 1950s) to dissolve NHBA's educational program. Lount was aware that realtors had made major strides in this area. The president of the Canadian Association of Real Estate Boards, Jack Weber, had succeeded, back in 1955, in establishing a Canadian Institute of Realtors — today's Real Estate Institute of Canada — to orchestrate real-estate courses in the provinces. Graduates would be entitled to call themselves Fellows of the Realtors Institute, and the University of Toronto

graduated the first class (via correspondence courses) in 1956. This model was soon being emulated from coast to coast. "The University of Manitoba," Lount told builders, "is to include a course for [the realtor] which will have improved his public image. We builders can strive for recognition of a similar nature. We are trying to put ourselves in the same place as the dentists, doctors, engineers and architects."[77] Charles Campbell added in 1965 that "the firm which refuses to acknowledge its responsibilities in these matters finds itself penalized for failure to provide for the future labour pool required by the industry."[78]

Yet by 1969, so little progress had been made that director Eric Johnson delivered the following assessment to NHBA's board:

> Our sector of the industry is failing sadly in any worthwhile attempts to train and attract tradesmen to our ranks — well aware as we are of the rising and continuous demand for our products in the next ten to fifteen years. Little worthwhile assistance seems to emanate from various federal and provincial training schemes, but it ill behooves us to point fingers in their direction whilst we make such an insignificant contribution to solving the problem ... The traditional apprenticeship conception does not seem to fill the bill in residential construction and there is need for a radical and dynamic approach to a new philosophy in securing and training the labour without which today some of our trades are truly becoming lost skills.[79]

The personnel question was touchy, because no one could discuss "apprentices" and "journeymen" without thinking about labour unions. Although the construction industry as a whole tended to be unionized, homebuilding was an exception; and the expectation of cordial relations with unions (which the builders had voiced in the 1940s) had evaporated.

"The problems and controls imposed on our industry by the labour unions in Ontario through the regulations made under the Industrial Standards Act continue to plague and infuriate us … Certainly if Canada is not to suffer the same fate as Great Britain at the hands of the labour movement, we must continue to fight …"[80]

This was the backdrop when NHBA received a peculiar invitation: the Canadian Construction Association wanted NHBA to participate in its Centennial Project. While the rest of the country was sponsoring parties, perogy-eating contests, or other forms of frivolity, CCA probably set a national precedent for earnestness in its selection of a project: it would stage an inquiry on construction personnel. The moderator would be H. Carl Goldenberg, one of Canada's foremost labour-management experts. NHBA dispatched its Ontario vice president, Eric Johnson.[81] When Johnson showed up on the first day, he was shocked to see representatives of labour unions at the table. He immediately declared he would walk out by day's end unless the unions were ejected. Despite a flurry of private entreaties Johnson held firm. Then Goldenberg replied that if the unions left, so would he. Johnson relented. Paradoxically, Johnson later confided to NHBA's board that these "were all top Canadian executives of the international unions. One must comment most favourably upon the calibre of these officials and, as the meeting progressed, the usefulness of their contributions to the discussions."[82] Johnson personally came to believe that his colleagues should organize builders exchanges to act as a single negotiating voice as "the day of unionization in all sectors of construction labour draws inevitably nearer," even though this could "only have the effect of bringing in increased costs to the production of shelter at a time when the public and government are already deeply concerned with those costs."[83] As it turns out, the predicted unionization never materialized.

Meanwhile, another file at NHBA covered mortgage interest deductibility: why couldn't Canadians deduct mortgage interest from taxable income, as Americans did? This issue had become such an old chestnut, however, that, aside from the perfunctory resolution at each general meeting, it rarely surfaced at strategy sessions. Then Diefenbaker launched

a Royal Commission on taxation. The builders thought their chance had arrived.

NHBA dredged up its longstanding proposals, and approached three of the largest chartered accounting firms in Canada for "big names" to present mortgage interest deductibility to Diefenbaker. All three balked. On April 21, 1963, the board read a twenty-two-page report "to the effect that it was not practical to advocate for these changes."[84] NHBA's reaction was stunned silence.[85]

In April 1963, the Diefenbaker government fell to the minority Liberal government of Lester Pearson, whose friend Walter Gordon became minister of finance. Gordon would present a new budget as part of "sixty days of decision" following the election. He did so on June 13th, which Liberal strategist Keith Davey later labelled "Walter's personal Bay of Pigs."[86] Among a host of controversial provisions was an 11 percent sales tax on building materials. This was part of the Manufacturers' Sales Tax — a tax reputedly so pernicious that, over two decades later, its replacement would be used as the excuse to introduce an even more unpopular tax: the Goods and Services Tax.

Gordon's 11 percent tax would obviously drive up home prices. The builders immediately lobbied Gordon, along with other senior ministers like Allan MacEachen, Paul Martin, and a former NHBA member in cabinet, Paul Hellyer. Gordon dismantled many of the June 13th proposals, and decreed that the 11 percent tax would be "phased in" with an initial tax of 4 percent. Despite this attempt to soften its impact, the tax was blamed for an immediate 45 percent drop in residential starts in Atlantic Canada.[87]

The tax "staggered the industry," said NHBA's president, Chesley McConnell.[88] It grew to the anticipated level of 11 percent, but by 1967 its removal was seriously considered. Premier Johnson of Quebec had agreed to remove his additional 8 percent sales tax on building materials if Ottawa would do likewise with its 11 percent tax. "The cost of a $15,000 home was expected to be cut by $1,300."[89] Ottawa's defence was to attack: it blamed rising costs on "profiteering" builders,[90] and ignored the proposal. The rest of the decade showed no particular improvement. In 1968, NHBA announced that it wanted "the federal government divorced from the unhappy

practice of using the housing industry as an economic manipulator";[91] it even hoped that "1968 will see this start to happen," but that prayer went unanswered.

The overall controversy over rising costs, squeezes on affordable housing, and the general fate of cities started a long simmer, leading eventually to a full boil. At the beginning of the 1960s, the ranking of cities and their problems on the public agenda differed little from that of previous decades. Various pundits bemoaned the aesthetic sterility of the suburbs (Scarborough had already acquired the label Scarberia), and others asked authorities to get serious about this "urban renewal" business; but public consciousness had hardly been inflamed.

The sixties changed all that. "The unplanned suburbs are like human monsters,"[92] said CMHC's Humphrey Carver. By the end of the decade, debate over Canada's cities and their future was at a fever pitch. There were dire predictions that if current trends continued, Canadian cities would become Calcuttas of the north: affordable housing would be beyond the reach of not only the working class but also the middle class, gridlock would set in, homelessness would be rampant, and inner cities would collapse under the weight of their own decay. Toronto would become Mexico-City-by-the-Lake, and the typical urban Canadian would not exist in green surroundings until after he was dead.

The notion of an "urban emergency" spread slowly at first; but by 1967, the government's own backbenchers were calling the lack of affordable quality shelter a "national crisis" purportedly so severe that it entitled Ottawa to seize constitutional jurisdiction over the issue from the provinces: "The provision of public housing in the large, rapidly growing urban areas is a question of national urgency involving the peace, order and good government of Canada."[93]

The reference to "peace, order and good government" was part of the incantation which, under Canada's constitution, could be used as a basis for federal takeover of what was otherwise provincial. Much of the pressure came from Toronto, which, between 1961 and 1967, absorbed one quarter of all Canadian immigrants. This elicited government concern over the fate of such "great urban areas."[94]

Initially, many Toronto boosters thought this growth would merely allow Toronto to take its rightful place as a world-class city; others believed that "economies of scale" would allow Toronto to service its population *more* efficiently, rather than less so. But some wondered whether Toronto and other large centres had passed the threshold of "economies of scale" and were now encountering "*dis*economies of scale": like New York with its perennial financial problems, each additional resident might be merely causing Toronto to dig itself in deeper. The federal government itself worried whether "the costs of concentration overbalance the savings of proximity."[95]

CMHC's solution would have been to build *new communities* — with land the federal government would acquire and develop itself (in association with private developers). CMHC would naturally pilot this initiative. The scale would be large: it would involve "the successive creation of properly planned new communities ... with each new community having its own town centre."[96] However, since both property and municipal affairs are under provincial jurisdiction, Ottawa needed provincial acquiescence to such massive intervention. Pearson decided to stage a first ministers' conference specifically on the subject: the Conference on Housing and Urban Affairs was scheduled for December 1967.

But Pearson had not counted on Ottawa's ability to scuttle itself. "A senior official of the department of finance managed to delay cabinet approval of the conference papers to such an extent that the legislative proposals could not be sent out to the provincial premiers in advance of the meeting."[97] Pearson was left in the unenviable position of springing these mushroom-cities on the premiers by surprise. When the first ministers met, CMHC's Humphrey Carver witnessed the realization of the corporation's worst nightmares. "The premiers [displayed] ... their most endearing style and territorial imperatives, like so many exotic birds displaying their plumage in some kind of sexual dance ..."[98] Worse, federal politicians departed from their bureaucrats' script. "Pearson didn't invite [CMHC's patron minister] Nicholson to make the key statement of the legislative proposal. He simply invited a spontaneous discussion ... With horror and amazement I heard Nicholson denying

any thought of federal government involvement in [land assembly] except for purposes of public housing ... Had Nicholson not even read the [CMHC] papers from which he was expected to deliver the key statement?"[99] Carver concluded that "Pearson acted with a good-natured innocence that was the beginning of about five years of stumbling confusion in housing and urban affairs."

But some politicians, at least, had a very clear idea of their own agenda. Although NHBA had been presenting its slide show on "Why Canada Needs a Royal Commission on Housing," some federal politicians went one better. Rather than appoint the umpteenth committee of experts to review the issue, a high-powered task force was created, headed by one of the most influential members of cabinet. His name was Paul Hellyer.

From the standpoint of his cabinet colleagues, "The nickname we had for [Hellyer] then was Charles de Gaulle, because he was stately and tall and he held himself aloof and thought quite highly of himself ... He wanted us to build super-cities in the wilderness ... Maybe he was too advanced for us. But his main problems were that he lacked political savvy, didn't have much of a sense of humour, and had a pretty big ego."[100] CMHC liked him even less. Hellyer was a wunderkind: he had been president of Toronto's Curran-Hall Limited, which built hundreds of houses in Etobicoke, North York, and Scarborough. He was elected to Parliament at the age of twenty-six; and at thirty-three he was touted by *National Builder* for a cabinet post. Unfortunately, he didn't view CMHC with the esteem that the institution felt it deserved. In the parlance of the BBC's *Yes Minister* series, he "ran loose" without the beneficent advice of his bureaucrats. "If he had accepted the momentum of ideas on which we, in CMHC, had been working for a number of years, there would have been much more rapid progress ... but Hellyer turned his back on CMHC, he started off on his own ... Paul Hellyer was anxious to protect his task force from contamination by those who had passed along this road before."[101]

Hellyer did indeed follow a different road. Even before his report was out, Hellyer had taken dead aim at many of the established wisdoms of the Canadian urban "emergency." One of his first targets was urban renewal: "A lot of urban renewal funds were going into primarily commercial redevelopment."[102] "In our studies we have [also] found that the traditional method used in urban renewal, of taking a large area, razing the whole area and rebuilding the whole thing, while it may be appropriate in some circumstances ... in other circumstances may not be the least bit appropriate. In some cases we have been razing perfectly habitable houses."[103]

The report came out on January 29, 1969. Hellyer proclaimed it "the most comprehensive review of housing and urban problems undertaken in Canada since the Curtis Inquiry [1943]."[104] The Opposition called it "a colossal fraud on the Canadian public";[105] "The report and the minister himself are complete washouts."[106]

NHBA, however, was tickled pink with its alumnus. It called Hellyer's report "the greatest step to our industry the government has proposed since the National Housing Act in 1938."[107] "The task force is unanimous," Hellyer said, "in agreeing that the industry is over-regulated and more freedom to do a job to meet the needs of all the people is desirable."[108] He continued: "The private land developer is forced to constantly compromise because of antagonisms ... between municipal officialdom and the land developer. This situation results in the imposition of higher standards than required, greater restrictions, as well as delay, and higher costs, with the misguided assumption that the developer pays for these things."[109] This was music to NHBA's ears.

Beyond the specifics, however, lay a more fundamental political issue: many of his proposals fell squarely within areas of provincial jurisdiction.[110] Was Ottawa's concern stepping on provincial toes or even laying the groundwork for a federal seizure of jurisdiction over urban affairs? Ontario "told Mr. Hellyer quite frankly not to come into direct contact with the municipalities."[111] Provincial comfort levels were not increased when David Lewis of the NDP announced unequivocal support for a *constitutional amendment* to transfer housing and urban development to the federal government.[112]

That constitutional dimension is where things became unstuck. Hellyer was one of few people in Canadian history to believe that the new prime minister, Pierre Trudeau, was soft on federal authority.

When Trudeau failed to charge into the housing field as Hellyer recommended, sparks flew.

Cabinet secrecy didn't keep the acrimony under wraps for long. The recommendation to abolish the 11 percent sales tax (at least on building materials for low-cost housing) was flatly rebuffed by Finance Minister Edgar Benson.[113] This wasn't significant by itself: there is a venerable tradition of Canadian finance ministers telling their cabinet colleagues to take a flying leap. However, cabinet divisions were being reflected elsewhere. The task force had also revived a proposal (around since at least 1965) to name a minister of housing and urban affairs. Almost two months later, however, the prime minister declared he had no such plans.[114] "By early April, rumour was rife that a split had occurred in the federal cabinet. One issue in this matter was the failure of Mr. Hellyer to announce government policy arising from the task force's recommendations."[115] Canada waited to learn whether *any* of the task force's recommendations would be formally adopted — and waited — and waited. Something was clearly wrong.

The dénouement occurred on April 24th. Trudeau announced Hellyer's resignation and then appointed a minister of housing — five days after Hellyer's departure.

The day after Hellyer fell on his political sword, retired CMHC official Humphrey Carver appeared at CBC studios with a prepared text for the National News:

> [Mr. Hellyer's] first political error was [being] … chairman of his own task force … Mr. Hellyer has no one but himself to blame, that he worked himself into this awkward position unless one can believe the suggestion that Mr. Trudeau allowed him to *hang himself.* The second political error was that in gathering views about housing policy, Mr. Hellyer pointedly didn't ask the advice of his own staff people and … CMHC. Nor did he speak to the housing administrators in the provincial governments … Mr.

Hellyer has said that he really parted company with Mr. Trudeau over the philosophy of Canada as a country with ten nearly autonomous provinces and a weak central government. He has suggested that Mr. Trudeau is still at heart a university professor attached to a nice political theory, but an unworkable one. Hellyer had genuinely hoped to deal with the problem of housing and the cities from a position of strength in a strong federal government. He was deeply attached to the heroic gesture of founding a new city, a splendid utopia. But surely, in this it was Mr. Hellyer who was being unrealistic. The problems of cities and housing are the problems of regions and communities; and if Canada had entered these decades of immense urbanization without a structure of provincial governments — well, we would have had to invent them.[116]

A CMHC denunciation of centralization might have caused some hilarity in provincial and industry circles, but what occurred next is not easy to explain from the standpoint of social psychology. Canadians had worked themselves into such a lather over housing that politicians pondered rewriting the constitution — and then suddenly lost interest. The topic almost disappeared. The prospect of a constitutional amendment on urban development evaporated. The institutions launched to "save" Canadian cities would be downsized or disappear altogether: Canada lost its minister of housing, the Housing Design Council, and the Community Planning Association. The Canadian Association of Housing and Renewal Officials would come within a hair of obliteration before re-emerging as the Canadian Housing and Renewal Association.

Did the problems of the city simply go away? Yes and no. One of the underlying motives for the Canadian debate did die a natural death: the fear that Canadian cities would "burn, baby, burn" as was

threatened in the U.S.A. After the Watts riots, many Americans speculated that unless the urban crisis was solved, cities like Washington itself would burn to the ground by the end of the decade. Gordon Lightfoot reflected on the riots in Detroit:

> Black day in July
> Motor city madness has touched the
> countryside …
> Motor city's burning and the flames are
> running wild
> The shapes of gutted buildings
> Strike terror in the heart
> And you say how did it happen
> And you say how did it start?[117]

Lightfoot wasn't the only Canadian watching U.S. urban violence erupt on the six o'clock news. By osmosis, apocalyptic thinking influenced Canada, and when American cities stopped fearing cremation, there was a similar effect here.

Furthermore, the urban issue was upstaged. Although the expressions "October Crisis" and "OPEC" had not yet entered common usage, it was difficult for cities to stay at the top of the political agenda — particularly since Canadian cities never reached the extended decay of downtown U.S.A., and predicted traffic gridlocks didn't materialize either.

Other developments were less reassuring.

Homelessness did accelerate: demands on public housing did not abate; and "affordability" could have reached apocalyptic levels if homebuilding had not continued to modernize and Canadian families hadn't doubled up on salaries. In short, the issues were and are real: the major variable was not the existence of the problem, but its public perception.

Does a comparable fate await the crusade of our own day, the environment? The parallels are not comforting. Both the urban issues of the 1960s and the environmental issues of the 1990s have received international media attention; both were common topics of conversation at all levels of society; both spawned a multiplicity of dedicated NGOs and university programs; both reached into the day-to-day existence of Canadians; and both acquired such priority on the political agenda that there were demands for constitutional changes to accommodate them.[118] Will environmental NGOs eventually be merely a fond memory, like flower power?

Environmentalists deny this prospect. Ecological sensitivity does not even appear to have peaked yet, as the Bambi generation is superseded by the Kermit generation. It is sobering, nonetheless, to observe that some great public causes sometimes lose momentum and go the way of the Age of Aquarius. To maintain its priority on the public agenda, an issue's proponents cannot slacken their efforts at keeping it there. As *The Neurotic's Notebook*[119] says, "They also serve who only stand and cheer."

Whites, Colours, and the Cold-Water Wash
1969–1975

In which experts debate the house's id; the federal government goes to the circus; boomers boom; the taxman gimme shelter; builders change identity; the pygmies are vindicated; housing gets the finger; and the Modern era gets hosed.

After the drug-crazed and frenetic sixties, North America decided to have its head examined.

Society was overrun with advice on how we could psychoanalyse ourselves — with books like *Games People Play, I'm Okay You're Okay,* or *Zen and the Art of Motorcycle Maintenance.* Did housing affect Canada's mental health? Some experts thought so. Toronto architect J.M. Kirkland later summarized: "The ideas about Bedroom posited are typological and suggest analogous paradigms for other spaces within the house — the Hearth, the Study, the Dining Room, each with its gestalt genesis."[1] According to Doug Eliuk of the National Film Board, certain films have also contributed to a kind of collective subconscious

> by preying on our associations with certain rooms in the house: the bathroom is a sanctuary, the bedroom a confessional, the kitchen a high altar. Alfred Hitchcock's 1960 thriller *Psycho* was a watershed film for the plumbing industry. When

Janet Leigh was murdered in the Bates' Motel shower — and blood circled the tub drain — the bathroom lost its quiet-oasis appeal. People beat a hasty retreat to the bathtub, which led to Jacuzzis and the hot tub and so on.[2]

In short, if the city is the image of the soul, as St. Catherine of Siena said, then perhaps the dining-room wall is the image of the subconscious.

The Neurotic's Notebook says that "we cannot understand other people's motives, nor their furniture,"[3] but that doesn't mean the experts couldn't try. Colour was a good place to start. According to Swiss psychologist Max Lüscher, whose theories hit North America in 1969, a person whose preference is for blue and red "seeks affectionate, satisfying and harmonious relationships, desires an intimate union, in which there is love, self-sacrifice and mutual choice."[4] A person whose first choices are yellow and black, however, "tries to escape from his problems, difficulties and tensions, by abrupt, headstrong and ill-con-

sidered decisions or changes of direction."[5]

Some theories are more demonstrable than others. If you ever wondered why so many bathrooms are blue, and hotel corridors red, the reason is the optical effect of these colours on the brain. Red walls appear closer to the eye than in reality; blue walls appear further. Other opinions, however, have nothing to do with the optic nerve.

"Never paint a nursery yellow," said Carlton Wagner, director of Wagner Institute for Colour Research in Santa Barbara, California … Yellow activates the anxiety centre of the brain … Trying to lose weight? Paint your kitchen or dining room blue. You'll spend less time eating … Red, however, produces the opposite effect. "We tend to eat more and eat longer in the presence of red," Wagner said … For those who need help going to sleep, go for the soft colours — but avoid even the palest yellow if you want to get along with your spouse! No matter how dark the bedroom is when the lights go out, the colour of the walls affects our sleep pattern.[6]

Other theorists have different objectives. According to Dr. Grant McCracken of the Royal Ontario Museum in Toronto, there is a recipe for "hominess":[7] "Homey colours, for example, are orange, gold, green, brown. Only one furniture material connotes hominess — wood — and the preferred style is traditional … [Survey] respondents also described certain interior details (bay windows, breakfast nooks, fireplaces) and exterior details (shutters, porches, tudor timbering) as homey."

And what does the smart money say today? "Green is the big colour in the 1990s palette," says one official at Benjamin Moore paints. "Look for more than 400 hues — from celery to hunter … Green is 'trustworthy.'"[8] An official of Para Paints agrees: "The palette of the '90s is strong on yellows, oranges and reds, with greens, of course, taking the lead. Our caring attitudes [toward the environment] will be reflected in recurring nature themes in fabrics, furniture and wallcoverings. The lime greens and the avocado shades of the '50s are due for a comeback."[9]

In the late 1960s and early 1970s, avocado was everywhere, including appliances and home exteriors and interiors. It was one of the "earth tones" which, in some places like Kanata, Ontario, became legally compulsory on housing.

Legislative intervention was proliferating, and there was no telling what direction it would take next. For his part, Pierre Elliott Trudeau had a saying: "There's no point in having power if you don't use it."[10] Trudeau's new housing czar was Robert Andras. Although Andras was Paul Hellyer's campaign chairman when Hellyer ran for the Liberal leadership in 1968, he stepped over Hellyer's political corpse to become his replacement.

Andras had no staff and no office. Based on the advice he was getting from CMHC, one academic concluded "that the major works on urban life, government and planning which had been published during the past century in Europe and America had passed Mr. Andras by."[11] Furthermore, the natives were getting restless: a growing body of public opinion actually took "participatory democracy" seriously. "Community groups" were openly challenging planners, particularly the élite that foisted urban renewal on the country. Ethnic minorities were organizing more effectively against the targeting of their own neighbourhoods. As Andras admitted, no one had consulted them "about bulldozing their homes and demolishing … the very place where they have felt safe and secure."[12]

Andras concluded that the fate of urban Canada was beyond the ken of any single-issue agency like CMHC. The file could not be dealt with "as if the case was a multi-ring circus and what was going on in one ring had no relationship to what was going on in the other rings."[13] Andras persuaded Parliament to designate a new circus master — the Ministry of State for Urban Affairs — with himself in charge. MSUA was announced in October 1970, with a gestation period of nine months. Andras referred to it as an "under-muscled but, we hope, supple and surprisingly lithe new creature."[14]

NHBA had looked to Andras's growing influence as the dawn of a new era of cooperation with

The notion of "public participation" was not joyfully received by officials who wanted neighbourhoods demolished immediately. "In many instances urban renewal affected highly remunerative sites near city centres ... The lower levels of government were dependent on quick and decisive action by the federal authorities to generate a *fait accompli* locally and to provide the scapegoat for blame in the event of excessive local concern."[15]

government. President Eric Johnson said, "There has probably never been closer liaison with CMHC and government than has occurred in the past few months. I would hasten to admit that this is [mostly because] there is now a minister responsible for housing on the scene and in the action. This, however, would not be so, if that minister were not of the type which Robert Andras is proving to be."[16] It took only two months for Johnson to reverse his opinion and blame the bureaucracy. By December 1970, NHBA had received letters rejecting almost every NHBA proposal made. Johnson alerted Andras to Winston Churchill's quote on "how official jargon can be used to destroy any kind of human contact, and even thought itself."[17] But Andras himself declared that "private investment, too, will have to be guided as never before — and I don't mean voluntary guidelines ... to achieve well-thought-out goals of urban design ... Some time-honoured beliefs have to be challenged."[18] Andras was joined by academic Dr. Harvey Lithwick, commissioned by Ottawa to produce still another report

on urban issues.[19] Lithwick argued that since provinces do not have a "full-blown notion of urban policy" and "there has never been any federal urban policy in name or in practice,"[20] Canada needed centralized policy-making that "replaces the existing concept of many semi-autonomous decision-making centres with one in which the machinery of government is an organic whole."[21] The key was to funnel decision-making through an all-powerful committee composed of "the few competent [advisors] available — some in government, others in university, and still others in consulting"[22] (no mention of builders or consumers). In Lithwick's phrase, this was called getting "aggregative."[23] Without such measures, he predicted that Canadian cities would drift to the point that spiralling land costs would force high-density development on everyone, single-family homes would be available only in the extreme boonies (with unreasonable commuting times), downtowns would be congested and polluted, public utilities and transport would cost a fortune, industries would also flee to the cow pastures, and segregation of economic classes would lead to ghettos.

In the name of getting "aggregative," Lithwick revived the idea of constitutional card-shuffling: Ottawa would appropriate "industrial location, inter-urban transport and communications, and inter-urban migration"; on the other hand, "public housing, urban renewal, and even the location of federal facilities — post offices, other federal buildings, transport routes — will fall into the domain of local governments."[24] Within the federal government itself, Lithwick argued that agencies that "are single-objective oriented ... without an urban perspective,"[25] would be forced to submit to a set of federal urban policies, and "all federal agencies with an urban impact would need to consider their policies in the light of these objectives."[26] Bureaucrats would be compelled to work with one another, regardless of turf. Some people might have interpreted such a requirement as the urban first cousin of an environmental impact assessment; but in the words of the University of Lethbridge's David Bettison, "There could hardly be a less realistic proposal!"[27]

The federal government was hardly alone, however, in contemplating internal reconbobulations: the

homebuilding industry itself was having an identity crisis. NHBA faced increasingly boisterous apartment builders complaining about insufficient representation. During the 1960s, renters in Canada had jumped to 40 percent of the population (as opposed to 34 percent in 1961). The Economic Council of Canada's 1969 report[28] declared that multi-family housing would exceed 60 percent of all Canadian housing by 1980 (incorrect, as it turned out; over 60 percent of Canadians still live in single-family homes today). Countless officials and their statisticians were assuming that changes in demand were based on new permanent trends rather than the more likely demographic reason: mobs of baby-boomers were moving their bellbottoms and beanbag chairs into their own "pad." Some could trade in their flower-painted VW microbus for a down payment on a condominium (a style of ownership that provinces had legalized in the late 1960s), or for that most affordable dwelling, a mobile home. However, most boomers had neither the resources nor the inclination to be "tied down" to property, and chose apartments instead. Although NHBA was trying to respond (it had thirty-one booklets in print on apartments by 1970), apartment developers still felt that their profile was not proportional to their importance.

For its part, the "mobile home" industry in 1969 built fully 4 percent of new homes in Canada, and that industry was continuing to grow. Throughout the early 1970s, mobile-home shipments topped 20,000 units per year, which was more than 15 percent of all the single-family starts in Canada. In 1974, the proportion reached 21 percent. This growth pattern might have continued, making suburban Canada into a giant trailer park — if a change in federal policy had not occurred in late 1974. The competitive position of mobile homes was undercut by the federal Assisted Home Ownership Program (AHOP) for site-built houses. At the same time, municipalities and lenders were tightening up on land availability and financing.[29] "In 1974, the Canadian mobile-home industry built over 28,000 mobile homes ... by 1984, the domestic industry had shrunk to twenty-one firms with fewer than 1,000 employees producing just over 3,100 units."[30] Canada would never achieve the status of trailer heaven.

The cost of "renewal": Winnipeg expropriation, 1967. CMHC had been accused in Parliament of being "absolutely useless in most of the fields in which it is empowered to act."[31] Even the new minister, Robert Andras, had to admit to Parliament that some initiatives had gone dreadfully wrong, notably urban renewal, which had produced a "net *loss* in low-income housing stock."[32]

As of 1970, however, the mobile-home industry was still a force to be reckoned with; and with apartment builders, it argued that "National House Builders' Association" no longer sounded right. However, builders also had to be careful of the image a new name would convey, in an increasingly acronym-conscious Canada. At that time, the federal government was contemplating an eventual Mines, Energy & Resources Department — MERD — until someone noticed what that sounded like in a bilingual Canada (hence Energy, Mines & Resources

Canada). By that reasoning, if the association picked something like Builders of Trailers, Condominiums and Housing (BOTCH), there could be talk.

A name change would also be the first step in a comprehensive overhaul: having a board with 150 directors didn't help either. The builders concluded that when major constitutional matters were afoot, they should do something properly political: they would hold a referendum. Bill Small's suggested name — Canadian Home Builders' Association — got onto the ballot — and was then taken off again. The elected winner[33] was Canadian Residential Development Association. Having held the vote, the directors then did something equally political: they disregarded the results. The organization wanted to imitate Robert Andras, who was calling himself Minister of State for Housing and Urban Affairs: so director Keith Morley suggested a name which hadn't even appeared on the ballot: Canadian Housing and Urban Development Association. By the time the lawyers got through with it and the name became official on February 18, 1971, it had evolved into Housing and Urban Development Association of Canada, or HUDAC.

The Canadian Association of Real Estate Boards, quite coincidentally, was on an identical track. It had resolved to change its name during a meeting in Banff in September 1970, and the change became official on January 1, 1971. It was now the Canadian Real Estate Association (CREA). The respective organizations representing builders and realtors had been founded in 1943 within four weeks of each other, and changed names in 1971 within some six weeks of each other, with no apparent connection between these events.

These two associations, by whatever name, had their hands full. The Carter Royal Commission on Taxation had recently reported that "a buck is a buck is a buck," and wanted profits (derived from any source) to be treated more-or-less equally; so in order to enforce this simple idea, the tax system should be made more complicated. Should Canada therefore tax profits on the sale of the typical Canadian's largest investment, namely home sweet home? Yes, said Finance Minister Edgar Benson: he produced a White Paper recommending a capital gains tax on homes (above an annual $1,000 exemption). This may have been predictable: as more homeowners and realtors realized that home values were increasing dramatically, the taxman could hardly have been far behind.

In the U.S.A., a homeowner's profit on the sale of a house is taxable — in return for tax deductibility of mortgage interest. Benson hit on a compromise: he would tax profits but not allow deductibility of the interest. NHBA was livid, and believed that the $1,000 exemption was a sham: "The White Paper [says that] 'generally, capital gains on the sale of (most) homes would not be taxed.' It then proceeds to refute this by describing how, in fact, they would be taxed. It is NHBA's contention that the three basic necessities of life — food, clothing and shelter — should either be tax-free or receive favourable tax treatment."[34] Finance Canada therefore trotted out some of its favourite arguments to justify any new tax:

- The new tax is so much fairer (it's just that the taxman hadn't noticed that before).
- To do anything else would bring out the crook in Canadians.
- Loyal Canadians wouldn't object, and might even enjoy paying those extra taxes.
- If Canadians disagreed, Finance Canada could hit them with something worse.

Benson was true to form. He argued that

- Keeping the capital gains tax off homes creates a "gaping loophole in the tax system and would be harmful to the housing problem in Canada."[35]
- If homes had no capital gains tax, unscrupulous Canadians would stampede to the buying of houses in order to "minimize their tax burden, [with a] resulting tendency to push prices up."[36]
- "Most Canadians who have expressed views on the White Paper agree there should be some form of capital gains tax."[37]
- "The homeowner also has an advantage already over a person who rents, because he is not taxed on the benefit he receives from investing in his home, the so-called '*imputed rent*' [the amount of rent which other Canadians would have to pay for the same house]. [Perhaps] *imputed rent* should be taxed."[38]

NHBA accused the federal government of having "no recognition of the needs of Canadian cities for increased revenue to allow them to deal with the problems of urbanization,"[39] and was joined by such a chorus of public dismay that the capital gains tax on homes was dropped.

Would the rest of the tax system look more favourably on the housing needs of Canadians? As of 1970, a house that cost $13,000 to build included over $1,000 in taxes.[40] "Inconsistent," said NHBA, "is a mild word to apply to a policy which seeks and finances lower-cost housing whilst adding $1,000 to every $12,000 worth of construction for federal and provincial sales taxes."[41]

The search for "consistency" was even more difficult when trying to make sense of federal policy on the subject of depreciation. Depreciation is one of those ghastly subjects that only an accountant could love, but which is essential to understanding how the taxman views property: it is a modest tax write-off, to compensate investors for the devaluation, or wear and tear, of property. In legalese, it is called Capital Cost Allowance. Depreciation could not be claimed on a person's own home; but since 1948, landlords could claim annually 5 to 10 percent of the purchase price of rental units as a tax write-off, in recognition of the depreciation of those units. This led to some interesting possibilities. A dentist who had just bought a $200,000 duplex might claim a $10,000 tax deduction for Capital Cost Allowance — but if the duplex was only earning $6,000 in net income, he could (a) first use that depreciation to wipe out his taxable income from the property, then (b) use the remaining $4,000 in deductions to reduce his taxable income from dentistry — render it tax-free. In tax parlance, the dentist had just used the depreciation to "shelter" $4,000 of professional income.

This "shelter" was abolished in late 1971. Landlords screamed. Builders who were left untouched by the move nevertheless cut back on multi-unit construction. Apartment and condominium construction dropped by over 30 percent. So the government decided to start over.

In government, Newton's laws of physics operate differently than elsewhere: for every perceived action, there is an opposite overreaction. This time, the new depreciation would be unusually high, and would provide exceptional tax shelters for newly constructed Multiple-Unit Residential Buildings, or MURBs. Between 1974 and 1981, over 380,000 MURBs were approved for this tax treatment. This program not only heated up construction of apartments and condos, but spawned the most prodigious building spree for townhouses Canada had ever seen. Suddenly, everyone wanted to dabble in the real-estate market, if only for tax reasons. "The majority of land speculation," said Costain's Keith Morley, "is carried on outside of the industry by our very own doctors, lawyers, maiden aunts and even politicians."[42] MURBs were the brainchild of a prominent duo, Benson's successor at Finance and his trusted deputy minister. They were John Turner and Simon Reisman, the same two who would crucify each other a decade later over free trade.

The industry warned that "government must be urged to stop using housing as its economic tool, if normal production patterns for the industry are to be established. Housing should not be an artificial stimulus or control for the economy which the government can use at will."[43] But the Turner/Reisman show went in the opposite direction. Baby-boomers represented a lot of votes (particularly in key urban ridings), and they were just reaching the age for homebuying. Turner and Reisman devised still another measure called RHOSPs — Registered Home Ownership Savings Plans — to "ease the formidable difficulties facing our young people in accumulating the savings required for a downpayment on a house and its initial furnishings";[44] Turner's budget of November 1974 approved this new tax deduction (up to $1,000 a year) for Canadians who wanted to save up for a house. Finally, the government also promised a $500 grant for new homebuyers, although it lasted only one year. In addition, provinces and municipalities had a plethora of their own programs. Not surprisingly, the decision-making of many builders was being driven less by the market than by the latest acronym-ridden program to come down the tube.

While high-profile MURBs and RHOSPs led Canadians to think Ottawa was improving "affordability," the taxman was simultaneously doing the opposite behind the scenes: Ottawa was extending the 11 percent tax on building materials. This led the

Economic Council of Canada to a simple question: instead of creating massive bureaucracies to administer MURBs and RHOSPs, why not just drop the sales tax? This was turned down flat. The government argued, without batting an eyelash, that the tax revenue involved was too small for Canadian taxpayers to be concerned about, but too large for the government to overlook. "The [federal sales] tax on building materials represents a small percentage of the total selling price of the house but still represents a sizeable source of revenue for the federal government."[45] How a tax could be simultaneously too small and too large was never explained.

This was not the only squeeze being felt by the housing industry. "Not only is business being told to moderate its profits; there is a new pressure on businessmen to take on responsibilities that were never considered their concern before — to help to solve social injustice and cure the problems of environment that are becoming intolerable, and threatening the nations' health."[46] HUDAC responded with a long shopping list:

- Better access to low-cost housing money,
- Housing standards to accommodate a variety of technologies,
- Streamlining approval procedures,
- Use of property taxes only for "real estate–related services,"
- A central mortgage bank,
- Government lending as a lender of last resort,
- A Canada-wide building code,
- Industry-initiated research,
- Dialogue with labour,
- A national urban policy,[47]
- Reduction in minimum house and lot sizes to make housing more affordable,[48] and
- A war on water pollution, with greater federal financing for sewage treatment.[49]

In 1974, HUDAC's social research committee also focused on accessible housing for the handicapped. HUDAC's Greater Vancouver chapter built a home entitled Housing for Independent Wheelchair Living, which opened in January 1975.

But the largest issue of the day was the age-old problem of controlling jerry-builders. Canada

received advice from an unimpeachable source, Charlie Farquharson:

> Another offal mess is yer housing. As the Anglishmen says, a man's home is his Cassel Loma, but it's gittin' tuffer'n ever to git yer wall-to-yer-wall carpet without them back-to-the-wall paymints ... Harld Leach moved down to yer sluburbs ... into one of yer split-levels. After he moved in, he found she wasn't s'posed to be split-level. It was jist the foundation had crack, and now, by hinkus, you have to go upstairs fer to git to the seller ... He says when they made that house he bets they was afraid to take away the scaffolding till after they got the wallpaper well-hung.[50]

Charlie was hardly the only Canadian who felt this way; so the industry's response was a national system of home warranties. It was spearheaded by builders Rod Gerla and Ernie Assaly, from Calgary and Ottawa respectively. HUDAC wanted neither a dictated centralized plan nor "ten provincially led plans with no indication of uniformity between them,"[51] but a system that relied on industry input at the provincial level while still being reasonably homogeneous.

The idea was to "offer a warranty against major structural failures for a minimum of five years, guarantee against defects in workmanship and materials for at least one year, [and] safeguard deposits made by new home purchasers. The programs [would be] funded through fees for builders' registration and for each housing unit registered under the program."[52]

The plan would need provincial governmental backup — but would get unstuck if provinces went their separate ways or (worse) did nothing at all. After intense lobbying, Alberta came on side, followed by Manitoba, Ontario, B.C., Quebec, the four Atlantic provinces together (under the banner of the "Atlantic New Home Warranty Program"), and finally Saskatchewan. "HUDAC's National Warranty Coordinating Council," crowed HUDAC's newslet-

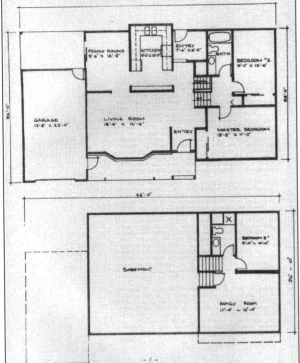

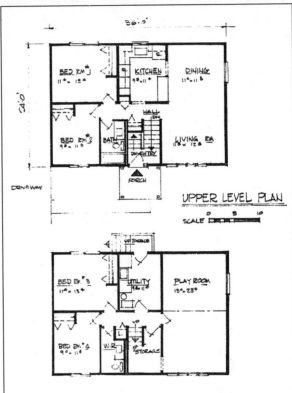

UPPER LEVEL PLAN

SCALE

The Mark IX in Regina (top left) tested construction techniques in the gummiest kind of prairie clay, known to locals as "gumbo." The Mark X in Guelph (top right), for its part, had a bolted steel foundation, and yet another system of plastic plumbing.

ter, "has been responsible for maintaining uniformity among the various provincial plans."[53] That, of course, is not how matters stayed. Ontario entrenched its plan in legislation; the other provinces did not. Some provinces, like Alberta and B.C., allowed warranties to be prolonged or extended; others did not. Some monetary limits on coverage varied. Nonetheless, the basics of the program stood firm. Furthermore, to this day the plans provide that on completion of houses,

a Warranty Certificate will then be issued to you by your provincial Warranty Program office. Your builder will also pass on to you any warranties by manufacturers, suppliers and subcontractors for products or services that went into the construction of your home ... The majority of problems will be corrected routinely and quickly by the builder; in some cases you may need to contact the New Home

Warranty Program directly. To ensure an amicable relationship between home buyers and their builder, the Warranty programs rely on a third-party process for dispute resolution.[54]

In 1973, it was predicted that a HUDAC warranty program could anticipate 6,000 enrolled builders and 130,000 certified units in the first five years. Instead, there were 8,000 builders and 310,000 homes under warranty — more than double the number of homes expected. It was also predicted that the program would need a government start-up loan of $1.6 million and a staff of 320; but HUDAC arranged for it to operate at no expense to taxpayers. Most importantly, the plan had teeth: in the first two years in Ontario alone, 600 builders had their registrations revoked, 700 were refused admission, and almost $2.5 million was paid to homeowners.[55] Over the first decade of its existence, the program paid $25 million to homebuyers.

Although Hamilton's Grisenthwaite Construction had called for the system almost two decades earlier, and HUDAC spent years developing it, it arrived just in time for Ottawa to claim the credit. Although Andras's successor, Ron Basford, was minister of state for urban affairs for only two years, Basford's successor, Barney Danson, announced that the entire program had been invented by Basford in 1973.[56]

Basford and Danson (another member of the old Hellyer team) had the pleasure of overseeing the headiest days for housing in Canadian history. Simply put, Canadians were rich. During the 1960s and 1970s, "real personal disposable income per capita climbed every year of those two decades, and income growth was especially buoyant in the early 1970s."[57]

Not only did Canadians have the cash for homes: they also had the inclination. Even teenage baby-boomers had enough money to leave the nest for their own pad: "Growing affluence, the availability of a supply of reasonably affordable rental housing and a growing desire for independence were among the factors."[58] This pattern fizzled only when spending money ran out at the end of the decade, forcing parents to suffer junior's mooching for several extra years. One consultant concluded that "the increase in

the proportion of the population in the twenty to twenty-four age group ... who reside with their parents, is undoubtedly permanent."[59] It is not known whether this consultant was a parent.

The realtors could see that something extraordinary was happening. In 1966, their total sales under the Multiple Listing Service (MLS) topped $1 billion for the first time, but by 1972 it was $2.5 billion, and by 1975, $6.7 billion. These were equally heady days for builders. In the single-family category, "the 1970s were categorized as a golden era ... the annual number of single-family houses built broke new records on four occasions, reaching its apex in 1976 when nearly 184,000 houses were built ..."[60] Total housing starts that year hit over 273,000. As of the mid-1970s, residential construction amounted to between 6 and 7 percent of the GDP. It has never resumed the same level since.[61]

With that level of output, did Canada finally adopt the manufactured house, out of sheer necessity? The government certainly expected this. The new Department of Regional Economic Expansion (DREE), launched under Jean Marchand in 1969, threw money at modular house factories. After all, that is what Richard Nixon was doing: his "Operation Breakthrough" called on General Electric and other corporate giants to introduce revolutionary factory-produced houses. However, "modular fashion, pushed in large part by DREE grants, peaked with two or three times too many plants in the Atlantic area and parts of Quebec."[62] Nonetheless, government thinking was too entrenched to be swayed by the marketplace, and the blame was again ascribed to builders' ignorance. According to a writer for the Economic Council of Canada in 1976, "The beneficial effects of stability to large builders will not be secured unless they improve their management skills and production planning on the basis of ... better techniques of production"[63] — meaning modular construction and mega-companies. Even in the 1980s, CMHC reports still mourned that "there are no very large homebuilders and never have been: no General Motors of housing, not even an American Motors."[64]

HUDAC's Eric Johnson replied, on behalf of the industry, that he was proud of what he called the "pygmies."[65] Admittedly, it wasn't always easy to be a

pygmy; of the sixteen homebuilding firms in Kingston in 1961, for example, only three were still in business a decade later. But the love affair with housing mega-companies came under withering attack after several American conglomerates tried housing, with financially disastrous results. By 1974, Nixon's Operation Breakthrough was dead, "chiefly because the industrial giants were unable to produce a markedly better house at a lower price."[66] Development decisions, explained the *U.S. Forest Products Journal,*

> cannot wait to be filtered through numerous committees and layers of vice-presidents. The chief asset which the large ... companies gained when they acquired building firms was the entrepreneur-builder himself, not the land, houses, trucks or lumber. The companies seemed to overlook this fact, however, and put their builders in such a corporate straight-jacket that most of them left ... The ones that stayed lacked the incentive they once had, now that they were on a fixed salary, and no longer put in the long hours scouting out land-deals, spotting market voids, and keeping in close touch with customers as they had previously done.[67]

This was borne out by Canadian experience. Campeau Corporation had taken Ottawa by storm, so it attempted to diversify its market in Montreal — without success. Consolidated Building Corp. moved from Toronto to the Montreal and Vancouver markets, franchised part of its operation, and on opening day in Richmond, B.C., 13,000 people attended; it sold 160 houses there in twenty days. Three years later, however, it was in full retreat and withdrew from Montreal and Vancouver — along with Calgary, Hamilton, and London for good measure. "Some firms tried running simultaneous operations in various city areas across Canada, and were known as multi-city builders. Almost every one of them failed because of lack of 'on-the-spot' knowledge and tastes."[68] By the early 1970s, the large builders were

licking their wounds, learning from their lessons, and making a modest comeback in the extraordinarily upbeat market — so long as they knew their own turf well. The experts in Ottawa seized upon this comeback to insist they had been right about mega-companies all along: at last "the Canadian housing industry is slowly becoming more rationalized."[69] They had to admit for the first time, however, that "the multi-project builder appears to have very little natural advantage over the small builder."[70]

In fact, overall efficiency was improving dramatically. In 1946, it took between 2.8 and 2.9 person-years to build the typical single-family house; by 1976, this figure had dropped by almost 60 percent, to 1.27 person-years.[71] The real problem with affordability was not the inefficiency of builders, but the spiralling cost of land. Between 1961 and 1968, total housing costs had risen by 80 percent; but the cost of serviced land had risen by 240 percent.[72] In Toronto the cost of accommodation in 1970 was absorbing "something like 50 percent of take-home pay of even the middle-income group."[73]

NHBA's Mark V house (1966) had illustrated the optimal cost breakdown: a house costing $18,300 would see 37.8 percent going to materials, 14.8 percent to labour, 28.9 percent to serviced land, 9.4 percent to professional/financial fees and permits, 5.6 percent to taxes and 3.5 percent to before-tax profit. The profits of homebuilders grew throughout the early 1970s and peaked in 1976, then slid downward, and plummeted in 1982. A slow rebuilding process occurred, but Canada never again witnessed the phenomenon of the early 1970s. Not surprisingly, speculators of the day wanted "a piece of the action." Speculation in houses was so rampant that some investors would simply buy vacant new houses with the intention of resale at a later date. In order to put the brakes on this practice, firms like R.J. Kaufman and Russ Howald Construction of Kitchener attached a condition that if the house was unoccupied for two years, the owner (speculator) would have to pay a 15 percent premium. This immediately caused a tiff with the Kitchener-Waterloo Real Estate Board, and the practice did not spread.

Governments chose, however, to disregard the distinction between "development" and "speculation": they too wanted a piece of the action. In the

words of Eric Johnson, "Municipal taxes and lot levies followed hard on the heels of an apparent philosophy that builders and developers, whilst not actually perhaps members of the Mafia, were some form of brigands who should be 'soaked'— but good — for whatever it was they wanted to create."[74] The result, said Johnson, was that "the three levels of government thrash about in our business affairs without any coordination worthy of mention."[75]

And thrashing there was. Urban renewal was about to get axed, despite Lithwick's plea that Ottawa "offset such political considerations and help to remedy ignorance of renewal goals."[76] The fate of other initiatives was more confusing. In 1972, the federal government introduced a Residential Mortgage Financing Act to beef up private financing: a Residential Mortgage Market Corporation would trade in mortgages, with $400 million in financing (including $100 million of federal money). The Act would also create Mortgage Investment Corporations to help pool private money. In 1973, Ottawa changed the title to the Federal Mortgage Exchange Corporation — then changed its mind altogether and decided this wasn't a worthwhile idea after all. On another front, Ottawa tried to revive CMHC's pet project on land banking in a new National Housing Act proposed in 1972 — and tried again in 1973 — but those initiatives also fizzled. In 1975, CMHC also axed its $100-million "urban demonstration program."

Other programs had a bit more staying power. The government announced the Neighbourhood Improvement Program (NIP), but it was killed a decade later. In 1972 Canadians were introduced to the Residential Rehabilitation Assistance Program (RRAP), as well as the Assisted Home Ownership Program (AHOP). HUDAC was concerned, however, that insufficient attention was being paid to how the plethora of federal, provincial, and municipal programs fit together. If officials weren't careful, programs could negate each other. For example, HUDAC asked whether the benefits of the RRAP program would be taxed away by municipalities in the form of property tax increases: "HUDAC is sceptical about the success of the Rehabilitation Program unless provinces and municipalities implement five- or ten-year tax moratoriums on properties which have

been rehabilitated."[77] They didn't, but RRAP nevertheless survives to the present day. Most programs, like AHOP, weren't so lucky. In fairness, many governmental initiatives of all kinds were clearly temporary, and even labelled *ad hoc*. That made the effect on industry no less chaotic. After yet another series of government announcements, commentator Larry Zolf summed it up: "It's ad hockery night in Canada!"[78]

HUDAC was reluctant to look gift horses in the mouth, but would have preferred more "natural" solutions, like lifting some of the restrictions on mortgages. Although HUDAC had some longstanding concerns about homebuyers taking on too much risk (foreclosures look bad for everybody), it nonetheless felt confident to lobby for a higher permissible borrowers' debt ratio: HUDAC's research director Bill McCance argued that if other investments did not have a financing ceiling, why should housing? Over the course of time, HUDAC claimed credit for lifting the ceiling, extending amortization from thirty-five to forty years on some loans, chopping mortgage insurance fees in half, and extending loan systems to home improvement.

Making sense of all the proposals wasn't easy: MSUA had three ministers in as many years. In addition, CMHC's president, Herb Hignett, retired in 1973, and was replaced by developer Bill Teron, a close friend of Pierre Trudeau. Despite Teron's homebuilder background, he elicited remarkably little comment from HUDAC. He did, however, attract the attention of Ottawa's journalistic gurus for two contributions to public administration. The first was purportedly his role in the campaign for Freedom of Information (FOI) in government. Not that Teron was in favour of the idea; but without him, the advocates of FOI might never have become sufficiently irate to do anything about it. According to commentator Richard Gwyn, Teron "promulgated the Teron doctrine that any civil servant had the right to stamp any document, whatsoever, CONFIDENTIAL."[79]

Journalists also immortalized Teron's little "chat" with Pierre Trudeau in 1974 concerning 24 Sussex. Gwyn describes it: "Wouldn't an indoor swimming pool be a great idea? It would cost, Teron reckoned, about $60,000 and could be built easily and without fuss by Public Works. It was not anyone's fault, exact-

ly, that the pool eventually cost over $200,000 — too much rock, mostly — and had to be paid for by wealthy Liberal donors, in exchange for anonymity and a tax write-off. What mattered about the pool was that it soon became a metaphor for breach of trust."[80]

Trudeau had re-entered 24 Sussex after a remarkable victory in the 1974 federal election, whose overwhelming issue was inflation. The Tories proposed their solution: wage and price controls. Trudeau scoffed; in fact, he brought down the house at one rally after another by pointing his inimitable finger at the audience and sneering "Zap! You're frozen."[81] But after Trudeau's victory, inflation only got worse. What was his solution? Wage and price controls, of course. These were announced on October 13, 1975. Inevitably, homebuilders (representing one of the largest industries in Canada) were among those fingered. *Zap,* they were frozen.

According to HUDAC director Bob Shaw, the anti-inflation guidelines applicable to the housing industry were "no more than all the rest of industry and business in Canada was expected to follow,"[82] at least for the time being. These patriotic stirrings, however, did not make administration any easier: "Profit margins after October 14th, 1975 must be no greater than in the last full accounting period before October 14th, 1975, and no greater than 95 percent of the average profits in the preceding five years … Even if we do not increase prices beyond the October 14th, 1975 level, we may still have to reduce prices to fall in line."[83] HUDAC's Colin Parsons described the reporting procedures of the Anti-Inflation Board as "a nightmare."[84]

Although the direct controls on profits were eventually dismantled, the sense of distrust felt by the rank-and-file of the homebuilding industry continued to grow. Where was the industry headed? There were always experts to predict that soon Canadians would have no houses at all. "If the future remains the same," said one, "cooperatives and condominiums will be the only housing for Canadians, and the latter is the more viable of the two."[85] If people didn't like highrises, then perhaps they could be persuaded with the right propaganda. One University of Toronto professor was bankrolled by the Canada Council to study how European strategists overcame the aversion of Danes and Swedes to living in highrises.

This would have suited architectural journals, swept away by the 1960s fascination with a notion called "the mega-structure." According to correct thinking, people would henceforth live in beehives, like the Empire State Building tipped over. In 1968, Indian mystic Sri Aurobindo actually started building one so that his loving followers could enjoy each other's company under one roof — all 50,000 of them. Not to be outdone, our National Capital Commission announced the Hammer Plan to encase Parliament Hill, the Hull river bank, and the Ottawa River islands in a single mega-structure, thereby creating "the Ottawa Lake."

But other journals started to hint at rumblings of heresy among Modernists. At first blush, that appeared logistically impossible. In the generation after World War II, Modernists had so systematically taken control of schools of architecture — beginning with Gropius himself — that Gropius could feel confident that "a majority of his own making — is with him now."[86] Canadian architecture schools, like those throughout the Western world,[87] were filled with accounts of students being flunked out for failing to imitate the Heroic leaders. It was usually as likely for an anti-Modernist to obtain an architectural degree as for a Rastafarian to graduate from a seminary.

But cracks were appearing in the Modernists' façade: Robert Venturi, a practising American architect, actually took a line attributed to Mies ("Less is more") and wrote "Less is a bore." He even built buildings that he tried to make interesting. This was disrespectful. Venturi "compared the Mies box to a roadside stand in Long Island built in the shape of a duck. The entire building was devoted to expressing a single thought: 'ducks in here.' Likewise, the Mies box. It was nothing more than a single expression: modern architecture in here."[88] According to some writers, Venturi's approach was like Pop Art: "A leg-pull, a mischievous but, at bottom, respectful wink at the orthodoxy of the date."[89] Others, however, hazarded a guess that architecture was moving into a new era. They picked up a label that Charles Hudnut had used in Toronto in the 1940s (and which had been coined as early as the 1870s): "Post-Modern."

Venturi's approach had a shortcoming, however: it was not encrusted with metaphysics. Venturi's buildings didn't look different because of cosmology,

but simply because he liked them that way. Other architects who wanted to explore new directions had to be more circumspect. The prize-winning New York duo of Gwathmey and Siegel were careful to explain that their "cubist" houses — which nonetheless had the occasional curve, circle, or even elaborate railings — were merely "the percepted implication, speculation and interpretation through the formal manipulation of volumetric space and form, made comprehensive by geometry, transparency, and spatial and facade layering."[90]

They and their followers were the subject of a 1972 book called *Five Architects*, and they became known as "The Whites," in honour of both the exteriors and interiors of their buildings (the only items that were not white were the profusion of high-tech tubing used for railings, track lighting, or whatever).

Unfortunately, the Whites pleased neither the Modernist establishment nor the Anti-Modernists. At an exhibition organized by London's architectural élite a decade later, their work was displayed in a giant garbage can. Anti-Modernist Tom Wolfe, on the other hand, said, "It looks like an insecticide refinery. I once saw the owners of such a place driven to the edge of sensory deprivation by the whiteness & lightness & leanness & cleanness & bareness & spareness of it all."[91] And in the Heroic tradition of Walter Gropius and Adolf Loos, Canada's would-be architectural "theologian" R.J. van Pelt dismissed the whole lot of Post-Modernists as perverts.[92]

In any event, Canadian architectural literature appeared less interested in white façades than in the so-called "Chateau Margaux of woods":[93] cedar. Diagonal cedar panelling became the reliable signature of an architect-designed (and hence expensive) home. The front of the house could also borrow a detail from the classic Modernist skyscraper: since the latter was almost invariably faced by a naked forecourt, no élite home of the 1970s was complete without a front yard of interlocking brick — to create your very own windswept plaza.

Interior designers, perhaps bored by white-on-white "colour" schemes, were finding new, "off-the-wall" sources. Some predicted that sooner or later, the psychedelic sixties would be reflected in stoned home design. Prosaic building supplies could even become art forms unto themselves: for example, a

banging door during John Lennon's Montreal stay provided the percussion for "Give Peace a Chance," representing a cultural high point in the history of Canadian doors. The 1972 book *Living for Today* announced a rethinking of room decor: "Living on such intimate terms with art, we needn't be deadpan about it, and may hang our best picture on the bathroom ceiling."[94] For the truly jaded this same volume recommended — foam. It highlighted the virtues of a "living space" whose interior had been turned into a series of grottos by the liberal use of insulation foam. Even the bathroom fixtures and the candelabra had been sprayed with this "versatile" and "reasonably-priced decorating medium" — UFFI.[95]

But most Canadians didn't want to live in caves. According to builder Keith Morley, "[The Canadian consumer] longs for Georgian gingerbread [*sic*] … It spells security and the old folks at home … It is safe to put the family's savings into one of the tried and true models that have been sold and resold over the years."[96] This continued to run squarely contrary to Le Corbusier's "shining city," replicated in many places around the world — but most of those were in the Soviet Union and weren't getting good press. The homebuying intentions of Canadians also continued to contradict CMHC's longtime expert Humphrey Carver, who insisted that "the colonial house-and-yard has begun to fade … We now know that the ideal home on the House Beautiful cover is not going to be a democratically achievable aspiration … We have to discover and sanctify some new images of the ideal home."[97]

Yet Canadian buyers stubbornly refused to sanctify anything else — whether cubes, mega-structures, or whatever else was recommended by their betters. In fact, polls indicated that most Canadians wanted housing that was (shudder) more suburban, not less so. A 1975 survey in the Vancouver area[98] indicated that most homeowners and renters alike were satisfied with where they were — and among those who weren't, over half wanted to be *farther* away from work in an even less urbanized setting. Fully 90 percent of suburbanites declared themselves in favour of suburban living. A majority stated that "visual appearance" was more important than size in a house — despite the fact that this "visual appearance," labelled by one expert as "bungaloid growth,"[99]

Bill Teron's Ottawa home flaunted diagonal panelling. Its indoor swimming pool so impressed Teron that he suggested one to Pierre Trudeau.

appalled every architecture school in Canada. For HUDAC's part, its Mark series was continuing to use conventional designs for the exteriors of its experimental houses, without apologies.

In any event, the question of bridging the chasm between Modernist theory and consumers' taste was becoming moot. Although most analysts now agree that Modern died in the early 1970s, some quibble over the exact time and cause of its demise. One theory is that Modern was killed, inadvertently, by a Canadian, Arthur Erickson. For over half a century, Modernists had been trying to reduce buildings to as close to "zero" as possible.[100] Erickson succeeded: his Canadian Pavilion at Osaka's Expo 70, with its tilted mirror walls, disappeared altogether. Shucks, you couldn't "reduce" any further than that. After Erickson's definitive work, Modern had hit the end

of that particular road, and architecture had no alternative but to reverse direction.

According to a different theorist,

> We can date the death of Modern architecture to a precise moment in time. Unlike the legal death of a person, which is becoming a complex affair of brain waves versus heart beats, Modern architecture went out with a bang ... The fact that many so-called Modern architects still go around practising a trade as if it were alive can be taken as one of the great curiosities of our age. Modern architecture died in St. Louis, Missouri, on July 15th, 1972, at 3.32 p.m. (or thereabouts) when the infamous Pruitt-Igoe scheme, or rather, several of its slab blocks were given the final *coup de grace* by dynamite.[101]

Pruitt-Igoe was a St. Louis public-housing project by the same architect as New York's World Trade Centre: it was the archetypal Corbu-style concept, and had won an award from the American Institute of Architects before it was blown up. Another giant project, in New Haven, designed by the dean of the Yale School of Architecture at the time of the dynamiting of Pruitt-Igoe, had only seventeen tenants eight years later; it too was demolished. In the United Kingdom, the highrise Chelmsley Estate followed suit in the 1980s.

But why should supporters of Modernist housing in the 1970s be daunted by the fact that society wanted to blow these buildings up? This had never bothered them before, as long as they were buoyed by the Heroic Modernists' philosophy of Redemption through mechanized housing. It is that very premise that collapsed in 1973, the year following Pruitt-Igoe. Until then, it was easy to believe that ever-growing mass-production was the key to salvation in a world of infinite resources. One such resource was energy. In 1969 the federal energy minister declared that since we had "many hundreds of years" of oil, we might need a continental deal so

Americans could relieve us of this "surplus" — cheap.[102] The 1973 *Energy Policy for Canada* struggled with what to do with these surpluses, which we would have for "eighty years,"[103] with luck (and inflation). This official policy assumed that oil prices might reach $5 a barrel by 2000 AD. Canada could only pray that generous multinationals would take this burden off our hands, for resale to foolish Americans.

But suddenly that all changed. In a 1967 "Blintzkrieg"[104] Israel had seized the Sinai Peninsula and built sand fortifications. On October 6, 1973, Egyptian troops stormed these defences with firehoses. Richard Nixon put NATO on military alert, and told the Soviets he would nuke the world if they meddled on the Arab side. The Arabs, for their part, announced that their wing of OPEC would cut oil production by 25 percent. Oil prices promptly doubled from $3 a barrel to $6, and by the end of the year had reached $10.

Ottawa's tune changed. Suddenly, Canada wondered if its oil would last the winter (Trudeau went on TV on November 22nd to reassure Canadians that it would). "To make matters worse," reported Richard Gwyn, "industry spokesmen declared that the public had misunderstood them all along; those estimates of supplies had been based on 'potential' reserves rather than 'recoverable' reserves ... To bring on additional supplies, they had to have higher prices."[105] The effect on the economy was immediate. So was the soul-searching, and the housing industry was no exception. The head of Domtar Construction Materials said that

> unfortunately, in the industrialized countries and particularly in the North American economy, we have been so mesmerized by our objective of achieving the ever-expanding GNP that we have treated our economy as if the resources were inexhaustible. Certainly we cannot claim either good sense or good management in the conduct of our affairs as they relate to natural resources ... The costs for energy require a re-evaluation of our methods of building construction with more emphasis on the conservation of energy.[106]

October 1973 washed away more than sand: it challenged the very notion of mega-anything. It certainly exploded the notion, as one Canadian writer put it, that Modern architecture was the "ultimate consummation [of] demonstrably limitless control [over Nature]."[107] The writings of the Heroic Modernists, with their allusions to human perfectibility through faith in machinery, looked worse than debatable: they looked ridiculous. According to Canadian architectural writers Ruth Cawker and William Bernstein,

> By the time the oil crisis struck in 1973, concern for the environment had been growing in Canada as elsewhere ... [but] the oil crisis marked a real turning point. Although in Canada the crisis was at first more a matter of anxious anticipation than of real scarcity, it sparked a genuine change in attitudes towards both natural and built environment. In the course of the post-1973 decline in the western world's economic health, notions of unlimited growth and technological progress ... were called into question ... There was suddenly a whole society faced with the threat to its prosperous way of life.[108]

One of the casualties was the belief that the Heroic Modernists were Always Right.

It was at this moment that society turned the page on the Modern era. That doesn't mean that change was instantaneous. Modernists continued to control the universities and the journals, and over 99 percent of architectural writing continued to discuss less than 1 percent of what was built. Yet the die was cast. Modernism continued to soldier on for another decade; but it was now like Ed Sullivan, who, it was said, continued to perform for several years after he had died, merely because no one had the nerve to explain to him that he *was* dead.

The Yuppie Revolution
1975–1982

In which homebuilding meets the underground; P.E.I. builds the Ark; houses go foggy; North America strikes oak; Finance Canada invites wrecking balls into the living room; Ronald Reagan gets plywood; builders barely ride their rowboats; and Canada goes bust.

The homebuilding industry will go metric on January 1, 1977.

HUDAC National Focus

The homebuilding industry will go metric on January 1, 1978.

HUDAC National Focus

The homebuilding industry will go metric on May 1, 1979.

HUDAC National Focus

Whatever happened to cubits?

Royal Canadian Air Farce

When the federal government announced that Canada would adopt the metric system, several opposition MPs set up a gas station west of Ottawa, for the sole pleasure of being able to pump in gallons. The proof of the pudding, according to some sceptics, was that the Canadian Amateur Football Association gave up on metric football: travelling ten metres in three downs was considered excessive, and four downs was unpatriotic. In due course, however, Canada did indeed adopt the metric system, and Canadian housing was a prominent part of the effort. HUDAC's Bill McCance described metric conversion as "a once-in-a-lifetime opportunity to change many irrational sizes."[1] On the principle that "you are what you eat," HUDAC's newsletter concluded that metric had thoroughly settled in by 1982, with the appearance of square metric pizza.[2]

Other revolutions launched in the mid-1970s were less controversial. As the oil-squeeze tightened, demand for energy efficiency heightened. Suddenly, even politicians were dusting off the pleas for domestic fuel economy, which had been published a decade earlier in books like *The Whole Earth Catalogue*[3] and *Silent Spring.*[4]

One proposed solution to the energy crisis would be for everybody to move underground. Why should Romans in catacombs have had all the fun? Mother Earth is warm in winter, cool in summer, and its residents don't necessarily have to be dead. In France, 25,000 people lived underground in the 1970s, primarily in decorated caves, as did forty million Chinese. H.G. Wells had described underground cities in *The Time Machine;* Jules Verne had also toyed with the idea. Most underground house designs featured earth berms (embankments) on

An ideal suburb of the future? American writers in the late '70s coined the elegant word "underliving" to describe semi-subterranean "houses of the future"; French writers had already coined the less elegant word *habitaupe* — mole-houses. In time, Canadian technology achieved comparable energy performance *without* going underground.

three sides with exposed southern window-walls. Publications such as *The Underground House Book* (1980) cited predictions "that in-earth structures will constitute as much as thirty percent of the housing market by the mid-1980s."[5] The architect who helped inspire *The Underground House Book* wrote his own book the following year, entitled *Superhouse*,[6] in which he dismissed many of his predecessors' notions as unrealistic: if "underliving" was to become a reality for the masses, it would require better cost control. "Like the armchair quarterback and the Mercedes Marxist, the eco-élitist is locked into an ethical bind, applying privileged standards to problems that others must solve without the benefits of hindsight, trust funds, or social leverage. Drawing the line between élitism and intelligent planning can be difficult."[7] In his humble opinion, his Superhouse did so triumphantly.

The Superhouse, however, was peanuts compared to the Ark, a 1978 bioshelter built at Spry Point, P.E.I., with designs from the Solsearch Architecture and the New Alchemy Institute.[8] The Ark was designed by a team of materials experts,

"Can't help that … starting Monday the building industry goes metric … which is when I plan to hang them 33-centimetre doors on them 16-inch cabinets …."

When U.S. lumbermen announced that they would not go metric before 1985 (if ever), Canadian softwood lumber producers announced that they would stick to the old measure, but simply re-label it in metric. One writer in HUDAC's newsletter concluded that "if God had meant us to go metric, there would have been ten disciples."[9]

agriculturalists, fishery experts, architects, engineers, computer designers, one philosopher, "and an integrated pest-control scientist." The philosopher's role became evident as the builders described their objectives: "Whether these [houses] become arks of new covenants with nature or arks of survival will depend on us, for [they] express the political ambiguities of our transitional age. On the one hand, they are strategies for decentralization, enabling families to live with high culture in wilderness circumstances; on the other hand, they are the miniaturization ecosystems NASA needs for the design of space colonies."[10] This project would reputedly contribute to the evolution of humankind through its six stages: "harmonization, symbolization, agriculturalization, civilization, industrialization, and planetization."[11] However, regardless of those cosmic forces, "The application of arks throughout society seems assured ... [although] the full value of bioshelters for northern societies will not be realized until power and fuel costs increase further and shortages and disruptions of fuel take place."[12] However, instead of eventually becoming "planetized," the Ark became a restaurant.

Other theorists were not content to stop at a single building. Plans were started for an entire underground city beneath Pittsburgh. The Canadian government's initiatives were more prosaic: it introduced a series of subsidy programs, such as the Canadian Oil Substitution Program to wean Canadians off oil and onto electricity or natural gas. The CBC speculated about applying one technology — later used by the Canadian Hunger Foundation in rural India — drawing methane gas from cow manure. Patties from a healthy bull, for example, can help meet a family's energy needs; CBC radio warned, however, that this might perpetuate Alberta's domination of Canadian energy production.[13]

In the wake of the OPEC oil crisis, Alberta was undeterred from playing hardball with the other provinces. In 1974 Winnipeg ran into a gas crisis when Alberta vetoed a gas "export" permit to Winnipeg for natural gas; the National Energy Board also denied a licence to Trans-Canada Pipelines to supply gas there on a limited basis. Local hydro authorities said they could not service more than four out of ten new houses on an all-electricity basis.

When local builders discovered that 60 percent of their output had no heat supply, they were frantic. Eventually, Manitoba did obtain an export permit for gas from Alberta, but only for half of what had been requested. HUDAC's Manitoba chairman, Eric Bergman, called on fellow homebuilders and on industry generally to insist that the energy "requirements of Canada and Canadians are met before exporting to other countries."[14] Bergman demanded what he called a "national energy policy."[15]

Although Bergman's wish came true in 1980, other initiatives came first. For instance, Ottawa introduced the Canadian Home Insulation Program (CHIP) to subsidize extra insulation. It is through CHIP that many Canadians learned of a wonder-product that could be quickly sprayed into every available nook and cranny of their homes: UFFI, urea formaldehyde foam. By 1978, over 100,000 Canadian homes had been "improved" by this method.

Then one day, a test was conducted in the U.S.A. in a poorly ventilated, mobile home. High levels of formaldehyde gas were detected — almost as high as the smoking section of a typical cafeteria (0.16 parts per million).[16] This would not do. In short order, UFFI was banned in Canada (1980) and in the U.S.A., although the latter ban was overturned. In the resulting blaze of publicity, homeowners came forward with health complaints ranging from deafness to constipation.

This produced one of the largest lawsuits in Canadian history — a massive class action that took eight years — and which was eventually thrown out of court. Although lab studies showed that excess formaldehyde causes nasal cancer in rats, researchers "couldn't find any UFFI insulated houses with formaldehyde gas levels above 0.10 parts per million."[17] In fact, formaldehyde can come from so many sources (new carpeting, chipboard) that "the homes tested were found, on average, to have formaldehyde levels slightly *below* that of homes of similar ages without UFFI."[18] That was embarrassing.

UFFI was never banned in Europe at all. The leadership of the Ontario Association of Home Inspections concluded that "people with the best intentions ... perhaps erred on the conservative side ... We would hate to think that people responsible

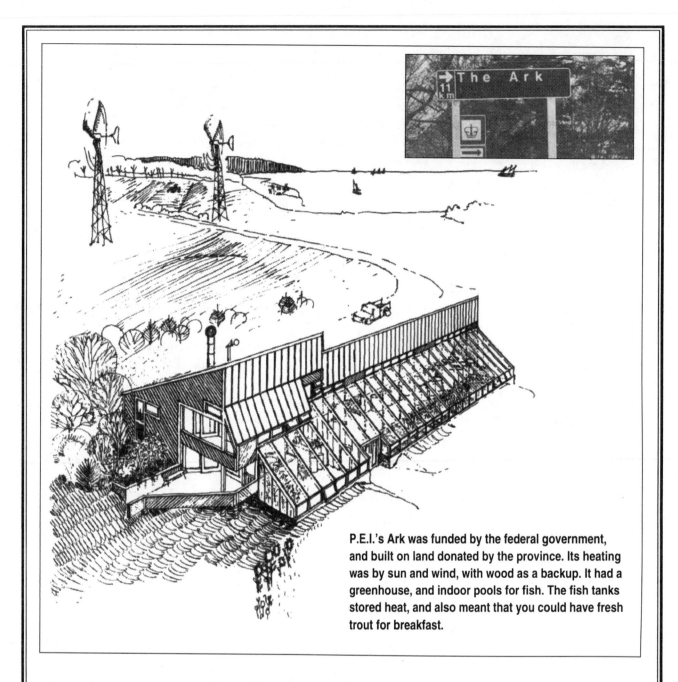

P.E.I.'s Ark was funded by the federal government, and built on land donated by the province. Its heating was by sun and wind, with wood as a backup. It had a greenhouse, and indoor pools for fish. The fish tanks stored heat, and also meant that you could have fresh trout for breakfast.

In the mid-1970s a profusion of books described or promoted everything from high-tech wood stoves and windmills to entirely new energy sources. The homebuilding industry's most immediate concern, however, was to prevent heat loss and reduce energy consumption. This Prize Home, built by HUDAC B.C., was exhibited at the Pacific National Exhibition, Vancouver, 1976.

for the health of consumers would err on the other, [but] we believe that those who have UFFI in their homes should enjoy their houses, and sleep well at night."[19] There has been continuing discussion of dropping references to UFFI in standard purchase and mortgage documents.[20]

Other government initiatives had less controversial effects. One was increased attention to solar energy. In 1979, Brampton even adopted an energy policy requiring all houses in future subdivisions to be aligned in a north-south direction to take advantage of passive solar heating.

The homebuilding industry, however, preferred to combine as many of these elements as possible. In 1980, the Toronto Home Builders' Association announced the Maximizer, a 1,400-square-foot house featuring high energy efficiency, a higher than normal basement, and a garage that was located sixteen feet from the house to create a courtyard

Solar energy has two facets: active solar houses require equipment, like rooftop "collectors," to convert the sun's rays into household energy; passive solar houses, on the other hand, have no special equipment — they have berms, windows, and positions selected to make optimal use of sunlight and southern exposures. HUDAC experimented with both. This active solar house above was built near Ottawa as part of HUDAC's Mark XI experimental project.

effect. HUDAC Saskatoon built fourteen energy-efficient homes for special display at a 1980 international energy conference in that city. Canada's energy minister, Marc Lalonde, responded by promising a thousand energy-efficient houses to be built with federal support across Canada. One of Lalonde's first conservation measures on this project, however, was to cut the number of these Super Energy Efficient Houses by 70 percent.

The energy crisis also led to a new confrontation between HUDAC and federal authorities over building codes. This was nothing new: in 1973, for instance, HUDAC had accused CMHC of using its builders' bulletins, which specified techniques acceptable for CMHC programs, to deviate unilaterally from the National Building Code, without approval of the National Research Council.[21] According to HUDAC's Bill McCance, "CMHC enhanced or retained directives contained in builders' bulletins — in spite of the fact that the [NRC] Standards Committee rejected those standards."[22] Ottawa replied that CMHC would switch the rules anytime it jolly well wanted, regardless of what NRC or its committees said: Barney Danson insisted that "any decision by CMHC to depart from the code ... will not be taken lightly, but the prerogative to do so, should it be necessary, must be retained."[23]

But where was this *ad hoc* code-drafting leading? Elsewhere in Ottawa, the federal government was piloting a new National Energy Conservation Code. It would make houses tight as a drum — so much so that HUDAC predicted indoor fog worthy of the Grand Banks. HUDAC's Bill Small accused Ottawa of ignoring the technical side effects, including condensation and warping: "The government seems to have lost the ability to relate to reality."[24] "Until there is some hard information out of [HUDAC's own] experimental project," he continued, "no further steps should be taken to change the code."[25] As a result, HUDAC's board undertook "to frustrate and delay implementation."[26] Ultimately, this Chinese water torture worked and the new measures were redrafted. HUDAC also succeeded in reaching a *modus vivendi* with CMHC itself: for example, in 1979, CMHC and HUDAC agreed that new CMHC Builders' Bulletins would "be screened by a HUDAC panel of experts prior to being issued."[27]

In 1981, HUDAC launched its own energy-saver program. The Manitoba Home Builders' Association built an energy-efficient demonstration house, and gave it away in a charity fundraiser. In a first in the Canadian housing industry, the home was handed over by the Dallas Cowgirls, whose costumes had never been known to provide much insulation for anything.

Although governments had a hand in many insulation projects, their economic role in other aspects of housing was much greater. The total of grants, subsidies, and forgivable loans (other than tax incentives) across Canada, to encourage owner-occupied housing, gradually escalated from $25 million in 1973 to over $1.1 billion in 1983. The largest increase was carried by the federal government, whose share moved from 4 percent of those funds to 70 percent. Federal tax incentives, such as RHOSPs, also had some provincial counterparts. By 1983, these various tax incentives had reached a total value of $188 million, of which two-thirds was federal.

But at the same time that Ottawa gave taxpayers high-profile perks, it took them away behind the scenes. This is one of the oldest stunts in the political repertoire: government raises a low-profile tax — which has a domino effect on the price of certain goods — and then the politicians establish a high-profile program to pay consumers back. This gives unlimited opportunity for press releases, conveys the false impression that Canadians are getting "benefits," and creates civil service jobs — until the program is phased out for budgetary reasons. The hidden tax remains in place, of course. That is precisely what Ottawa did in 1975. Usually, the cost of financing any investment is tax deductible, but Ottawa chose to make a special exception of the housing industry, and abolished the deductibility of interest on financing land assemblies. The amounts at stake in Canada were gigantic, raising the price of virtually every house under construction, and wiping out many of the benefits of the housing giveaway programs. HUDAC objected to the minister of finance, who told HUDAC to stop wasting its breath: "I have a good appreciation of the issues involved, and further discussion at this time would not be necessary."[28]

HUDAC appealed to the Ministry of State for Urban Affairs (MSUA) — and learned how timid that ministry was. Relations had always been delicate; according to HUDAC's Keith Morley, "Urban Affairs department [people] are not easy to liaise with on a regular basis."[29] In 1977, however, CMHC and MSUA both reassured HUDAC of formal endorsement of the industry's position. CMHC even deplored the inequity of the tax treatment of interest.[30] After such assertions, HUDAC waited for MSUA and CMHC to take action. It would have had a long wait. HUDAC learned through the grapevine that "while CMHC and the minister of state for urban affairs were in agreement with HUDAC's point of view that the legislation should be changed, they had not even put it in writing to the finance minister to change his thinking."[31] That prompted some pointed telephone calls. The new minister of MSUA, André Ouellet, finally assured HUDAC's president, Bill Small, that he had written to the new minister of finance, Jean Chrétien, in April 1978 to reinstate deductibility.[32] The joint efforts paid off: in November 1978 Chrétien restored deductibility of carrying costs on land.

But HUDAC's leadership already despaired of the Trudeau government, whose national popularity sank daily. On October 5, 1978, HUDAC officers held a high-level meeting with Joe Clark and his top housing people. Although the discussion was amicable, the HUDAC president confided to his board that the Tory authorities on housing "had a shallow grasp of the industry."[33] Nonetheless, the Tories had resurrected the builders' age-old dream of allowing homebuyers to deduct their mortgage interest from their taxable income, as in the U.S.A. This caught HUDAC off guard — because just as the future prime minister was latching on to the idea, HUDAC was having second thoughts: a sub-committee chaired by Reg Ryan, of the Mortgage Insurance Corporation of Canada, concluded that HUDAC should part company with the Canadian Real Estate Association, and abandon the holy grail of mortgage interest deductibility. The committee argued that deductibility would put pressure on mortgage rates, and "therefore there was a feeling that the whole policy was somewhat inflationary."[34] Furthermore, "there appears to be some inequity between tenants and homeowners."[35]

In retrospect, that is precisely the criticism that

some American media subsequently delivered on mortgage interest deductibility — adding that this gimmick was inequitable: as of 1991 an American making $74,000 and paying $13,200 in mortgage interest wound up saving over $3,700 in taxes, thanks to mortgage interest deductibility. The conclusion, according to *Newsweek,* was that under this "holiest of sacred cows, the poor received the smallest average benefit of any group … and that the benefits to the wealthiest group was the highest of all."[36]

The negative opinion from Ryan's committee put the HUDAC board in a bind, because it knew that large segments of the HUDAC membership still supported the idea. Some directors argued that HUDAC should continue to support mortgage interest deductibility, but balance it by saying that Ottawa should compensate itself for the lost tax revenue by stiffer enforcement of the capital gains tax.[37] Others thought that this formula was unworkable, because the Fraser Institute had just predicted the imminent demise of the capital gains tax.[38] Finally, after some thrashing about, HUDAC decided not to look Joe Clark's gift horse in the mouth: the board held its nose and re-endorsed mortgage interest deductibility, on condition that the lost tax revenue be made up by "real cuts in government expenditure."[39] This entire approach was promptly denounced as "expensive, wasteful and unfair" by André Ouellet.[40] Ouellet's counter-proposal was a system of tax credits, to compensate for housing costs that exceeded 25 percent of income. But on May 22, 1979, the Trudeau government went down to defeat at the hands of Joe Clark. The very next day, HUDAC president Keith Paddick announced that he expected the promised mortgage interest deductibility to "spur the economy, and restore the confidence of consumers across the country."[41]

Not all of HUDAC's leading members were impressed. John Sandusky of Toronto's Sandbury Building wrote: "It is by no means the financial knight in shining armour which some people would have us believe … It is simply an election goody which attempts to buy our votes with our own money."[42] The government nonetheless went forward. In September 1979 John Crosbie, Clark's minister of finance, adjusted the plan slightly: Canadians in all income brackets would be allowed a tax credit with annual increases up to a maximum of $1,250 for mortgage interest payments and $250 in property taxes, for a total of $1,500 per year by 1982. An estimated three million homeowners were expected to benefit from this plan.

At the same time that Crosbie was phasing in one of the most conspicuous tax give-aways in Canadian history, he also followed the classic textbooks and quietly increased taxes on housing elsewhere. Amid all the controversy surrounding his budget, Crosbie's elimination of tax incentives for MURBs (Multiple Unit Residential Buildings) went almost unnoticed.

Then fate intervened. To the astonishment of many Canadians (including Liberal strategists), Clark manoeuvred himself into defeat in the House of Commons on the subject of Crosbie's budget. This triggered an election and Trudeau's return to power. HUDAC's president, George Frieser, immediately advised Trudeau that the highest priority of the new government should be to lower interest rates … but the question of deductibility came almost in the same breath.

What Frieser got was a saw-off. Mortgage interest deductibility, with its Conservative political overtones, was out of the question, but the Trudeau government re-introduced incentives for MURBs in October 1980. HUDAC wasn't satisfied and continued to accuse the government of "failure to take any positive action on these and other issues facing the industry."[43] However, HUDAC had seen nothing yet.

The new finance minister was now Allan MacEachen, who had a special gift for giving his cabinet colleagues the willies. "If the finance minister disagreed with my position," recalls fellow minister Eugene Whelan, "that was it, unless there was sufficient support for me from other ministers that Finance could be won over. But this happened very rarely since nobody wanted to cross the finance minister — he was too powerful and could kill you in cabinet."[44]

In 1981, MacEachen followed Crosbie's example: he abolished the incentives for MURBs all over again, and again cancelled deductibility of developers' interest. However, he not only undid Jean Chrétien's 1978 reforms, but went further: his budget announced that the housing industry would become a special excep-

tion for all "soft costs." Soft costs are the package of expenses which any industry incurs when it puts products on the market: that package includes not just financing, but also marketing, legal, and accounting costs, which are normally tax deductible.[45] MacEachen declared that in the housing industry, soft costs would no longer be deductible. HUDAC responded with a lobby that eventually mitigated that proposal, but the impact on housing costs was still serious. The day following the budget, HUDAC sent a telegram concerning not only soft costs, but also the treatment of MURBs. HUDAC predicted a reduction of "housing activity to a disastrous level [and] … unwarranted future inflation in the housing market." Both predictions came true.

Liberal bagman extraordinaire Keith Davey had this view about that budget. "My great admiration for Allan J., as [MacEachen] is affectionately known, was sorely tested by this budget. Combined with soaring interest rates, it had a devastating effect right across the board. All classes were threatened. The political fallout would force Allan into an extended series of retreats. We looked incompetent, uncaring, and our political support plunged downward precipitously." Davey blamed the gnomes at Finance: "This budget was undermined by bureaucrats who thought they knew what *they* were doing and proceeded with very little ministerial or political input."[46] In fact, it was rumoured that the minister responsible for housing never saw any of the budget provisions in advance, and had to sit helplessly in the House awaiting whatever bombshell might explode.

MacEachen's budget so spooked the Canadian building industry that the rumour mill worked overtime. Stories began to circulate of a forthcoming "imputed rent tax": Canadian homeowners would be charged a tax on the rent they would otherwise have to pay for their homes, *if* these were rental properties. This prospective tax was modelled on European taxes of the same kind. MacEachen denied that such a tax was being considered; but that didn't stop Dominion Life from circulating a letter to customers announcing the likelihood of the tax. Ontario's treasurer Frank Miller jumped in and corroborated this view.[47] HUDAC and other organizations denounced the idea, and the concept eventually disappeared from public discussion.

Although MSUA had provided modest moral support in previous tax battles, it could not do so now. It had been killed. In 1978 Joe Clark promised that if elected, he would phase out MSUA,[48] and he did precisely that. Trudeau did not resurrect it. That left CMHC in its old role of senior governmental agency on matters pertaining to housing. One of Clark's first moves as prime minister had been to change CMHC's name: "*Central* Mortgage and Housing Corporation" sounded too authoritarian; so effective July 1, 1979, it was relabelled "*Canada* Mortgage and Housing Corporation." The new name retained the corporation's initials, for the sake of continued public recognition; yet when the corporation did a man-in-street survey asking people what CMHC was, "most said it was a radio station."[49] Bill Teron had been replaced as president of CMHC, and moved upstairs to become its chairman of the board. HUDAC was also going through some upheavals of its own.

HUDAC discovered what countless Canadians have witnessed, namely how much fun it is to live in the middle of a renovation project. The venerable King Edward Hotel, which had been home to the association for decades, was undergoing a facelift, along with litigation between the new owners and the Sheraton chain. Thanks to this commotion, HUDAC found a way to wiggle out of its lease — and, being footloose, dabbled with the idea of leaving Toronto altogether. That idea was quickly scotched, as the board wanted renewed access to Toronto's industrial and media networks.

The media, however, were not favourably disposed to builders. Builders of new homes were still viewed as evil "developers" — and the entirety of the real-estate community was in bad odour. Paul Rush of the *Financial Post*[50] gave the consumer his translation of typical housing ads:

> "Little charmer. Close to schools
> and transportation …"
> Translation: Tiny rooms in a tiny
> house. The schools to which this is
> close are the reformatory … the
> nearby transportation is the main-
> line of the CNR, which runs where
> your front yard once was. Indeed, to

go out the front door you have to wait until the gate is up …

"Perfect starter home. Needs finishing touches."
Translation: builder went bankrupt after he got the walls up …

"Renovator's dream home …"
Translation: Archaeologists regard the house as a valuable kitchen midden of Canadian primitive life. The Plumbing Museum wants to buy the fixtures which, incidentally, have not functioned for nineteen years.

"Victorian house. Neighbourhood showpiece …"
Translation: The plumbing and wiring have not been touched since Victoria Regina dawdled with Disraeli … The paint was put on by Sir John A. Macdonald as he worked his way through law school … The children say it's haunted and the elders who pass by after dark make the sign against the evil eye and wear necklaces of garlic.

But housing was indeed expanding in both quality and quantity. Growth in house size was paradoxical: in the decade following 1976, the size of the average family in Canada declined from 3.5 persons to 3.1 (11 percent) but "the average size of new single-family houses financed under the NHA climbed from 99 square metres (1,065 square feet) to 113 square metres (1,215 square feet), a rise of fourteen percent."[51]

Quality was also changing, particularly in response to the energy squeeze. During the 1970s, plastic vapour barriers and weeping tiles were introduced, along with higher levels of insulation and air tightness. Studs were now placed further apart to accommodate more insulation. Builders experimented with other new products and techniques, although some worked better than others: lumber producers had relaxed the stiffness of their products, and suc-

ceeded in having standards changed for floor spans; but the cumulative result was floors that bounced and squeaked like mice. This was solved only after laborious research undertaken jointly by HUDAC, CMHC, and Forintek (formerly the Forest Research Laboratories).

Changing technologies also meant new demands on the labour force. Some trades were wiped out. As of 1955, plasterers represented 7 percent of on-site labour costs; by 1969, because of drywall, that figure was less than 1 percent. On the other hand, between 1971 and 1981, the relatively uneducated segment of the construction labour force (Grade 9 education or lower) dropped by half (45 percent to 23 percent). The number of builders with university training tripled from 5 percent to 15 percent. Occupational training projects were appearing; training courses on construction and design were being offered; and one of the best-known training lectures was provided by Professor Noseworthy. He was particularly knowledgeable about wood, being a ventriloquist's dummy. Don Bryan of Toronto accompanied Professor Noseworthy on his lecture tour.[52]

The problem was that the training was not providing enough new blood, and the average age in many trades was increasing noticeably. Even today, the average age of a Toronto bricklayer is about fifty-seven. One traditional way of recruiting new artisans was to rely on immigrants trained overseas. As of 1981, about 23 percent of the homebuilding work force was born outside Canada; 20 percent was from Europe, of which half were from southern Europe. In particular trades, the figures were even more lopsided. As of 1981, fully half of Canada's brick and stone masons (as well as tile setters) came from southern Europe. Countless Canadian homes would not stand as solidly as they do today were it not for training subsidized by the government of Italy.

The work force was also overwhelmingly male, although some inroads were being made. Toronto's John Sandusky predicted in 1981 that as old attitudes withered away, "women will jump at the chance to enter the [homebuilding] industry."[53] The first female lumber inspector took office in 1977, although today, sixteen years later, the Canadian Lumbermen's Association has still not become the Canadian Lumberpersons' Association.

HUDAC was going through its own upheavals, again. Its operations were reviewed by Peat Marwick in 1977, its headquarters moved, and its longtime research director, Bill McCance, stepped down. Shortly afterwards, HUDAC's communications director left to take up an identical position at the Metro Toronto Zoo. This wasn't for lack of work. On the contrary, HUDAC staked territory in one of the most controversial topics ever to affect Canadian housing: rent control. These controls began nationwide in 1941 as part of the war effort. They continued until 1947, and were then gradually phased out by 1951. Although Quebec and Newfoundland retained a form of rent control, most other provinces had dropped them by 1954. The NDP government of Dave Barrett re-introduced them to British Columbia in 1974, and by 1976 rent control had returned to all ten provinces — largely in response to Trudeau's anti-inflation drive. Trudeau's minister of finance, Donald Macdonald, formally requested the provinces "to undertake responsibility for implementing a program of rent-control."[54] Although most of the new provincial arrivals on the rent control scene had announced that their measures were temporary,[55] only three provinces actually rescinded rent control after the federal Wage and Price Program wound down: Alberta, Manitoba, and New Brunswick. The Socred return to power in British Columbia brought the same result there. However, Manitoba and New Brunswick re-introduced controls in 1982.

HUDAC denounced rent controls at every turn, and did so not only on its own behalf — it also acted as the spearbearer for the banks, which loathed rent controls but chose not to risk their public image if HUDAC would do their complaining for them. A private meeting between major lenders and the Ontario branch of HUDAC in July of 1975 had resulted in lenders saying that they "could not publicly say they were against rent control, so it looked like it was up to [HUDAC] to continue to emphasize their opposition."[56] Both HUDAC and the lenders predicted that the controls would put a damper on apartment construction; in fact, by the late 1970s, Cadillac Fairview's production of apartment units alone had dropped by over 60 percent from the levels of a decade before.

The industry tried everything. The HUDAC Saskatchewan Council took rent control to the Saskatchewan Human Rights Commission as a breach of human rights, because it "discriminates against homeowners and tenants not under the [Residential Tenancies Act's] control."[57] The complaint was rejected, but the accusations continued. Rent controls led HUDAC's president, Klaus Springer, to insist that property rights be entrenched in the new Charter of Rights and Freedoms, under discussion at the time. Jean Chrétien replied that when the federal government "discussed a protection of property provision with the provinces, they were virtually unanimously opposed to including any such right in the Charter."[58]

Springer's dissatisfaction with the Trudeau government culminated in a war of words over a most unlikely subject, the National Energy Program, which capped Canadian oil prices. Although HUDAC's Eric Bergman had pleaded for this kind of policy only a few years earlier, Springer (an Albertan) used his podium at HUDAC to declare that "the failure of the federal government, the provincial government and the petroleum industry to reach agreement on adequate energy policies imperils the future of Canada."[59] In correspondence with Trudeau, Springer listed the "settlement of the dispute with the oil-producing provinces" ahead of the crisis in spiralling mortgage rates.[60]

Even longstanding government policies concerning mortgage rates were ideologically suspect. HUDAC got an earful from the National Association of Home Builders in Washington. In 1976 its president warned his Canadian counterparts: "We are at the crossroads of our continued existence of our free system of private enterprise"; government mortgage programs like CMHC's would purportedly lead to land-use policies, conservation of land, controls on housing costs, and ultimately a socialist takeover "of all land, buildings, and ownership. That's where we're headed … I urge your leadership to join with me … Ownership of housing delivered by the free enterprise system is the only way for survival."[61] HUDAC changed the tone of its annual resolutions to "condemn any policies or proposals of government which would infringe upon or further reduce the effectiveness of the free enterprise system of Canada."[62]

By 1982, the three headline speakers for the HUDAC national conference in Winnipeg were (a) Ronald Reagan's chief economic advisor, (b) a former Miss America, and (c) colourful sports-team owner Nelson Skalbania. Skalbania was described as "inspiring."[63] The former Miss America got equal billing "to bring inspiration and motivation to all."[64] Ronald Reagan's man was true to form. Shortly afterwards, HUDAC's position hardened. Its official policy statement said that "HUDAC is opposed to the presence of government and crown corporations in the production, renovation or delivery of housing," and that "HUDAC is opposed to any form of government price or rental control in housing." HUDAC finally accused rent control of being "inflationary."[65]

But despite all the public statements and government policies, the largest event of the era was developing almost unnoticed — the rediscovery of Canada's older houses along with an overwhelming urge to renovate them.

Renovation had always bubbled along, just barely below the surface of public and institutional attention. Old CBC shows like "Mr. Fix-it" idealized the handyman in the obligatory red-check shirt. Knowing the working end of a hammer was as essential to male self-esteem as doing the steaks correctly on the barbecue. The monetary value of the renova-

tion industry was also starting to add up. Builders acknowledged this as early as 1960, when *National Builder* predicted that "renovation and remodelling in all its aspects could be a life-saver for the building industry in Canada."[66] In 1962, the National House Builders' Association tried to start up a "Home Improvement Council" — although without much success.

Other movements were afoot, however. In districts like Toronto's Cabbagetown, "whitepainters" were moving in — young urban professionals ("yuppies" had not been coined yet) who felt that a coat of paint and some modest renovations would be enough to turn older houses around and make them more attractive. Some did so because they liked the older districts' proximity to downtown; others did so because they simply couldn't afford anything else.

In the early 1960s Jane Jacobs, who would eventually become the toast of Toronto, wrote a compelling indictment of urban development patterns[67] and how they would destroy the vibrancy of cities. The key, in her opinion, was to maximize the re-use of many of the city's existing components. Senior spokesmen at HUDAC agreed. Past president Eric Johnson said in 1972, "We have a situation where we press madly for more and more units at one end of the scale while behind our backs, a million units are decaying.

Drawing by Koren; © 1978 The New Yorker Magazine, Inc.

"We live a few miles from here in an architecturally significant former gas station."

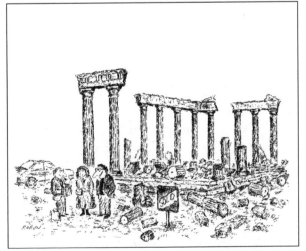

Drawing by Koren; © 1987 The New Yorker Magazine, Inc.

"Our goal is to modernize it but retain the historical flavor."

The ultimate barometer of the tastes of the American intelligentsia, *The New Yorker*, signalled the dawning of a revolution that would sweep the continent. Although Nelson Rockefeller continued to live in his modern apartment complete with fireplace by Matisse, Washington's upper crust was moving into Georgetown; Philadelphia society was rediscovering Society Hill; and Boston's inimitable highbrows were putting the Back Bay district up front.

Obviously such a situation cannot continue."[68]

But it did continue, at least for a few years. As of 1970, renovation expenditures were still outdistanced by new construction by a factor of 4.2 to 1 (in housing, it was 3.7 to 1). The gap was expected to grow, not narrow.[69] The entire governmental apparatus had been geared, over the course of decades, to the destruction of older districts, not their renovation. This went far beyond multi-million-dollar grants for "urban renewal"; it seeped into more subtle areas. The Income Tax Act, for example, provided tax write-offs for demolition of buildings; these write-offs were so large that an owner got better tax treatment for demolishing his building than for donating it to charity. That situation is still partly applicable today.[70] Furthermore, the property tax legislation of most provinces gave better treatment to parking lots than to almost any other land use of *identical* value — an aberration that also prevails to the present.

Renovation, on the other hand, enjoyed no such largesse. When landlords renovated their buildings, they had almost no guidance on what work was tax deductible and what was not. Revenue Canada issued instructions from time to time[71] — but these were both restrictive and confusing. When the courts made mincemeat of these instructions (as eventually they did),[72] Revenue Canada replied that this may have been what the courts said, but the department knows this is not what the courts meant.[73]

To add to the confusion, the red tape accompanying major renovations was suffocating. Although a renovated building should become as safe as a new building, did that mean that it must also have the same measurements and materials as a National Building Code building — particularly if the structure predated the Code? The Code applied *verbatim* would often have required tearing the structure apart — hence killing the economics of the renovation, even when alternative approaches could have made the building every bit as safe as brand new. Some building inspectors, like Andy Cahill in St. John's, who was determined to see wide-scale renovation in his city, had no patience with Ottawa bureaucrats who refused to develop alternative safety techniques for existing buildings. "They say we've got to have things so many feet by so many feet. Jesus, Mary, and Joseph, it's as if we weren't here first."[74] The National

In the 1970s, the renovation bug caught up with "Gorffwysfa," the 1867 Ottawa house originally built by a Massachusetts architect for lumber baron J.M. Currier. Not only were the rooms redone, but an indoor swimming pool was added. Gorffwysfa (Welsh for "the place of peace") is better known as 24 Sussex Drive, residence of the prime ministers of Canada.

Research Council has not, to this day, codified alternative safety procedures for renovated buildings.

With the deck stacked against renovation, nothing short of a social revolution would launch a wave of fix-up activity. Conveniently, a social revolution happened.

The American élite was finding "heritage" increasingly fashionable. Would-be members of the élite were in hot pursuit; and since the latter were far more numerous, their impact was more widespread. The Yuppie Revolution was on.

In "Doonesbury," one sequence illustrated a house which is quiet — except for loud scraping noises — until there is a cry of "… it's … it's … it's OAK! WE'VE STRUCK OAK!" Taking their cue from England's fashionable *House & Garden* magazine, Flanders and Swann wrote the consummate description of an entire new lifestyle:

> We're terribly *House & Garden*
> Now at last we've got the chance
> The garden's full of furniture
> And the house is full of plants …
> With wattle screens and little lamps
> And motifs here and there,
> Mobiles in the air,
> Ivy everywhere,
> You musn't be surprised to find a cactus
> in the chair.[75]

Even the prime minister got into the act. The mid-1970s refit of 24 Sussex cost $250,000 including $62 for a soap dish. That did not mean, however, that the bureaucracy was one iota more sympathetic to the renovation of Canada's housing stock. The Heritage Canada Foundation, which had been founded in 1973 to help promote heritage buildings, dispatched its lawyer to negotiate elimination of the tax write-offs for demolition, and a corresponding improvement in the tax treatment of renovators. The reply from the Finance Canada spokesman was only three words long: "Are you serious?"[76]

In due course, Finance Canada advised that it "wasn't about to overhaul the tax system for a bunch of old buildings."[77] By 1979, however, the federal minister responsible for heritage was becoming sufficiently agitated that he commissioned several of Canada's most respected tax experts to provide a solution. They suggested that renovation, at least of designated heritage buildings, should be in a preferential tax category similar to MURBs. This was publicly rejected outright by Finance Canada. Its spokesman declared that although such a measure would deprive National Revenue of vast sums, it would not provide any significant benefits to the renovating property owners. How the money could disappear (if it wasn't collected by Ottawa, but didn't benefit the taxpayers) was never explained.

Finance Canada also told the minister responsible for heritage that existing tax give-aways for demolition were a myth. True, the Income Tax Act did provide for such write-offs, called "terminal losses"; but, said Finance, these write-offs occur only when the demolished buildings aren't owner-occupied. Most demolitions are ineligible, said Finance, because most of the buildings were still "owner-occupied at the time of demolition."[78]

Clearly, it had never occurred to the bureaucrats at Finance that most Canadians vacate the premises before a wrecker's ball comes through the wall.

In any event, Allan MacEachen squelched that argument. In his 1981 budget, he sliced *part* of the write-offs for demolition. However, Finance never agreed to the flip side of the coin, namely to provide a corresponding improvement in the tax treatment of renovation. To add insult, the write-offs for demolition were increased twice in the late 1980s.

Nonetheless, despite the taxman's recalcitrance, the impetus for widespread renovation had been firmly launched by society at large, and was now irreversible. Other federal agencies were providing assistance: CMHC's Neighbourhood Improvement Program (NIP) and Residential Rehabilitation Assistance Program (RRAP) were having widespread effect, and in 1982 Ottawa also introduced the Canada Home Renovation Plan (CHRP) with a variable grant of up to $3,000 for renovation work. "This program was unique since it represented the first effort by the federal government to use the renovation sector as the focus of housing incentives designed to achieve economic stabilization objectives."[79] Overall renovation spending in Canada, in the residential sector, passed new construction in mid-1981; and except for a blip in the late eighties, has showed signs of continuing on top for the indefinite future.[80]

In 1992, interior renovation expenditures were divided as follows: 16 percent for kitchens, 11 percent for carpeting, 9 percent for basements, and almost 9 percent for bathrooms. Exterior renovations focused on landscaping (almost 13 percent), roofing (almost 11 percent), and windows (almost 10 percent). Much of this work is "do-it-yourself": Canadians did up to 85 percent of their own painting, weatherstripping, landscaping, and replacement of light fixtures. Furthermore, Ontarians, for instance, also did 53 percent of their own kitchen work and 64 percent of their bathroom work.[81] Since so much work was homemade, this often led to still further renovation, to repair or replace the botched job. This was particularly true of Canada's foremost passion in this era, the "energy retrofit." People were making their houses so airtight that moisture accumulated and air quality plummeted. HUDAC Ontario decided that it was time for professional renovators to organize, and created the first provincial renovators' council in 1980 (a national council would follow four years later). Paul Cosgrove, who became the minister responsible for housing in 1980, approved. "Rehabilitation of existing stock is to the future of the housing industry what the small-car market was to the auto industry a few years ago. Unless you are geared to participate heavily in this area, you will be missing the boat."[82]

In retrospect, not all of these activities have turned out to be equally profitable for the owner. "Don't expect to get all the money you've sunk in a luxury tub back in the sale price of your home."[83]

At first, the outward appearance of renovation projects tended to fall into two categories: unbelievably punctilious restorations of "historic" houses, and the "Heinz 57" remodelling of everything else. The remodelling trend, which had been around for a long time, tried to tart up old buildings by giving them a renewed appearance, of no identifiable parentage. The results were homes that looked to be designed by committee. The distinguished St. John's architect Beaton Sheppard expressed qualms about the attitude of his fellow architects, who felt compelled to "leave their mark on the building," as if many architects and renovations were like St. Bernards and fire hydrants. This is not surprising: to this day, almost no Canadian architecture schools teach renovation as part of their core curriculum, so consumers have little idea whether their architect (if they have one) understands renovation. More and more Canadians, however, were starting to suspect that the optimal appearance of their "reno" should be at least consistent with what it was supposed to look like in the first place.

That was becoming less difficult. Not so long before, any restoration usually implied high-cost, customized work; but with the North American renovation market expected to generate several trillion dollars in business over the next decade, a broader range of competitive goods and services was coming on the market. This exploded the old assumption that it was "cheaper to replace the building than to repair it." Further, Canada had never developed the same passion for pristine restoration some other places did. In Edinburgh, for example, restorers insisted on putting grime back on buildings so that no one could tell they had been worked on. This proved more difficult than expected: the dirt kept falling off. Renovators tried spraying it on, or even brushing it on with rollers; but the grit was uncooperative. Finally, with some pride they discovered a solution of soot and stale beer that, when applied to a building, would turn it properly black. They called this process "grunging." Edinburgh has now abandoned this practice (the city is now "de-grunged"), possibly because it figured out better uses for its beer.

The mushrooming renovation industry of the late 1970s was not matched by the rest of the housing sector. Between 1978 and 1981, the Canadian homeowner was put into a massive squeeze by rising interest rates. In 1978, a family with "median family income" and a 20 percent down payment was paying 30 percent of its family income (for an average-priced home) in mortgage payments, property taxes, and utilities; by 1981, that figure had jumped to 56.7 percent. Every major centre in Canada recorded at least a one-third increase in the carrying cost of a home. The upward push on mortgage rates stemmed from the Bank of Canada's war on inflation. Inflation averaged only 2.5 percent in the 1960s, reached 9 percent in the late 1970s, and peaked at 12.5 percent in 1981. With the escalation in interest rates, various institutions tried an assortment of remedies. In 1978, Greymac Mortgage Corporation and Kinross (an affiliate of the Canadian Imperial Bank of Commerce) introduced "open mortgages," namely mortgages that could be paid back without a penalty. In 1980, HUDAC asked Ottawa to introduce a Mortgage Interest Assistance Program for all homebuyers (for new homes or resale) to cover the cost of mortgages that exceeded a specified rate. The plan would provide assistance "equivalent to the difference between a base mortgage interest rate and the prevailing rate,"[84] with the program "phased out after the second year, assuming mortgage rates moderate as expected."[85] HUDAC estimated the total cost of the program in the range of $320 to $330 million annually, and argued that the cost would be entirely offset by the sales tax and income tax on salaries affected by the extra new homes built. Ray Hession, the president of CMHC, replied that the proposal was "a responsible approach"[86] — but it still went nowhere. In mid-1982, government officials said that they were committed to introducing a scheme which would allow mortgages to be negotiated for homes at a rate 3 to 6 percent below market; that idea also went nowhere. Canadian mortgage holders were left out in the cold.

The government's best offer was cash perks. As of June 1982, Canadian homebuyers were provided with a grant of $3,000 for new homes. Furthermore, all homeowners who had to spend more than 30 percent of gross income as a result of mortgage renewal

would be eligible for a grant of up to $3,000. But that only addressed the symptoms of high interest; it did not address the disease. In 1982, Trudeau told HUDAC that he blamed high interest rates largely on the United States; he also professed to be using every effort to persuade Ronald Reagan to lower his interest rates, whereupon Canada could follow suit. He was not alone in trying to convince Reagan. The head of the U.S. builders confided to his Canadian colleagues that "our hopes for a modest recession and an early recovery were shot to hell when the Federal Reserve Board announced its now-famous credit tightening moves last October (1979)."[87] To protest rising interest rates in the United States, U.S. builders and their supporters mailed thousands of two by fours, bricks, desktop-size plywood postcards, and other building materials to Washington.

Despite the protestations, some experts here laid the blame squarely with the Bank of Canada. "The determined effort of monetary authorities to bring inflation under control in the early 1980s, through the pursuit of an extremely tight monetary policy, caused the production of new housing to plummet and brought the economy to a standstill."[88] Others accused financial institutions of taking a bad situation and making it worse. According to Toronto builder Norman Godfrey, "Financial markets demanded, and received, interest rates to cover *not only* the inflation rate, but asked for and got an extra cushion on rates to cover that contingency of even higher inflation in the future."[89]

Within the space of a few months in 1979, the five-year mortgage rate jumped from 11 percent to over 14.5 percent.[90] By 1981, Canada Savings Bonds were carrying an interest rate of 19.5 percent. The effects on the demand for housing were catastrophic. Paul Hellyer reflected: "When interest rates went as high as 22 percent, there were people who actually paid more interest on the mortgage in one year than the original price of (their 1950s) house."[91] The effect on new construction was predictable.

The markets collapsed in areas where activity was fervent in the spring of 1981 when monetary authorities in the United States and Canada decided that drastic action was required if intensify-

ing inflation was to be stopped. Mortgage interest rates rose sharply, reaching 21.5 percent for five-year term mortgages in September. Housing market activity across the country came to an abrupt stop. By the final quarter of the year, [single family housing starts] … had suffered a decline of 60 percent from the first half activity. The MLS residential sales-to-active listings ratio fell from 30 percent in April of 1981 to less than 10 percent by October. The explosive rise in interest rates put the economy into the worst downturn since the Great Depression.[92]

The GDP was growing at 5.4 percent in the first half of the 1970s, but by the first half of the 1980s that rate had dropped to 2.5 percent. Some companies responded with a fast shuffle: they diversified. By 1981, Bramalea was building an office tower in Dallas, a third of Costain's assets were in the U.S., Carma Developers had 9,200 acres in the U.S., Genstar had taken over several of the largest U.S. builders, and Nu-West had acquired a large share of a U.S. developer. Housebuilders did not have the same resources: "Very few of us," said future HUDAC president Albert De Fehr, "are able to diversify into other business activities or operate in other countries. When our markets decline dramatically, we [can't] divest ourselves of our investments, reschedule our financial obligations and move easily into other business activities. We are the people who are left behind when the easy pickings are gone." In short, he said, "High rollers in real estate were knocked to the canvas for the 10 count. Many blamed their plight on the National Energy Program, the Federal Investment Review Agency, Harold Ballard, or anything else that seemed to originate from our national sporting institutions."[93]

In 1982, housing profits fell by 44 percent; and losses outdistanced profits on an industry-wide basis.[94] Most firms tried to weather the storm and hold on to their personnel; in fact, the record for construction employment in Canada was set in 1981, with 660,000 people. That effort could not last. Two years later some 100,000 of those jobs had

disappeared. Toronto's Norman Godfrey described 1981 as "the year of the tight ship" and 1982 as "the tight ship becomes a rowboat."[95] Between 1980 and 1982, nearly 30 percent of Ontario builders went under; 25 percent of all London builders and about half of all Windsor builders who had been in business in 1979 had left the industry by the fall of 1981. Within a single year (1980) over half of Winnipeg's homebuilding firms had gone out of business. HUDAC executive meetings witnessed the gloom and doom, as even officers of the association disappeared from the table. By the time it was over, there were fewer building firms in the 1980s than there had been in the 1950s.

Countless homebuyers were caught in the crash of house values; and even tenants pulled up stakes. In 1983 Alberta, vacancy rates exceeded 10 percent. A quirk in Alberta's mortgage legislation said that a dissatisfied mortgage holder could leave his keys in the door and walk away from his property for good; and that is precisely what many Albertans did when they discovered that their mortgage was now greater than the market value of their home. Others struck bargains with "Dollar Dealers," who would buy their house for $1, rent it to the old homeowners at perhaps half the rate of the former mortgage payments, and assume their mortgage under an unusual Alberta law that provided foreclosure as the only recourse for most lenders. Instead of making the mortgage payments, the Dollar Dealer would use every tactic imaginable to delay the foreclosure proceedings. By the time the lender (or the mortgage insurance company) had finally repossessed the property, the former homeowner would have occupied the premises for eight to nine months at low cost; the Dollar Dealer would have pocketed a sizeable rent; and the institutions would have taken a bath.

HUDAC's lobby against spiralling interest rates, the overwhelming cause of the '80s Bust, were conducted while hopping on one foot. To mount a more politically effective lobby, George Frieser had urged HUDAC to join forces with consumer groups,[96] but this logical alliance failed to materialize. The next thought was to join forces with the other real-estate organizations like CIPREC (Canadian Institute of Public Real Estate Companies) and UDI (Urban Development Institute); but HUDAC's executive

pooh-poohed the idea, believing HUDAC's political clout was better than theirs. In any event, said Klaus Springer, "They do not always say exactly what HUDAC would want to say, and HUDAC has a better 'in' than the other groups, and can get to see people, whereas [the others] cannot."[97] The result, however, was a failure of the real-estate organizations to lobby jointly for lower interest rates, leading in some quarters, to defeatism. CIPREC and UDI said to HUDAC, "We are not going to change [interest rates] anyway, [so] let's go after something a little more feasible."[98] Their primary target was MacEachen's budget. Springer, however, felt that HUDAC was already doing fine with its budget lobbying, which in his view "probably saved a billion dollars worth of work for this industry."[99] On interest rates, however, HUDAC hit a brick wall — despite the largest campaign in its history: in May 1982, HUDAC officials made a pilgrimage to over a hundred MPs, including the prime minister and leader of the Opposition. Without an easing of interest rates, said Springer, "the industry would grind to a halt."[100] Not only did the exercise fail, but Springer confided this to his colleagues: "Our words and appeals were met with disbelief."[101]

Did the devastation have one iota of influence on the Bank of Canada or on federal economists? Would more industry lobbying have made a difference? The prospect is unlikely. It has been said that if you laid all the economists in the world end to end, you still wouldn't reach a conclusion;[102] but there is a consensus in the profession that from time to time, the economy *must* undergo an "adjustment" when it is "overheated." Unfortunately, for those on the receiving end of this economic fix, it feels like a cat must feel when it gets fixed.

The Canadian homebuilding industry was never the same after the early '80s Bust. Although new firms did enter the field, neither the number of companies nor the housing starts would resemble the 1970s. In the 1980s the industry would re-emerge in what many observers consider a more solid and rational form than it had in the fool's paradise of the previous decade; but that was cold comfort for those riding out the Bust, who were reminded of the dictum of English statesman William Pitt: "Poverty of course is no disgrace, but it is damned annoying."[103]

Jumps, Dumps, Wumps, and Gazumps
1982–1988

In which the housing industry swears off roller coasters and the dole; architects agree with Gary Cooper; Charles is a Prince (though some disagree); streets are boxed and leaders are canned; and the demise of the home is predicted yet again.

On Good Friday in some countries, penitents walk the streets flagellating themselves. Some crucify themselves, which can get complicated. In Canada one Toronto preacher decided to found a new religion in which he would take the sins of the world on his own shoulders; he rented Massey Hall for the occasion, and not a single person showed up.

Throughout North America, it seemed like economic gurus were demanding similar sacrifices and navel-gazing from all our industries. Books like *Theory Z* and *Japan Inc.* fuelled speculation that the Bust was due, in some part, to North America's failure to imitate business culture in Japan. *The One-Minute Manager* attacked corporate constipation. Economic writer Peter Drucker announced, at the beginning of the Bust, that "a time of turbulence is a dangerous time, but its greatest danger is a temptation to deny reality … The greatest and most dangerous turbulence today results from the … delusions of the decision makers."[1] The ensuing flood of corporate soul-searching permeated society, as even car jockeys and fast-food attendants studied *In Search of*

Excellence. HUDAC was hardly immune: it held its own think tank in Scarborough in 1983, under the care of a California psychologist.

Inevitably, this soul-searching turned to builders' problems in their lobbying campaign over interest rates and the MacEachen budget. Some HUDAC directors said HUDAC was being suckered into fighting other people's battles. Vice president Lloyd Graham accused HUDAC's own mortgage finance committee of being "too heavily weighted by banks. I still do not hear them coming up with alternative methods of financing, which I thought was one of the purposes of the committee."[2] This view had been echoed by president Klaus Springer[3] and Springer's successor, George Frieser: "HUDAC could be used … by the financial community to achieve their own needs. Builders are the people carrying the load these days and banks are carrying no part of the responsibility … As corporate citizens the builders are better than the financial community … [HUDAC will] hopefully take a firm stand with the lending community."[4] It didn't. In fact, in late 1983 HUDAC's board sided with the financial establishment in

179

opposing early pay-down of mortgages: "Early pay-ments without penalty would have a detrimental effect on long-term fixed mortgage funds and conse-quently on housing sales and production."[5] Dissenters eventually had this position reversed — but that would take time.

There were other problems. Springer had encap-sulated HUDAC's classic lobby: "Mr. Minister, you might say you have no money to put into the hous-ing industry, but it will cost you several hundreds of millions of dollars if you don't do something."[6] However, the ensuing blitz on MPs, according to the new president, Cyril Morgan, was "not very effec-tive."[7] George Frieser added: "I have learned after three years of being involved that I do not seriously think [the politicians] are interested in the industry's concerns ... We must talk about the consumer and how the consumer is affected ... [Whether] we keep the industry alive — they could care less."[8] HUDAC's chief staffer, Bernie Bernard, put a brave face on matters by calling the MP blitz "a tremen-dous improvement over last year,"[9] but had to admit that when HUDAC was challenged to present coun-terproposals to the government, it came up short: "We are not too strong on solutions, but what *are* the solutions?"[10]

One group of builders, called the Young Turks (1979), believed it had the beginnings of the answer.[11] Spokesmen John Sandusky and Albert De Fehr, who became president and vice president of the builders' association in 1984, announced perhaps the most radical shift ever undertaken by a major Canadian NGO:

> [In the 1970s] we encouraged the inflationary mentality for our own purposes ... High debt and low equity became accepted business practice for many of us. Inflation made us feel smarter than we were. We borrowed far more than we should have in order to expand far more than was sensible. We built up far too much inventory. We forgot about cost controls. We became fat and complacent.[12]

Furthermore, perhaps builders should have fore-seen that neither the buying spree of the 1970s nor the government programs that propped it up could continue forever, for the simple reason that the crest of the baby-boom generation had already passed through the marketplace. De Fehr added comments on Gross National Stupidity:

> [The 1970s were] the time when everyone became smart overnight ... Doctors became financial investors, Air Canada pilots became contractors ... even some house builders took their profits and bought hockey teams ... But by the late 1970s, the economic climate quickly changed ... We assumed it was just a temporary case of finan-cial indigestion and, of course, that was the first mistake ... It was fun-damental to call into question the reason for being of all components of our companies. That is a really tough job. There is an old saying, "Never give a horse a name — you may have to eat him someday."[13]

"If there is cynicism in the public mind and in the media about the private sector," continued Sandusky, "perhaps it is time to reflect on why this is so."[14] The reason why, according to the new builders' leadership, was that

> we brought this trouble on ourselves by indulging in seemingly honest government trifles ... We allowed ourselves to be manipulated by ill-timed government programs which distorted our markets but which then required a continued short-term fix. As you know there is a fine line between seduction and rape, and governments in Canada used our industry when economic conditions deteriorated to further their own self-interest ... The days of sponging off the public purse are over.[15]

In the words of Sandusky, "The Multiple Unit Residential Building (MURB) tax shelter and the Canadian Rental Supply Program (CRSP) … were inordinately expensive and contributed nothing to stability in the private rental market.[16] In today's context they are socially irresponsible and economically unjustifiable — and for this reason without moral foundation. If we ignore the lessons of the past, the next [bust] will make the last one look like a ripple on a pond."[17] "Our claims to be entrepreneurs and supporters of private enterprise," De Fehr concluded, "were little more than the hot air of political rhetoric and self-serving activities … We [also] have had to forge a different relationship with government — a relationship which emphasizes consultation and partnership. We have had to accept that private enterprise requires *us* to be responsible for the creation and development of our markets."[18] "We can no longer be gladhanders — pressing the flesh in high places without substance."[19]

This did not mean abandoning government programs altogether. According to De Fehr, who succeeded Sandusky as president in 1985 and entrenched the new philosophy, there was a distinction between evil bail-outs and good strategy:

> To suggest that all government programs and their bureaucratic authors are bad, and inevitably wind up in distorting markets is, to be perfectly blunt, dumb … When our financial proverbials are on the table, and the economic knife is on its way down, we must not submit to political expediency or ideological extremism, but be prepared to work with government in developing and implementing policies [to] assist our industry over the *long* term *and* accomplish Canada's social and economic objectives.[20]

According to Dennis Grayhurst of the *Toronto Star*, "HUDAC told governments that it would rather see the deficits reduced, even if it meant that there would be no grant programs for the industry. Who had ever heard of a lobby group asking the government not to give it benefits?"[21]

In the meantime, the architectural establishment was fighting a last-ditch battle of its own. Some of its members, despite their training in Modern philosophy, were dabbling in Post-Modernist housing, whose occasional curved lines and historical allusions were having an increasing influence on builders as well. "Post-Modern designs," said one writer, "are marked by recognizable architectural forms and details drawn from a variety of historical sources, from ancient Greece to present-day, 20th-century, automobile-oriented vernacular."[22] The Modernist establishment girded for a fight — not over what occurred on residential construction sites (aside from highrises, it had already lost that cause), but over what remained of its philosophy of the machine-for-living. In Ayn Rand's *The Fountainhead,* the hero architect, played in the 1949 movie version by Gary Cooper, was guided by destiny to build his Modern structure notwithstanding the "stupidity" of developers and the public: in the same vein, in 1983 a major exhibit called "Taste" was staged in London: minimalist Modern design was listed as "good," whereas "busy" Post-Modernism was "bad" or even "kitsch" — exhibited in a garbage pail. *Time*'s architecture critic called Post-Modern buildings "dangerous and heavy-handed Pop surrealism … from some second-rate stage set for Mozart's *The Magic Flute.*"[23] Canada's Macy Dubois agreed: if architecture evolved, it would be toward "a more fine-muscled, unclothed Spartan … We will be unashamed of the nakedness of our buildings. Some buildings are now being built in a false, eclectic and nostalgic manner. This aberration is only temporary."[24]

But then an unexpected party turned the topic into a full-scale international controversy. It was Prince Charles, invited to speak to an audience of architects. In a break with royal tradition, Charles said something: in fact he undertook, in his words, "to throw a proverbial royal brick through the inviting plate glass of pompous professional pride."[25] His audience never expected a diatribe so "spectacularly impolite to his hosts."[26] Charles denounced Modern projects as "monstrous carbuncles." "Large numbers of us," he said, "are fed up with being talked down to and dictated to by the existing planning, architectural and development establishment."[27] Instead of

Some Post-Modern houses had curves, like the award-winning house in Ottawa (left); others saw the return of historical flourishes like Palladian windows.

"Frankenstein monsters, devoid of character, alien and largely unloved, except by the professors who have been concocting these horrors in their laboratories,"[28] he said, "we need design and layout which positively encourage neighbourliness, intimacy, and, where possible, a sense of shared belonging to a recognizable community."[29] "This is only possible," he concluded in words reminiscent of NHBA's Charles Dolphin in 1944, "if the architects, planners, trusts, and so on, provide what people want and not what they think people *should* want."[30] Britain's *Architects' Journal* replied that the Prince's "sadly superficial views would merely lead to a horrendous Disney World collision."[31] His opinion was variously described by architects as "offensive, reactionary and ill-considered," allied with "the forces of reaction and the proscriptions typical of totalitarian regimes."[32]

Furthermore, argued another architect, the real sources of evil were the builders and the public.[33] The *Architects' Journal* agreed that the fault lay with architects' clients (notably builders) who were "frequently philistine and penny pinching."[34] The media didn't buy that explanation. "The Modern Movement," said *The Sunday Times*, "was not just a phase, it was a mistake. It was architecture torn loose from style,

invading politics and posing as social engineering. It is now being corrected in revitalized, restored city centres from Munich to Vancouver."[35] *The Times* was right, and as the most high-profile aesthetic debate in decades ground toward a conclusion, dissidents jumped on the bandwagon. The Austrian designer of Vienna's most flamboyant new housing project commented on the Heroic Modernist who had labelled ornamentation "criminal and pathological": his compatriot Adolf Loos was sincere, he said, but so had been his compatriot Adolf Hitler. *Megatrends* author John Naisbitt agreed that the new byword would be "the sense of exploration and experiment, using all of history and technology as source material."[36] The notion of *home* as more than a "machine for living" had not only been vindicated, but was finally *seen* to be vindicated.

Even Modern interiors were coming under attack. If they were supposed to be stark, where would notoriously acquisitive yuppies put all their stuff? "The design look was to obtain a bare, clean look ... and it supposed a willingness to eliminate most of one's possessions."[37] This ran against the grain of many Canadians of all generations; as diplomat Charles Ritchie said, "O God, leave us our

luxuries, even if we must do without our necessities."[38] And leaving no turn unstoned, dissident architects were even taking aim at the furniture of the Heroic Modernists. British architect James Stirling had said that he liked his favourite chairs "in an intellectual way. They aren't awfully comfortable to sit on, although of course you can sit in them for an hour or so without danger of collapse"[39] — to which McGill's Witold Rybczynski replied: "So that is what we can expect, an hour without cardiac arrest? Hardly a ringing endorsement."[40]

In 1986, Rybczynski published a North American best-seller stating his own version of the three most important elements of a house: comfort, comfort, and comfort. He also warned against perpetual theorizing:

> Post-Modernism too has missed the point; putting in a stylized strip of moulding or a symbolic classical column is not really the issue … What is needed is a sense of domesticity, not more dadoes … Post-Modernism is more interested in mostly obscure architectural history than in the evolution of the cultural ideas that history represents. Moreover, it is reluctant to question any of the basic principles of Modernism — it is aptly named, for it is almost never anti-modern. Despite its visual wit and fashionable insouciance, it fails to address the basic problem.[41]

That basic problem is livability. Rybczynski's recommendations included "returning to house layouts that offer more privacy and intimacy than the so-called open plan, in which space is allowed to 'flow' from one room to another. This produces interiors of great visual interest, but there is a price to be paid for this excitement. The space flows, but so also does sight and sound — not since the middle ages have homes offered as little personal privacy to their inhabitants."[42]

According to still others, the styles of North American suburbs today (and since World War II) cannot even afford to correspond to any abstract the-ory: they must be "safe" in terms of resale value. People select a given house not only because it appeals to them, but also because it has the "curb appeal" that will appeal to others. They have to. "The efforts at innovation [by] architects tend to be stymied by the American priority given to resaleability — and increasingly [to] profit. As such, style and configuration are enormously conservative. Only the rich can afford experimentation. Only the poor are subjected to it. The middle must hoard the key-wealth depository."[43]

Although change in housing exteriors was proceeding discreetly, the fabric of homes was nonetheless being transformed. Waferboard, which uses primarily waste woods, replaced plywood in many construction uses. Power nailers became commonplace. The 1980s also witnessed the wide-scale acceptance of all-plastic plumbing. As the housing market returned to normal after the Bust, a shift was noticed toward demand for larger houses. This was predictable: some baby-boomers had substantial joint incomes, which promised the cushy lifestyle of DINKs (Double-Income-No-Kids), whereas other boomers wanted larger houses to accommodate the children (the Yuppie Puppies) they had postponed for so long. But the greatest change in housing was in energy efficiency. Over the years, Ottawa had introduced an alphabet soup of programs to address heating, insulation, and building efficiency generally: COSP, CHIP, RRAP, CHRP, and so on. However, in the early 1980s, the jewel in Ottawa's crown was a pet project called the Super Energy Efficient Housing Program.

In a country preoccupied with heat leakage, it might have been embarrassing to label the program SEEHP: it needed more ring, so it would be called "R" (the scientific symbol for resistance to heat loss) and "2000" in honour of the coming millennium. Trudeau's energy minister, Jean Chrétien, had encouraged expansion of the program. HUDAC was pleased to discuss a joint venture — partly because it agreed in principle, and partly because it felt a government-run project without practical builders' input might botch the job. R-2000's publicity summarized the program's features:

> To ensure that their R-2000 homes will make the grade, R-2000

builders are specially trained and must have their plans computerized and analyzed at the R-2000 program office to make sure the energy performance of each home will meet the specific R-2000 requirements for their region ... Regular on-site inspections occur to make sure the home meets all R-2000 requirements and displays the quality workmanship that people have come to expect from R-2000 homes. They have up to three times the amount of insulation in exterior walls, roofs and basements as conventional homes, depending on how cold the local winters are ... R-2000 homes have double- or triple-glazed windows and insulated exterior doors ... Site conditions permitting, the homes are oriented toward the sun, with south-facing the most window area, and the north walls the least, while roof overhangs are positioned in such a way that the sun pours through the windows in winter but is blocked in the summer when the sun is higher in the sky ... All R-2000 homes are equipped with controlled ventilation systems which provide a steady supply of fresh outdoor air to every room while exhausting the stale inside air and its innumerable contaminants.[44]

One way to save energy was to copy the tipi. Tipis had a liner which trapped a layer of air, which is now called a vapour barrier and which is key to most insulation techniques. In the 1960s and 1970s, special kinds of paper "lined" the house next to the insulation. New polyethylene liners improved performance in the 1980s, as did new sealants and weatherstripping.

All this efficiency had a down side. Although the traditional house leaked energy like a sieve, those same cracks assisted ventilation. When a home was

Super Energy Efficient Houses were built in Saskatoon as the precursor to the R-2000 program. HUDAC threw its support behind this new generation of houses to an extent unprecedented in its history.

sealed like a drum, the lack of ventilation harmed air quality, and condensation could make the inside of the house sweat, like a glass of cold beer. Unless you wanted to grow mushrooms in your living room, the solution would be to install new equipment, called HRVs (Heat Recovery Ventilators). For example, R-2000 homes are not only cheaper to heat: their ventilation usually assures better quality air, noise insulation, and controls on humidity, odours, smoke, dust, pollen, and other indoor pollutants. The evenness of temperature makes basement space far more habitable, and hence increases the overall usability of the house. In the words of buyers from Campbell River on soggy Vancouver Island, "We never have condensation on the windows out here, while a lot of other homes get mildew on the windowsills and lots of condensation."[45]

The next challenge in improving energy efficiency was not with the house proper: it dealt with its openings. One quarter of the house's heat could escape through the windows. In the 1980s, however, Canada's development of "superwindow" technology resulted in windows that could be as energy efficient as the walls themselves.

The process of HUDAC gearing up to throw full support behind R-2000 was complicated. It was occurring in 1983, on the eve of the overhaul of HUDAC's philosophy, and of the recommendation for a new name; it also coincided with the retirement of HUDAC's chief staffer, Bernie Bernard. Bernard's replacement, civil servant Kenneth Kyle, was succeeded in less than two years by Dr. John Kenward, who had taken over HUDAC's policy files in January 1984 after some twenty years of research in political economy, housing, and municipal affairs. By the time the dust had settled, HUDAC had a new name — Canadian Home Builders' Association or CHBA — had reorganized its board, committees, and head office, and had prepared its first five-year plan.

To some ears, a Five-Year Plan sounds alarmingly like what Nikita Khrushchev used to do: the kind of topsy-turvy strategy that could only come from a country run by a "secretary." In Western countries, however, strategic plans took a different tack, and

After the Mark XI project, the next full-scale houses in the Mark series were called Mark XIV (shown here). The Mark XII project (not shown) had been a special study of trusses installed in the Mark III house, and the Mark XIII project (not shown) was a detailed report on how, after a generation, the Mark III and IV had stood up to the elements. Mark XIV, also called the Flair Energy Demo houses, covered twenty-four Winnipeg houses, including one hundred energy conservation features and a variety of ventilation measures. The Mark XV project (not shown), the last in the series, tested wall moisture in the Maritimes in a series of uninhabited test huts.

since the late 1960s had become indispensable to many corporations and institutions. Organizations would adopt a Mission Statement, a limited set of precise goals, and a series of specific tactics to achieve them over a set period of time. Policy would be developed in a linear way, rather than being buffeted by knee-jerk reactions to the latest crisis. The organization would be less liable to contradict itself, and would have some benchmarks against which to assess its long-term success or failure.

CHBA's new plan, introduced by its president, Bob Shaw, in 1986, focused more on the operational aspects than on policy or strategy: the latter were being articulated in separate documents. With the passage of time, however, those statements were fused into a plan that confirmed the first priority of the organization: policy development and government liaison, followed closely by technical research. The plan reiterated goals like avoiding housing programs "which disrupt and distort the marketplace," and supporting the principle of a "professional, self-regulating industry whose members are committed to ethical standards, quality construction and consumer satisfaction."[46] At the same time, age-old objectives were trashed, such as tax-deductibility for mortgage interest. "The cost of such a program to the government would be immense," said Sandusky. "How can we justify it, while, at the same time, calling for control in government expenditures? ... [Furthermore] are we prepared to accept the American system which includes the capital gains tax on housing?"[47] This view evolved into the entire "industry's opposition to the concept of mortgage interest deductibility," according to Bob Shaw; "It would run completely counter to government's commitment to tax reform."[48]

Changes didn't stop there. One of the nagging questions that arose in the wake of the MacEachen budget was whether the real-estate lobby was out of touch with Ottawa. HUDAC Alberta had complained in 1982 that from its Toronto location, the national executive wound up "communicating to the government and membership through the media."[49] Both the Canadian Real Estate Association (CREA) and the builders heard the grass roots call for a move to Ottawa, despite professed concerns about mental health:[50] once people were posted to Ottawa, said some directors, they "do not know how to adjust to real life"[51] because of the "danger of the mind-set of the majority of those working in the capital,"[52] and in any event, they said, "Top government officials do not mind flying to Toronto for a day to see real people in the real world."[53] Nonetheless, in 1986 both CHBA and CREA moved to the nation's capital.

CMHC, like CHBA and CREA, had also undergone transformations between 1982 and 1986. Ray Hession quit as president in 1982 to become deputy minister of supply and services; he was succeeded by Robert Montreuil, who couldn't help noticing what many government agencies were doing at the time. One of Ottawa's favourite occupations is to do management reviews. These allow senior officials to declare that they are doing something without doing anything. All initiatives can be deferred until the study is over — whereupon bureaucrats have new titles, new business cards, new telephones, and a profound conviction that the earth moved. Montreuil launched his own version at CMHC, called The Reconfiguration.

During those three years, however, CMHC had issues on its plate that it couldn't duck. The Canada Rental Supply Plan and the Canadian Home Ownership Savings Plan were flash-in-the pan initiatives, but the tax measures being cooked up were more long-lasting. In November 1983, the Trudeau government had slapped even further taxes on soft costs for construction projects.[54] This was labelled anti-business, and in 1984 the new Mulroney government announced a more conciliatory attitude — then expanded the scope of federal sales tax on construction materials,[55] raised tax rates, phased out RHOSPs, removed the sales tax exemption on energy conservation materials, and increased CMHC'S mortgage insurance rates. The government insisted, however, that these were all coincidental,[56] and in no way reflected any disregard toward the need for affordable housing.

Where was industry's lobby now? Unlike interest rates, which ebb and flow like the tide, taxes tend to go only in a single direction, and hence effects can be long-lasting. The real-estate lobby knew it could accuse the government of "inconsistency"; but the various real-estate and construction associations generally responded, as one put it, by "adopting a discreet approach."[57]

Would lobbying have done any good? The Buildings Revival Coalition, a group of organizations working on better tax treatment for renovation, discovered that it made no difference which elected politicians were in power, as long as the bureaucracy was indifferent. Supportive organizations received identical letters of rejection — some signed by the Liberal finance minister, Marc Lalonde, and some by the Conservative finance minister, Michael Wilson. No mandarin had even bothered to change the programming in the word processor. Mulroney's hand-picked deputy minister of finance, Stanley Hartt, told one meeting[58] that he enjoyed the title Ottawa's Abominable No-Man. "People come up to me and say, 'Stanley, how can you say no to this? It's supported by the politicians and people of Canada; how can you say no to incorporating it in the tax system?' I say, 'It's easy. I pucker my lips, exhale, and it comes out *no*.'"

The new government was also saying no to the previous government's programs. In September 1984, it launched a major cutting exercise, chaired by Erik Nielsen. Its study team on housing programs produced a report entitled *Housing Programs in Search of Balance*, in June 1985, but it was not made public until March 1986, along with other volumes of the Nielsen Task Force. "Nielsen subsequently recommended that social housing assistance be directed solely to households in need, and that too much emphasis was placed on new construction rather than on the rehabilitation of existing housing. CMHC quickly sought a cabinet decision to implement these recommendations, which it obtained."[59]

The new minister responsible for CMHC also launched his own initiative. Bill McKnight, the only cabinet minister to come from downtown Wartime, Saskatchewan, struck up such a positive relationship with builders that they eventually inducted him into the CHBA Hall of Fame, which they launched in partnership with CMHC. McKnight's *Consultation Paper on Housing* of January 1985 called for a review of public policy by all stakeholders. The results were presented in December 1985 in a report entitled *A National Direction for Housing Solutions*.

CHBA's submission to McKnight's consultation paper turned into an encyclopedic statement of the builders' new philosophy.[60] It opened with an appeal for the federal government "not [to be] influenced by the overtures of those who would exploit the housing sector for short term ... financial gain," and urged instead that "the elements of housing policy [be viewed as] interrelated." CHBA named fifty-four elements, ranging from the role of renovation to the importance of "flexibility ... in determining whether housing allowances, social housing, or a mix of the two approaches is the best means of solving the essentially income-deficiency problems of ... needy households." To this day, the document remains key to the industry's overall policy on almost everything.

CHBA also used the opportunity to tell CMHC what it hoped for after the "Reconfiguration": consultation, technical development and research, industry training, consumer awareness initiatives, transparency in CMHC's strategic plans ("so that short-term tactics do not dominate the need for long-term policy development and implementation")[61] — and without limiting the federal mandate in any way, more responsibility at provincial and municipal levels. ("The tradition of the other levels of government simply using housing issues as a means of getting a larger share of the federal pie needed to be broken.")[62]

CHBA's John Kenward told *Canadian Housing* magazine what he thought of the results:

> We argued for proper targeting and cost effectiveness for the social housing programs; that has occurred; we wanted CMHC to get more involved in technical research and training; now we have [several] renovation and building contractor seminar series and a solid commitment for technical research by CMHC. CHBA wanted a forum through which it and other groups can discuss major policy issues and directions; the National Housing Research Committee was put in place. We were keen on regulatory reform; the tripartite ACT initiative [Affordability and Choice Today, supported by CMHC, CHBA, Canadian Housing and Renewal Association, and the Federation of Canadian Municipalities] is the result.[63]

Kenward believed that this exercise also opened new avenues for liaison between builders, planners, social housing officials, and other stakeholders: for example, CHBA sought a far greater understanding between it "and organizations such as Canadian Housing and Renewal Association; the consultation process was seen as helpful in permitting diverse groups to discuss and appreciate differing points of view."[64]

CMHC was also taking on a new look. Robert Montreuil's Reconfiguration was complete, and he moved on to make way for a new CMHC president, George Anderson. Anderson had been a CMHC staffer for eleven years; but after three intervening years with a mortgage company, he resolved that if he ever returned to CMHC, he would "come back with an agenda."[65] That agenda was similar enough to the builders' that CHBA's Bob Shaw declared that CMHC "is now ... developing a new mandate, one much more in tune with the realities of our industry and the interests of the public and consumers generally."[66] Anderson returned Shaw's compliment, albeit lefthandedly: CHBA, he said had acquired "a policy approach very different from a few years ago ... CHBA has been able to learn."[67]

One joint effort, between CHBA and CMHC, would offer more training for builders. Training experiments had been tried in the early 1970s in various parts of the country. On-the-job training in Kitchener had proved successful in delivering the desired level of performance; but the old "institutional" training in Toronto and Winnipeg was bluntly categorized as "a failure."[68] The new builders' workshops, introduced as a joint venture of CMHC and CHBA in 1986, gained credibility and acceptance throughout the industry, and were complemented by new courses that CHBA offered, with government support, for R-2000.

Although memories of the recession were fading, a new cause of chronic glumness appeared. It was summarized in a single word: demographics. "Average annual population growth amounted to 202,000 persons in the first half of the 1980s, less than one-half that of the 1950s."[69] Population predictions indicated not only that the baby-boom had been succeeded by the baby-bust, but also that the number of housebuying Canadians would go into

steady decline right into the twenty-first century. One consultant gave CHBA this advice: "Builders would be wise to recognize good times for what they are — possibly the last major hurrah before the commencement of a long-term decline in the demand for new single-detached houses in the 1990s resulting from unfavourable demographic forces."[70]

Even if houses continued to be built, they might not be affordable. In the mid-1980s, Toronto's single-family home sales rose by 163 percent in a two-year time span.[71] Flips, mass speculation, and general paranoia had sent housing into an inflationary spiral. Some private sellers were even accused of raising their price after the offer of purchase arrived; the *Oxford Shorter Dictionary* calls this questionable practice "gazumping." For builders, the demand was so great that "buyers closing in the middle two quarters of 1986 reported an average delay of three months."[72] Fears were revived about public housing being the *only* housing that an escalating percentage of the population might afford.

This prompted the builders to revisit their position on social housing with greater precision. They started with the premise that there would be, for the foreseeable future, a recognizable segment of the population who could not afford anything else. "There is justification," said De Fehr, "for direct government participation in the production of various types of housing" in certain cases of the underprivileged.[73] According to Sandusky, it was silly to even try "to eliminate social housing programs ... Social housing will still be required as a shelter of last resort for families and the elderly who may not be able to find suitable private rental accommodation."[74] Having said that, however, the builders turned to the crux of their argument, which restated a forty-year-old theme: why should the housing sector be used by governments for economic ulterior motives? If governments want to combat poverty — as well they should — why don't they do it via the front doors of anti-poverty programs, rather than the back door of manipulating the housing industry?

Only a lunatic or an ideologue could dispute that housing, like food and clothing, is an essential component of the "social safety net" that civilized societies provide to even their poorest members. Yet, in the case of food and clothing, Canada's income-

support programs are designed (or at least intended) to provide the disadvantaged with enough cash flow to make their own purchases on the open market. We do not tell supermarkets to carry one price of macaroni for the rich and one for the poor; nor do clothing companies compete with any government manufacturers of jeans, overshoes, or underwear for the underprivileged. But that is precisely what we do for shelter: instead of governments acknowledging that their income-support programs are fundamentally inadequate to meet the housing needs of many Canadians, they have used devices like rent control to abdicate their own responsibilities, and shuffle them onto the real-estate sector.

It was nonetheless clear, however, that solving the problem of shelter for the disadvantaged would be more complicated than the pricing of macaroni or overshoes. CHBA agreed that public housing projects should continue, but their actual cost should be

In 1982, MLS transactions on resale houses in Canada totalled $12.9 billion; by 1989, prices had more than quadrupled, to a total of $55.7 billion.

accurately stated, to provide (among other things) a comparison with direct income-support programs. Improvement of the latter programs, like the prospect of monetary "shelter allowances," also deserved a closer look; and Canada would still need mechanisms, although very different ones, to prevent gouging by a minority of unscrupulous landlords. Finally, Canada's existing public housing stock should be reserved for people who needed it the most: experts retained by CMHC itself concluded that "only about one-third of the social housing units built went to households in need; the remainder competed with housing that was or could have been provided by the private sector."[75] CHBA urged CMHC, however, to contemplate remedies which stemmed from a broad vision of national housing policy, instead of proceeding in "bits and pieces." The time was ripe, said CHBA, to bring the stakeholders into a closer consultative relationship in pursuit of that national vision.

CMHC already had a renewed commitment to that same goal; the problem was that it couldn't speak for the entire federal government, let alone for other governments which have a role in housing. In fact, whether CMHC liked it or not, governments at all levels were contributing to the affordability problem via their tax systems. In the course of a decade — and despite the rhetoric of the politicians of the day — Canada had the most rapid rise in taxation among the G-7 countries.

Furthermore, more municipalities tried loading taxes onto newcomers instead of their traditional constituents: it was politically more expedient to collect "a form of taxation imposed on new residents without their involvement or approval"[76] rather than on existing voters. "Lot levies" also called "development charges" did precisely that: various capital projects could be paid by a one-time hefty tax on new housing — instead of being covered by the traditional method of the municipality borrowing money, then having *all* the taxpayers pay back the loan. This proved irresistible.

The industry had seen this coming. As early as 1976, the minister of state for urban affairs had agreed with HUDAC that lot levies were "often improperly used as a means of raising funds for purposes not directly related to the lots being devel-

oped," and blithely predicted that CMHC's new "municipal incentives grant program should help to alleviate the need for such levies."[77] That prediction proved absurdly wrong. For example, in 1977 Ontario municipalities financed 37 percent of their capital expenditures with long-term borrowing; by 1988, this share was down to 16 percent,[78] with lot levies making up most of the difference. In the mid-1980s, one Ottawa area developer paid "about $130,000 to the municipality for processing a development for which the planning, transportation study, parks design, landscape planning and engineering had been prepared by the developer himself."[79] A comparable situation exists to the present day: as of 1990, local and regional lot levies in a community like Thornhill, near Toronto, added an average of almost $15,000 to the price of a typical house; in nearby Richmond Hill, the figure was even higher.[80] One report in Vancouver suggested that lot levies support the city's art program, so that new homebuyers would bear the brunt of bankrolling the city's culture aficionados. In 1989 Ontario laid the groundwork for a still more expensive structure of lot levies, this time by school boards: instead of lot levies being charged as a *quid pro quo* for essential services delivered directly to the lot (like water and sewer hookup), they were evolving into a cash cow for purposes totally unrelated to the lot itself. That legislation was challenged in court by the Ontario Home Builders' Association, and in 1993 was struck down. The case is currently under appeal.

With the financial squeeze coming from every direction, it was not surprising that the late 1980s witnessed yet another revival of the Heroic Modernist dream of mega-companies mass-producing housing to improve efficiency and beat spiralling prices. This recycled idea appeared in a lengthy report released in 1989 as a joint project by two consulting firms for CMHC under the name *The Housing Industry: Perspective and Prospective*. Homebuilding, according to Clayton Research Associates, exemplifies the complaint of the Economic Council of Canada that Canadian industry is slow to adopt changes essential to prosperity:[81] "The single-family homebuilding industry is an anomaly to many observers, having remained an industry seemingly dominated by smaller firms

despite the tremendous surge in production that has occurred during the post-war period."[82] As of 1984, of Canada's almost 9,000 builders, 96 percent built fewer than twenty-five homes per year; two-thirds built three per year or fewer. This, said Clayton, has technological implications: "The dream of the 1930s and the following decades — the 'house in a day' springing more or less wholly from a pristine factory — has failed to become common. Even as homebuilders accept higher factory content … their mainstream industry is little interested in the more completely manufactured house."[83]

Furthermore, said Clayton, "[there is a] lack of acceptance of bolder innovations … The housing industry is often perceived as backward, unwilling to try new ideas or technologies and whose product has changed little over many decades. To illustrate this backwardness, its failure to adopt large-scale factory assembly-line techniques is often raised … Either the industry is using obsolete management and production methods, resulting in higher housing costs than need be, or it is not producing what consumers really want."[84] Clayton drew the following conclusions: "The more an industry is dominated by small firms, the less likely its members will search for and adopt changes enhancing their efficiency or improving or expanding their line of products, and the slower the diffusion of both domestically generated and imported change … Builders likely are more reluctant to search for and adopt new or improved ideas."[85] The solution, said Clayton, lay in the hands of government: "Since the single-family homebuilding industry is not over-responsive to technological change … there is a role for government to encourage the search for, adoption, and diffusion of change in this industry."[86]

This argument, however, no longer disturbed the industry as it had since 1943. As international feedback started to flow in concerning the success of the R-2000 program, builders lost any qualms they may have had about Canada's "sluggish rate for technological change." The industry also appeared satisfied with the pattern that had emerged in its relations with both the housing manufacturers and Canada's research and development (R&D) establishment. Rather than perceiving site-built housing and manufactured housing as the sworn enemies of one another,

the housing industry was watching a growing alliance as manufactured housing occupied an important niche in the overall market, and manufactured components made progressive inroads into the site-built market, which were dictated by economics, not ideology. The voice of the house manufacturers, Canadian Manufactured Housing Institute, and CHBA even ventured into a kind of cohabitation agreement, and now work together on a variety of issues.

A similar pattern of cooperation marked builders' relationship with the R&D establishment. Although it was true that virtually no builders were large enough to afford an in-house R&D wing, that was not the only way to assure technological progress: in fact, the early 1980s had witnessed immense government programs to support in-house research among industries generally — like Scientific Research Tax Credits (SRTCs) — with questionable results. For that matter, management textbooks were questioning whether the in-house R&D people in North America's mega-companies in other industries were doing such a great job in preparing for global competitiveness anyway.

Instead of dredging up the old idea of mega-companies to do the R&D for Canadian housing, builders and officials agreed on expanding ventures between existing industry and government groups such as CHBA's Technical Research Committee, Energy Mines and Resources Canada (now Natural Resources Canada), CMHC, and the National Research Council. With a proper mutual commitment to the development and dissemination of technology, these organizations were convinced that together they could confirm and maintain Canadian pre-eminence in state-of-the-art residential construction. This would provide a reliable technological base, even for Canada's resurgent plethora of small and cost-conscious builders. "The very structure of our industry has changed," said De Fehr. "The small operation has gained the ascendancy while the larger firms have gone into retreat ... The work of this industry has once again returned to its fundamental base — the adaptable, skilled, small homebuilder plying his craft in both the new and renovation market."[87] "The industry is fairly efficient," Rybczynski agreed. "While there are certain savings to be had, say, in mass production, there are also big problems

... There might be some savings in the long run if the building industry finds ways to do things cheaper, but in the short run it's probably not an area in which large savings are available."[88]

When Rybczynski was asked what *would* reduce costs, his answer was straightforward: "The whole process of getting permits is very drawn out and expensive. If that process were streamlined, that would probably have a much bigger impact."[89] For example, CHBA noted that "in many southern Ontario centres, what took two to three years to complete in the late 1970s is now often taking over five years." Clayton agreed that "the most significant change in the land development process over the past forty years is the growth of bureaucracy in the planning and approvals process."[90] Some of this was inadvertent. For example, one consultant reported that "one of the main problems with building code regulations is 'layering' — new requirements are added to cover new building forms and new technologies, but very few of the old requirements are ever taken out."[91] Other regulations may have a less innocent origin: "Municipal officials," said De Fehr, "might even have the view that higher-cost housing is beneficial; first, because of the higher tax base, and second, because lower-income people are less likely to be able to live in the municipality."[92] But the most oft-cited reason for red tape was a belief in the virtue of bureaucracy:

> It is argued that ... if site design requirements have contributed to the value of our houses for municipal taxation, then the same-or-greater standards will continue or increase that value. At one time, that type of thinking led CMHC to require two entrance doors to each apartment. The corporation did not, however, control the location of those doors, and apartments were built in Dartmouth with two immediately adjacent doors into a single passage and undivided by a wall internally ... Regulations are often increased, mostly on the principle that, if a specified standard has been satisfactory, then

an increase in that standard must be even more satisfactory.[93]

Some end results, however, were notably *un*satisfactory. After decades of layering rules (some of which were contradictory), the resulting agglomeration was indecipherable. A 1982 study by the Toronto Home Builders' Association of a typical downtown block demonstrated that fifty-four of the fifty-five houses on the block no longer coincided with the rules.[94] Back in the 1970s, even Ontario NDP spokesman Stephen Lewis concluded, "Builders are tired of regulations, complexities, and red tape … an obstacle course of municipal government and a labyrinth of approvals … I've changed my perspective in seeing developers exclusively as villains. I see the villainy spread more equitably in other areas."[95]

The solution, said some observers, lay in a concept sweeping the country, from the border with Ronald Reagan's U.S.A. to the stratosphere over our heads. It was called "deregulation." Regulatory simplification had been demanded by the Hellyer Report in 1969, the Ontario government's Comay Report (1973), and the federal government's Greenspan Report (1978). To prove what was at stake, HUDAC had undertaken a demonstration project at the international Habitat conference in Vancouver in 1976: "A three-month time loss was eliminated because there were no construction delays normally caused by waiting for inspections and spacing out the sequence of a building operation."[96] The end result: the house was built in nine days.

The industry resisted the temptation, however, of supporting any Reaganite vision of total deregulation: instead, it focused on rationalization and reform. "While a common approach to regulations — which seem to be proliferating or becoming too costly — is to talk of 'deregulation,'" said De Fehr, "such a drastic approach is not needed, and, indeed, would be unproductive. Much of our regulatory environment is something which our industry can live with and even support. We do, however, need to 'rationalize' our regulations and obtain a balance between regulations and appropriately priced house production."[97] Another way to reduce the demand for regulation was to beef up the industry's ability to police its own members. In the words of Sandusky,

To the extent that the private sector disclaims responsibility for the social consequences of its actions, it strengthens the case against deregulation. To the extent that we do not have means for self-regulation, we create the environment for over-regulation. There must be clear evidence of the will and ability of the private sector to work within the values framework of society. To the degree that we are motivated by pure greed, and disregard the values of our community, we can expect the heavy hand of government to control our activities to protect the rest of society. Leadership in our industry depends on this point.[98]

That was easier said than done. The builders' association didn't yet have mechanisms to slap the wrists of recalcitrant members. Furthermore, bureaucracy showed no inclination to streamline its processes. One consultant reported that "in Ontario, for example, the fire marshall's office so far has successfully resisted all attempts to consolidate the fire code into the building code — or even to move it to the housing ministry."[99]

The bureaucratic battle of obfuscation was even more noticeable in the renovation sector. Clayton concluded that "regulations are specially inhibiting to sizeable [renovation] projects, such as converting large buildings into apartments … Government regulations, building codes, and standards have not kept pace with the renovation industry."[100] In fact, the National Building Code still assumed that renovation did not exist. If a renovated building could be made *as safe* as a new one, building inspectors could usually issue an "equivalent," namely permission to use an approach that is as reliable, even if it doesn't correspond *verbatim* to the Code; but many inspectors were reluctant. If they exercised their judgment instead of going by the book, some day they might be called upon to *defend* that judgment — so who wanted the hassle?

This reluctance peaked after the World Series Earthquake in San Francisco. Within days, there were

pundits on almost every talk show in Canada predicting that Montreal and Quebec City could be hit with a whopper, a tsunami could roar into Vancouver Harbour, and fish could wash ashore in the ruins of Victoria. Even Ottawa sat on fault lines, which caused what CBC called "the occasional geo-burp."

The only acceptable strategy, they said, was to tear Canada down and start over — for at least a quarter of the building stock.

But couldn't this housing be repaired? With today's technology, almost anything is fixable — but some officials treated such talk as seditious. Attempts to codify renovation technology in the National Building Code were equated with a plot to dilute the Code and lower standards; and if renovators insisted that they, too, wanted buildings as safe as new ones, they were supposedly lying. One official accused the proponents of renovation of conspiring "to have substantially different levels of safety [for] new and existing buildings."[101] In December 1992, however, senior NRC officials changed that position. Observers now hope that the codes will finally recognize that no two renovation projects are identical, and that it is possible to draft rules that allow several alternative technologies to fix buildings safely.

Glitches were also occurring among experiments in energy conservation. Builders discovered that certain kinds of cellulose insulation were "linked with a number of residential fires as well as the corrosion of metal building materials across Canada and the United States."[102] This proved to be only the tip of the iceberg. According to U.S. writers, Americans invented the study of indoor air pollution — in Los Angeles, to be precise. During one smog attack, L.A. warned people to stay indoors — until one researcher turned on his measurement equipment indoors, and discovered worse levels inside.[103] Soon the Environmental Protection Agency had 850 citizens conduct a test by carrying air monitors around all day (and night); "The results showed indoor personal exposure to be 3 to 70 times higher than outdoor levels."[104]

Air tightness in buildings was now being viewed as a vice, not a virtue.

The proportion of synthetic materials used in constructing and furnishing modern buildings has increased tremendously ... In 1963, it was still possible to buy a brand new tract house with solid wood cabinets and wool carpets over a hardwood floor. Today common new homes are filled with artificial materials, most of which give off vapours with known toxic effects. Compounding this problem is the fact that ventilation in both new and old houses has decreased. Older buildings were generally drafty enough to allow an adequate rate of exchange between indoor and outdoor air ... Whereas people once tended to rely on screen doors and open windows for ventilation, they now are more likely to turn on an air conditioner.[105]

"The easiest way to improve the air quality in a house," they continued, "is to open the windows."[106] Those who declined to do so, out of either foolishness or climatic necessity, would face untold problems. For example, "All products made of particleboard will release small quantities of formaldehyde." There has been criticism of vinyl and soft linoleum floor coverings, with allegations of release of polyvinyl fluoride. Lead problems can arise from old plumbing or paint dust. Many homes have a problem when uranium-bearing soil causes radon gas to seep through cracks in basements. Some land in Winnipeg, for example, is suspected of emitting more radon than a typical uranium mine. North America was set on its ear by stories of industrial contaminants in the Love Canal area of Niagara Falls, N.Y., which triggered massive (and predictable) concern over the possible inadvertent use of other contaminated land for housing. At the opposite end of the spectrum, for people who never tire of environmental horror stories, homeowners from Rouyn-Noranda, Quebec, made national headlines in November 1992 when they were under siege by ravenous woodpeckers.

As of today, even *Newsweek* predicts doom and gloom: "If, at this point, you're not scared stiff about owning a piece of real estate, this column isn't doing its job ... So far, banks have gone easier on single-family homes. Quick audits are done by the bank's

appraiser, who looks for such things as asbestos, a suspicious oil sheen on puddles, and proximity to landfill. [But] … an environmental audit won't necessarily find every hidden bit of glop."[107] *Canadian House and Home*'s prediction was no rosier: "We will as likely employ an environmental consultant as we would a decorator."[108]

Canadian governments responded at all levels. CMHC started thinking about developing a "healthy house"; new initiatives were launched on the contaminated-land issue, and CMHC campaigned to inform consumers and renovators about lead. Safer paints and finishes came on the market and the national focus on air tightness was balanced with an emphasis on proper ventilation, as exemplified by the R-2000 Program. Paradoxically, at the same time that Canadian builders were further developing R-2000, American pundits concluded that "energy conservation began to fade as an important public issue in the 1980s … Most housing built in 1987 is little more climate-responsive than it was twenty years before."[109] Canadians, on the contrary, continued to load up on insulation — and ponder the level of professionalism of the renovation contractors who installed it. The first official national meeting of renovators took place December 5, 1983; it called for the creation of a HUDAC committee of renovators, which was done in February 1984. "The worst problem facing the renovation industry," said the new chairman, Terry Mills, "is lack of recognition. Governments address themselves to new construction. Manufacturers perceive the new construction industry as the 'market.' Lending institutions prefer new construction as do developers. Traditional builders are leery of entering the renovation field, or have had frustrating experiences doing so. Architects, engineers, and designers fail to show commitment to the burgeoning task ahead. The labour force is not being equipped fast enough."[110]

The most obvious signal of this malaise was the absence of warranties. The typical "reno" crew in baseball caps and pickup trucks didn't stand behind its contract; it couldn't even *find* its contract. A CMHC video depicted a renovation contractor searching unsuccessfully for the quoted price he had written down, saying, "Shoot, I threw out that pack of cigarettes." Would anyone provide a warranty for this work, as many consumers demanded? HUDAC had discussed renovation warranties in 1982 with cabinet minister Romeo LeBlanc, and in the same year, its National Warranty Council concluded that "a renovation warranty is both possible and practical."[111] However, this was categorically rejected by HUDAC Ontario, which formally opposed any industry-sponsored warranty program for renovation.[112] In 1985, CHBA revisited the issue, via a general resolution that if renovators supported the idea, warranties for renovation should be introduced via existing provincial warranty programs. To this day, however, only Quebec has introduced such warranties on a comprehensive basis.

The most controversial innovation of the era, however, was introduced by Canada Post. Over howls of protests, it changed the suburban landscape with a creation called the "superbox." Procedures for subdivision approvals varied among different areas of Canada, but often "over fifty different agencies are given the right to comment on subdivision plans … The most recent agency seeking input to subdivision plans is Canada Post for its 'super boxes.'"[113] CHBA took grave exception: "New home purchasers are first-class citizens and deserve the same rights as resale purchasers"; and "New homebuyers pay the same taxes and postage rates as other Canadians."[114] CHBA's angry resolutions demanded retention of door-to-door mail service. Ottawa replied that this was financially unthinkable — and Canada Post offered to show CHBA a twelve-minute film on superboxes.

Canada Post also declared that Canadians "preferred" superboxes[115] — without specifying a preference over *what* — door-to-door service, smoke signals, or pigeons. Mail slots have now been eliminated from most doors supplied to new houses. Although there are suburbanites who tell their child, "Yes, Virginia, there is a Mailman," memories are fading fast. The day may be approaching when nothing will be delivered to the Canadian home unless it has pepperoni and double cheese.

The GST and Other Carnivores
1988–1994

In which the Mackenzie Brothers turn the other chic; houses Get Smart; junk becomes politically correct; houses Grow on you; and Canadians are invited to love the GST.

To be a stylist is to be yourself, but on purpose.

Peter C. Newman[1]

What do you do when your decorator tells you that your home doesn't make the right "statement," and that your decor is a cross between Late Heirloom and Early Woolco?

Fear not, says *Canadian House & Home*. This influential magazine devised an idiot-proof way for Canadians to master the daunting art of decoration. According to its recent book *Home Style,* there are six main themes worth emulating in Canada: English Country, French Country, Southwest, Folk, Contemporary, and True North. Other styles, like Mediterranean and Oriental, are conspicuous by their absence.

Any room from *Brideshead Revisited* would serve as a quintessential example of English Country, knee deep in comfortable but expensive fabrics. And *Home Style's* hints help balance the extraordinary oriental carpets and elegant furniture with that "lived-in look." One decorator helpfully offers a recipe for the consummate English Country aura: "First you have to have the perfect chintzes, and the perfect antiques, then you lock two poodles in the house for the weekend."[2]

Equally instructive are their pointers for other styles. For example, "In recent years, the distinctive design traditions of Santa Fe, New Mexico, have become the most popular destination of our southern decorating journey … Southwest style seems suddenly everywhere."[3] This is the perfect theme for people who develop sudden cravings for guacamole dip.

The most intriguing of the six styles is what the book calls True North, emphasizing exposed wood, twig (also called "stick") furniture, and "an informal uncluttered approach."[4] For colours in a True North house, "think of the red, green and black check of a lumberjack jacket, and of the bold yellow, green and red stripes on a cream background of a Hudson's Bay Blanket."[5] This True North may be strong, but it is hardly free. The components displayed in *Home Style* were supplied by New York's Ralph Lauren, who "brought the Northern style to our attention"[6] and has been that theme's "most obvious promoter."[7] The illustrations of True North include Navaho-style carpets and leather armchairs, along with other American ideas of what the Mackenzie Brothers' house might look like. The book doesn't say whether

the obligatory moosehead on the wall is also by Ralph Lauren.

Comfort in the True North house, as elsewhere, also means being toasty warm. In 1990, the federal government produced its *Green Plan* for Canada's environmental strategy, in which R-2000 was listed as a principal component. A more sophisticated version of R-2000 was being pondered at the National Research Council just as the Mulroney government axed NRC's Division of Energy. Suddenly, the idea was a home without a home; so the scientists resorted to CHBA's Technical Research Committee, which decided that the project should be overhauled. The resulting synthesis of scientific and industrial thinking produced perhaps the world's most advanced house, which was given the original name of Advanced House. CHBA's Advanced Houses program supported by Energy, Mines and Resources Canada (now renamed Natural Resources Canada) recently completed ten houses including such features as faucets that sense users' hands and shut off automatically, fluorescent light bulbs that use one-fifth of the energy of traditional bulbs, insulation from recycled newspapers, "and interior paint that's so safe it's edible."[8]

And the work goes on. CMHC's Healthy Housing competition displayed designs in 1992 for one house that does not require energy or water hookups, and another that covers "an area not much larger than would be needed for a two-car garage."[9] In the words of one expert: "I'd love to work on a zero-energy system, one based solely on renewable energy. We already know how to do it."[10]

The industry's commitment "to place the housing industry within the environmental context"[11] also took shape. CHBA president John Bassel pointed to homebuilding as an ideal partner in sustainable development:[12] housing takes only 2 percent of Canada's lumber harvest, and its technologies (like roof trusses) allow an almost total shift away from old-growth forests. Materials that would have otherwise ended in landfill sites are now being recycled into weeping tiles, roof shingles, back decks, and other components. The most important "house" in the country, the House of Commons, installed high-efficient bulbs to cast its own light on the environmental front. "These bulbs are a major way of saving energy," said MP Marlene Catterall: if every household in Ottawa installed just one bulb, the impact on generators could reduce the emission of carbon dioxide by 50,000 tonnes — as much as 10,000 cars produce in a year.[13]

The issue of contaminated land, however, is not as easy: some environmental standards are not yet as

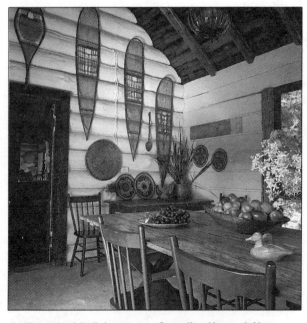

A "True North" dining room: *Canadian House & Home* recommends snowshoes as a good accessory.

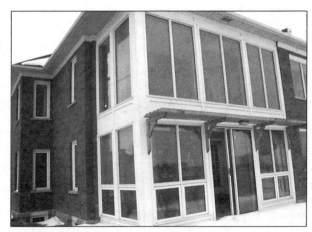

Canada's first Advanced House, in Brampton, covers 3,500 sq.ft. Its annual energy bill is $785 (compared to $2,862 for a comparable house built according to normal Ontario Building Code standards).

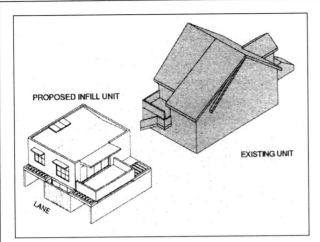

PROPOSED INFILL UNIT

EXISTING UNIT

LANE

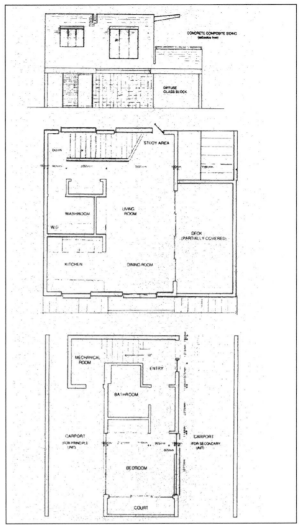

Canada's first Healthy House (1993), in East Vancouver, uses materials that require 60 percent less energy to produce than those for conventional homes. This infill project, 918 sq.ft., is to be shoehorned behind existing houses. Vancouver's codes require sprinklers in every new house — without solid evidence that they would save lives ("a profoundly dumb idea," said CHBA president John Bassel).[14] At first, the city insisted that CMHC install sprinklers throughout the entire block of its project.

sophisticated as Canadians might hope. In some parts of Canada, land may be listed as unusable if there is a spill of lemonade concentrate, soya sauce, or cola syrup, unless the syrupy soil is dredged out with a backhoe. On the other hand, some current cleanups in Vancouver and Calgary deal with nastier toxins and could cost $100 million each; one site in Toronto could cost $160 million. In 1991, the Canadian Council of Ministers of the Environment addressed these problems with Interim Canadian Environmental Quality Criteria for Contaminated Sites; and in 1992 the council set up a Task Force on Contaminated Sites Liability to combat not only pollutants, but also unnecessary costs. It wanted to avoid the U.S. precedent, where some 70 percent of the "cleanup costs" are spent on lawyers, accountants, and expert witnesses. CHBA proposed its own seventeen-point program, ranging from testing to overall

"remediation procedures guided by the principle of sustainable development." These issues promise to be with us for some time.

Other environmental concerns include water conservation in new housing: low-flow shower heads, faucet aerators, and low-flow toilets are all being introduced. For the hyperallergic, CMHC is working with the Canadian Manufactured Housing Institute on a Super Clean House in Quebec. Still another new concept is CMHC's Open House which is barrier-free on the inside for people with disabilities.

But that doesn't make a house "smart." The Smart House was proposed by the U.S. National Association of Home Builders: its single-wiring cable connected to a host of micro-processors would "enable appliances to 'talk' to one another, and regulate heat and lighting in each room automatically."[15] In 1988 one American book predicted that by the

end of the 1990s, there would be eight million Smart Houses in North America. Some of the benefits were obvious: not only could you program your appliances — even by calling them up on your car phone — but the risk of electrical fires would decline. Other advantages were more esoteric, like being able to plug your telephone into the same outlet as your toaster. "Gone will be the conventional wall socket and light switch in favour of cables and multi-functional sockets that allow the circuits to talk to each other."[16]

For consumers who are less demanding about how directly their telephone talks to their toaster, the CEBus and Echelon systems use conventional wiring. Consumers must nonetheless prepare for the odd occasions when they switch on lights and perform other menial tasks. "It's enough today when the TV or the fridge go on the fritz, but imagine the domestic calamity if the home automation system breaks down: no appliances, no gas, no lights. That's why

most of the systems will feature a built-in back-up system that reverts to manual operation during emergencies."[17] The first Smart Houses in Canada were built in Calgary and near Toronto.

As Canadians worked on perfecting individual houses, effort was also devoted to putting our collective house in order: Meech Lake was the site of the umpteenth attempt to put the constitution straight. This effort has a long history. In 1977 André Ouellet, then minister for urban affairs, told HUDAC that "1977 will go down in history as that year when French and English will have learned to live together in the same back yard,"[18] but someone must have tampered with the sandbox. The controversies included one that CREA brought to the table: the constitutional entrenchment of property rights, as in the U.S. Bill of Rights. It hit a responsive chord. In 1986, Housing Minister Stewart McInnes had told CREA that,

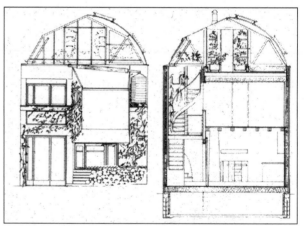

This Toronto winner in CMHC's (1993) Healthy Housing Competition was intended to generate its own electricity, compost its own sewage, store rain water for drinking, and recycle its own dirty water. Unfortunately, the house was caught in a maze of municipal approval procedures.

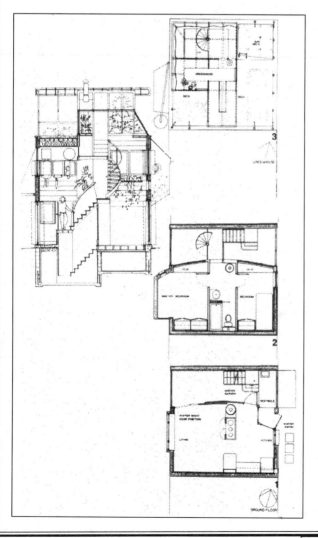

This R-2000 home, north of Toronto, was the first Smart House in Canada to be built (1993) with modular technology. As modular systems grow more sophisticated, they become more attractive to builders and consumers. Although total housing starts were expected to drop by 13.8 percent in 1993, modular/mobile home sales were expected to rise by 17 percent.[19]

wherever we turn, we find that property has been considered as proper, and that proper people have respected property. I quote to you the Prime Minister of Canada, the Right Honourable Brian Mulroney, [who] endorsed the slogan of Private Property Week, "Come honour our heritage — and preserve your property rights." [This, said Mr. Mulroney,] "is an appropriate theme because it reaffirms that the ownership of property represents one of the fundamental achievements of a democratic and progressive society. This country was built upon the toil of our forefathers whose burning spirit and unrelenting sacrifices shaped our programs."[20]

McInnes carried this same message, burning spirits and all, to CHBA's executive board in November 1986. This time, however, he added that the federal government would be "bequeathing greater responsibility to the provinces."[21] No one asked him indelicately whether this "bequest" meant the federal government expected to die.

Although CHBA's membership had adopted a resolution favouring property rights in the constitution, CHBA's leadership was hesitant, as was the Urban Development Institute. No one knew how such entrenchment might affect urban planning, among other things. CHBA's head office reported to the membership that "at the present time that inclusion of property rights may very well have a detrimental impact on the industry."[22] It also stuck to this view after the demise of Meech Lake and the reintroduction, by the Mulroney government, of an even more overt draft entrenching property rights.[23] CHBA replied that it "does not wish to see such entrenchment if it is going to exacerbate what is already an extremely difficult and onerous regulatory environment."[24] Ultimately, in the absence of any groundswell of support, entrenchment of property rights was abandoned by the government even before the Charlottetown Accord went down to defeat.

The impression that Canada's constitutional house was falling apart did not surprise some people — irrespective of politics. Some theorists argued that all houses (both figurative and literal) are supposed to fall apart — or at least *appear* to do so. This was Deconstruction, the latest theory to sweep architectural journals; like Modern, it decreed that 99 percent of Canadians were still politically incorrect when it came to their taste in homes.

Although Deconstruction refused to be defined,[25] its goals (like Modern) were to strip away the superficial and discover the Truth underneath. If the cosmos is made of bits and pieces, the only Authentic art or architecture should be that which acknowledged these bits and pieces — and probed the subconscious of people who put them *together* to make literature, art — or houses. All construction, whether verbal or architectural, was being psychoanalysed.

Like Modern, Deconstruction suffered no rivals: one art critic for the *Globe and Mail* argued in 1990 that since Inuit sculpture, for example, was not representative of "seriality and deconstructed hierarchies,"[26] it should all be thrown out of the Art Gallery of Ontario. Toronto was also the home of the world's most famous Deconstructionist architect. Frankie Goldberg came by it honestly: as a child in the Dundas and Dufferin area, he scavenged bits and pieces from his grandfather's hardware store to create

"futuristic cities."[27] In due course he followed in the footsteps of Palladio, Mies van der Rohe, and Le Corbusier: he acquired a new name; and after moving to California, architect Frank Gehry took the journals by storm, his homes looking like upscale versions of a back-yard treehouse. His philosophy is simple: "Buildings look like hell when they're finished, but when they're under construction, they look great."[28]

Newsweek's experts said Gehry's renovated home "had a crazy, in-your-face toughness ... Gehry's lively sculptural designs are a big relief after the glitzy and ponderous Post-Modern excesses of the last decade; their appeal to the average guy is unmistakeable ... This [is] architecture of controlled chaos."[29] Before he remodelled it, Gehry had what he called "a dinky little cutesy-pie house. We had to do *something* to it.

I couldn't live in it."[30] Gehry isn't sure how to remodel it further now that his family requirements have changed: "Every time I try to do something to it, I'm screwed. I've thought of tearing it down."[31]

He isn't the only one. Artist Michael Heizer issued a cautionary note on Gehry: "It's too bad you can't build out of materials that will last two thousand years, when people might start to appreciate your work."[32] McGill's Rybczynski gave Gehry's style less time than that: "I doubt that it will make it to the year 2000. It's too idiosyncratic to last."[33]

Rybczynski's own preference was to install even less than what was required for a functional home, and let the occupant fill in the blanks — or make additions. He called it the Grow Home. With the help of a colleague in the architecture faculty, he built his model on the McGill campus in 1990. "Within a year, [Montreal-area builders] built 660 houses based on the Grow Home model. The houses sold like hot cakes."[34] Like so many inventions, however, the Grow Home has a disputed parentage. A similar concept, called "compact housing," generated so much print in the early 1970s that Port Coquitlam passed a by-law permitting houses of 500 square feet. In the same era, HUDAC and CMHC were busy advocating shell housing: "The only work

City & Country Home's article on "The Shape of Things to Come" profiled Frank Gehry's works, including his own house (top left) and houses for clients (bottom left). "Credit goes to [Gehry] for showing us [that] simple inexpensive materials like corrugated steel, plywood, cardboard, felt and wire glass can be beautiful for buildings and furniture."[35] Above: this house (not by Gehry) in London, Ont., makes a stiff bow to Deconstructionist influence.

the builder does on the inside is to partition and dry-wall the bathroom."[36] This approach had been endorsed in 1970 resolutions by the National House Builders' Association, but some Maritimers claimed that their region had developed the concept generations before that. Meanwhile, one professor of architecture attributed the Grow Home to the Heroic Modernists.[37]

Most magazines doing the rounds among North American consumers, however, were displaying substantially larger houses. In fact, "an American survey indicated that the median desired house was almost 2,400 square feet, a third larger than the median size of respondents' present houses."[38] That was a problem because, in Rybczynski's view, "The high cost of land dictates smaller and smaller lots. This has produced housing developments that resemble parking lots filled with stretch limousines; no matter how attractive the individual houses, the overall effect is slightly ridiculous."[39] A single-car garage is only twelve feet [3.7 m] wide, he added, "but a three-car garage is thirty-six feet [11 m] wide; on a narrow lot this barely leaves space for the front door. Even with the best intentions, it is difficult for a builder to avoid giving the impression that the house is really a converted service station or carwash."[40]

This is unavoidable in most parts of Canada, not only because of lot sizes, but also because the inhabitants of the world's snowiest cities hate shovelling long driveways. Whether consciously or unconsciously, many builders have been compensating by cranking up "homey" historical touches on houses. This stems partly from the influence of Post-Modernism, and partly from a renewed realization that these touches carry subliminal messages that all spell *home*. Gabled roofs, for example, can be trickier to build than Modern's obligatory flat roof: but it's hard to generate warm fuzzy feelings about "bringing all your family under one roof" when that roof is invisible from the street. Similarly, fireplaces — even today's high-tech recirculating variety — add little to the efficiency of a home, but they appeal to the collective subconscious of a society that uses the phrase "hearth and home" as a synonym for domesticity. As CHBA's president Tom Cochren said, "In the process of building homes, we are also building a way of life."[41] The typical homebuyer wants more than shel-

The very name Grow Home is said to have marketing appeal: "In Creating the Grow Home," says one magazine, "McGill [University] has created a name like Frigidaire or Kleenex that people will ask for."[42] That labelling is more upbeat than was the case for two ultra-small house designs which CMHC toyed with almost forty years earlier, which staff had nicknamed the "mouse house" and "louse house."[43]

ter; he or she is hoping to buy a piece of Norman Rockwell.

The very word *home* is a loaded concept that is part of our culture; some might even argue that homebuying baby-boomers are secretly trying to relive *Leave It to Beaver,* their own suburban childhood, or the childhood they wish they had. This is reputedly one reason why intercity builders have had so much difficulty: despite the accusation that all new houses look alike, the history of the industry suggests that local builders have somehow — and probably without knowing it — captured a subtle architectural "language" that was more *familiar,* and hence more subconsciously appealing, to local buyers than the forms of their intercity competitors.

Building a successful house, therefore, appears to be more than a matter of shelter, economics, architecture, or technology: it also operates on a level that, to paraphrase Dante, is in the vestibule of the soul.

Even today's theorists would agree with that conclusion: the definition of a house as a "machine for living" is now discredited. However, in other respects, the gulf between architectural theorists and the rest of society remains unbridged. While Deconstructionists speculate about houses' different cosmological statements — and others ponder what one Toronto architect recently called "the Metaphysics of House"[44] — Canada goes on building and renovating, with few hang-ups about any latter-day Cabala or architectural equivalent to the Curse of King Tut's Tomb.

A decade ago, architect Peter Hemingway issued a dire prediction to his colleagues: "A spectre is haunting architecture today — the spectre of irrelevancy. Architects in their existing role are an anachronism."[45] In fairness, that comment would have been better addressed to the theorists than to the profession at large. Even when recriminations between the professors and the builders were at their worst, there were always architects who turned a blind eye to official metaphysics and designed projects that appealed to people. Builders, for their part, were seldom at a loss to find designs in architectural journals which, with a little filtering for local tastes, could provide the basis for an appealing project. The thundering of the pundits masked what was, over the decades, a viable working relationship. The difference today is that this relationship need be surreptitious no longer.

In recent years, the architectural establishment has distanced itself from the theorists. Two of Toronto's most famous critics of the Modern box, David Crombie and Jane Jacobs, were inducted as honorary members of the Ontario Association of Architects. Meanwhile, the American Institute of Architects' 1993 selection for award-winning housing went to a Toronto firm: it was mind-boggling, not only in acknowledging superior Canadian design in a traditionally insular market, but also because the design had all the "homey" touches that had been so reviled for half a century. The page of ideological history has turned: architects can now put ornamenta-

tion on buildings without being accused by their colleagues of "perversion" or other sexual deviancy. Although Deconstructionists decry such designs as "functionalism in drag,"[46] the bulk of the architectural profession appears to be positioning itself for a return from its ideological exile, to play a more relevant role in the future of the Canadian home.

Consumers' tastes are also changing. Intuitively, one would expect a strong demand today for smaller houses, to reflect not only a recession which has

When the Heroic Modernists demanded factory-made housing, they never anticipated that it would finally look like this neo-Victorian modular Dream Home (complete with "parlor") displayed at the 1993 National Home Show. Canada's two major associations for manufactured housing (Canadian Manufactured Housing Institute and Manufactured Housing Association of Canada) are currently joining forces, but are keeping a close eye on the consumers' idea of "homeyness."

grossly outstayed its welcome, but also changing demographics. Baby-boomers are about to join the "empty-nest" generation: their Yuppie-Puppie children are reaching the age to move out. However, two factors are causing owners of big houses to hang on. First, Junior (who may not have a job) refuses to ship out as long as he maintains access to his parents' fridge. Second, even after the nest has been emptied, aging Yuppies are staying put because their house is the only place with enough room for their stuff.

"There may be fewer people in the house of the nineties," says Rybczynski, "but there are a lot more things."[47] One room has been identified as the most likely to be affected: "Surveys indicate that families spend less time together ... When the family does get together, it is usually for a meal, and it is to this part of the house that the centre of gravity is shifting."[48] The result is that Canadian houses are increasingly imitating the traditional Quebec layout, where, as on the set of "La famille Plouffe," life unfolded in the kitchen.

So now Rybczynski posits that the kitchen is fast becoming the repository of the family's status symbols, in the same way that Victorian parlours were in their time. "Kitchen appliances are the new carriers of domestic status — German cabinets rather than Turkish upholstery, granite counters instead of lace antimacassars. Just as the parlour manuals counselled aspiring Victorian cosmopolites, a modern primer ... proposes a variety of kitchen styles ... to suit the owner's self image."[49]

Over the past several years, kitchen remodelling has also been a mainstay of the Canadian renovation industry, and that industry has been growing across the board. Experts agreed that renovation spending continued to outdistance new construction — but by how much? Estimates fluctuated wildly, because the pundits couldn't agree on a single definition of "renovation." For example, Clayton Research (using Statistics Canada methodology) said that the typical Canadian household spends $1,850 a year on "reno";[50] however, Environics Research calculated "maintenance" differently and said that, as of 1989, the average homeowner spent over $4,400 on renovations annually.[51] The Statistics Canada methodology is now the norm; but whichever way you slice it, the renovation boom is expected to continue. One estimate suggested that by the year 2000, over 80 percent of all residential construction will be in renovation.[52] This economic powerhouse already employs 200,000 Canadians directly and indirectly, and every dollar spent on reno creates over twice as many direct jobs as new construction.[53]

GROUND FLOOR PLAN

SECOND FLOOR PLAN

In 1993, this 1,300 sq.-ft. house, designed by Baldwin & Franklin of Toronto, won the American Institute of Architects competition for affordable housing. The jury decision was unanimous.

This was not always appreciated. Former cabinet minister Paul Hellyer recalls that "a major achievement [of the last twenty-five years] was to stop the bulldozing of entire city blocks just because twenty to thirty percent of the houses were in need of major repair or replacement."[54] CHBA geared itself for such challenges: "The renovation issue remains a top priority for our members."[55] CHBA even introduced an annual month-long publicity campaign, called Renovation Month, in October 1990.

Nevertheless, "as an organization we have yet to hear formally from the federal government on how it plans to address the growing renovation needs of our aging housing stock."[56] To expect a national renovation policy was not considered unreasonable. In 1987, the World Commission on Environment and Development (the Brundtland Commission) called on countries to entrench policies of sustainable development in the name of the environment. This sounded made-to-order for the renovation industry: with our climate, the "environment" for a mostly indoor, urban population is a *built* environment. Furthermore, a city is the largest tangible object that a civilization produces; if we recycle items as small as bottles and cans, shouldn't we also be committed to reusing items as large as buildings and districts?

The answer, apparently, is no. Demolition is still so widespread that one of every six cubic metres of waste deposited at Canadian landfills is used construction material.[57] On a Sunday afternoon, countless Canadians pack the kids and the beagle into the station wagon to go see "some environment," without realizing that their *Funk & Wagnall's* says "environment" is where they started from, not where they're going. Among professionals, hardly a single planning school in Canada teaches strategy for "the built environment" as part of its core curriculum; few architecture schools teach repair; and almost no municipality ever includes renovation in its official plan.

Municipal governments should be expected to support renovation wholeheartedly: by adding to the assessed value of existing buildings, it increases the tax base without costly increases in infrastructure (roads, sewers, etc.). But although the Federation of Canadian Municipalities made oblique mention of this in a publication on heritage,[58] most municipal politicians still routinely disregard the statistics and equate development only with new construction.

The position of some federal officials, however, is not benign neglect, but opposition — despite CHMC's increasingly cogent statements about renovation's economic importance. Although Ottawa monitors Canada's national assets (forests, fish stocks, oil reserves), there is no national policy which regards Canada's building stock as a "resource" — even though, in 1986, Statistics Canada evaluated our pre–World War II building stock *alone* at $114.9 billion.[59] The lack of policy on that resource is reflected in the Income Tax Act, which entrenches the notion that our buildings will fall down, or at least suffer from a degenerative disease. By following the Act, a landlord who bought a walk-up apartment in 1980 would declare by 1990 that the building lost one-third of its value — or two-thirds of its value in "constant" dollars adjusted for inflation. This is absurd. Furthermore, if the building outlived the Act's expectations, there could be tax penalties to pay; but if the landlord demolished it, the Act provides for healthy write-offs called "terminal losses." Canadian rental housing must have a poor sense of direction, because under Canada's tax system, not a day goes by without some building getting "lost" — at taxpayers' expense.

The unwillingness of the tax system to support sustainable development wasn't new. As Canada prepared its *Green Plan*,[60] groups, including the Canadian Institute of Planners, succeeded in inserting comments on the tax system[61] in their recommendations; but when the *Green Plan* was published, every last reference to tax had been deleted.

One person who had noticed the controversial tax treatment of older buildings in 1987 was Avril Phaedra Campbell, who chaired a B.C. task force. She reported that both "codes and the tax system ... discriminate against heritage building renovation."[62] "We strongly believe," she added, "that the simplest, most effective and most desirable approach ... [is] to make heritage restoration and renovation so attractive financially that developers opt for [them] by choice ... We feel this not only assists heritage, but helps to create jobs that are necessary and will also improve the livability and attractiveness of our communities."[63] In June 1993 Avril Phaedra Campbell, who prefers to be called "Kim," became

Canada's nineteenth prime minister, although this turned out to be just a summer job.

Just as Campbell was finishing her 1987 report, which called for "changes in income tax laws that would provide additional write-offs for investments in heritage buildings,"[64] her dream came true — not thanks to the government, but to the courts. This resulted from lawsuits that had nothing to do with perks for heritage but that, instead, addressed principles applicable to rental housing generally. In one decision, the Quebec Court of Appeal dealt with a Mrs. Goyer, whose walk-up apartment building needed new doors, windows, plumbing, wiring, and balconies.[65] When the taxman disallowed her expenses, her employer took offence: she worked for a Montreal law firm whose former resident-Irish-tenor was one Brian Mulroney. The Quebec Court of Appeal agreed unanimously that in the case of rental housing, her expenses were deductible so long as (a) they didn't add any pieces to the building, (b) they didn't replace disappeared items, and (c) they weren't out of character with its normal value.

Tax authorities took exception and applied to the Supreme Court of Canada. That Court ruled, however, that the issue was sufficiently open-and-shut that it wasn't worth its time.[66] Meanwhile across the hall, the Federal Court of Canada reached a similar conclusion in an Edmonton case on the same subject.[67]

Revenue Canada, however, refused CHBA's request to redraft its rules in light of the findings. That department's bureaucrats declared that what the Court of Appeal and Federal Court had written could not be what the judges *meant* — and that what the Supreme Court had *meant* to say was that it had no opinion.

But the courts ground onward.[68] One tax court judge looked at Revenue Canada's arguments on non-deductibility, and called them "wholly unreasonable and arbitrary … Had the minister applied common sense in making the assessment here, the appellant would not be before the court."[69] Revenue Canada's position still did not change: it told CHBA that the department should be entitled to "a degree of flexibility in making each determination."[70] Although Revenue Canada says that it has nothing against restoration or responsible property management, it continues to advise the public that such expenses are non-deductible.[71] Any conscientious landlord must wonder whether the only way to compel departmental compliance with the jurisprudence is by legal confrontation, with dramatic courtroom scenes, dramatic speeches by government-paid lawyers, and dramatic expense.

Elsewhere in the federal government, there was also a belt-tightening on renovation and maintenance. In what the *Ottawa Citizen* called "the recession finally catching up with the country's official residences," capital and operating costs at the prime minister's residence at 24 Sussex Drive dropped to $248,000 in 1991–92, compared to $350,000 the year before. At Jean Chrétien's house, Stornoway, costs were "a mere $71,000."[72] Rideau Hall, for its part, spent $25,000 on "lightning protection." When the Mulroneys left town in 1993, they surveyed their furniture and struck a deal to sell their leftovers back to the taxpayers of Canada for $150,000. Public outcry made them keep the furniture; but elsewhere in Ottawa, the Canadiana Fund had already been launched to prevent Canada's most high-profile homes from going through such ordeals again. The Fund would assemble a worthy permanent collection of antiques and art (preferably donated) for the "state areas" of these homes, so that with each change of occupant in Canada's official residences, taxpayers wouldn't have to flinch every time they heard the cry, "Get that hideous thing out of here!"

Still elsewhere in Ottawa, Canada's long-term plans for the renovation industry were now entrusted (in 1992) to a CHBA committee assisted by Human Resources Development Canada and CMHC. Strategic plans were getting popular: this group was modelled on a similar committee launched in 1989, to prepare Canadian builders for the challenges of the next century. A 1990 CHBA meeting followed up with a strategic plan for its own organization, reiterating many longstanding themes such as "quality, affordability, and choice." It also placed increasing emphasis on the industry's commitment to regulating its own builders: in 1989, CHBA adopted a Code for Disciplinary Action, to expel members who mistreated the public or their colleagues.

This coincided with a renewal of interest, among many provincial builders' associations, in the idea of

certifying or licensing builders and renovators, as had been suggested by NHBA almost fifty years earlier. In order to simplify government regulation, CHBA also entered into a joint project with the Federation of Canadian Municipalities, CMHC and the Canadian Housing and Renewal Association. Under the name of ACT (Affordability and Choice Today), these groups would find and promote new ways to slice through red tape. Some proposals, like putting intelligent renovation practice in building codes (suggested by the Association for Preservation Technology), are currently moving forward with the help of NRC. In other areas, like municipal systems, progress takes more time. "Since the responsibility for the servicing was passed on [in most municipalities] to the developer, the municipalities have no incentive to adopt the most effective servicing techniques or systems. The municipalities are more likely to adhere to excessive or obsolete standards that they have applied for a period of time and are familiar with in terms of expected performance and maintenance costs."[73]

Municipal taxes, above and beyond lot levies, also added to the challenges to affordability. In many southern Ontario centres, property tax rates more than doubled over the 1980s. The federal tax system also continues to be a major stumbling block for new as well as renovated housing.

"Death and taxes may be the most certain things in this world," said writer Don Harron, "but at least death doesn't keep getting worse every year."[74] This has become part of a longstanding pattern. Between 1961 and 1990 the cost of shelter to the typical Canadian family rose by 695 percent (unadjusted for inflation), but taxes increased 1,367 percent. If the further governmental debt load (which will have to be paid out of tax revenues in the future) is added to the equation, the tax bill since 1961 increased by 1,565 percent. Under the circumstances, it would have come as no surprise to either builders or homebuyers that they would feel the pinch; but what ensued was more galling. "Builders are prepared to pay their fair share of taxes," said CHBA's president, Tom Cochren, in 1989; "We ask for no special treatment [but] we demand that there should be no discrimination … This industry has been targeted as a cash cow."[75] "The important point," said one accounting firm, with classic understatement, "is that the Canadian tax system is not neutral and does provide various incentives or disincentives for a variety of alternate investments, including owner-occupied and rental housing."[76] In particular, housing had been subjected to decades of smoke-and-mirror tax perks accompanied by even larger tax hikes that were as surreptitious as they were idiosyncratic. By the late 1980s, countless observers were pleading for a rationalization of this mess; and when the government predicted "tax reform," many believed their time had come. CHBA's president, Norm Godfrey, however, issued a careful prediction in 1987: "We have no reason to believe that as a result of tax reform, the government will be looking to collect any less revenue than they collect today."[77] That warning proved to be an understatement.

Between 1989 and 1991, the UI premiums payable by employers rose by 44 percent, and the federal sales tax on building materials rose from 5 percent in 1984 to 9 percent in 1990, when it was replaced by the Goods and Services Tax (GST). At the same time, the deductibility of carrying costs was reduced even further, provincial sales taxes and land transfer taxes were generally increased, municipalities imposed higher lot levies; and the GST increased the price of new homes *and* imposed further administrative costs on builders. In addition, as of 1987, the Income Tax Act again singled out the development industry, by further specifying how property taxes and interest could no longer be treated by developers as a claimable business expense, as they are for other industries.

Much of this was done in the name of deficit reduction — although another technique for this purpose, called downloading, proved even more popular among politicians than tax increases. Under this technique, a higher level of government simply cancels a cash transfer that a lower level of government was expecting — leaving it to the latter to make up the difference. For example, in several federal budgets, Ottawa slashed the funds transferred to provinces: this made the federal deficit look less awful, but at the expense of provincial deficits; so provinces responded by doing likewise to municipalities. This shifted tax burdens among governments, and let some politicians call themselves deficit-

fighters — without actually changing the lot of hapless Canadian taxpayers. "Downloading," explained CHBA's president, Gary Reardon, in 1991, "is to taxation what sludge ponds are to sewage treatment — the 'you-know-what' ultimately settles to the bottom … It is the municipalities who are on the bottom of the sludge pond of the tax system …[78] Municipalities have no one to pass on the costs to, except their ratepayers and builders."[79] As municipalities felt the weight of downloading, they became even less interested in picking up the mounting bills to install or repair their infrastructure of roads, sewers, bridges, and other essential public works.

The temptation to shuffle most of that cost onto new homebuyers was becoming irresistible — but that promised to create a "deficit" problem of another kind. "The financial solution to Canada's infrastructure is not merely to shift the debt burden," said Reardon; "Development charges are adding to the mortgages [the debt burden] on new entrants into the housing market. Current practices do not solve the overall problem of debt; they reshuffle the cards and in a way which is simply not fair."[80] However, this was only one of many challenges to affordability: according to CHBA, "Government actions in terms of regulation, various types of taxes and charges, downloading of taxes, and increasing service standards, which cause new and/or higher charges to development, have added substantially to building and development costs. This is reflected in housing affordability."[81]

CHBA pulled no punches about one root cause. Since "these increased charges are a result of fiscal restraints which have led to reductions in transfer payments … CHBA has pointed to the direct link between federal financial policies and the cost of housing."[82] Municipalities, however, shared the blame: "Lower-priced developments (e.g. small-lot singles, semis, or apartments) with large numbers of children generate a greater deficit between tax revenues and costs for municipalities than large-lot, more expensive housing. Because of this, many municipalities encourage the development of larger homes on larger lots and place restrictions which limit the incidence of smaller, more affordable homes in new developments."[83] Some provinces like Ontario respond by demanding a percentage of "affordable housing" in certain new developments. The result, for builders, was that in some instances they were blocked from building smaller houses when they wanted to, or were forced to build them when they didn't want to. These specifications for types of housing are then added to the rest of the extensive approval process, which Prince Charles called "the Spaghetti Bolognese of red tape."[84] CHBA president John Bassel estimated that if the regulatory process could be consolidated and expedited, this could knock as much as 15 percent off the price of some housing.[85]

To add to the present confusion, there is the cumulative effect of the unique up-front taxes and fees for housing. Clayton Research Associates offered the example of a development firm which buys $10 million worth of land for a subdivision in Ontario: it will first pay $150,000 in Land Transfer Tax. Typical interest rates and municipal taxes will total $900,000 per year. Consultants' studies to satisfy upper- and lower-tier municipalities would cost "about $300,000 to $500,000. However, these fees could double or triple if the Official Plan Amendment and/or draft plan approval face serious opposition. Fees of engineering consultants designing the subdivision services are likely to be $500,000 to $700,000 provided no serious obstacles are encountered."[86] Lot levies in the greater Toronto area would add $4.5 million. The developer then has to pay for facilities like sidewalks, roads, sewers, water, lighting and landscaping; these would cost $6.5 to $7.5 million, and interest on these bills would probably add some $450,000 to the annual bill. Since many municipalities now require letters of credit or bonds to secure payment, this bonding would likely add another $100,000 a year to financing costs. Management time and office costs in order to orchestrate all of the above would presumably cost another $200,000 a year — and not a single housing unit has been built yet.

Almost none of those expenses enjoy the same tax-deductibility as in other industries. Furthermore, thanks to the 1992 federal budget, rental housing became almost the only investment in which the owner could not claim a $100,000 capital gains exemption when he resold his property. "The government's decision," said CHBA, "discriminates against rental housing as an investment."[87]

Another assault on affordability was expected to result from the GST. As early as 1985, CHBA was sensing a chilling feeling about what might be around the corner, and started to look at "the implications of the proposal for value-added tax measures on the home building industry."[88] Journalist Garth Turner warned in 1987: "I think [the GST] is a dangerous and backward step. It hurts the risk-takers, kills incentive, raises taxes and threatens the economy."[89] Six years later, Turner became the minister responsible for collecting it, until the Tory debacle of October 1993.

Finance Canada promised business that the GST would reduce overhead: "With GST you should benefit from savings in your operating costs." Furthermore, it promised no additional paper burden: "Documentation currently required for income tax is essentially what you will need for the GST."[90] The GST did the opposite, but Revenue Minister Otto Jelinek insisted that "we know what we're doing is good for Canada — that's why Mr. Wilson and Mr. Mulroney don't lose any sleep at night."[91] Michael Wilson, for his part, told Parliament that "the GST will lead to a stronger economy ... It will make industries more competitive; it will lead to $9 billion more in economic output, equivalent to $350 a year for each and every Canadian. These gains will be shared by all regions of Canada."[92] Coincidentally, Canada went into a recession.

By the time the GST was introduced, the tax had been cut from the initially proposed level of 9 percent to 7 percent. Resale homes were exempted from the tax for a variety of reasons. But the fate of new homes was uncertain, and CHBA's president, Gary Santini, was negotiating for a rebate. This was a ferociously hard sell, since no other industry in the private sector had such an arrangement; but Santini was successful in persuading the government to give a 2.5 percent rebate. The resulting 4.5 percent tax rate for new homes was supposed to be mathematically equivalent to the hidden taxes that homebuyers were paying under the old federal sales tax — just as the entire GST was supposed to be "fiscally neutral." Santini's successor, Gordon Thompson, continued Santini's battle: "The GST, even with the rebate, is estimated to raise the price of a typical new house nationally by about two per-cent or approximately $3,000."[93] Furthermore, added CHBA,

> new rental construction is fully taxed by the GST — there is no rebate as is the case with new ownership housing ... In combination with the fact the GST is also fully payable on operational costs, this ultimately is reflected in higher required rents.[94] ... As a consequence of the GST, average rents for the country as a whole could ultimately rise by about two percent over previous levels. The federal government must take action to remove this discrimination against tenants and rental housing in general.[95]

CHBA was also specific about its calculations for new homes: since "the proposed maximum rebate of 2.5 percentage points is inadequate,"[96] CHBA called for an increase to 4.5 percent.[97]

The effect of the GST on the renovation industry was an even tougher nut to crack. The system produced twenty different ways of handling the GST, depending on the species of renovation project. For years, CHBA's Canadian Renovators Council had been attempting to fight the "black market" in renovations; suddenly its job got much harder. According to Revenue Minister Garth Turner, "Now it's like every Tom, Dick and Harry who rolls up your driveway to build a new bathroom is giving you two prices."[98] *Maclean's* described one Vancouver contractor "who is often offered — and occasionally accepts — cash from customers who wish to avoid paying the GST. He described himself as fundamentally honest, but added, 'If I didn't do it that way, I wouldn't be working.' He said that not all such customers are motivated solely by a desire to save money. 'I did a cash job for a well-off older couple in Richmond. They had the money, but they were really angry about the GST.' "[99] Another contractor reported, again on condition of anonymity, that he got the same treatment in the home of an official of Revenue Canada itself.

It is not easy for Revenue Canada to respond.

According to *Maclean's*, some officials suspect that the real figures are even worse than the wildest estimates; said one, "They're trying to hide an elephant behind a shower curtain."[100] McGill economist Reuven Brenner says that all governments prefer to underestimate the cheating: "They want to minimize it because it [would mean] that there is something wrong with their tax policies."[101]

According to some economists, the upward pressures of the GST on housing and renovation prices would to be countered by the deflationary effects of the 1990 recession. This was another of life's modest "adjustments" — supposedly an economic hiccup that would disappear almost as soon as anyone noticed it was there. It didn't. Although Canada expected to become a post-industrial society, it never expected to become a post-employment society. Builders were caught in the worst of both worlds: land prices continued to escalate, but solvent buyers disappeared. Thanks in part to continuing pressure from infrastructure costs in places like Toronto, in 1990 land prices there rose by 1.6 percent but house prices dropped by 7.3 percent. In Vancouver, in the same year, the percentage rise in land prices was three times that of house prices.[102]

The Bank of Canada, for its part, was busy revisiting its policies of the last recession, namely raising interest rates. Its president, John Crow, described himself as "fanatical" on the subject, and proud of it.[103] The impact was predictable: "Each rise of one percent point in mortgage interest rates (between nine and fourteen percent) means that another four percent of potential homebuyers (approximately 80,000 households) no longer can afford to buy an average-priced resale home."[104] For example, when interest rates are at 9 percent, 31 percent of all renters could afford an average-priced MLS house.[105] However, if interest rates are running at 14 percent, only 12 percent of renters[106] can afford it.

It is not that Canadians were living decadently before the recession. Middle-income Canadians had made no progress in the 1980s: by 1988, Canadians' median income (in constant dollars) was actually $1,400 less than it was in 1980. Whatever progress had been made on housing starts also evaporated: from only 126,000 in 1982, starts returned to a level of 246,000 in 1987, but were back to 156,000 in

1991. When CHBA president Norm Godfrey said in 1987, "We are in an industry that has been on a roller coaster ride of terror,"[107] he never expected that within three years, the industry would be buckling up for another spin.

By 1990, CHBA was already referring to federal declarations on the mildness of the recession as "authoritative myths": there was "a serious discrepancy between the data being reported publicly by federal authorities and the realities being experienced by builders in their markets."[108] Discussions were not producing the desired results: the 1991 CHBA Annual Report referred to "the seeming insensitivity on the part of the federal government to the industry's role in the economy."[109] By 1992, the cumulative effect of the recession and of the other squeezes on the industry were reaching serious proportions. In the words of CHBA's John Kenward, "Frankly I never want to live through another three-year bloody recession."[110]

According to the U.S. National Bureau of Economic Research, the recession ended in March 1991. Unfortunately for people like George Bush, the bureau did not announce that until December 1992. According to *Newsweek*, "It's important for professional economists: their studies will henceforth treat the past twenty-one months as part of an economic upturn."[111] This bit of revisionism, however, did not solve anything. As long as businesses continued their restructuring — in recognition of the revolution in office technology and business practices — the economic future would be a Jobless Recovery. This meant that homebuying would be hampered by the only factor even more damaging than high interest rates: a failure in consumer confidence. People won't spend if they are worried about being "outplaced" or "de-hired." Various parties tried an assortment of supposed remedies: some financial institutions, for example, experimented with longer-term mortgages (ten years to twenty-five years), but got few nibbles. In CHBA's view, the right approach was to allow Canadians to use RRSP funds as down payments,[112] and its president, Gordon Thompson, put particular emphasis on lowering down payments on insured mortgages to 5 percent. CHBA's lobbying proved successful.

In the latter part of 1992, the Bank of Canada

felt that the time had come to put interest rates into gradual descent. This obviously helped homebuyers: "The number of renters able to afford the average-priced resale home has almost tripled since 1990 — due to the decline in interest rates alone."[113] However, CHBA expressed concern that housing prices may become inflationary as soon as the current recession ends. The reason is that "pent-up demand continues to accumulate during the current low level of housing activity." The upturn would lead to a rebound "to levels which will be significantly higher than housing requirements projections indicate — leading to an abnormal increase in costs."[114]

Nonetheless, ownership is what Canadians want. Only 26 percent of renters say they would prefer to continue renting over the next ten to fifteen years. A meagre 3 percent of homeowners state that they intend to move into rental accommodation in the same timespan.[115] It is not because Canadians are fanatical homebuyers: by international standards, we are (as usual) intensely average. In a survey of twenty-seven countries, Canada, Japan, and Italy are tied for the same percentage of homeownership (62 percent).

Ireland has the highest percentage (90 percent), Switzerland the lowest (30 percent).[116]

In Canada, however, it has made good economic sense to be a homeowner. A typical person buying a house in 1961 — with the same shelter budget as a renter — was much better off by 1991: because the home appreciated and shelter costs remained more constant than rents (notwithstanding fluctuations in interest rates), the net worth of that homeowner was hundreds of thousands of dollars higher than that of the renter who started with an identical shelter budget. The margin ranges from a low of $101,000 in Quebec City to a high of $396,000 in Toronto. Similarly, people who bought in 1983 are also in a better position a decade later than those who rented.

To this day, despite the predictions of the experts, the single-family home is shelter for nearly two-thirds of the country's 9.5 million households.[117] The typical Canadian family pays 19 percent of its income in taxes, 16 percent in shelter, and 14 percent on food. However, the figure rises for renters, who pay 19 percent of their income for shelter.[118] This is largely because many renters with low incomes, who

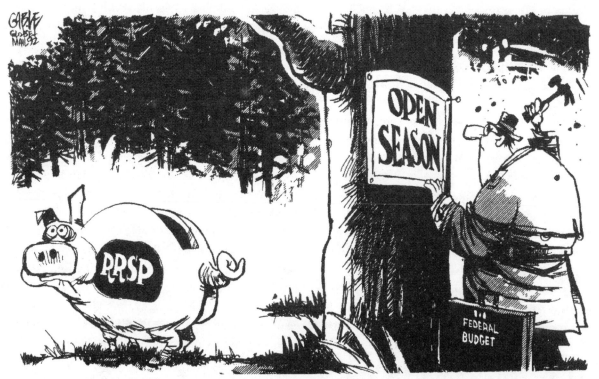

In 1992 the federal government introduced the Homebuyers' Plan, to allow certain funds to be withdrawn from RRSPs and redirected to home purchases. In addition, the First Home Loan Insurance initiative reduced the minimum down payment required for CMHC loan insurance from 10 to 5 percent.

could not afford homeownership anyway, are more seriously squeezed: 36 percent of tenants pay over 30 percent of their household income on shelter[119] compared to only 13 percent of homeowners.

The staggering changes in Canadian demographics have played a role in this dichotomy: for instance, single-parent families accounted for "fully one-third of the growth in family households in the first half of the 1980s."[120] By the same token, between 1961 and 1986, the number of single-parent families nearly tripled and the percentage of non-family households doubled.[121] At the other end of the demographic spectrum, in the late 1950s almost 56 percent of families included three or more children. Today, this figure is reduced to 20 percent, and one-child families account for 35 percent, up from 11 percent in the past. This is a recipe for a large population of "empty-nesters" hanging on to their homes until it is time to plant tulips in Victoria or play shuffleboard at Tampa Bay. Not surprisingly, the incidence of ownership peaks in the 45 to 64 age group: three-quarters of these households are owners.[122] If and when these owners unload their houses on the market, there may be a crash in demand for new housing. This might be offset if there is an upturn in immigration — which builders would like also, because it could replenish their aging supply of skilled tradespeople — but that is a tall order. Although Canada today admits only half the number of immigrants that it did before World War I (and only one-eighth the number in proportion to population), it is historically difficult to interest Canadians in raising immigration quotas in hard economic times. So where are new homebuyers going to come from?

This demographic prospect poses the greatest challenge to the homebuilding industry, after the recession ends (whenever that may be). That causes a catch-22, however, because the recovery of the industry is a necessary part of the recovery from the recession: the industry is so large that it carries much of the Canadian economy on its coattails. Between 1946 and 1986, total spending (in constant dollars) on Canadian housing grew by some 500 percent.[123]

It is fashionable in some circles to assume that in the light of such figures, builders, developers, and other real-estate people must be "fat cat" manipula-

tors of gigantic, speculative profits. Granted, some of them — in today's correct parlance — are "calorically challenged"; and some, like Robert Campeau, are retiring to castles in the Alps despite the slings and arrows of recent years. The statistics, however, paint a different picture of the homebuilding industry. First, the rate of attrition has been horrific. Of the sixty-two firms listed in the Halifax area in 1962, for instance, only five were still in business by 1986. Furthermore, economists agree that heavy competition remains a feature of the industry: "Even ... where large builders are most dominant, these firms do not control sufficiently large shares of the market to allow the opportunity for collusive pricing practices."[124] The effect on profit margins is clear: "With the exception of the mid-1970s, homebuilders have, on average, fallen considerably short of the ten percent rule of thumb for profits ... The average profit margin in [a good year like] 1984 was only 3.6 percent."[125] Housing is no gravy train, despite the fact that, in heady years like 1986, residential construction spending was estimated to have generated more than one million person-years in employment: nonetheless, "its importance in the 1980s was less than it has been during much of the post-war period, particularly the 1950s and the 1970s."[126] That is the challenging picture which still lies ahead for the industry.

So where does that put the Canadian home in national economic policy? In 1993, Finance Minister Don Mazankowski declared that "homes are nothing less than the starting point of any community — the primary infrastructure of any nation ... The homebuilding industry is a vital engine for economic renewal and growth. That is why our government has taken a number of steps to stimulate the housing industry directly."[127] CHBA replied that "these words must be reflected in action."[128]

CHBA told the federal government that Ottawa has

> no national strategy in relation to infrastructure ... There is an absence of coherent national policy in relation to housing and the environment; there is a lack of coordination within the tax system ... The federal government has not ade-

quately responded to critical issues in the real-estate market involving rental housing and renovation; the federal government commitment to social housing has been subject to *ad hoc* reductions; the federal government has raided CMHC's Mortgage Insurance Fund — a critical resource for financing housing and improving financing mechanisms; federal government research and development allocations in the housing area have been severely reduced; [and] there is no export strategy for Canadian housing technology.[129]

In fairness, CMHC has been working on these issues with CHBA, and the byword is "consultation," not confrontation. Eugene Flichel, the CMHC vice president who succeeded George Anderson as president when the latter returned to the private sector in 1990, continued the policy of building rapport with other stakeholders on behalf of what CHBA's president, John Bassel, called "the country's most efficient and cost-effective crown corporation."[130] When media reports suggested that new constitutional arrangements might dismember CMHC, Gordon Thompson, then CHBA's president, issued repeated statements of alarm; and when CMHC was threatened with cutbacks, CHBA told the government that "CMHC has done extraordinarily well with current resources, and continues to have an important role to play in the housing of Canadians ... The Corporation should be getting more attention from Cabinet."[131] Furthermore, said CHBA, CMHC's *Strategic Plan 1992–1996* and its 1991 policy and research initiatives "demonstrate the breadth and importance of CMHC's role."[132] It is not that industry and bureaucracy have performed a total flip-flop from their sometimes frosty relationship of a generation ago. That is partly because the old relationship was never quite as sour as the rhetoric suggested: despite the periodic mutual denunciations, both builders and officials realized that the public interest in housing needed them both, and day-to-day cooperation was a necessity. Otherwise, joint projects like

the Mark houses could never have happened.

The fact remained nonetheless that over the course of some forty years, the people responsible for Canadian housing periodically "went ballistic" with each other. That is what has changed today. This is not because there is always consensus about the best interests of the Canadian home; but since each side now has an excellent picture of the other's philosophy and agenda, builders and officials have less occasion and inclination to turn their debates into major events.

A somewhat different methodology exists among the realtors. Their lobbying activities bear more resemblance to the Washington model — even in the choice of terminology. The Canadian Real Estate Association (CREA), in its publications, refers to its political liaison group by its American acronym PAC (Political Action Committee). It has produced a *PAC Training Manual,* which it claims is "invaluable in establishing a solid relationship between realtors and those seeking public office in Ottawa."[133]

CHBA and CREA also derive their political and financial strength in slightly different ways. CHBA is based on a voluntary membership of some 12,000 firms; but it also has the clout that goes with the economic dimensions of the industry. As of 1990, spending on new housing and renovation totalled some $42 billion, or 7 percent of Canada's Gross Domestic Product; it created jobs directly and indirectly, amounting to 1.3 million person-years. CREA, on the other hand, has the Multiple Listing Service as both a funding source and an inducement for some 90,000 realtor members.

MLS is tied to 111 real-estate boards in Canada. "Unlike some professional organizations — such as those for lawyers and doctors — real-estate associations and boards do not have the statutory right to set up entry requirements and to revoke the licenses of realtors for unethical conduct. It is the potential loss of board membership, and with it the loss of access to MLS, that prompts most members to adhere to a code of ethics and regulations."[134]

The emphasis on ethics and professionalism is common to both these organizations. Bill Strain, who became CHBA's president in 1993, waged a long campaign to entrench training at the top of the agenda of every component of the housing industry;

and the very first page of the *CHBA Strategic Plan for the '90s* is a Code of Ethics, which, since 1989, is backed up by a Code for Disciplinary Conduct. "The future," said CHBA's president, Tom Cochren, "will be decided by our commitments to training and education, technical research, consumer education and counsel, sales and marketing, and regulatory reform."[135]

In retrospect, the creation of Canadian homes has gone through six major eras. During prehistoric times, most Canadian natives created their own shelter, except for the presence of some specialized trades on the West Coast. With the coming of the Europeans, there was a split: many people still built their own homes, but Champlain also arrived with crews of trades that specialized in constructing for others. This incipient professionalism could not come to fruition, however, in the absence of organizations to push for standards; these did not start emerging at the local level until the early part of this century. A national commitment to professionalism was clearly enunciated after 1943; but it moved down the agenda after 1958, as the builders' association shifted priorities in the direction of technology, marketing, finance, and (in the 1970s) warranties. By the 1980s, however, the development of more sophisticated organizational methods, like strategic plans, allowed these goals to be pursued more systematically and simultaneously, and "professionalization" could again share the top of the agenda.

Debates over "professional" status in today's residential construction industry do not imply that the housing of previous generations was any less an achievement. From prehistoric times, shelter has been a favourite focus of human ingenuity, and Canada's has been no exception. The passion with which heritage organizations can fight for even "ordinary" houses is testimony to the pride that these buildings have elicited in our communities.

That pride has been severely tested. In the twentieth century, our housing — including its design, construction, and very *raison d'être* — came under withering academic attack, and sometimes suffered disastrous losses in the name of government programs, tax give-aways, and ill-advised management; yet the Canadian housing tradition survived nonetheless, to provide world-class shelter for today

and inspiration for tomorrow.

In that process, Canadians have learned about accomplishments to emulate and mistakes to avoid. We can take particular pride in the government's technological support programs that EMR (now Natural Resources Canada), CMHC, and NRC devised to improve the industry's product. "[Where] National Building Code standards applied," said CHBA's president, Gary Reardon, "[and] CMHC has helped to implant sound approaches to servicing ... these development standards have [contributed to] the health and safety of all Canadians today."[136] This technical support is essential, said Reardon, because "only institutions operating on a national scale can achieve the critical mass needed to carry out R&D programs for housing on an efficient [basis]."[137]

The builders also played an unprecedented role by insisting that the Canadian home should remain a consumer-driven product. Paul Hellyer, who was the minister responsible a generation ago, recently offered this conclusion: "One of the most fascinating discoveries from that experience was that the 'experts' and ordinary citizens held virtually opposite views on almost everything."[138] To pick just one example, if it had not been for the lobbying of the builders in the 1940s, most Canadians might today be living in prefabs of plasticized asbestos and urea formaldehyde. It is also the builders who stood their ground when experts recommended mega-companies to produce politically correct, Modernist, assembly-line houses. This is only one of many reasons why the builders developed a horror of being reduced to mere "workies" for the governmental experts, now and for the future. It is also the reason why CHBA president Bill Strain argued in 1993 that "CHBA is not only the home of the homebuilder; it is the home of the home."[139]

Some issues have been more difficult to solve than others. Among the builders, Jack Price and the other founders of the original National House Builders' Association would probably have been surprised to learn that "professionalization" turned into such a tough nut to crack. The government has also had its share of hurdles to overcome; and the greatest lapse in that regard, yesterday as today, has been on the tax front. Both the housing and renovation

industries operate in a fiscal Oz: Canadians pay idiosyncratic taxes when building houses; they are subjected to a unique accounting system concerning the write-off of their expenses; they are treated to such a maze when renovating or repairing that neither the courts nor the GST system can figure it out; they are presumed to suffer cataclysmic devaluation of the rental housing they own; and they are paid to tear housing down. The system is so divorced from either the realities of daily life or the precedents in other industries that there are continuous calls for fundamental reassessment. But Ottawa's tax gnomes have repeatedly chosen to duck that process by offering stopgaps, each of which made the treatment only more artificial than it was before. The Canadian home never deserved to be turned into such a make-work project for accountants.

At least Canada's housing officials are now more careful about "artificial" programs. That's easy to say, because they are also under less immediate demographic pressure to produce ad hoc programs. For forty years, the baby-boom kept throwing the housing system on its head: in the 1950s, as millions of Canadians raised boomer children, there was hysterical pressure on the suburbs. When boomers of the 1960s moved out in search of some "groovy pad," intense pressure shifted to downtown apartments. Young boomer families moved into the market for homes in the 1970s, and the demand for starter homes like townhouses promptly went crazy again. By the 1980s, double incomes and the Yuppie lifestyle fuelled the market for larger houses, and that pattern may not encounter drastic changes until some years from now, when boomer empty-nesters decide to change their housing yet again.

During these various eras, there has been a strong temptation for statisticians and pollsters to be misled: they could mistakenly assume that as demand shifted from one kind of shelter to another, Canada was undergoing a gigantic cultural shift in its tastes — when the real change was based (predictably) on the evolving needs of individuals as they progress through life, not on some transcendental upheaval in social psychology.

Granted, many changes did occur that were, indeed, cultural. Fifty years ago, the "open-concept" of linking rooms was almost unknown; the idea then grew exponentially, but is now in some retreat again. The "den" rose in importance with the advent of the "family" television, then dropped in importance as boob-tubes spread elsewhere in the house. At present, the kitchen is regaining influence as the family hub; how long it will stay there is anyone's guess.

But there are limits to the extent that we can explain houses in terms of social psychology. At some levels of consciousness, a home cannot be defined; it can only be "felt." Since shelter is one of the primal needs of the human species, it should not be surprising that houses can elicit a visceral, tips-of-your-toes response, independently of any intellectualized factors. In some cases, the response is *too* visceral: given the fact that a home is "the investment of a lifetime," a few precautions seem in order. New homebuyers, for example, are urged to consult their builder's warranty record, which is published by the warranty programs. Canadians may be shocked to learn that "the average person buying a home, be it a condo or single family home, spends seventeen minutes looking at a house before [making] a decision to buy."[140]

In a sense, that gives the Canadian home short shrift — but most Canadians seem to survive nonetheless. The housing industry appears to have met Canadians' expectations. As of 1988, 53 percent of Canadians said they were "very satisfied" with their homes; 31 percent were "somewhat satisfied"; 10 percent were "not very satisfied"; and only 5 percent were "not at all satisfied."[141] Even a portion of the category that is "not at all satisfied," however, might have enjoyed a happier fate if they had looked before they leaped — and asked a home inspector to investigate a resale house before they bought. "Safety is the number one reason to get a home inspector, who will probably charge about $300. But it also may give you some leverage in negotiating the house price. If, for example, you know it's going to cost $2,000 to fix something, you might be able to push the price lower by $2,000. However, you should note that there is no regulatory agency, federal or provincial, that governs home inspectors."[142]

Canadians might also derive some satisfaction in reflecting on more than the emotional aspects of their homes. Although much ado is made of affordability — and rightly so — it is nice to remember that the new Canadian home of today absorbs

roughly the same percentage of family income as did the new Canadian home of fifty years ago. That may not sound remarkable — until we compare the median house of 1993 with its counterpart of 1943. The consumer gets, to put it mildly, a lot more house; and that house outperforms virtually any counterpart in the world.

It wasn't easy to do this; but as CHBA president Tom Cochren emphasized, increasingly sophisticated techniques could deliver greater quality without sacrificing affordability. In the words of one CMHC publication,

> Over the last fifty years, more than four months have been shaved off the time required to take a building from excavation to completion. And on-site person-hours required in the construction of the home have decreased from 2,400 in the 1940s to less than 800 today ... Yet operating costs to the Canadian home-

owner have decreased through the decades ... In addition, homes today are more energy efficient and environmentally sensitive than would have been dreamt of even twenty years ago, and the housing industry has assumed a leadership role in the renovation and renewal of the existing housing stock — showing how 1990 technologies can be applied to all housing.[143]

Where does that leave the Canadian home today? As of June 1993, and according to Norwegian professor Anne Grete Hestness, "Canada leads the world in housing technology."[144] To take just one example, Canada's Advanced Houses are the first of their kind, and have the jump on all foreign counterparts being developed under the auspices of the International Energy Agency in Paris. This country's work is so authoritative that when other countries produce energy-measuring software, our data is used

Hot research. This building incurs smoke damage about once per month, not because its location near Almonte, Ont., is overrun with pyromaniacs, but because this is one of the National Research Council's fire labs. The NRC's Institute for Research on Construction (IRC) tests a wide range of housing materials and techniques that help put Canada in the international forefront of housing.

Canadian housing received the highest accolade that the real-life international business community can bestow: our technology is being "borrowed" by the Japanese. R-2000 systems are being used under licence, Canadian firms are selling into the Japanese market, and this Edmonton-designed complex called Maple Court is being built in Osaka with Canadian methodology and a Canadian crew. "Canadian framers [will] handle the first 22 units, and … Japanese framers [will] build the second 22. Seminars also are planned for Japanese builders and professionals."[145]

as the basis on which to check the accuracy of their computer programs. In the U.S.A., the National Fenestration Rating Council uses Canada's work as its basis to assess the performance of windows. Phyllis Lambert's brainchild, the Canadian Centre for Architecture in Montreal, has become a priceless resource for researchers from around the world; and on the technical front, Ottawa's Institute for Research on Construction plays a similar role. Japan is busy copying R-2000 housing as the basis of techniques that it acquired from Canada under licence. In short, Hestness's opinion is shared by countries around the world.

And then there was the professor from Denmark who travelled halfway across the world, to the Innovative Housing Conference in Vancouver in June 1993, to present a paper on state-of-the-art Scandinavian window technology.[146] After hearing the presentations by Canada's counterparts, he admitted to some "embarrassment" as he returned his paper to his briefcase, since the Scandinavian work had been so outclassed. In the finest tradition of European academics, he then filled the rest of his allotted time discussing another subject altogether.

"When the shoe drops": IRC conducts tests on, among many other things, the acoustic properties of houses. For scientific accuracy, it consistently uses the same pair of shoes on various floors; IRC also has special machines to bounce tires, weights, and other paraphernalia off potentially noisy building components.

Future Chic, Future Shock, and the Electronic Cocoon

Beyond 1994 ...

In which Canadian housing to come includes predictions about the ultimate mobile home; tubs go soft; ornithopters replace cars; houses are designed by cads, and cities' answers are blowing in the wind (or above the clouds); Canadians sleep with the fishes, and houses keep your coffee warm; and some Canadians find a mission to boldly build where no one has built before.

Over the hills and through the woods
To grandmother's condo we go.

Bumper sticker

Some behaviour baffles scientists. From time to time, an entire generation of a species does the inexplicable: we are told that groups of whales will beach themselves, hordes of lemmings will jump into the sea, and a multitude of aging baby-boomers will take up golf.

Yes, say some experts, the house of the future will be a residential nineteenth hole: the aging of the baby-boom population will reputedly translate into "low-maintenance, high-amenity homes with access to recreation such as golf."[1] Perfect houses, by that reasoning, will be those designed for people who believe that when you're over the hill you pick up speed and who look for a maximum of "personality" with a minimum of maintenance. That isn't what pundits previously expected.

Some years ago, soothsayers predicted that by the end of this century our homes would be as sleek as spaceships. Robots would do the housework, and computers would fix the morning coffee. While such technology is possible, nobody asked consumers what they wanted ... They did not long for a high-tech "machine for living" with computerized gadgets. The qualities they did want included "comfort and tradition, combined with the best of relaxed modern conveniences in a family home that expresses personal style."[2]

The materials of such homes are the subject of debate. "Most experts on housing trends believe the typical new home at the end of this decade and century will look much like today's, at least on the outside, and will be built largely of today's materials: wood, brick, concrete."[3] Others disagree. "At one time, we had to settle for whatever Mother Nature gave us. Now if we are not satisfied we can go out and create our own materials."[4] In Massachusetts, General Electric has built a house in which the wall finish, shingles, floors, doorframes, light fixtures, and plumbing are plastic. It is the heir to an all-plastic house built in Paris in 1956; a variety of imitators followed suit (including one at Disneyland). Some claim that Buckminster Fuller fathered an all-plastic house in 1955, and that there were even all-plastic houses in Berlin in 1945–46. For its part, the University of Florida is currently looking at the durability of houses built of styrofoam. According to Jay Leno, at least "your coffee wouldn't get cold."[5]

Some predictions appear prosaic. One report for CMHC expects that houses a decade hence will look almost identical to those of today — except that the fieldstone, clapboard, shakes, and shingles will be fake: they will be "light insulating precast concrete" or "reconstituted wood."[6] Other predictions have been less conventional, so exponents build demonstrations of their "house of the future." Acorn House, by Carl Koch in 1948, was the first folding house; in 1972, Alberto Rosselli built another folding house on the principle of the accordion. If people were otherwise unenthused, French architect Guy Rottier fashioned a cardboard house in 1968, with instructions on how to trash it the next day.

French designers also speculated about future houses built in the shape of an egg or a spiral; others reflected upon houses based upon the principle of the snail (or, more elegantly, *l'escargot*). The egg, according to industrial designer Raymond Loewy, has an ideal profile: "The shell, despite its thinness, can withstand pressures of eighteen pounds per square inch, applied gradually, without breaking … A marvellous example of aero-dynamism for an object which moves slowly. Any other shape [a cube for example] would render the life of hens impossible."[7] A house of this kind was accordingly built in France.[8] In Canada, Guy Gérin-Lajoie recommended struc-

tures built of modular rooms with "each unit, shaped a little like an igloo, four metres square and positioned on a steel grid in endless configurations. Like a Lego set, the units can be linked."[9] This was akin to hanging the rooms of your house on a giant coat rack.

Not to be outdone by architects, decorators have also issued predictions on the house of the '90s and beyond. Aside from the prevalence of green, the new décor is expected to emphasize the exotic. Wildlife is also expected to be *the* theme of this environmental decade: "Artifacts from far away countries such as Africa and South America are hot decor items … so are animal prints with zebra or tiger motifs."[10] Few Canadians, however, are expected to imitate the homeowner in Rivière-au-Renard, Quebec, who decorated his house with sculptures of giant spiders.

Another theory is based on the assumption that just as civilization's aesthetic pendulum has swung in the past, so it will swing again — and has already begun doing so. To Mies's dictum "less is more," the future would respond "more is more," or even "busy is beautiful." By this reasoning, Canadian home decor will eventually look like a cross between Eaton's Christmas storefront and the cake department at Woolworth's.

Rooms in the Canadian home are also expected to evolve. McGill's Rybczynski argues that bathrooms are too austere, considering that they are often "the only totally private room in the house."[11] But what good is privacy if Canadians cannot luxuriate in an extended soak? Although writer Edmund Wilson

The home of skater and artist Toller Cranston in Toronto. Will the 21st century inaugurate a latter-day baroque?

wrote that "I have had a good many more uplifting thoughts, creative and expansive visions — while soaking in comfortable baths in well-equipped American bathrooms than I have ever had in any cathedral in Europe,"[12] that only led CBC's Arthur Black to suspect "that Edmund Wilson — Giant of American Letters — wasn't an inch over five foot two."[13] The comfortable bath, says Black, requires a future tub that is bigger, has its knobs at the other end, and is *soft*.[14]

Lest the Canadian bathroom descend into Roman-style decadence, other experts predict that it will evolve into a gym. Further changes are also suggested. Noting that cats now outnumber dogs as pets in North America, Vancouver's Doug Medly invented a flush toilet for cats. He is certain his "idea will catch on."[15]

The bathroom is hardly the only subject of prediction. The *New York Times* showcased a bedroom whose motorized bed rises to the ceiling, creating office space below. "The designers suspended the bed near the ceiling on a system of pulleys, equipped with a one-third-horsepower motor so that it can be lowered at night. Pull-out storage drawers, used as a desk during the day, roll out to become the base of the bed."[16]

And then there is the garage. Although French writer Michel Ragon referred to man, wife, and car as the twentieth century's *ménage à trois*,[17] this may not last far into the twenty-first century if some people at the University of Toronto have their way. The family garage may no longer be used for cars, but for ornithopters with ten-foot wingspans. Ornithopters are flapping-wing aircraft, and are being tested 100 kilometres north of Toronto by the U of T's J.D. De Laurier and his American colleague J.M. Harris: "People could fly like birds."[18]

Even more dramatic changes would supposedly hit the kitchen. One CMHC report predicts "a computer-based control centre."[19] Not everyone is enchanted with this prospect; in the words of Arthur Black, "I live in a world full of magical domiciles that are in turn crammed with voodooistic totems — microwaves and VCRs, electric-eye garage doors and refrigerators that talk back to me — and I understand none of it. Actually, there are quite a few of us around. We bite a lot of nails."[20] But the tide in

Canada is moving in that technological direction, led by Alberta. Albertans are the most gizmo-happy homeowners in Canada — 57 percent have gas barbecues (compared to 31 percent in Quebec) — and Albertans also have the most microwave ovens, automatic dishwashers, and VCRs.

That is still nothing compared to the electronic invasion predicted for the future. The house itself, of course, is predicted to be totally computer-conceived: it will rely upon CAD (computer-aided design) and CAM (computer-aided manufacturing). Detailing may be assisted by Virtual Reality, a new computer technique that was a hit at the 1993 CHBA convention. Virtual Reality allows a "three-dimensional" analysis of buildings: with the help of a view screen, a homebuyer or architect can virtually walk through the structure, open and shut doors, and "be" in rooms. There is less agreement on how this will affect its appearance: Frank Clayton predicts "no major technological shake-up arising from computer-based technologies."[21] Others argue that the very notion of *home* will change to reflect the growing role of electronics in our lives.

The American writer on trends, Faith Popcorn, predicts that the house of the future will be so encrusted with technology that it will be seen as an "electronic cocoon."[22] Two Washington experts, James A. Smith and John D. Rivera, argue that the product will be so complex that it will not be repairable: the whole house will have to be replaced when components break down,[23] which is like trading in your car when the ashtrays are full.

The path to that future is reputedly being paved at this very time: according to David Nagel of Apple Computers, "We'll see these [next] couple of years as a real turning point in the way we live, work, and play."[24] The reason, says *Newsweek*, is that the role of the computer in the home is about to change. "For all its billions in sales, the computer revolution has reached only fifteen percent of American homes by some estimates — largely because people really don't need expensive and complex machines to balance their checkbooks. The next revolution will involve computers that consumers will actually be able to use — and might *need* to use." Reputedly, the computer-based house also re-opens a lifestyle that has not existed for centuries: the return of the office to the

home. Work would be done by electronic hook-up — but so would banking, shopping, and bill paying. High-tech companies are crawling over one another to make this a reality. Other observers, however, agree with Neil Postman,[25] who says, "You'll never have to go out and meet anyone. Is that great? It's a catastrophe!"[26]

Still other writers have headed in the opposite direction. Instead of a world of homes for hermits scattered across the landscape and linked only electronically, Iannis Xenakis — better known for music than architecture — says giant highrises are closer to Le Corbusier's Heroic vision. Xenakis should know: he worked for Corbu for twelve years and claims to have carried forward his Heroic vision of the future city. Xenakis's book *The Cosmic City* insists that "the interior architecture of the cosmic city must orient itself towards the notion of interchangeable units, which can be adapted to the most diverse uses: internal nomadism [population movements] tends to grow once you reach a certain threshold of progress. The architecture of mobility will therefore be the

Journals have made much ado about architect Paolo Soleri, who has been busy designing "arcologies," namely mega-structures to accommodate, say, 170,000 in a single building like the one above. According to Iannis Xenakis, an entirely industrialized and standardized technology "will transform the city ... The great altitude of the city ... would permit 2,500 to 3,000 inhabitants per hectare ... putting the population in contact with the vast spaces of the heavens and the stars: the planetary and cosmic era has begun and the city must be turned to the cosmos and its human colonies, instead of crawling on the ground."[27]

fundamental characteristic."[28] Kenzo Tange, a Japanese theorist much beloved of architecture schools, inspired an entire movement called the Metabolists, who proposed mega-structures by the sea, under the sea, and over the sea. Each building is designed for 10,000 residents. In 1960, the prestigious Premier Grand Prix de Rome was awarded to Jean-Claude Bernard for his concept of a "total city," namely an entire city in a single building, which Bernard called a "labyrinth." A proposed vertical city for 250,000 people won the Cannes Grand Prize for international architecture in 1970. One Tokyo group is working on a design for a 500-storey building to accommodate 300,000 people.

Buildings of that size need to adopt peculiar shapes to be even remotely livable. One proposal was an immense concrete wok, with trees in the middle of the bowl, looking like giant bok choy. In 1965 two architects in Madagascar proposed Atelopolis, a city built like a Great Wall, up to 400 metres high and 35 metres wide. A smaller version was suggested by one London firm, with highways on the roof; they called their concept Motopia. Stanley Tigerman proposed cities built like pyramids. Buckminster Fuller suggested a tetrahedron to house a million people.

Fuller's pet project, however, was the geodesic dome; he experimented successfully with the dome at Montreal's Expo 67, but this was intended only as a demonstration for larger things. Fuller's ally William Zeckendorf, the builder of Montreal's Place Ville Marie, told Toronto homebuilders that geodesic domes are the "dawning of a new concept in housing." Together with Fuller, he was proposing to cover entire cities with domes.[29] Zeckendorf, however, was late: five years earlier in Calgary, Enrique Fernandes Iglesias had published his theory of Temporalism, namely mega-structures to be built over existing cities.[30]

These designs were hardly the only ones for gigantic expanses: after the success of Houston's astrodome, various architects fell in love with inflatable buildings. In Canada, the Interdesign group proposed an inflatable city:

> The buildings of ten to seventeen storeys, entirely inflatable, would be prefabricated and erected in a rela-

tively short time. A city of 100,000 people could be built within six months ... screens would permit rooms to be set up with a system of hooks on the ceiling and on the floor, thereby allowing great freedom of expression in interior design ... after several years of use, the inflatable buildings, with the exception of the concrete foundation necessary to support the central core with the elevators, could be dismantled and re-assembled elsewhere.[31]

But if the city was inflatable, why not take extra advantage of that fact? Again Fuller led the way: in 1967, he patented a design for communities in "tensegrity spheres," which could be tethered or, on the whim of their inhabitants, be allowed to float away on their own hot air. Tensegrity spheres have elicited many studies at Carleton University's architecture school.

However, portable cities would not need to be confined to the floating variety. The British Archigram group designed a mobile home for several thousand people, the Walking City. It was intended to embody the "concept of modern society as mobile, dynamic, and ever discarding the obsolete to embrace innovation."[32]

But while Archigram's giant bugs crawled across the land, other structures were expected to take up positions. "The architecture of tomorrow," said Roger Taillibert, the architect of Montreal's Olympic Stadium, "will be aquatic."[33] Why should, say,

The University of Western Ontario is part of a group currently developing plans for highrises targeted for their most logical destination: Tokyo. The first is called the Millenium Tower, and would have 150 storeys. Its design is being tested in Western's wind tunnel (left).

Buckminster Fuller's "tensegrity spheres" would enclose cities that would be lifted by air, heated by the sun with the help of the special plastic skin that surrounded the sphere. This would produce "floating ... cities, air-deliverable skyscrapers, flyable dwelling machines — and much more!"[34] There is no evidence, however, that Ottawa was or is enthused about the notion of a city whose own hot air might cause it to float away.

Toronto stop at the lakeshore just because Lake Ontario is there? Why couldn't Vancouver's Skytrain link suburbs built at the bottom of Georgia Strait? After all, there is already an underwater hotel off the coast of Florida (guests get to their rooms by scuba). For the less courageous suburbanite who prefers to wake up mornings on the surface instead of underwater, the English architects Mowgridge and Martin proposed a floating sea city. A variety of proposals have also come forward for floating cities off Monaco (some with the assistance of Jacques Cousteau). Paris's Yona Friedman proposed eight bridge-cities to tie the continents together, including a 150-kilometre bridge-city across the Bering Strait. "It would be the easiest to build," said Friedman, "because there is no marine traffic through the strait: it is therefore possible to build it as a floating bridge."[35] Canadians might also feel at home with Rudolf Doernach's proposed city on a refrigerated iceberg.

The sea has not been the only preoccupation of the journals. Futurist Herman Kahn predicted that the next two migrations of humanity will be toward the sea and toward space, so could architects and developers be far behind? One NASA-sponsored conference invited participants to "preview prime real estate at the World Space Congress."[36] "We have a good idea," says Princeton's Gerard O'Neill, "of what the cities in space will look like. During the 1970s, the National Aeronautics and Space Administration (NASA) sponsored two studies on the design and construction of cities in space ... When all factors were considered in the NASA studies, the preferred shape proved to be a sphere ... for 10,000 people. Ultimately, the construction of space-cities will be an industry itself ... Scientists foresee a gradual migration of the human species throughout our solar system."[37] O'Neill proposed cities that would float through space, rotating to create their own gravity. Others described the settlements on other planets. According to *Life* magazine,[38] the process of suburbanizing Mars can begin as early as 2015. "Biospheric towns" can start to be erected around 2115; and the ultimate witness of suburbanization,

Architect's plan for the Walking City: "These complexes would meander across the landscape like gigantic bugs, forming aggregates with other mega-structures, and uncoupling for a while to seek new configurations."[39]

the car, could arrive by 2130. Today's suburbanite will feel right at home: "One fine day we'll see the first traffic jam in space."[40]

The idea is to turn Mars into a model subdivision. The average temperature on Mars is colder than in Edmonton in January, but that is no obstacle: by churning carbon dioxide into the atmosphere, we can do "global warming" to bring the climate to comfortable levels, and even melt the Martian permafrost. The result will purportedly be Yuppie heaven. "Rushing streams, ample rivers, large lakes, and substantial oceans will have formed. The oceans will be carbonated and not yet salted — oceans of Perrier."[41] No wonder *Life* calls it "the promised land of the twenty-second century":[42] residents will "drive golf balls more than half a mile, commute to the office by parasail and leap small trees in a single bound in pursuit of genetically altered Martian moose."[43]

Canada's role in this human epic has received considerable press. A generation ago, Eric Nicol predicted that "Canada is assured a place in the race for space. So that he will be ready for a rocket landing on planets where deadly gases foul the atmosphere, extremes of temperature make life unbearable, and

hostile inhabitants must be expected, every astronaut will complete his training with a stay in Toronto."[44] Sudbury was actually used instead.[45] The Department of National Defence has its own Cosmic Control Officer[46] and some Canadians claim to have already discovered tasteful interplanetary decor. In his book *The Wall of Light*,[47] Henry Matthews describes alien tourists visiting Lac Beauport, Quebec. Their spaceship quarters had "a small hallway, a large living room, bedroom, bathroom with toilet, and storage locker. All rooms were carpeted ... [and] the outer door of each compartment led out to a small flower-bedded garden."[48] The aliens took Matthews on many interplanetary trips including one to Mars, which "reminded [him] of our beautiful Eastern Townships."[49]

Although reports such as this have not led the National Research Council to ponder interplanetary broadloom, the NRC and the Canadian Space Agency nonetheless have their own plans for real estate among the stars. These extend beyond the medical work that Canadian astronauts have done on human habitation in space; Canada will also be assisting in the construction of an orbiting space sta-

tion. Canada's share will be the maintenance facility, a kind of giant interplanetary garage.

The fact that Canada has not yet started to build in space has not stopped some developers from trying to build Buck Rogers cities on earth. The consummate example of this was a mega-project in Hull proposed by developer Glen Kealey. Kealey's nemesis was Roch Lasalle, former public works minister, who was never anxious to move into this "city of the future." In short, Kealey couldn't find the right people who would pay good money for the pleasure of living or working in a set from *Star Trek*.

This consumer reluctance has been the bane of every futuristic proposal. Ultimately, the reason why Buck Rogers cities have not been built by now is not technological (the technology is available), nor is it even economic (the cost of Brasilia was equivalent to only three of today's aircraft carriers). The problem is that most mortals share the sentiment that Joan Kron ascribed to Americans: they "may be fascinated with the future, but they don't want to live in it."[50]

Besides, "sweeping, confident articles on the future," said Kenneth Clark in his *Civilisation* series, "seem to me, intellectually, the most disreputable of all forms of public utterance."[51] Clark founded this view on the notion that the world is simply too unfathomable, and he quoted J.B.S. Haldane: "My own suspicion is that the universe is not only queerer than we suppose, but queerer than we can sup-

pose."[52] It doesn't take much of a miscalculation to turn a "house of the future" into a laughingstock. On the other hand, perhaps the flaw in the models of future cities is not that they are unpredictable, but rather that we can predict only too well how Canadians and other peoples would react to, say, Yona Friedman's bridge-city over the Bering Strait, or Rudolf Doernach's city on an iceberg: who wants them? Would anyone who has ever spent February in Winnipeg volunteer to live on an iceberg 365 days a year? And if no one has yet built Archigram's megastructure on movable stilts, it is perhaps because there aren't many people who want a home that looks like a giant bug in search of a mate.

Instead of embracing grand predictions, Clark's preferences were so prosaic as to "reveal [him] in [his] true colours, as a stick-in-the-mud."[53] There is something to be said for sticks in the mud. In a skit about an astrophysicist, Sid Caesar was asked to name the greatest problem in space; he offered the reply "closet space."[54] It is in the same prosaic vein that the Clayton Report made its own predictions about housing, at least over the next decade. Instead of a list of technological bells and whistles, the authors focus on:

- "Continuing preference for homeownership";
- Reduced demand from traditional buyer groups (notably baby-boomers) and new families;

The Canadian Space Agency's depiction of this country's share of the proposed permanent space station. Canada is the first country to have staked out a formal claim to the interplanetary renovation business.

Glen Kealey's futuristic mini-city proposed for Hull would have relied on the federal government to become his principal tenant; when this didn't materialize, he was ruined and spent the next several years on the grounds of Parliament Hill bellowing that Brian Mulroney and his cabinet were descended from a long line of bachelors.

- A growing focus on "lifestyle housing" (with special amenities) including growing popularity of highrise condos and one-storey clustered housing villages;
- A decline in average size of new single-family homes;
- Continued increases in renovation activity; and
- The "intelligence [computerization] of new houses will increase."[55]

Rybczynski takes a comparable view. He argues that the largest single change in the house of the future will not be designs like a flying saucer, but ergonomics — the science of human comfort. Some practitioners used to call it Human Engineering — but that sounded too much like what Dr. Frankenstein did in his lab. Ergonomics, say the experts, will help Canada design kitchens where appliances are easier to reach, bathrooms are more convenient, and the home is generally easier to manage.

But if builders focus on these consumer-inspired improvements, will even these be appreciated? Some observers are cynical about the "ordinary Canadian's" ability to comprehend innovative thinking on the subject of housing. "Canadians don't like cleverness," says architect Raymond Moriyama; "We design and build more scrupulously than Americans tend to do. We have to, with our climate and our more cautious national character."[56] Other writers argue that consumers are better informed than they are given credit for, regardless of their nationality. In the words of Prince Charles, "The man in the street knows exactly what he wants, but he is frustrated by form-filling and the mystique that surrounds the professionals. I want to see laymen and professionals working together."[57] This participation is demanded by the citizenry, not as a matter of privilege but of right.

That demand is hardly new. "A comfortable house," said American writer Sydney Smith in 1843, "ranks immediately after health and a good conscience."[58] In the mid-1980s, the Housing America Foundation attempted to assess how important housing was for Americans; it discovered that "buying a home ranks fourth in priority, just behind good health, job security, and financial independence. It ranked higher than a happy marriage."[59]

In the words of CHBA's past-president, John Bassel, "Housing Canadians is not some parlour board game."[60] Of all the peoples on earth, we Canadians have to take our homes particularly seriously, since we are stuck in them for so much of the year. We demand not only that our homes reflect our individuality, but also that they perform at optimal efficiency in one of the world's least forgiving environments. By force of climate we are driven, more than almost anyone else, to agree with Benjamin Disraeli that "the best security for civilization is the dwelling, and upon proper and becoming dwellings depends more than anything else the improvement of mankind."[61]

The Canadian homebuilding industry is necessarily at the centre of any such equation; as writer Andrej Derkowski said, "New housing is no more possible without land development than is motherhood without sex."[62] For its part, CHBA's position on the housing of the future is not surprising: such housing should enjoy "quality, affordability and choice." However, CHBA has recently articulated further "fundamental principles" in its *Strategic Plan for the '90s,* including "the right of all Canadians to decent, safe and appropriate housing; and the right of all Canadians to a reasonable opportunity to own their own homes."[63] Such goals lack the ungrammatical panache of *Star Trek*'s slogan, "to boldly go where no one has gone before." If anything, the rest of CHBA's documentation[64] is even more prosaic; for example, the growing emphasis on renovation reflects the premise that the Canadian city of the future will not be a giant bug, but might (and perhaps should) look remarkably like the city of today. After all, if sustainable development means anything, it means making our cities more durable and re-using as many buildings as possible. The Canadian renovation industry is expected to be the key to that process.

That vision may disappoint some experts, particularly those who think of cities as sand castles where marvels of fantasy are created, wiped out by the tide, and created again. In the change-obsessed 1960s, for example, the editorial page of the *Vancouver Sun* would revel in the prospect that, "excitingly, Vancouver was destroying without qualm the things of its childhood to be better prepared for full stature

in a fast-changing world."[65] To destroy without qualm the houses of "one's childhood," however, is now viewed not only as bad environmental policy; it is bad business. Canada's long tradition of home construction has produced a solid collection of buildings which — with intelligent maintenance, repair, and the occasional upgrade — can meet the needs of future Canadians admirably.

In short, the overwhelming majority of buildings that will house Canadians comfortably in the year 2010 AD have already been built.

The next generation of Canadians will, nonetheless, witness the construction of countless new homes. Again, the most likely prospect is that these new houses will look reasonably similar to those of today — assuming that the tastes of the Canadian public don't take some bizarre turn. If builders stick to the philosophy that NHBA's Charles Dolphin laid down in 1944, they will build what they think Canadians want, not what some futurist thinks they *should* want.

The end result is unlikely to look like a suburb designed by artist Salvador Dali. Paradoxically, the attitude of the Canadian industry toward the house of the future emulates the great surrealist in one respect. Dali once received a card from another artist who exclaimed that "by daring the impossible, we create the possible." "By daring the possible," Dali corrected him, "we create the impossible."[66] That is, perhaps, the most reliable prediction about the future of the Canadian home.

And how will posterity view the efforts of our own generation? In *Motel of the Mysteries*, author David Macauley predicted that at some time, millennia hence, archaeologists would return to decipher the buildings of the late twentieth century. This was feasible, according to this fictional work, because our suburbs (like Pompeii) became entombed by a natural calamity: one day, "an accidental rate reduction on a substance called third- and fourth-class mail literally buried the North Americans under tons of brochures, flyers, and small containers called *free*. That afternoon, impurities that had apparently hung unnoticed in the air for centuries finally succumbed to the force of gravity and collapsed on what was left of an already stunned population." In 4022 AD, archaeologists unearth the remains. They marvel at a substance called Formica, which they believe to be named after the local god of craftsmanship. The ceiling tiles are "decorated with a series of parallel perforations, and then color … [is] added by applying the occasional and always subtle watermark." The television set is described as "the great altar"; the toilet is interpreted as a musical instrument.[67]

Will posterity indeed gush over the latter twentieth century? In other works by the same author, posterity is less generous toward its antecedents. In *Great Moments in Architecture*,[68] Macauley describes one dwelling: "The project remains unexecuted to this day and so unfortunately does the architect."

What verdict can we expect for ourselves? In terms of quantity, Canada has fallen short of providing proper housing to 100 percent of its population; but the nation's output has nonetheless been gigantic. In terms of quality, debates over architectural correctness have not altered the fact that most Canadians have found homes corresponding to their own tastes and needs, and there is simply no other country with a more sophisticated housing technology. Finally, Canada's housing market has — despite the prophecies of the pundits — remained consumer driven; and there is no country on earth that can lay claim to a finer or more diverse product.

That does not mean that Canada can rest on its laurels. The goals of quality, affordability, and choice should remain paramount in providing and improving Canadian housing over the next generation. In one sense, the typical new subdivision — with its seemingly endless parade of work and families and dreams and mud — is the symbol, not only of the future of the Canadian home, but of life itself; for as W. C. Fields observed, "The road to success is always under construction."[69]

CAL

Appendix

PRESIDENTS OF NHBA/HUDAC/CHBA

Kenneth J. Green (Interim)	Ottawa	1943
Joseph L. E. Price	Montreal	1944
Frank R. Lount	Winnipeg	1945/46
Hon. George Prudham	Edmonton	1947/48
John A. Griffin	Richmond Hill	1949
Phil A. Mager	Winnipeg	1950/51
William H. Grisenthwaite	Hamilton	1952
Gordon S. Shipp	Mississauga	1953/54
Harry J. Long	Toronto	1955/56
Lesley E. Wade	Calgary	1957
Maurice Joubert	Laval	1958/59
Campbell C. Holmes	Toronto	1960
Graham Lount	Winnipeg	1961
William M. McCance	Toronto	1962
Chesley J. McConnell	Edmonton	1963
Ernest R. Alexander	Barrie	1964
Charles B. Campbell	Hamilton	1965
Jean-Yves Gelinas	Montreal	1966
Willam G. Connelly	Ottawa	1967
Edward L. Mayotte	Thunder Bay	1968
Ralph T. Scurfield	Calgary	1969
S. Eric Johnson	Mississauga	1970
Harold G. Shipp	Mississauga	1971
C. Donald Wilson	Calgary	1972
H. Keith Morley	Toronto	1973
Ernest W. Assaly	Ottawa	1974
Bernard Denault	Laval	1975
Howard E. Ross	Calgary	1976
H. Eric J. Bergman	Winnipeg	1977
William E. Small	Mississauga	1978
Keith G. Paddick	Edmonton	1979
George P. Frieser	Edmonton	1980
Klaus Springer	Calgary	1981
Cyril Morgan	St. John's	1982
Robert Flitton	Vancouver	1983
John B. Sandusky	Toronto	1984
Albert DeFehr	Winnipeg	1985
Robert Shaw	Halifax	1986
Norman Godfrey	Toronto	1987
Gary Santini	Vancouver	1988
Tom Cochren	Hamilton	1989
Gordon Thompson	Toronto	1990
Gary Reardon	St. John's	1991
John Bassel	Toronto	1992
Bill Strain	Vancouver	1993
Ted Bryk	Orangeville	1994

CHIEF EXECUTIVE OFFICERS OF NHBA/HUDAC/CHBA

Joseph T. Crowder, Secretary-Manager	1944–1949
Grant Smedmor, National Executive Secretary	1949–1951
Angus Gordon, National Executive Secretary	1951–1952
John Caulfield Smith, Secretary-Manager	1952–1963
Bernie Bernard, Executive Vice-President	1963–1983
Kenneth Kyle, Chief Operating Officer	1983–1985
Dr. John Kenward, Chief Operating Officer	1985–present

CHAIRMEN OF CMHC

William Teron	1976–1979
No appointee	1979–1983
Ian A. Stewart	1983–1985
Robert E. Jarvis	1985–1990
Claude F. Bennett	1990–present

PRESIDENTS OF CMHC

David Mansur	1946–1954
Stewart Bates	1954–1963
Herbert W. Hignett	1964–1973
William Teron	1973–1976
Raymond V. Hession	1976–1982
Raymond J. Boivin (Acting President)	1982–1983
Robert C. Montreuil	1983–1985
Raymond J. Boivin (Acting President)	1986–1986
George D. Anderson	1986–1990
Eugene A. Flichel	1990–present

FEDERAL MINISTERS RESPONSIBLE FOR HOUSING

	Date Appointed
C. D. Howe	1 January 1946
Robert H. Winters	15 November 1948
Howard Green	22 June 1957
David J. Walker	20 August 1959
E. Davie Fulton	9 August 1962
John E. Garland	23 April 1963
John R. Nicholson	19 March 1964
Edgar J. Benson	18 January 1968
Paul T. Hellyer	25 April 1968
Robert K. Andras	5 May 1969
Ron Basford	28 January 1972
Barney Danson	8 August 1974
André Ouellet	5 November 1976
Elmer MacKay	4 June 1979
Paul Cosgrove	3 March 1980
Romeo LeBlanc	30 September 1982
Charles Lapointe	30 June 1984
Bill McKnight	17 September 1984
Stewart McInnes	30 June 1986
John McDermid	15 September 1988
Alan Redway	30 January 1989
John McDermid (acting)	15 March 1991
Elmer MacKay	23 April 1991
Paul Dick	25 June 1993
David Dingwall	4 November 1993

Notes

Hearts, Souls, and a Cast of Millions: Introducing the Characters

1 Taylor, Lisa, ed., *Housing: Symbol, Structure, Site*. New York: Rizzoli, 1990, 8-9.
2 Taylor, 9.
3 Quoted in Taylor, 9.
4 *The Canadian Encyclopedia* says: "Canada, a name derived from the Huron-Iroquois *kanata*, meaning a village or settlement." Edmonton: Hurtig, 2nd ed. 1988, 322.
5 In the words of architect James Wines, "The writing of architectural manifestos, programs and theories is an activity that seems to go hand in hand with the practice of building as an art form." Wines, James, *De-Architecture*. New York: Rizzoli, 1987, 20.
6 Rybczynski, Witold, *Looking Around*. Toronto: HarperCollins, 1992, 99.
7 William Campbell quoted in Colgate, William, *Canadian Art: 1820-1940*. Toronto: Ryerson, 1943, 255-256. Similar sentiments can be found in any of a wide assortment of texts available today.
8 Macrae-Gibson, Gavin (of Yale University), *The Secret Life of Buildings*. Cambridge Mass.: MIT Press, 1985, 35. *Architectural Record* says, "This book should be a primer for anyone wanting a more sophisticated reading of contemporary architecture."
9 In the words of McGill's Rybczynski, "Most leading architects and architectural theoreticians, whose interest is in formal manipulation rather than environmental issues, have ceased to concern themselves with housing." For that matter, "The architectural profession was never interested in the problem of 'the little house', which it left to the developer and the builder, whose popular and often unsophisticated designs were disdained and deplored ... Picture windows and basement playrooms do not stir the soul of the art historian." Rybczynski, *Looking Around*, 5, 7, 67.
10 Van Pelt, R. J. and Westfall, C. W., *Architectural Principles in the Age of Historicism*. New Haven: Yale University Press, 1991, 6.
11 "Khan believed that all buildings had intrinsic spiritual functions that transcended the circumstantial and local requirements of site, construction technology, and the [client's] purpose." Rybczynksi, *Looking Around*, 125-126.
12 This is the title of Macrae-Gibson's book.
13 Macrae-Gibson, xvi.
14 Berton, Pierre, *Hollywood's Canada*. Toronto: McClelland and Stewart, 1975, 38.
15 Quoted in Gowans, Alan, *The Comfortable House*. Cambridge Mass.: MIT Press, 1986, 12.
16 Rossi, Aldo, *A Scientific Autobiography*. Cambridge Mass.: MIT Press, 1981, 23.
17 Macrae-Gibson, 180.
18 Macrae-Gibson, 180.
19 Rybczynski, Witold, *Home*. New York: Viking Penguin, 1986, 232.
20 Rybczynski, *Home*, 231.
21 Quoted in Taylor, 92.
22 Prof. Hestness quoted in *Homebuilder*, July/August 1993, 5. Prof. Hestness leads the International Agency Task 13 Solar Low Houses program.

In the Beginning ... : Caves and Abstract Theories

1 Nicol, Eric, *An Uninhibited History of Canada*. Toronto: Musson, 1965. Unpaginated.
2 Charpentier, Louis, *The Mysteries of Chartres Cathedral*. Sir Ronald Fraser, trans. Kent: R.I.L.K.O. Books, 1972, 20.
3 "Tesla, Nikola" (alias Childress), *The Anti-Gravity Handbook*. Vancouver: Raincoast Book Dist. Ltd., 1990.
4 Rossbach, Sarah, *Feng Shui*. New York: Dutton, 1983.
5 Quoted in Tierney, Ben, "Ill Feng Shui Blows No Good for Architects in Hong Kong," *Ottawa Citizen*, 3 October 1987, H-5.
6 Rybczynski, Witold, *The Most Beautiful House in the World*. New York: Viking, 1989, 76-77.
7 Vitruvius, Marcus, *On Architecture*. Granger, Frank, trans. London: William Heinemann, 1955, 43.
8 Doyle, Sir Arthur Conan, "Winnipeg's Psychic Possibilities," in Colombo, John Robert, *Extraordinary Experiences*. Willowdale: Hounslow, 1989, 177.

9 Cinq-Mars, Jacques, "Bluefish Cave I," *Canadian Journal of Archaeology,* No. 3, 1979, 1.

10 James Adovasio, quoted in Lemonick, M.D., "Coming to America," *Time,* 3 May 1993, 55.

11 Outside Flagstaff, Arizona, to be precise: Goodman, Jeffrey, *American Genesis.* New York: Summit, 1981.

12 Dobbs, Kildare, *The Great Fur Opera.* Toronto: McClelland & Stewart, 1970, 64.

13 Quoted in Nabokov, P. and Easton, R., *Native American Architecture.* New York: Oxford University Press, 1989, 123.

14 *Ezekiel*, Ch. 40-42.

15 Wittkower, Rudolf, *Architectural Principles in the Age of Humanism.* London: Alec Tiranti, 1962, 121.

16 Wittkower, 104.

17 Tompkins, Peter, *Secrets of the Great Pyramid.* New York: Harper Colophon, 1971, 257.

18 Tompkins, 277.

19 Gimpel, Jean, *The Cathedral Builders.* Teresa Waugh, trans. New York: Harper Colophon, 1984, 98.

20 "The Children of Father Soubise," "The Children of Master Jacques," and "The Children of Solomon."

21 Gimpel, 109.

22 Quoted in Gimpel, 111.

23 Quoted in Gimpel, 102. The conference took place in Regensburg.

24 Knoop, D. and Jones, G.P., *The Genesis of Freemasonry.* Manchester: Manchester U.P., 1949, quoted in Gimpel, 111.

25 Charpentier, Ch. 19.

26 Wittkower, 9.

27 Wittkower, 8.

28 Franscesco Giorgi.

29 Wittkower, 102.

30 "Plato describes in words, which Palladio directly or indirectly borrowed from him, the world as a sphere ... Earlier writers had adumbrated more or less clearly the Platonic substance of their thought and it is this knowledge that enables us fully to appreciate the strength which prompted the aesthetic aspirations of a whole century." Wittkower, 23.

31 Like Giorgi and Giovani Battista Villalpando.

32 Wittkower, 121.

33 Blunt, Anthony, *Philibert de l'Orme.* London: A. Zwemmer, 1958, 138.

34 Quoted in Rybczynski, *The Most Beautiful House,* 57

35 Blunt, 124.

36 By Sir Henry Watton.

37 Wolfe, Tom, *From Bauhaus to Our House.* New York: Farrar Straus Giroux, 1981, 121.

38 Quoted in "The New Modernism: a Toronto Symposium" (various authors/panelists), *The Canadian Architect,* January 1991, 10-11.

39 This slogan, often attributed to Ludwig Mies van der Rohe, was actually coined by Robert Browning.

40 Quoted in Fitch, James Marston, *Walter Gropius.* New York: George Braziler, 1960, 11.

41 Gowans, Alan, *Building Canada.* Toronto: Oxford University Press, 1966, Plate 1.

42 Adolf Loos, quoted in Fitch, 14.

43 Wolfe, 23-24.

44 Louis Sullivan, quoted in Rybczynksi, *The Most Beautiful House,* 162.

45 Walter Gropius, quoted in Fitch, 15.

46 Henry-Russell Hitcock, quoted in Fitch, 16.

47 Gropius, quoted in Fitch, 15.

48 Moholy-Nagy, quoted in Fitch, 15.

49 Gropius, quoted in Fitch, 13.

50 Ruth Cawker, quoted in "The New Modernism," 10.

51 Van Pelt/Westfall, 6.

52 Quoted in Olive, David, *Canadian Political Babble.* Toronto: John Wiley & Sons, 1993, 127.

Buffalo, Whales, and Other Building Supplies: Canada to 1600

1 McGhee, Robert, *Ancient Canada.* Ottawa: Canadian Museum of Civilization, 1989, 24.

2 Nabokov/Easton, 150.

3 Nabokov/Easton, 162.

4 Nabokov/Easton, 150.

5 Clayton, Maurice, *Canadian Housing in Wood.* Ottawa: CMHC, 1990, 37.

6 Nabokov/Easton, 153.

7 Quoted in Nabokov/Easton, 56.

8 Quoted in Nabokov/Easton, 60.

9 Nabokov/Easton, 60.

10 Nabokov/Easton, 57.

11 Nabokov/Easton, 64.

12 Quoted in Nabokov/Easton, 64.

13 Quoted in Nabokov/Easton, 58.

14 Quoted in Nabokov/Easton, 63.

15 It has counterparts among the Chukchi of Siberia. Nabokov/Easton, 186.

16 The direction of beams had mystical significance, indicating both the world and the afterlife. Nabokov/Easton, 176.

17 Nabokov/Easton, 179.

18 Nabokov/Easton, 193.

19 Clayton, 48.

20 Archaeologists refer to this model as the "Thule House" after an area of Greenland. Martin Frobisher referred to them in 1577 as houses "raised of stone and whalebone."

21 Nabokov/Easton, 192.

22 Quoted in Nabokov/Easton, 192.

23 Nabokov/Easton, 195.

24 Payson, Sheets and Grayson, eds., *Volcanic Activity and Human Ecology.* New York: Academic Press, 1978.

25 Nabokov/Easton, 195.

26 Clayton, 51.

27 Quoted in Nabokov/Easton, 189.

28 Nabokov/Easton, 82.

29 Nabokov/Easton, 84.

30 Quoted in Nabokov/Easton, 82.

31 Quoted in Nabokov/Easton, 84.

32 Quoted in Nabokov/Easton, 84.

33 Farb, Peter, *Man's Rise to Civilization.* New York: E.P Dutton, 1968, 137.

34 Farb, 145.

35 Quoted in Nabokov/Easton, 243.

36 Quoted in Nabokov/Easton, 243.

37 Nabokov/Easton, 244.

38 Nabokov/Easton, 244.

39 Quoted in Nabokov/Easton, 228-229.

40 Quoted in Nabokov/Easton, 228-229.

41 "Front posts often stood eighteen feet high, while rear posts, forty to fifty feet back, were raised about ten feet high. Long beams connected them, producing a succession of parallel post-and-beams that held the lattice of lighter rafters ... these boards were also of split cedar which sometimes was gouged on one side to overlap like roofing tile. Rocks helped hold them in place during storms." Nabokov/Easton, 231.

42 Quoted in Nabokov/Easton, 231.

43 Quoted in Nabokov/Easton, 247.
44 "The house dimensions were carefully staked out … On house-raising day, the heavy posts were manoeuvered into the holes so they extended fifteen feet above ground. With the help of levers and pivots the huge roof beams were hoisted onto the posts as work crews chanted in unison. Then the gable roof was framed and the building was covered with roof and wall planks … the nearly square floor pit was lined with carved retaining planks … the walls were hung with mats." Nabokov/Easton, 247.
45 Nabokov/Easton, 248.
46 Nabokov/Easton, 248.
47 Clayton, 248.
48 Farb, 147-148.
49 Farb, 150.
50 Farb, 142.

La Douce France Meets 40° Below: 1600-1763

1 Rybczynski, *Home*, 24.
2 McFarlan, Donald, ed., *The Guinness Book of Records*. London: Guinness Publishing, 1990, 187.
3 Rybczynski, *Home*, 59.
4 Rybczynski, *Home*, 66.
5 "Each frame was pre-assembled to ensure a fit, then it was dismantled and erected on site … Most of the smaller houses followed a similar layout; a central entrance flanked by two rooms, a staircase in the centre, as well as a massive chimney of masonry." Clayton, 56.
6 Cited in Clayton, 62.
7 Clayton, 63.
8 Kidder, Tracy, *House*. New York: Avon Books, 1985, 134
9 Moogk, Peter, *Building a House in New France*. Toronto: McClelland & Stewart, 1977, 13.
10 Nicol (unpaginated).
11 Moogk, 94.
12 Moogk, 101.
13 Moogk, 14.
14 Moogk, 15.
15 Rybczynski, *Home*, 82.
16 Moogk, 13.
17 Clayton, 59.
18 Morisset, Gérard, *L'architecture en Nouvelle-France*. Quebec: Pelican, 1949, 27.
19 Quoted in Rybczynski, *Home*, 41-42.
20 Quoted in Moogk, 17.
21 Moogk, 60.
22 Moogk, 53.
23 Moogk, 57.
24 Moogk, 15.
25 Moogk, 64.
26 Moogk, 49.
27 Quoted in Moogk, 62.
28 Richardson, A.J.R., *Quebec City: Architects, Artisans and Builders*. Ottawa: History Division, National Museum of Man, 1984, 381.
29 Harron, Don, *Charlie Farquharson's Histry* [sic] *of Canada*. Toronto: McGraw-Hill Ryerson, 1972, 54.

Amusing, Artificial, and Awful: 1763-1850

1 Brierley, John, and Macdonald, Rod, *Quebec Civil Law*. Toronto: Emond Montgomery, 1993.
2 *Samuel v. Jarrah*, [1904] Appeal Cases 323, at 326.
3 Quoted in Megarry, Sir Robert, *Megarry's Manual of the Law of Real Property*, 4th ed. London: Stevens & Sons, 1969, 1.
4 Marler, William de Montmollin, *The Law of Real Property, Quebec*. Toronto: Burroughs, 1932, 14.
5 Marler, 16. See also Marquis, Paul-Yvon, "La tenure seigneuriale dans la province de Québec," *Répertoire de Droit, Titres immobiliers, Doctrine #4*. Montreal: Chambre des Notaires, 1987.
6 The French *pied* (foot) is equivalent to 1.066 English feet.
7 Mayrand, A., *Revue du Barreau*, 1958, 347.
8 Quoted by Wright, Lawrence, in *Clean and Decent: the History of the Bath and the Loo*. London: Routledge and Kegan Paul, 1980, 122.
9 Wallechinsky, David, and Wallace, Irving, "Fifteen famous events that happened in the bathtub," *The Book of Lists*. New York: Bantam, 1978, 272.
10 Rybczynski, *Home*, 92.
11 "Architects prided themselves on aligning all the doors *en filade*, so that there was an unobstructed view from one end of the house to the other." Rybczynski, *Home*, 41.
12 Wren's proposal, after the Great Fire of London in 1666, was rejected as too expensive.
13 Quoted in Williams, Prof. D. Carlton, "Twenty-six Letters that Opened the World," *The Globe and Mail*, 8 July 1991, A21.
14 Williams, A21.
15 Blumenson, John, *Ontario Architecture*. Toronto: Fitzhenry & Whiteside, 1990, 13.
16 Latremouille, Joann, *Pride of Home*. Hantsport, N.S.: Lancelot, 1986, 43-44.
17 Rybczynski, *The Most Beautiful House*, 156.
18 Quoted in Kidder, 120.
19 Kidder, 319.
20 Blumenson, 21.
21 Kidder, 20-21.
22 Rybczynski, *Home*, 127.
23 Rybczynski, *Home*, 128.
24 Rybczynski, *Home*, 117.
25 Rybczynski, *Home*, 130.
26 Rybczynski, *Home*, 130.
27 Taylor, 73.
28 Kent, Nathaniel, *Hints to Gentlemen of Landed Property* (1775). Described by Harris, Richard, *Discovering Timber-Framed Buildings*, 2nd ed. Anglebury Bucks: U.K. Shire Publications, 1978.
29 Cummings, Abbott Lowell, *The Framed Houses of Massachusetts Bay, 1625-1725*. Cambridge, Mass.: Harvard University Press, 1979.
30 Quoted in Kidder, 137.
31 Pacey, Elizabeth, *Historic Halifax*. Halifax: Hounslow Press, 1988, 20.
32 *The Seven Lamps of Architecture* (1849); *The Stones of Venice* (1850).
33 Colombo, 116.

Electrifying! 1850-1914

1 The Canadian inventor of kerosene, quoted in Nostbakken, J., and Humphrey, J., *Canadian Inventions Book*. Toronto: Grey de Pencier, 1976, 32.
2 Quoted in Prochnow, H.V., *The Toastmaster's Treasure Chest*. New York: Harper & Row, 1979, 48.
3 Nostbakken/Humphrey, 37.
4 O'Brien, Robert, *Machines*. New

York: Time-Life, 1964. This publication also routinely credits Fulton with the invention of the commercial steamboat (not Molson, etc.). As to the telephone: "I have often been asked if Brantford is the home of the telephone … This I will say: The telephone was invented here." Alexander Graham Bell speaking in Brantford, March 1906, quoted in Nostbakken/Humphrey, 100. Bell repeated the same message in a speech in Boston in 1911.

5 Quoted in Humes, James, *Speaker's Treasury of Anecdotes about the Famous*. New York: Barnes & Noble, 1985, 99.

6 "It is astonishing [that] … many people … seem to insist on somebody else — often anybody else — doing their thinking for them." Thomas Edison, quoted in Prochnow, 368.

7 "The first recorded application of electricity to run a machine occurred in 1883, in a grocery store in New York, when an electric motor was used to run a coffee grinder." O'Brien.

8 Quoted in Ontario Hydro Archives, OR-510.001.

9 Service, Robert, *Collected Poems of Robert Service*. New York: Dodd, Mead, 1940, 98.

10 Stamp, Robert, *Bright Lights Big City*. Toronto: City of Toronto Archives, 1991.

11 Gowans, *Building Canada*, 141.

12 Both quoted in Rybczynski, *Home*, 134.

13 Rybczynski, *Home*, 136.

14 Architect John James Stevenson, referred to in Rybczynski, *Home*, 137.

15 Downing, Andrew Jackson, *The Architecture of Country Houses*. Originally published in 1850; republished, New York: Da Capo, 1968, 472.

16 Quoted in Rybczynski, *Home*, 147.

17 Rybczynski, *Home*, 155.

18 The use of camels to reach the B.C. goldfields was a short-lived experiment.

19 Nicol (unpaginated).

20 Rybczynski, *Home*, 149.

21 The term is used by, e.g., Robinson, Barbara, *Gingerbread*. Halifax: Nova Scotia Museum, 1990.

22 Blumenson, 71.

23 Fowler's 1849 book, *A Home for All*, was the foundation for this movement: Blumenson, 71-76.

24 Arthur, Eric, and Ackland, James, *Building by the Sea*. Halifax: Legislative Library, Government of Nova Scotia (undated).

25 Described in *Ventilation and Warming of Buildings*. New York: Putnam, 1962.

26 Her 1841 book was entitled *Treatise on Domestic Economy for the Use of Young Ladies at Home and at School*. Boston: Marsh, Capeen, Lyon and Webb.

27 From *American Women's Home*, quoted in Rybcznski, *Home*, 161-162.

28 Rybczynski, *Home*, 163.

29 Rybczynski, *Home*, 164.

30 Description by Robinson, 43.

31 Quoted in Friedman, Lawrence, *Government and Slum Housing*. Chicago: Rand McNally, 1969, 77.

32 Friedman, 83.

33 Reiss, Jacob, "The Clearing of Mulberry Bend," *Review of Reviews*, 12 (1985), 172. Emphasis in original.

34 Quoted in Friedman, 74.

35 Wright, Gwendolyn, *Building the Dream: A Social History of Housing in America*. New York: Pantheon, 1981, 185.

36 Forsey, Eugene, *National Problems of Canada: Economic and Social Aspects of the Nova Scotia Coal Industry*. Toronto: Macmillan, 1930, 16-24.

37 Latremouille, 60.

38 Latremouille, 57.

39 Latremouille, 60.

40 *Report of the Royal Commission Respecting the Coal Mines of the Province of Nova Scotia* (Duncan Commission) 1925, 41.

41 Bruce, Jean, *The Last Best West*. Toronto: Fitzhenry & Whiteside, 1976, 1.

42 Rossbach, 78.

43 "Promotion, 1908," quoted in Bruce, 28.

44 "Canada West: The Last Best West," poster, 1906. Quoted in Bruce, 30.

45 Morton, W.L., *Manitoba, A History*. Toronto: University of Toronto Press, 1957, 171.

46 Quoted in Newman, Lena, *The John A. Macdonald Album*. Montreal: Tundra, 1974, 60.

47 Gray, James H., *Red Lights on the Prairies*. Toronto: Macmillan, 1971, 26-27.

48 Gray, 88.

49 Gray, 2. Emphasis added.

50 Saskatoon Board of Trade promotion, 1908, quoted in Bruce, 153.

51 J.S. Woodsworth, quoting "an ordinary police court item from a Winnipeg daily newspaper," in *Strangers Within Our Gates* (1909).

52 Gray, 9.

53 English settler, 1903, quoted in Bruce, 67.

54 French settler, Alberta, early 1900s, quoted in Bruce, 149.

55 Calihoo, Victoria, "Early Life in Lac Ste. Anne and St. Albert in the 1870s," *Alberta Historical Review,* November 1953.

56 Quoted in the *Winnipeg Telegram*, judgment in *R v. Chudek*, 15 October 1909.

57 Scottish settler, Saskatchewan, 1903, quoted in Bruce, 94.

58 Scottish settler, Alberta, quoted in Bruce, 148.

59 English settler, Saskatchewan, 1906, quoted in Bruce, 94.

60 Reverend George Grant, quoted in Cunningham, David, and Sternthal, David, *Alberta Album*. Edmonton: Lone Pine/Alberta Culture, 1985, 22.

61 German settler, Saskatchewan, 1890s, quoted in Bruce, 82.

62 Gray, 9.

63 Gray, 60.

64 Gray, 11.

65 *Calgary*, The 20th Century Cities Series, London, 1912.

66 Quoted in Gray, 125.

67 Gray, 125-126.

68 Burke, James, *Connections*. London: Macmillan London Ltd., 1978, 240.

69 By Nicolas J. Cougnat, France.

70 Thomas Turnbull's "Andromonon carriage" was immediately "hailed as the machine that would supersede railroads, but … never caught on." Nostbakken/Humphrey, 46.

71 Scott, Frank R., introductory lecture to the McGill Faculty of Law, 1970.

72 Leacock, Stephen, *Leacock's Montreal*. Toronto: John Culliton, ed. McClelland & Stewart, 1963, 176.

73 Leacock, 212.

74 Leacock, 229.
75 Reyburn, Wallace, *Flushed with Pride*. London: Macdonald, 1969, 29-30.
76 Quoted in Wright, Lawrence, *Clean and Decent: the History of the Bath and the Loo*. London: Routledge & Kegan Paul, 1980, 122.
77 Chisholm, Dorothy, "Throne Speech." *Renew*, November 1991, 51.

Criminals and Pathological Cases: 1914-1939

1 Quoted in Humes, 31.
2 Delaney, Jill, "The Garden Suburb of Lindenlea," *Urban History Review*, Feb. 1991, 151-158; this was further described in "The Housing Problem and Production," *Conservation of Life*, July 1918, 49-57.
3 Louis Sullivan, quoted in Rybczynski, *The Most Beautiful House*, 162.
4 Browning, Robert, *Andrea del Sarto*, line 75.
5 Quoted in Lasden, Susan, *Victorians at Home*. Abrams: New York, 1982.
6 Quoted in Rybczynski, *The Most Beautiful House*, 126.
7 Quoted in Fitzhenry, Robert I., ed. *The Fitzhenry & Whiteside Book of Quotations*. Markham: Fitzhenry & Whiteside, 1987, 27.
8 Blumenson, 185.
9 Rybczynski, *The Most Beautiful House*, 46.
10 Loos, Adolf, "Ornament and Crime," Roger Banham, trans. London: *Architectural Review*, Feb. 1957, Vol. 121, 85.
11 Quoted in Banham, 88.
12 The title "Silver Prince" was coined for Gropius by Paul Klee, who taught at the Bauhaus, a design school which created accepted wisdom for "modern architecture": quoted in Wolfe, 12.
13 This source of "shame," said Gropius, resulted from "perverted academic training": quoted in Fitch, 14-15.
14 Rybczynski, *The Most Beautiful House*, 9.
15 Fitch, 15.
16 Wolfe, 47. See also Tafel, Edgar, *Apprentice to Genius, Years with Frank Lloyd Wright*. New York: McGraw-Hill, 1979.
17 E.g. "The New Modernism" (Symposium), *Canadian Architect*, January 1991, 10.
18 Adolf Behne, quoted in Conrads and Sperlich, *Fantastic Architecture*. London: Architectural Press, 1963, 134.
19 Quoted in Rybczynski, *Home*, 190.
20 Jeanneret, Charles-Edouard, *L'Art décoratif d'aujourd'hui*. Paris: Crés, 1925, 79.
21 It was named for Corbu's small magazine, *L'Esprit Nouveau*.
22 Rybczynski, *Home*, 186.
23 Rybczynski, *Home*, 187-188.
24 Jeanneret, Charles-Edouard, *Le Corbusier et Pierre Jeanneret Oeuvre Complète de 1910-1929*. Zurich: Editions d'Architecture Erlenbach, 1946, 31.
25 In his book, *Towards a New Architecture*, Frederick Etchells, trans. London: John Rodker, 1931, 122-123.
26 Rybczynski, *Home*, 191.
27 Bayer, Isee, and Gropius, *Bauhaus: 1918-1928*. New York: The Museum of Modern Art, 1938, 24.
28 Quoted in Prochnow, 112.
29 Le Corbusier's lecture at Harvard University, quoted in Wines, 23.
30 Wines, 22.
31 Wines, 22.
32 Quoted in H.R.H. Prince Charles, *A Vision of Britain*. London: Doubleday, 1989, 7-9.
33 Quoted in Prochnow, 138.
34 Rybczynski, *Home*, 204.
35 The selection was made in 1957; see Kaplan, Ralph, *By Design*. New York: McGraw-Hill, 1982, 91-92.
36 Kron, Joan, *Home-Psych: The Social Psychology of Home and Decoration*. New York: Clarkson N. Potter, 1983, 178.
37 Aldous Huxley, in *Studio Magazine*, 1930.
38 Simpson, Michael, "Thomas Adams in Canada, 1914-1930," *Urban History Review*, XI (1982), 2.
39 Adams, Thomas, "The Housing Problem," *Addresses — Canadian Club of Montreal 1918-19*. Montreal: Canadian Club, 1919, 186.
40 Adams, 186.
41 Latremouille, 70.
42 Simpson and Adams, *The Modern Planning Movement: Britain, Canada and the United States, 1900-1940*. London and New York: Alexandrine, 1985, 3.
43 Simpson/Adams, 3.
44 Doyle, Cassie, *Municipal Initiatives in Housing, 1900-1970: The City of Ottawa*. Ottawa: City of Ottawa, 1982, 14-15.
45 Windsor (1918); Toronto (1920); Victoria, Regina, Hamilton and Ottawa (1921).
46 The Toronto Home Builders' Association was founded 5 April 1921 by Addison Johnston, H.B. Taber, John Macpherson, Kenneth Grimshaw, and Thomas Edmonds. One of the members of its first board of directors, W.W. Hiltz, became a mayor of Toronto.
47 Beck, Boyd E., *Art in Architecture: Toronto Landmarks 1920-1940*. Toronto: Market Gallery of City of Toronto Archives, 1988, 25.
48 Delaney, 159-160.
49 The word *streamlined* entered the English language in 1913, in relation to aircraft.
50 *Electrical News and Engineering*, 15 July 1938, 17-18.
51 Beck, 41.
52 Harron, 118.
53 Toronto Home Builders Association, *1931 Home Builders' Annual*. Toronto: THBA, 1931, 140.
54 Sayegh, Kamel, *Housing: A Canadian Perspective*. Ottawa: Academy Books, 1987, 78.
55 Sayegh, 78.
56 *House of Commons Debates*, 1937, 1:739.
57 *House of Commons Debates*, 1937, 740.
58 Quoted in Archibald, Peter, "Distress, Dissent and Alienation," *Urban History Review*, Oct. 1992, 6.
59 Clayton cites this evidence, without saying that it necessarily proves paternity for this technique: Clayton, 123.
60 Quoted in Sayegh, 78.
61 Sayegh, 123. It set the pattern for legislation to come. The overwhelming purpose was "to assist the construction of houses by

increasing the amount of firstmort-gages available to the borrower and lowering their interest rate."

62 Bettison, David, *The Politics of Canadian Urban Development*. Edmonton: University of Alberta Press, 1975, 73.

63 *House of Commons Debates*, 1935, 4:3917.

64 Bettison, 63.

65 Sayegh, 61.

66 Bettison, 62.

67 Sayegh, 124.

68 Nicol (unpaginated).

69 Bettison, 65.

70 *House of Commons Debates*, 1935, 4:3945.

71 Bettison, 64.

72 Bettison, 69.

73 Sayegh, 126.

74 Sayegh, 163-164.

75 Toronto Home Builders' Association (THBA), 89.

76 Cheney, Sheldon, *Towards a New World Architecture*. New York: Longmans, 1930, 76.

77 Lyle, John, RAIC *Journal*, April 1929, 136.

78 Lyle, John, RAIC *Journal*, March 1932, 70.

79 Lecture, Art Gallery of Toronto, 10 February 1931. Paradoxically, Carlu's major achievements were in Art Deco.

80 Thompson, P.W., editorial, *Mail and Empire*, 20 June 1932.

81 Reported by CMHC in retrospect (1947) in *67 Homes for Canadians*. Ottawa: CMHC, 1947, 2.

82 Quoted in Wolfe, 32.

83 Quoted in Latremouille, 84.

84 *Dominion Housing Act Architectural Competition*. Ottawa: Department of Finance, 1936, 13.

The Luftwaffe and Other Development Services: 1939-1946

1 Hamilton contractor Joseph Pigott led WHL from Toronto, but day-to-day work was decentralized throughout 51 offices. Ottawa supervision came from no less than Deputy Minister of Finance Clark.

2 Clayton Research Associates and Scanada Consultants, *The Housing Industry: Perspective and Prospective*. Ottawa: CMHC, 1989, Vol. 2, 10.

3 Clayton/Scanada, Vol. 2, 15.

4 Quoted in Clayton/Scanada, Vol. 1, 19.

5 Editorial, RAIC *Journal*, October 1940, 170.

6 RAIC *Journal*, January 1942, 12.

7 RAIC *Journal*, May 1942, 73.

8 Dr. F. Cyril James, Address to the Annual Dinner of RAIC, 20 February 1943.

9 RAIC *Journal*, May 1942, 73.

10 Leacock, Stephen, "Rebuilding Cities," RAIC *Journal*, December 1942, 229.

11 Leacock, 229.

12 The quotation is apocryphal.

13 Quoted in Clayton/Scanada, Vol. 1, 18.

14 Like Foundation Co. of Canada, Smith Bros. & Wilson, Carter Halls Aldiger, or Bird Construction.

15 The Dept. of Finance estimated an average margin of 10 percent in 1943.

16 The quotation is apocryphal.

17 Kennedy, T. Warnett, "Plastic Possibilities," RAIC *Journal*, April 1942, 53.

18 Kennedy, 53.

19 Bolton, Richard, book review of "The Modern House in America," RAIC *Journal*, October 1940, 183.

20 Clayton/Scanada, Vol. 4, 7.

21 Lawson, Harold, "Third Report of the R.A.I.C. Committee on Housing," RAIC *Journal*, October 1942, 209.

22 The original CAREB was founded by representatives of eleven Ontario local real-estate boards, plus the boards of Victoria, Vancouver, Edmonton, Winnipeg and Montreal. 79 delegates attended CAREB's first confer-ence, at Niagara Falls in April 1944.

23 NHBA Minutes, 22 February 1944.

24 NHBA brief to the prime minister, March 1944.

25 McCarthy, J.J., "Serenity in the Oilfields," *Canadian Heritage*, February 1981.

26 Mathers, A.S., "Book Review: National Building Code," RAIC *Journal*, December 1942, 233.

27 Mathers, "Book Review," 233.

28 The Toronto group dated from 1921, Winnipeg from 1937, Ottawa and Hamilton from 1942.

29 J.A. Gosselin, J.L. Guay, J.L. Price, A. Aisenstadt.

30 G.M. Garton, H.J. Long, A.C. Jennings, H.E. McRobb.

31 K.J. Greene, C.A. Johannsen.

32 C.K. Jutten, A. Sharp.

33 R.J. Lecky.

34 S.W. Robb.

35 E. Moir.

36 H.L. Sifton.

37 "To associate the homebuilders of Canada for purposes of mutual advantage and cooperation." Letters Patent, 8 February 1943.

38 "To improve the quality and char-acter of homes for the Canadian people." Letters Patent.

39 "To develop and establish stan-dards of practice for those engaged in home building." Letters Patent.

40 "To exchange experience and information for those engaged in homebuilding." Letters Patent.

41 "To represent its members in mat-ters of national, provincial and local policy and legislation affect-ing homebuilding." Letters Patent.

42 "Buyer Beware."

43 Pogo creator, Walt Kelly, quoted in Fitzhenry, 91.

44 Resolution, NHBA Annual General Meeting (AGM), 31 March 1944.

45 Resolution, NHBA AGM, 31 March 1944.

46 NHBA Minutes, 24 July 1944.

47 NHBA Minutes, 24 July 1944.

48 Covering language, math, estimat-ing, plan-reading, data require-ments and law.

49 Quoted in NHBA Minutes, 18 May 1944.

50 NHBA Minutes, 24 July 1944.

51 Rybczynski, *Home*, 201-202.

52 NHBA AGM Minutes, 31 March 1944.

53 NHBA AGM Minutes, 1944.

54 NHBA Minutes, 8 March, 1944.

55 NHBA Minutes, 1 May 1944.

56 NHBA Minutes, 18 May 1944.

57 NHBA Minutes, 1 May 1944.

58 NHBA Minutes, 1 May 1944.

59 Quoted in NHBA Minutes, 1 May 1944.

60 NHBA Minutes, 1 June 1944.

61 NHBA Minutes, 18 May 1944.

62 NHBA Minutes, 1 June 1944.

63 "Canadian workers should be paid sufficient wages to allow them to pay an economic rent or carrying charge for housing."

64 "Canadians who by reason of physical or other incapacity are unable to earn an economic wage should be subsidized."

65 "We believe that all citizens should be given an opportunity of availing themselves of the benefits that home ownership provides."

66 "In each municipality where a housing problem exists, a competent commission or agency should be established [to] ascertain the immediate as well as the long term policy to deal with the housing situation."

67 "The remedies proposed by [many officially appointed housing groups] whose members have, in most cases, little if any practical experience with the business of housing, are political rather than practical. Rather than remedying the housing situation, actions of such bodies have added to the confusion which exists in the minds of the public ... We believe it political expediency of a most temporary nature to advocate, as these bodies have, Wartime Housing Ltd.'s type of government construction, and that when Canadian citizens realize the wastage of public funds this construction entails, there will be severe public reactions."

68 "Housing is of national importance, second only to the actual war effort, in all congested urban areas, and as such justifies the release of more men and materials, essential to the house building industry."

69 "The Controller of Construction will grant permits for essential construction only ... confined to the smaller units ... during the present emergency."

70 NHBA AGM Minutes, 1944.

71 NHBA Minutes, 15 May 1944.

72 NHBA Minutes, 15 May, 1944.

73 NHBA Minutes, 15 May 1944.

74 NHBA Minutes, 18 May 1944.

75 NHBA Minutes, 15 November 1944.

76 NHBA Minutes, 13 November 1944.

77 NHBA Minutes, 16 May 1944.

78 Resolution, AGM, 31 March 1944.

79 Resolution, AGM, 31 March 1944.

80 NHBA Minutes, 1 May 1944.

81 NHBA Minutes, 1 May 1944.

82 NHBA Minutes, 1 May 1944.

83 NHBA Minutes, 1 May 1944.

84 NHBA AGM Minutes, 31 March 1944.

85 It published the report of its Subcommittee on Housing and Community Planning, chaired by Professor Curtis, a Queen's University economist.

86 Clayton/Scanada, Vol. 1, 19.

87 Carver, Humphrey, *Compassionate Landscape*. Toronto: University of Toronto Press, 1975, 107.

88 Carver, 105.

89 Carver, 112.

90 Quoted in Fitzhenry, 218.

91 NHBA Western Conference Minutes, 15 June 1948.

92 Bettison, 92.

93 Carver, 106.

94 Carver, 107.

95 Carver, 107.

96 Woodard, Herbert, *Canadian Mortgages*. Toronto: Collins, 1959.

97 Carver, 107.

98 NHBA Western Conference Minutes, 15 June 1948.

99 Professor R.A. Stern, Columbia University, says Americans invented the planned suburb in 1869: Taylor, 68.

Canada Does the Wreggle's Wriggle: 1946-1954

1 Nostbakken/Humphrey, 52.

2 Nostbakken/Humphrey, 52.

3 Nostbakken/Humphrey, 52.

4 Mathers, A.S., "The Place of the Architect in Society," RAIC *Journal*, Sept. 1942, 186.

5 Pratt, C.E., "Contemporary Domestic Architecture in Society," RAIC *Journal*, June 1947, 179.

6 Mathers, A.S., "Housing and Building Construction," RAIC *Journal*, May 1940, 74.

7 Royal Bank of Canada Monthly Letter, reproduced in RAIC *Journal*, June 1945, 129.

8 CMHC, *67 Homes for Canadians*. Ottawa: CMHC, 1947, 2.

9 By the Toronto firm of Burniston & Storey.

10 CMHC, *67 Homes for Canadians*, 76.

11 *Sketch Designs* (1946), *67 Homes for Canadians* (1947), and *Small House Designs* (1949).

12 Latremouille, 87.

13 Nobbs, Percy, "Ramsay Traquair," RAIC *Journal*, June 1939, 147.

14 Wade, Les, "Design Trend Evident," *National Builder,* June 1957, 10.

15 Hudnut, Joseph, "The Post-Modern House," RAIC *Journal*, July 1945, 135-137.

16 Hudnut, 132.

17 Hudnut, Joseph, "Le Corbusier and American Architecture," RAIC *Journal*, April 1949, 95.

18 Carver, 106, 108.

19 Carver, 81.

20 Carver, 81.

21 Carver, 105.

22 Carver, 105.

23 Clayton/Scanada, Vol. 2, 5.

24 Feldman, David, *Why Do Dogs Have Wet Noses?* New York: Harper Perennial, 1990, 12.

25 NHBA Minutes, 15 July 1946.

26 NHBA Minutes, 15 July 1946.

27 Quoted in NHBA Minutes, 15 July 1946.

28 Dana Porter, quoted in NHBA Western Conference Minutes, 15 June 1948.

29 NHBA Minutes, 2 December 1946.

30 NHBA Minutes, 27 September 1948.

31 Quoted in NHBA Western Conference Minutes, 15 June 1948.

32 Quoted in NHBA Western Conference Minutes, 15 June 1948.

33 Quoted in NHBA Minutes, 2 December 1946.

34 Quoted in NHBA Western Conference Minutes, 15 June 1948.

35 Quoted in NHBA Western Conference Minutes, 15 June 1948.

36 Quoted in NHBA Western Conference Minutes, 15 June 1948.

37 Quoted in NHBA Western Conference Minutes, 15 June 1948.

38 Carver, 107-108.

39 H.W. Brooker, quoted in NHBA Minutes, 15 July 1946.

40 Draft legislation was prepared in 1948.

41 Quoted in *National Builder*, August 1954, 11.

42 NHBA Minutes, 27 September 1948.

43 NHBA Minutes, 27 September 1948.

44 NHBA Western Conference Minutes, 14 June 1948.

45 NHBA Minutes, 22 February 1948.

46 Norman Long, NHBA Minutes, 10 March 1947.

47 Quoted in NHBA Western

Conference Minutes, 15 June 1948.
48 Quoted in Carver, 84.
49 Friedman, 148.
50 Friedman, 113.
51 Friedman, 121.
52 Carver, 109.
53 Carver, 108.
54 Carver, 108.
55 Carver, 118.
56 Carver, 118.
57 Quoted in "Over-safe, Ancient Building Rules Wasting Building Dollars," *National Builder*, March 1958, 24.
58 CMHC Industry Survey interview with former CMHC appraiser/manager Ernest Lelacheur, 17 July 1986. (In 1986, during its 40th anniversary year, CMHC hired researchers to interview oldtimers about the living history of the homebuilding industry and CMHC. These interviews were never published, but the interview notes are among CMHC's files.)
59 The *Oxford English Dictionary* credits Blumenfeld with coining the phrase in 1949.
60 Frank W. Cortright, in NHBA AGM Minutes, 29 April 1949.
61 NHBA AGM Minutes, 19 April 1950.
62 R.H. Winters, Address to NHBA AGM, 20 February 1951, 4.
63 Winters, 6.
64 NHBA AGM, 12 February 1951.
65 NHBA Minutes, 16 August 1951.
66 NHBA open letter to the Provincial-Municipal Committee of Ontario, 12 December 1951.
67 Quoted in *National Builder*, December 1952, 7.
68 NHBA Central Committee Minutes, 4 February 1953.
69 Winters, 7.
70 Winters, 8.
71 Quoted in NHBA Minutes, 28 November 1951.
72 NHBA AGM Minutes, 12 February 1951.
73 Resolution, NHBA AGM, February 1951.
74 Quoted in Perigoe, Rae, "Concrete Masonry Withstands A-Bomb," *National Builder*, June 1955, 22.
75 Perigoe, 22.
76 *National Builder*, October 1955, 26.
77 Taylor, *Housing*, 53.
78 Rybczynski, *Looking Around*, 14.
79 *Oxford* attributes it to the *New York Times*.
80 *New York Times Canadian Supplement*, 12 November 1957.
81 CMHC Industry Survey interview with retired MICC president Reg Ryan, 22 July 1986.
82 *National Builder*, June 1955, 30.
83 CMHC Industry Survey interview with Clayton Development's Russell Smith, 16 July 1986.
84 CMHC Industry Survey interview with Costain's Keith Morley, 22 July 1986.
85 It later became the Canadian Mobile Home Association, then the Canadian Mobile Home and Travel Trailer Association, then (in 1975) back to Canadian Mobile Home Association, and finally (since 1978) the Canadian Manufactured Housing Institute.
86 These were CSA's Z240 Standards.
87 Carver, 112.
88 Carver, 112.
89 Carver, 112.

Where the Wildebeests Roam: 1954-1960

1 Flanders, Michael, and Swann, Donald, *The Songs of Michael Flanders and Donald Swann*. Reprint. London: Elm Tree Books, 1977, 166.
2 Carver, 134.
3 Carver, 134.
4 Carver, 147.
5 Carver, 140.
6 Carver, 140.
7 CMHC Industry Survey interview with retired CMHC Chief Engineer Edward Locke, 21 July 1986.
8 Carver, 141.
9 Carver, 122.
10 Quoted in Carver, 138.
11 Carver, 138.
12 Quoted in Carver, 140.
13 "Le Maire Drapeau déplore le mauvais programme," *National Builder*, March 1957, 8.
14 McKenna, Brian, and Purcell, Susan, *Drapeau*. Toronto: Clarke Irwin, 1980, 142.
15 NHBA Western Conference Minutes, 2 August 1955.
16 Alternatively, in 1953 NHBA proposed an Allied Council of the Housing Industry to bring together private-sector interests.
17 CMHC, *Brief to the Royal Commission on Canada's Economic Prospects*. Ottawa: CMHC, 1956. Extract reprinted in *National Builder*, June 1956, 8.
18 NHBA Minutes, 17 January 1958.
19 CMHC Industry Survey interview with Edward Locke, 21 July 1986.
20 Clayton/Scanada, Vol. 4, 13.
21 NHBA Minutes, 23 October 1958.
22 Letter printed in *National Builder*, November 1955, 37.
23 Quoted in NHBA Minutes, 24 May 1958.
24 NHBA Minutes, 23 October 1958.
25 Carver, 156.
26 NHBA Minutes, 8 July 1960.
27 NHBA Minutes, 8 July 1960.
28 Quoted in *National Builder*, November 1960, 20.
29 NHBA Minutes, 22 August 1961.
30 Bettison, 110.
31 *National Builder*, December 1960, 21.
32 CMHC, *50 Years of Innovation*. Ottawa: CMHC, 1993.
33 Builders reversed the system of convection heating of the 1940s (calling it, logically, "counter-convection") so that the warm air registers were now on your house perimeter, and it was the return air registers which were in the central halls.
34 Bettison, 110.
35 Bettison, 184.
36 NHBA Project Builders and Land Developers Institute (PBLDI) Minutes, 12 October 1955.
37 Long, Norman, Report to the NHBA Board, 15 August 1951.
38 Quoted in NHBA Minutes, 12 December 1951.
39 PBLDI Minutes, 30 May 1955, 3.
40 PBLDI Minutes, 30 May 1955, 3.
41 PBLDI Minutes, 30 May 1955, 2.
42 PBLDI Minutes, 5 July 1955, 5.
43 PBLDI Minutes, 5 July 1955, 4.
44 Founded by NHBA in November 1954.
45 Although the OAA was not involved.
46 PBLDI Minutes, 5 July 1955, 2.
47 PBLDI Minutes, 5 July 1955, 2.
48 PBLDI Minutes, 5 July 1955, 2.
49 Winters, 4.
50 PBLDI Minutes, 5 July 1955, 2.
51 PBLDI Minutes, 5 July 1955, 3.
52 PBLDI Minutes, 5 July 1955, 3.

53 PBLDI Minutes, 5 July 1955, 3.
54 For example, it is while Mansur was chairman, at the meeting of 12 October 1955, that the Minutes recording his advice were approved.
55 Of Don Mills Development. PBLDI Minutes, 7 September 1955.
56 Winters, 9.
57 Clayton/Scanada, Vol 2, 12.
58 Clayton/Scanada, Vol 2, 12.
59 Clayton/Scanada, Vol. 2, 12.
60 Clayton/Scanada, Vol. 2, 17.
61 NHBA Minutes, 14 January 1958.
62 NHBA Minutes, 14 January 1958.
63 Bill McCance, quoted in NHBA Minutes, 24 May 1958.
64 Quoted in NHBA Minutes, 14 January 1958.
65 Quoted in NHBA Minutes, 18 July 1958.
66 Ontario House Builders' Association Minutes, 24 October 1955.
67 PBLDI Minutes, 15 May 1956.
68 "Any Picture Windows," *National Builder*, Oct. 1955, 34.
69 Bates, Stewart, "Think in Terms of Communities," *National Builder*, February 1958, 14.
70 Lewis, Thomas S., *Empire of the Air, The Man Who Made Radio*. New York: Edward Burlingame Books, 1991.
71 Quoted in "Has Apartment Building a Future," *National Builder*, March 1955, 14.
72 Scheick, William, "The House of the Future," *National Builder*, September 1957, 6.
73 Scheick, 6.
74 Scheick, 7.
75 "Builders a Healthy Lot," *National Builder*, May 1957, 22.
76 "Choose a Color," *National Builder*, March 1954, 10.
77 NHBA Minutes, 28 November 1951.
78 "The members either approve a revised constitution with a sound financial set-up and go on to bigger things or WE FOLD UP ENTIRE-LY." (Emphasis in original.) NHBA AGM Minutes, 29 September 1952.
79 NHBA Minutes, 23 October 1958.
80 Quoted in "This is Canada's Mortgage Story," *National Builder*,

81 Smith, Lawrence Berk, *The Postwar Canadian Housing and Residential Mortgage Markets*. Toronto: University of Toronto Press, 1974, 139.
82 Smith, 133.
83 Edmonton House Builders' Association (EHBA) Minutes, 13 June 1956.
84 EHBA Convention Minutes, 13 June 1956.
85 EHBA Convention Minutes, 13 June 1956.
86 NHBA Minutes, 9 July 1956.
87 EHBA Convention Minutes, 13 June 1956.
88 NHBA Minutes, 9 July 1956.
89 NHBA Minutes, 9 July 1956.
90 NHBA Minutes, 9 July 1956.
91 NHBA Minutes, 9 July 1956.
92 NHBA Minutes, 9 July 1956.
93 NHBA Minutes, 9 July 1956.
94 NHBA Minutes, 24 May 1958.
95 NHBA Minutes, 9 July 1956.
96 NHBA Minutes, 9 July 1956.
97 NHBA Minutes, 14 January 1958.
98 NHBA Minutes, 18 July 1958.
99 William McCance (P.Eng., NHBA Research Director) in address to the Society of the Plastics Industry, Royal York Hotel, 15 April 1970.
100 NHBA Memo to Local Associations, 22 May 1959.
101 Quoted in *National Builder*, October 1957, 7.
102 Quoted in *National Builder*, December 1957, 13.
103 Quoted in *National Builder*, August 1960, 17.
104 Quoted in addendum to NHBA Minutes, 18 July 1958.
105 NHBA Minutes, 18 July 1958.
106 NHBA Minutes, 18 July 1958.
107 NHBA Minutes, 18 July 1958.

Revenge of the Cliff-Dwellers: 1960-1969

June 1956, 11.

1 Reynolds, Malvina, *Little Boxes*. ©1962, Schroder Music Co.
2 *House of Commons Debates*, 1966-1967, 13:14377.
3 Delys, Claudia, *What's So Lucky About a Four Leaf Clover?* New York: Bell Publishing, 1989, 380.
4 "A Place Called Home," Royal Bank *Reporter*, Fall 1990, 10.
5 *Reporter*, 10.
6 *Reporter*, 10.

7 Clayton/Scanada, Vol. 1, 65.
8 Clayton/Scanada, Vol. 2, 23.
9 Clayton/Scanada, Vol. 1, 67.
10 Clayton/Scanada, Vol. 2, 23.
11 "Whatever the mitigating measures were, the rush to make Canadians apartment dwellers obliged them to accept the status of rent-payer rather than dwelling-owner and mortgage-payer ... There was much publicity given at this time to the advantages, and even the neces-sity, of super-concentrations of population in city centres. Images and drawings of cities of the future and other mind-boggling prognosti-cations of what the future held were common." Bettison, 165.
12 Clayton/Scanada, Vol. 1, 66.
13 Bettison, 156-157.
14 Scanada Consultants Ltd, *Industrialized Housing Production*. Ottawa: CMHC, 1970.
15 Clayton/Scanada, Vol. 2, 26.
16 Clayton/Scanada, Vol. 2, 27.
17 Clayton/Scanada, Vol. 2, 28.
18 Peter Barnard Associates, *Concrete Building Systems in the Toronto Area, 1968-74*. Ottawa: CMHC, 1974.
19 Personal conversation with a mem-ber of the federal Eastern Arctic land claims negotiating team, 1980.
20 Clayton/Scanada, Vol. 2, 14.
21 Clayton/Scanada, Vol. 2, 16.
22 Clayton/Scanada, Vol. 2, 16.
23 Blumenson, 228.
24 "Brutalism," launched in England in the 1950s, and popularized in Canadian architecture schools by the 1966 book *New Brutalism*.
25 Blumenson, 237.
26 Blumenson, 237.
27 Quoted in McGuigan, Cathleen, "How to Talk to a Brick," *Newsweek*, 4 November 1991, 76.
28 McGuigan, 76.
29 Blumenson, 237.
30 Wolfe, 62.
31 *National Builder*, September 1962, 54.
32 Wolfe, 64.
33 Rybczynski, *The Most Beautiful House*, 36.
34 Quoted in Carver, 178.
35 Quoted in Safdie, Moshe, *Beyond Habitat*. Montreal: Tundra Books, 1970, 170.
36 Safdie, 172.
37 Safdie, 168-169.
38 Carver, 178.

39 McKenna/Purcell, 155.

40 McKenna/Purcell, 155.

41 NHBA Minutes, 4 April 1960.

42 Minutes of Meeting with the Minister of Public Works, 14 March 1960.

43 NHBA Minutes, 7 July 1960.

44 Donald Johnson, NHBA Minutes, 7 July 1960.

45 NHBA Minutes, 7 July 1960.

46 NHBA Minutes, 7 July 1960.

47 Clayton/Scanada, Vol. 3, 24.

48 Clayton/Scanada, Vol. 3, 18.

49 Communication from the vice president of CMHC to the chief executive officer of NHBA, recorded in NHBA Minutes, 4 April 1960.

50 NHBA Minutes, 5 April 1962.

51 NHBA Minutes, 5 April 1960.

52 Bettison, 127.

53 Bettison, 128.

54 Bill McCance, Address to the Society of the Plastics Industry, Royal York Hotel, 15 April 1970.

55 McCance.

56 *National Builder*, January 1961, 43.

57 Wines, 24.

58 "Most architecture-school curricula have all the flexibility of military drills. Restraints on the type of information imparted to students, compared to education in any of the other arts, amounts to repression." James Bezanson, City of Saint John. Personal correspondence with this writer, 1992.

59 Wines, 48.

60 Location in downtown Toronto would purportedly cost $9,200 less per year than in Ottawa.

61 NHBA Minutes, 19 July 1961.

62 NHBA Minutes, 4 July 1962.

63 "Tight money policies have had a negative impact on new housing production in the past. The declines in housing starts in the latter part of 1958 through 1959, in 1965-66 and in 1970 were partly owing to tight money policies pursued by the Bank of Canada. Likewise, a relatively loose money policy contributed to the upturn in starts in 1967-69." Clayton/Scanada, Vol. 3, 24.

64 NHBA President C.B. Campbell, NHBA Minutes, 12 January 1966.

65 NHBA Minutes, 12 January 1966.

66 CMHC Industry Survey interview with Alan Scott, former CMHC official, 22 July 1986.

67 CMHC Industry Survey interview with Joseph Ryan, former CMHC appraiser, St. John's, 16-17 July 1986.

68 L. Gunby, chairman of the Economic Research Committee, NHBA Minutes, 1 April 1968.

69 Carver, 158.

70 C.B. Campbell, quoted in NHBA Minutes, 22 August 1961.

71 NHBA Minutes, 22 August, 1961.

72 NHBA Minutes, 22 August, 1961.

73 Lount added: "If an architect or an engineer wants to practice his respective profession he must apply to his provincial association. These associations function on the authority given them by the province. They are not government associations, but function under the terms of an Act and have the right to give or take away the license to practice … In the initial instance, we must take everybody in [among builders to be registered] who is functioning as a builder today … and everyone qualifies to start with. Then you set up your standards and gradually the poorer ones drop out through bankruptcies and inability to compete." NHBA Minutes, 28 March 1961.

74 NHBA Minutes, 12 April 1969.

75 NHBA Minutes, 12 April 1969.

76 CMHC Industry Survey interview with Joseph Ryan, former CMHC appraiser, St. John's, 16-17 July 1986. A similar view was expressed by Donald Tibbitts of the National Research Council on the founding of the Nova Scotia Home Builders' Association, in CMHC's interview, 16 July 1986.

77 NHBA Minutes, 28 March 1961.

78 NHBA Minutes, 22 January 1965.

79 NHBA Minutes, 12 April 1969.

80 NHBA Minutes, 30 March 1968.

81 Recorded at NHBA Minutes of 12 January 1966.

82 NHBA Minutes, 3 April 1966.

83 Eric Johnson, NHBA Minutes, 23 November 1968.

84 NHBA Minutes, 21 April 1963.

85 NHBA Minutes, 21 April 1963.

86 Davey, Keith, *The Rainmaker*. Toronto: Stoddart, 1986, 22.

87 NHBA Minutes, 19 November 1963.

88 NHBA Annual Report, 1963.

89 Bettison, 200.

90 "The removal of this tax was only asking the government to receive less revenue while leaving intact the profit margins of the private interests concerned with housing." Bettison, 200.

91 "Where Do We Go From Here?" *National Builder*, March 1968, 57.

92 Carver, 157.

93 Ian G. Wahn, Liberal Member for St. Paul's, *House of Commons Debates*, 1967, 3:2609.

94 Ian Wahn, *House of Commons Debates*, 1967, 5:5716.

95 J.B. Stewart, parliamentary secretary to the minister of public works, *House of Commons Debates*, 1967, 3:2758.

96 Carver, 164.

97 Carver, 181.

98 Carver, 182.

99 Carver, 182.

100 Whelan, Eugene, *Whelan*. Toronto: Irwin, 1986, 116.

101 Carver, 185.

102 *House of Commons Debates*, 1968-1969, 6:5902.

103 *House of Commons Debates*, 1968-1969, 3:2972.

104 *House of Commons Debates*, 1968-1969, 5:4881.

105 Quoted in Bettison, 207.

106 *House of Commons Debates*, 1968-1969, 6:6185.

107 According to L.C. Gunby, NHBA Minutes, 31 January 1969, Hellyer had discussions with NHBA, in the company of his executive assistant, Lloyd Axworthy.

108 NHBA Minutes, 31 January 1969.

109 NHBA Minutes, 31 January 1969.

110 "The significance of the Hellyer task force report lay not in the details of its recommendations … From the political perspective its significance lay in the extent to which the federal minister and CMHC were to intrude into details of decisions about the local suitability of federally funded programs. The minister froze urban renewal and public housing because the task force came to the opinion that many programs were wrongly conceived or were being abused." Bettison, 206.

111 Bettison, 220.

112 Bettison, 209.

113 *House of Commons Debates*, 1968-1969, 6:6184.

114 *House of Commons Debates*, 1968-1969, 6:6748.

115 Bettison, 213.
116 Quoted in Carver, 186-187.
117 Lightfoot, Gordon, "Black Day in July." New York: Warner Brothers-Seven Arts Inc., 1968.
118 In September 1991, the Government of Canada's constitutional proposals included the entrenchment of "sustainable development" in the constitution. *Shaping Canada's Future Together*. Ottawa: Queen's Printer, 1991.
119 McLaughlin, Mignon, *The Neurotic's Notebook*. New York: Bobb-Merrill, 1960.

Whites, Colours, and the Cold-Water Wash: 1969-1975

1 Toronto architect J. Michael Kirkland in "The Metaphysics of House," *City & Country Home*, April 1991, 18.
2 Quoted in Elliott, Julia, "Hollywood Set Design at Home," *Ottawa Citizen*, 28 March 1992, D-1.
3 Elliott, D-1.
4 Lüscher, Dr. Max, *The Lüscher Color Test*. New York: Pocket Books, 1969, 112.
5 Lüscher, 118.
6 *Ottawa Citizen* (from Cox News Service), 25 April 1992, I18.
7 Dr. McCracken's views, published in *Hominess: a Cultural Account of One Constellation of Consumer Goods and Meanings* (Utah Association for Consumer Research, 1989), were summarized on the editorial page of *Chatelaine*, October 1990, 9.
8 Harrington, Leslie (of Benjamin Moore & Company), "Decor for the '90s," *Ottawa Citizen*, 26 January 1991, C1.
9 Beech, David (of Para Paints Canada Inc.), "The Shape of Things to Come," *Canadian House & Home*, December/January 1991, 50.
10 Davey, 191.
11 Bettison, 244.
12 *House of Commons Debates*, 1968-1969, 10:10620.
13 Andras, Robert, *House of Commons Debates*, 1969-1970, 2:1700.

14 Andras, Robert, Address to the National Forum of the American Institute of Architects, Detroit. CMHC Press Release, 23 June 1971, 10.
15 Bettison, 237-238.
16 Johnson, Eric, Report of the President to the Board, October 1970, 5.
17 Letter of 17 December 1970.
18 Address to the Union of B.C. Municipalities, 17 September 1970. Ottawa: CMHC, 1970.
19 Lithwick, Harvey, *Urban Canada: Problems and Prospects*. Ottawa: CMHC, 1970.
20 Lithwick, 37-38.
21 Lithwick, 178.
22 Lithwick, 40.
23 Lithwick, 233.
24 Lithwick, 221.
25 Lithwick, 206.
26 Lithwick, 220.
27 Bettison, 263.
28 Economic Council of Canada, *6th Annual Review*. Ottawa: Queen's Printer, September 1969.
29 Clayton/Scanada, Vol. 1, 31-32.
30 Clayton/Scanada, Vol. 1, 32.
31 Steven Otto, M.P., *House of Commons Debates*, 1968-1969, 9:9201.
32 Andras, Robert, 18 December 1969, *House of Commons Debates*, 1969-1970, 2:2119.
33 Referendum held 25 August 1970.
34 NHBA brief to the House of Commons Committee on Finance, Trade and Economic Affairs, 1970, 6.
35 Address to the Ontario Association of Real Estate Boards, 16 March 1970.
36 *Globe and Mail*, 17 March 1970.
37 *Globe and Mail*, 17 March 1970.
38 *Globe and Mail*, 17 March 1970. Benson added that any move to allow deductions of mortgage interest or property taxes "would be unfair to lower income groups or to Canadians generally who rent their accommodation."
39 Johnson, 11.
40 Johnson, 12.
41 NHBA Addendum to the Brief to the Canadian Construction Association, Fall 1970, 3.
42 Keith Morley, NHBA Economic Research Committee Newsletter, February 1970, 3.
43 "That's the general consensus of

the HUDAC brief to the Economic Council of Canada." *HUDAC National Focus*, 18 August 1972, 3.
44 *House of Commons Debates*, 1974.
45 The Hon. Barney Danson, minister of state for urban affairs. Minister's written response to HUDAC's 1976 annual resolutions.
46 Costain's Keith Morley, NHBA Economic Research Committee *Newsletter*, Feb. 1970, 5.
47 *HUDAC National Focus*, 28 February 1972, 3.
48 *HUDAC National Focus*, 16 March 1972, 1.
49 *HUDAC National Focus*, 5 June 1973, 2.
50 Harron, Don, *Charlie Farquharson's Jogfree of Canda*[sic], *The World and other Places*. Toronto: Gage, 1974, 40.
51 *HUDAC National Focus*, 15 July 1974, 1.
52 *New Home Warranty — Security for New Home Buyers*. CHBA (undated).
53 *HUDAC National Focus*, 2 July 1976, 2.
54 *HUDAC National Focus*, 2 July 1976, 2.
55 *HUDAC National Focus*, August 1979, 3.
56 News Release, 28 February 1975 from the Hon. B. Danson.
57 Clayton/Scanada, Vol. 1, 9.
58 Clayton/Scanada, Vol. 5, 10. "During the 1960s and early 1970s, increasing numbers of young adults established their own households."
59 Clayton/Scanada, Vol. 5, 10.
60 Clayton/Scanada, Vol. 1, 6-7.
61 Clayton/Scanada, Vol. 3, 3.
62 Clayton/Scanada, Vol. 2, 54.
63 Chung, Joseph H., *Cyclical Instability in Residential Construction in Canada*. Ottawa: Economic Council of Canada, 1976, 107.
64 Clayton/Scanada, Vol. 2, 17.
65 He used this term in his speech to the Toronto Home Builders' Association, 8 April 1970, 2.
66 Rybczynski, *Looking Around*, 90.
67 Quoted in *HUDAC National Focus*, 15 March 1973, 3.
68 Fowke, Clifford, "When HUDAC was the NHBA," *Canadian Building*, March 1979, 48.
69 Gluskin, Ira, *The Cadillac Fairview Corporation: A Corporate Background Report*. Ottawa: Royal

Commission on Corporate Concentration, January 1976, 133.

70 Gluskin, 134.

71 Clayton/Scanada, Vol. 3, 7-8.

72 *House of Commons Debates*, 1968-1969, 9:9337.

73 *House of Commons Debates*, 1968-1969, 9:9337.

74 Johnson, 7.

75 Johnson, 4.

76 Lithwick, 204.

77 *HUDAC National Focus*, 15 March 1973, 4.

78 Larry Zolf quoted in Lynch, Charles, *A Funny Way to Run A Country*. Edmonton: Hurtig, 1986, 5.

79 Gwyn, Richard, *The Northern Magus*. Markham: PaperJacks, 1980, 166-167.

80 Gwyn, 166.

81 Davey, 177.

82 HUDAC Minutes, 4 December 1975.

83 HUDAC memorandum to its membership, 9 April 1976.

84 HUDAC Minutes, 7 October 1976.

85 Bill McLean, consultant, speaking at "Housing of the Future" Conference of HUDAC, quoted in *HUDAC National Focus*, 30 June 1975, 3.

86 Fitch, 31.

87 "When it comes to the information imparted by teachers in the design studio, nothing has changed. Students are told emphatically what *is* and what is *not* permissible in architecture, and these rules are all but engraved on the walls." Wines, 49. (Emphasis in original.) "What makes the situation even worse is the fact that architectural education functions as a self-perpetuating continuum. Professors teach as they have been taught." Wines, 49.

88 Wolfe, 99.

89 Wolfe, 103.

90 Gwathmey, Charles, and Siegel, Robert, *Buildings and Projects 1964-1984*. New York: Harper & Row, 1984, 9.

91 Wolfe, 7.

92 "The ruins of the modern architect's pretension and post modern architect's perversion." Van Pelt/Westfall, 3.

93 Kidder, 227.

94 Fisher, Karen, *Living for Today*.

New York: Viking, 1972.

95 Fisher, 110-111.

96 NHBA Economic Research Committee, *Newsletter*, February 1970, 1.

97 Humphrey Carver, quoted in *HUDAC National Focus*, 16 September 1975, 4.

98 Published in *The Housing Game* and presented in summary format in *HUDAC National Focus*, 28 July 1975, 4.

99 Nikolas Pevsner, quoted in Taylor, 90.

100 "The end purpose of modern architecture is the elimination of architecture itself." Andrea Branzi, quoted in Wines, 30.

101 Jenks, Charles, *The Language of Post-Modern Architecture*, 4th ed. New York: Rizzoli, 1991, 23.

102 Joe Greene, quoted in Gwyn, 152.

103 Quoted in Gwyn, 152.

104 The word "Blintzkrieg" was coined in New York and used by *Life* Magazine in its special issue on the Six-Day War.

105 Gwyn, 154.

106 Jack Cochran, president, Domtar Construction Materials Ltd., quoted in *HUDAC National Focus*, 5 March 1974, 3.

107 "We can recognize in twentieth-century Western World architecture the ultimate consummation of the thousand-year road that Western man has been travelling, from merely potential and implicit power over Nature to demonstrably limitless control stretching from the grass beneath his feet to the farthest planets." Gowans, *Building Canada*, 169.

108 Cawker, Ruth, and Bernstein, William, *Contemporary Canadian Architecture*. Toronto: Fitzhenry & Whiteside, 1982, 55.

The Yuppie Revolution: 1975-1982

1 HUDAC Minutes, 3 October 1975.

2 Abba Donair and Pizza Restaurant in Ottawa, duly noted in *HUDAC National Focus*, January 1982, 8.

3 Brand, Stuart, *The New Whole Earth Catalogue*. New York: Random House, 1980.

4 Carson, Rachel, *Silent Spring*. Boston: Houghton Mifflin, 1962.

5 Campbell, Stuart, *The*

Underground House Book. Charlotte, Vermont: Gardenway, 1980, 11.

6 Metz, Don, *Superhouse*. Charlotte, Vermont: Gardenway, 1981.

7 Metz, 122.

8 Todd, J. and Todd, N.J., *Tomorrow is Our Permanent Address*. New York: Harper & Row, 1980.

9 *Hudac National Focus*, August 1979, 2.

10 Todd, 16.

11 Todd, 9.

12 Todd, 100, 102.

13 CBC Radio Comedy, to be precise.

14 HUDAC Minutes, 31 July 1974.

15 HUDAC Minutes, 31 July 1974.

16 "Ambient formaldehyde levels in houses are typically .03 to .04 parts per million. By comparison, typical levels in the smoking section of a cafeteria are 0.16 ppm. Houses with new carpeting can also reach these levels." Carson, A. and Caverly, J., *Urea Formaldehyde Foam Insulation*. Toronto: Carson, Dunlop Assoc., October 1992, 1.

17 Carson/Caverly, 3.

18 Carson/Caverly, 3. (Emphasis in original.)

19 Carson/Caverly, 3.

20 Québec Real Estate Association, *Dropping the UFFI Clause: What are Members Bound To Do?* Montreal: Law Reference File #9.

21 HUDAC Minutes, 3 October 1973.

22 HUDAC Minutes, 30 November 1973.

23 Letter of Barney Danson to HUDAC President Howard Ross, 10 May 1976.

24 HUDAC Minutes, 30 May 1978.

25 HUDAC Minutes, 4 April 1978.

26 HUDAC Minutes, 4 April 1978.

27 *HUDAC National Focus*, August 1979, 1.

28 Letter of Donald MacDonald to HUDAC President Howard Ross, 4 May 1976.

29 HUDAC Minutes, 28 July 1973.

30 HUDAC Minutes, 26 May 1977.

31 HUDAC Minutes, 4 April 1978.

32 HUDAC Minutes of the Meeting with the Hon. André Ouellet, 4 July 1978.

33 HUDAC Minutes, 19 October 1978.

34 HUDAC Minutes, 19 October 1978.

35 HUDAC Minutes, 19 October 1978.

36 *Newsweek*, 10 August 1992, 56.

37 HUDAC Minutes, 19 October 1978. The proposal was to remove the capital gains allowance.

38 "Rules of Thumb Need to Change," *HUDAC National Focus*, September 1978, 3.

39 "Rules of Thumb," 3.

40 Keynote address to HUDAC 1979 Conference, quoted in *HUDAC National Focus*, February 1979, 1.

41 *HUDAC National Focus*, May 1979, 1.

42 *HUDAC National Focus*, April 1979, 2.

43 *1980 HUDAC Annual Report*, 1.

44 Whelan, 199.

45 Section 15 of the Notice of the Ways and Means Motion, 12 November 1981.

46 Davey, 278.

47 *HUDAC National Focus*, March 1982, 2.

48 Minutes of HUDAC meeting with Joe Clark, 5 October 1978.

49 "Private [Sector] Lessons," *Ottawa Citizen*, 18 August 1986, A17.

50 *Financial Post Magazine*, 5 August 1978.

51 Clayton/Scanada, Vol. 5, 24.

52 *HUDAC National Focus*, May 1978, 2.

53 *HUDAC National Focus*, May 1981, 8.

54 MacDonald, Donald S., minister of finance, *Attack on Inflation: a Program of National Action*. Ottawa: Queen's Printer, 14 October 1975.

55 Clayton Research Associates, *Rental Housing in Canada Under Rent Control and Decontrol Scenarios, 1985-1991*. Report, Toronto, November 1984.

56 HUDAC Minutes, 24 July 1975.

57 *HUDAC National Focus*, January 1982, 7.

58 Quoted in *HUDAC National Focus*, March-April, 1981, 1.

59 Committee chaired by HUDAC President Klaus Springer, quoted in *HUDAC National Focus*, March/April, 1981, 1.

60 *HUDAC National Focus*, May 1981, 1.

61 Quoted in *HUDAC National Focus*, 5 March 1976, 2.

62 *HUDAC National Focus*, 5 March 1976, 1.

63 *HUDAC National Focus*, January 1982, 3.

64 *HUDAC National Focus*, January 1982, 5.

65 *Policy Statement and Resolution*. HUDAC, Vancouver, 1983, 1.

66 May 1960.

67 Jacobs, Jane, *The Death and Life of Great American Cities*. New York: Random House, 1961.

68 Eric Johnson, quoted in *HUDAC National Focus*, 28 February 1972, 3.

69 "Forecast of Canadian Construction Activity," *Report of the NHBA Research Sub-Committee*, September 1970, Table II.

70 See, for example, "Conserving and Upgrading the Built Environment," by this writer, in Estrin, David, and Swaigen, John, eds., *Environment on Trial*. 3rd ed. Toronto: Emond Montgomery, 1993.

71 E.g. *Interpretation Bulletin IT-128R*. Ottawa, Revenue Canada, 1984 (and its predecessors).

72 E.g. *SMRQ v. Goyer, R. v. GoldBar, R. v. Bergeron, R. v. McLaughlan*, cited in Estrin/Swaigen, 400.

73 Two personal conversations, September and November, 1991.

74 Personal conversation, 1976.

75 Flanders/Swann, "Design for Living." (This song was written in the early 1950s.)

76 Personal conversation, 1976.

77 Personal conversation, 1976.

78 The memo is confidential. The contents were disclosed to this writer by an informed source.

79 Clayton/Scanada, Vol. 3, 24-25.

80 CMHC graph, cited in *Canadian Building*, September 1990, 38.

81 Survey by Environics Research Corporation, Toronto, 1985, cited in Clayton/Scanada, Vol. 2, 31.

82 Speech to HUDAC Annual Conference, Montreal, quoted in *HUDAC National Focus*, January-February 1981, 7.

83 Speech to HUDAC Annual Conference, Montreal, quoted in *HUDAC National Focus*, January-February 1981, 7.

84 *HUDAC National Focus*, March 1980, 1.

85 *HUDAC National Focus*, March 1980, 1.

86 Quoted in *HUDAC National Focus*, April 1980, 2.

87 Merrill Butler (NAHB), quoted in HUDAC Minutes, 13 January 1980.

88 Clayton/Scanada, Vol. 3, 24.

89 Toronto's Norman Godfrey speaking to the Toronto Home Builders' Association, 29 January 1985.

90 Clayton/Scanada, Vol. 4, 17.

91 "The Last Word," *Canadian Housing*, Spring/Summer 1993, 38.

92 Clayton/Scanada, Vol. 4, 18.

93 Albert De Fehr in inaugural address to CHBA, Ottawa, 11 February 1985.

94 Clayton/Scanada, Vol. 4, 20.

95 Address to the Toronto Home Builders' Association, 29 January 1985.

96 HUDAC Minutes, 1 December 1981.

97 HUDAC Minutes, 1 December 1981.

98 HUDAC Minutes, 11 February 1982.

99 HUDAC Minutes, 13 February 1982.

100 HUDAC Minutes, 13 February 1982.

101 HUDAC Minutes, 13 February, 1982.

102 McLaughlin.

103 Esar, Evan, ed., *Dictionary of Humorous Quotations*. New York: Horizon, 1949, 161.

Jumps, Dumps, Wumps, and Gazumps: 1982-1988

1 Drucker, Peter, *Managing in Turbulent Times*. New York: Harper & Row, 1980, 45.

2 HUDAC Minutes, 7 October 1981.

3 HUDAC Minutes, 11 February 1982.

4 HUDAC Minutes, 2 September 1981.

5 HUDAC Minutes, 5 December 1983.

6 HUDAC Minutes, 7 October 1981.

7 HUDAC Minutes, 19 May 1982.

8 HUDAC Minutes, 19 May, 1982.

9 HUDAC Minutes, 19 May 1982.

10 HUDAC Minutes, 19 May 1982.

11 *HUDAC Convention Times*, 21 Februray 1979, 3.

12 John Sandusky, "The Impact of the Past on the Future." Address to CHBA, Quebec, 1984, 3-4.

13 Albert De Fehr, address to the Alberta Home Builders' Association, Jasper, 22 September 1984.

14 John Sandusky, "Notes on Leadership." Address to the Toronto Home Builders' Association, 5 December 1984.

15 Albert DeFehr, address to the National Association of Homebuilders, Washington, 18 May 1985.

16 Sandusky, John, *Overview Statement on Rent Control*. Toronto: CHBA, 5 December 1984.

17 Sandusky, "The Impact of the Past," 7.

18 Albert De Fehr, address to the Ontario Home Builders' Association, Kingston, 11 October 1985.

19 Albert De Fehr, address to the Canadian Gas Association, Winnipeg, 23 October 1984.

20 De Fehr, address to the Alberta Home Builders.

21 "HUDAC is Happy That Ottawa at Last Acting on its Beefs," *Toronto Star*, 18 February 1984, E1.

22 Blumenson, 244.

23 Quoted in Rybczynski, *Looking Around*, 155.

24 Bernstein, William, and Cawker, Ruth, eds., *Building With Words*. Toronto: Coach House, 1981, 44-45.

25 Quoted in Jencks, Charles, *The Prince, the Architects and New Wave Monarchy*. New York: Rizzoli, 1988, 7.

26 Jenkins, Simon, "The Prince and the Architects," *The Sunday Times*, Week in Focus, 3 June 1984.

27 "Mansion House Speech," 1 December 1987, reproduced in Jencks.

28 Prince Charles, *A Vision of Britain*, 7-9.

29 Prince Charles, *A Vision of Britain*, 156.

30 Quoted by Prince Charles in his speech to the Institute of Directors, 26 February 1985, reproduced in Jencks.

31 Editorial, 9 December 1987.

32 British architect Peter Ahrends, and Sherban Cantacuzino of the Royal Fine Art Commission. Both quoted

33 "Developers with their hack architects in tow ... in a climate of civic indifference and public apathy." Foster, Norman, "A Force for Good But the Wrong Target," *The Sunday Times*, 6 December 1987.

34 Editorial, 9 December 1987.

35 Editorial, 9 December 1987.

36 Naisbitt, John, *Megatrends*. New York: Warner, 1982, 238.

37 Naisbitt, 5.

38 Ritchie, Charles, *The Siren Years*, quoted in Colville-Reeves, Lynda, *Home Style*. Toronto: Random House, 1991.

39 Quoted in Rybczynski, *Home*, 211.

40 Rybczynski, *Home*, 211.

41 Rybczynski, *Home*, 220-221.

42 Rybczynski, *Home*, 221-222.

43 Taylor, 97.

44 Doran, Susan, *Living in R-2000 Comfort*. Ottawa: CHBA, 8. Reprint from *Select Homes Magazine*.

45 Doran, 14.

46 *CHBA Five Year Operating Plan*, Halifax 1987, 3.

47 John Sandusky, "Change and Opportunity: A New Future for the Canadian Home Building Industry." Address, 12 October 1984.

48 Pre-budget consultations, 25 November 1986: Submission to the Minister of Responsible for CMHC.

49 HUDAC Minutes, 26 October 1982.

50 HUDAC Minutes, 26 October 1982.

51 Lyle Hallman of Kitchener, HUDAC Minutes, 18 August 1982.

52 Appendix B to HUDAC Minutes, 5 December 1983.

53 Appendix B.

54 Clayton Research Associates, *Rental Housing in Canada under Rent Control*.

55 1985.

56 Quoted in HUDAC Minutes, 20 June 1985.

57 Quoted in HUDAC Minutes, 20 June 1985.

58 Of the McGill Society of the Ottawa Valley.

59 Savoie, Donald, *The Politics of Public Spending in Canada*. Toronto: University of Toronto Press, 1990, 139.

60 CHBA, *CHBA Submission to the Federal Government's Consultation Paper on Housing*. Ottawa: CHBA, March 1985.

61 Kenward, Dr. John, "The Industry Perspective," *Canadian Housing*, Fall 1990, 35.

62 Kenward, 35.

63 Kenward, 35.

64 Kenward, 36.

65 Quoted in Eggertson, Laura, "Private (sector) Lessons," *Ottawa Citizen*, 18 August 1986, A17.

66 Robert Shaw, Comments to the Board, 25 November 1986.

67 CHBA Minutes, 1 November 1986.

68 HUDAC Minutes, 26 June 1974.

69 Clayton/Scanada, Vol. 1, 10-11.

70 Clayton Research Associates (1986), quoted by De Fehr in Address to the Ontario Home Builders.

71 Clayton/Scanada, Vol. 4, 24.

72 Clayton/Scanada, Vol. 4, 25.

73 Albert De Fehr, Address to the Deputy Ministers of Housing, Edmonton, 11 January 1985.

74 Sandusky, John, *Overview Statement on a Proposal for a National Housing Allowance Program for Canada*. Ottawa: CHBA, January 1985.

75 Clayton/Scanada, Vol. 5, 16.

76 Dillon Consulting, *Literature Search on Residential Construction Regulatory Reform*. Report, Toronto, Dillon Consulting (Undated), 31.

77 Letter of Barney Danson to HUDAC President Howard Ross, 10 May 1976.

78 Clayton Research Associates, *The Changing Financial Environment: What it is Doing to the Housing Industry*. Ottawa: CHBA/CMHC, July 1991, 24.

79 De Fehr, address to deputy ministers, 11.

80 Urban Development Institute Ontario, *UDI Survey of Levy Structure*. Toronto: UDI, November, 1990.

81 Economic Council of Canada, *Innovation and Jobs in Canada*. Ottawa: ECC, 1987, 157.

82 Clayton/Scanada, Vol. 1, 15.

83 Clayton/Scanada, Vol. 2, 9.

84 Clayton/Scanada, Vol. 4, 1.

85 Clayton/Scanada, Vol. 4, 7.

86 Clayton/Scanada, Vol. 4, 9.

87 De Fehr, address to the Ontario

Home Builders.

88 Rybczynski, Witold, "The Little House That Grew," *Ontario Homebuilder*, June/July 1991, 28.

89 Rybczynski, "The Little House," 28.

90 Clayton/Scanada, Vol. 2, 46.

91 Dillon Consulting, 10.

92 De Fehr, Albert, *Homebuilders and the Regulatory Environment*. Ottawa: CHBA, October 1986, 14.

93 De Fehr, *Homebuilders*, 4-5, 9.

94 Dillon Consulting, 19.

95 Quoted in *HUDAC National Focus*, 17 May 1976, 2.

96 *HUDAC National Focus*, 19 July 1976, 3.

97 De Fehr, *Homebuilders*, 17.

98 Sandusky, "Notes on Leadership."

99 Dillon Consulting, 9.

100 Clayton/Scanada, Vol. 2, 29, 31.

101 Aikman, Alastair, *Guidelines for Rehabilitation of Buildings Regulated by Part 3 of the National Building Code of Canada*. Ottawa: Associate Committee of the National Building Code of Canada Working Paper, February 1991, 5.

102 HUDAC Minutes, 5 September 1978.

103 Taylor, 32.

104 Taylor, 32.

105 Taylor, 32.

106 Taylor, 32.

107 Samuelson, R.J., "Who cleans up the waste?" *Newsweek*, 20 May 1991, 49. Samuelson recommends *A Homebuyer's Guide to Environmental Hazards*, from the Consumer Information Center-W., P.O. Box 100, Pueblo, Colo. 81002.

108 Ann Coombs, quoted in *Canadian House & Home*, December/January 1991, 48.

109 Fisher, Thomas, executive editor of *Progressive Architecture*, quoted in Taylor, 151.

110 Mills, Terry, *Renovation Requires a New Attitude*. Presentation to the Canada First Annual Construction Marketing Seminar, Toronto, 29 October 1985.

111 *HUDAC Renovation Warranty Preliminary Report*. Toronto: HUDAC National Warranty Council, October 1983, 5.

112 HUDAC Ontario Memorandum, 14 November 1983.

113 Dillon Consulting, 26.

114 External Resolution No. 8, 1987 CHBA Annual Conference.

115 Canada Post promotional brochure.

The GST and Other Carnivores: 1988-1994

1 Quoted in Colville-Reeves, Lynda, *Home Style*. Toronto: Random House, 1991, 79.

2 Attributed to Mario Buatta by Richard Salter, quoted in Colville-Reeves, 27.

3 Colville-Reeves, 45.

4 Colville-Reeves, 75.

5 Colville-Reeves, 166.

6 Colville-Reeves, 71.

7 Colville-Reeves, 165.

8 Males, Anne Marie, "Houses Make Advances in Energy-conservation," *Toronto Star*, 8 February 1992, E1.

9 *The National* (CHBA), June 1992.

10 Allen, Greg, quoted in "Saving Energy Begins At Home," *Macleans Magazine Supplement*, 2 September 1991, 6.

11 CHBA, *The Canadian Housing Industry and the Environment*. Ottawa: CHBA, January 1991, 2.

12 John Bassel, CHBA Inaugural Address, Winnipeg, 3 February 1992.

13 Estimate by Friends of the Earth, quoted in House of Commons Communiqué, 12 February 1990.

14 Bassel, Inaugural Address, 1992.

15 *Reporter*, 12.

16 "What will they think of next?" *Renew*, January 1992, 8.

17 "What will they think of next?" 9.

18 Quoted in *HUDAC National Focus*, 5 March 1977, 8.

19 James Cooke, "Canadian Manufactured Housing." Address to the Innovative Housing Conference, Vancouver, 24 June 1993.

20 Speech of 27 October 1986, Halifax.

21 CHBA Minutes, 1 November 1986, 2.

22 *Status Report: CHBA 1987 Annual Conference Resolutions*, Ottawa: CHBA, July 1988, 11.

23 Government of Canada, *Shaping Canada's Future Together: Proposal*. Ottawa: Supply and Services Canada, 1990.

24 *1990 CHBA Annual Report*, Ottawa: CHBA, 8.

25 Deconstruction's major proponents, like France's Jacques Derrida, insist that it defies definition: "All the lexical significations and even the syntactic articulations, which seem at one moment to lend themselves to this definition ... are also deconstructed and deconstructible." Quoted in Benjamin, Andrew, *What is Deconstruction?* London: Academy Editions, 1988, 33.

26 16 June 1990, C-4.

27 "Frank Gehry's House," *City & Country Home*, September 1987, 113.

28 Quoted in "Frank Gehry's House," 113.

29 McGuigan, Cathleen, "A Maverick Master," *Newsweek*, 17 June 1992, 52.

30 McGuigan, "Maverick," 52.

31 McGuigan, "Maverick," 52.

32 Quoted in McGuigan, "Maverick," 56.

33 Quoted in McGuigan, "Maverick," 56.

34 Elliott, Julia, "The Grow Home," *Ottawa Citizen*, 16 May 1992, I1.

35 "Frank Gehry's House," *City & Country Home*, 113.

36 *HUDAC National Focus*, 29 June 1973, 3.

37 In this case to Marcel Breuer's 1949 design for an "expandable house": "The Grow-Home," Fridman, Avi, *McGill News*, Fall 1990, 8.

38 Rybczynski, *Looking Around*, 69.

39 Rybczynski, *Looking Around*, 69.

40 Rybczynski, *Looking Around*, 68.

41 Tom Cochren, CHBA Inaugural Address, Hamilton, 6 February 1989.

42 Prof. Avi Friedman, quoted in Boothroyd, Peter, "McGill Poised to Profit from Grow Home," *McGill News*, Summer 1992, 9.

43 Carver, 144.

44 Kirkland, 18.

45 Hemingway, Peter, in Bernstein, W. and Cawker, R., eds. *Building with Words*. Toronto: Coach House, 1981, 56.

46 Peter Eisenman, quoted in Wines, 37.

47 Rybczynski, *Looking Around*, 79.

48 Rybczynski, *Looking Around*, 20.

49 Rybczynski, *Looking Around*, 16

50 *Building* Magazine, October/ November 1992, 37.

51 Environics Research Group, quoted

in *Reporter*, 11.

52 Estimate by John Fennell, then editor of *Building Renovation* magazine.

53 CMHC, *The Canadian Renovation Market*. Ottawa: CMHC, 1986.

54 Quoted in "The Last Word," *Canadian Housing*, Spring/Summer, 1993, 36.

55 Bill Strain, CHBA Inaugural Address, Toronto, 8 Feburary 1993.

56 Kenward, 36.

57 Toronto Home Builders' Association, *Making a Molehill out of a Mountain*. Toronto: THBA, 1990.

58 The Federation of Canadian Municipalities published, for example, this writer's *Capitalizing on Arts, Culture and Heritage*, discussing municipal strategies in this area. Ottawa: FCM, 1992.

59 Report commissioned by the Buildings Revival Coalition, Ottawa: unpublished (1986).

60 Environment Canada, *Canada's Green Plan for a Healthy Environment*. Ottawa: Supply and Services Canada, 1990.

61 *Green Plan Consultations National Wrap-up Session*. Ottawa: Government of Canada, August 1990.

62 Campbell, Kim (chair), *Stewardship and Opportunity*. Victoria: Project Pride Task Force, 1987, 23.

63 Campbell, 47-48.

64 Campbell, 48.

65 *SMRQ v. Goyer*, 1987 *Recueils de jurisprudence*, 981.

66 Application for Leave to Appeal dismissed, 21 October 1987.

67 *Gold Bar Developments Inc. v. R.*, 1987 *Dominion Tax Cases* 5152.

68 *Bergeron v. MNR.*, 1990 *Dominion Tax Cases* 1533.

69 *McLaughlin v. MNR*; 1992 *Dominion Tax Cases* 1030.

70 Revenue Canada letter to CHBA, 22 January 1992.

71 E.g. TV Ontario, 22 April 1993, 8:00 p.m.

72 Lapointe, Kirk, "Cost of Keeping up Goes Down," *Ottawa Citizen*, 20 July 1992, A4.

73 Clayton/Scanada, Vol. 2, 45-46.

74 Don Harron, quoted in "How Heavy is Your Tax Burden?"

75 Tom Cochren, CHBA Inaugural Address, Hamilton, February 1989, 11-12.

76 Arthur Andersen & Co., *Federal and Provincial Government Expenditure to Assist and Promote Owner-occupied Housing in Canada*. July 1985.

77 Norman Godfrey, CHBA Inaugural Address, Halifax, 16 February 1987, 8.

78 Gary Reardon, CHBA Inaugural Address, Montreal, 13 May 1991.

79 Reardon.

80 Reardon.

81 CHBA, *Housing in Canada*. Ottawa: CHBA, March 1993, 19.

82 CHBA, *Competitiveness of the Housing Industry*. Ottawa: CHBA, March 1992, 25.

83 *Competitiveness of the Housing Industry*, 29.

84 Quoted in Jencks, 7.

85 Bassel, 8.

86 Clayton Research Associates, *The Changing Financial Environment*. Ottawa: CHBA/CMHC, July 1991, 19.

87 CHBA, *Competitiveness of the Housing Industry*, 22.

88 *1985 CHBA Annual Report*, 6.

89 Quoted in "Cheaters," *Macleans*, 9 August 1993, 23.

90 *GST Information For Small Business*. Ottawa: Finance Canada (undated), 4-5.

91 *Montreal Gazette*, 2 November 1991, B4.

92 Quoted in the *Montreal Gazette*, 2 November 1991, B4.

93 Thompson, Gordon, *Why Homebuilders Do Not Like the GST*. Toronto: CHBA, January 1990.

94 *Housing in Canada*, 10-11.

95 *Housing in Canada*, 17-18.

96 Kenward, 36.

97 *Housing in Canada*, 16.

98 Quoted in "Cheaters," 18.

99 "Cheaters," 19.

100 Quoted in "Cheaters," 20.

101 Quoted in "Cheaters," 20.

102 Clayton Research Associates, *The Changing Financial Environment*, 14.

103 Address to the Ottawa-Carleton Home Builders' Assocociation, November 1992.

104 *CHBA Strategic Plan for Nineties*. Ottawa: CHBA, May 1991, 10.

105 Clayton Research Associates,

quoted in *Reporter*, 22.

106 Renter households with heads under 45 years of age.

107 Godfrey, CHBA Inaugural Address.

108 *CHBA 1990 Annual Report*, 1.

109 *CHBA 1991 Annual Report*, 2.

110 Interview, December 1992.

111 *Newsweek*, 4 January 1993, 58.

112 *CHBA 1991 Annual Report*, 2.

113 *Housing in Canada*, 38.

114 *Housing in Canada*, 29.

115 *Reporter*, 15.

116 *Reporter*, 15.

117 *Reporter*, 5.

118 Statistics Canada, quoted in *A Place Called Home*, 22.

119 Filion, Pierre, and Bunting, Trudy E., *Affordability of Housing in Canada*. Ottawa: Statistics Canada, 1990.

120 Clayton/Scanada, Vol. 5, 14.

121 *Reporter*, 7.

122 Clayton/Scanada, Vol. 5, 20.

123 Clayton/Scanada, Vol. 3, 3.

124 Clayton Research Associates, quoted in CHBA, *Housing in Canada*.

125 Clayton/Scanada, Vol. 1, 43.

126 Clayton/Scanada, Vol. 3, 27.

127 Address by Hon. Don Mazankowski to CHBA, 10 February 1993, 1.

128 *Housing in Canada*, 7.

129 *Housing In Canada*, 2-3.

130 Bassel, 9.

131 Thompson, Inaugural Address.

132 *Competitiveness of the Housing Industry*, CHBA, March 1992, vi.

133 "PAC Training Manual: a 'How-to' of Lobbying," *Canadian Realtor News*, July 1993, 4E.

134 "The Magic of MLS Serves Buyer and Seller," *Canadian Realtor News*, June 1993, 4F.

135 Cochren, Inaugural Address.

136 Reardon, 6.

137 Reardon, 10.

138 "The Last Word," 36.

139 Strain, CHBA Inaugural Address.

140 Douglas Gray, *Making Money in Real Estate*, quoted in the *Montreal Gazette*, 1 June 1992, 6.

141 *Reporter*, 6.

142 Yellin, Susan, "Inspector Can Help You Avoid Home Buying Pitfalls" (Canadian Press), *Montreal Gazette*, 1 June 1992, 6.

143 *50 Years of Innovation*, CMHC, 1993, 28.

144 Prof. Hestness leads the International Agency Task 13 Solar

Low Houses program. She was quoted in *Homebuilder*, July/August 1993, 5.

145 "Maple Court Woos Japanese," *Globe and Mail*, 30 August 1993, B1.

146 Innovative Housing Conference, Vancouver, June 1993.

Future Chic, Future Shock, and the Electronic Cocoon: Beyond 1994 …

1 John Tucillo of the U.S. National Association of Realtors quoted in Austin, Gene, "Housing toward the 21st Century" (Knight-Ridder Newspapers), *Ottawa Citizen*, 26 May 1990, C1.

2 Werne, Jo, "A Home in the '90s" (Knight-Ridder), *Ottawa Citizen*, 19 January 1991, C1.

3 Austin, C1.

4 Prof. Robert Newnham, quoted in McCarroll, Thomas, "Solid as Steel, Light as a Cushion," *Time*, 26 November 1990, 67.

5 Tonight Show, 19 August 1992.

6 It is supposed to become the "prestige" cladding (but will look like traditional shakes, tiles, clapboard or random stonework); Clayton/Scanada, Vol. 5, 31.

7 Loewy, Raymond, from his book *La laideur se vend mal* (Ugliness Doesn't Sell) quoted in Ragon, Michel, *Histoire mondiale de l'architecture et de l'urbanisme modernes: prospectif et futurologie.* Paris: Casterman, 1986, 59.

8 Pascal Hausermann.

9 King, Annabelle, "Buying a house a room at a time," *Ottawa Citizen* (from the *Montreal Gazette*), 14 July 1990, C-1.

10 Linda Nolan, quoted in King, C-1.

11 Rybczynski, *Home*, 223.

12 Edmund Wilson, quoted in Black, Arthur, *Basic Black*. Moonbeam, Ont.: Penumbra, 1981, 218-219.

13 Black, 218.

14 Black, 218.

15 Nostbakken/Humphrey, 147.

16 Slezin, Suzanne, *The New York Times Home*. New York: Times Books, 1982, 122.

17 Ragon, opposite 61.

18 Harris, quoted in "A Step Towards Flight as Free as Birds," *International Herald Tribune*, 1 June 1992, 3.

19 Clayton/Scanada, Vol. 5, 32.

20 Black, Arthur, *Arthur! Arthur!* Toronto: Stoddard, 1991, 184.

21 Clayton/Scanada, Vol. 5, 26.

22 Quoted in CHBA *National*, November 1990, 3.

23 CHBA *National*, November 1989, 3.

24 Quoted in Schwartz, John, "The Next Revolution," *Newsweek*, 6 April 1992, 44.

25 Author of *Technopoly: the Surrender of Culture to Technology*.

26 Schwartz, 44.

27 Quoted in Ragon, 111.

28 Quoted in Ragon, 111.

29 *HUDAC National Focus*, 3 January 1972, 2.

30 Iglesias, Enrique Fernandes, *Extracity*. Calgary: (private translation) 1967.

31 Vilder, André, in *Culture Vivante*, No. 15. Quebec: November 1969.

32 Schuyt, M., Elffers, J., and Collins, G., *Fantastic Architecture*. New York: Abrams, 1980, 106.

33 Schuyt/Elffers/Collins, 104.

34 Quoted in Ragon, 149.

35 Quoted in Ragon, 121.

36 Conference August 28-September 5, 1992 (Washington). Advertisements published in e.g. *Discover*, May 1992, 29.

37 Taylor, 170-171.

38 "Our Next Home," *Life*, May 1991, 24.

39 Schuyt/Elffers/Collins, 106.

40 *Life*, 34.

41 *Life*, 34.

42 *Life*, 34.

43 *Life*, 34.

44 Nicol (unpaginated).

45 The Apollo astronaut program did include a short stint in the Sudbury area.

46 The title refers to certain security classifications.

47 Matthews, A.A., *The Wall of Light: Nicola Tesla and the Venusian Space-ship the X-12*. Mokeluhmne Hill, Calif.: Health Research, 1973.

48 Quoted in Colombo, 240.

49 Quoted in Colombo, 236.

50 Quoted in Kron, *Home-Psych*, 177.

51 Clark, Kenneth, *Civilisation*. London: BBC, 1969, 345.

52 Clark, 345.

53 Clark, 346.

54 Quoted in Slezin, 122.

55 Clayton/Scanada, Vol. 5.

56 Raymond Moriyama, quoted in Whiteson, Leon, *Modern Canadian Architecture*. Edmonton: Hurtig, 1983, 19.

57 Prince Charles, *A Vision of Britain*, 77.

58 Quoted in Taylor, 82.

59 Quoted in "NAHB Report" to HUDAC, May 16-21, 1985, 4.

60 Inaugural Address, Winnipeg, 3 February 1992.

61 Benjamin Disraeli, 1874, quoted in Taylor, 82.

62 *HUDAC National Focus*, 28 March 1977, 3.

63 *CHBA Strategic Plan for the '90s*. Ottawa: CHBA, May 1991, 12.

64 CHBA, *A Further Submission by CHBA to the Federal Government Consultation Paper on Housing*. Ottawa: CHBA, 1985.

65 Quoted by this writer in *Heritage Fights Back*, 201.

66 Lake, Carlton, *In Quest of Dali*. New York: Putnam, 1969, 159.

67 Macaulay, David, *Motel of the Mysteries*. Boston: Houghton Mifflin, 1979, 80.

68 Macaulay, David, *Great Moments in Architecture*. Boston: Houghton Mifflin, 1978, Plate V.

69 Quoted by Robert Shaw, in address to the CREA National Conference, Ottawa, 22 October 1984.

Illustration Credits

ABBREVIATIONS

BR/NSM	From *Gingerbread*, copyright © 1990 by Barbara Robertson, published by Nova Scotia Museum
CHBA	Canadian Home Builders' Association
CMC	Canadian Museum of Civilization
CMHC	Canada Mortgage and Housing Corporation
HNF	*HUDAC National Focus*
JB/FW	From *Ontario Architecture*, copyright © 1990 by John Blumenson, published by Fitzhenry & Whiteside, Markham, Ontario
JMF/GB	From *Walter Gropius,* copyright © 1960 by James Marston Fitch, reprinted by permission of George Braziller, Inc.
MMCH/NPA	McCord Museum of Canadian History, Notman Photographic Archives
MD	Marc Denhez
MJC/CMHC	From *Canadian Housing in Wood*, copyright © 1990 by Maurice J. Clayton, published by Canada Mortgage and Housing Corporation
MTRL	By permission of Canadian Trade Catalogue Collection, Special Collections Room, Arts Department, Metropolitan Toronto Reference Library
NA	National Archives
NB	*National Builder*
NRC	National Research Council
RAIC	Royal Architectural Institute of Canada
RDA	From *The Buildings of Canada*, by Barbara Humphreys and Meredith Sykes © 1974 The Reader's Digest Association (Canada) Ltd., Montreal; reproduced with permission
RE	Robert Easton, from *Native American Architecture*, copyright © 1989 by Peter Nabokov and Robert Easton, published by Oxford University Press, New York

The author is grateful for the use of illustrations provided courtesy of the following:

Frontispiece: NA, from anonymous 1824 drawing; p. 4 (top), British Film Institute; p. 4 (bottom), Sears Roebuck & Co.; p. 6, Alootook Ipellie; p. 8, J. Cinq-Mars, CMC; p. 9, Austrian National Library; p. ll, Helmut Schade; p. 12 (top), De l'Orme's drawing (1554-1558) from his *Architecture*, pl. 255, reproduced in Blunt, Anthony, *Philibert de l'Orme*. London: A. Zwemmer, 1958; p. 12 (bottom), RDA; p. 16, CMC; p. 17, RE, after Ted J. Brasser in *Conceptual Studies of Material Culture*. Ottawa: CMC, 1978 (Paper 43); p. 18, CMC; p. 19, MJC/CMHC; p. 20, CMC; p. 21, RE, after Asen Balikci in *The Netsilik Eskimo*. Garden City: Natural History Press, 1970; p. 22, Parks Canada; p. 23, London Museum of Archaeology/Ivan Kocsis; p. 24, CMC; p. 25 (top), CMC; p. 25 (bottom), B.C. Ministry of Tourism and Ministry Responsible for Culture; p. 26 (top left) MJC/CMHC; p. 26 (top right), Royal British Columbia Museum, No. PN793; p. 26 (bottom), Special Collections Division, University of Washington Libraries No. NA701; p. 28, Drawings by F. Boas (1889, 1927) reproduced in United States National Museum Proceedings and by RE.; p. 30, MJC/CMHC; p. 32, NA; p. 33, Queen's Printer for Ontario; p. 34 (left), RDA; p. 34 (right), McGill-Queen's University Press; p. 35, Archives nationales du Québec, notaire Romain Becquet; p. 39, RDA; p. 40 (top left), from Latremouille, Joann, and Rentoul, Joan, *Pride of the Home*. Hantsport: Lancelot Press, 1986; p. 40 (middle left), MD; p. 40 (top right), MJC/CMHC; p. 40 (bottom left), Yukon Heritage Branch; p. 41, MD; p. 42, JB/FW; p. 43, *Canada Farmer*, 1865; p. 45 (top), Provincial Archives of New Brunswick, No. P27/38; p. 45 (bottom), JB/FW; p. 46, Alvin Comiter; p. 48, Archives of Ontario Library Pamphlet, 1876, No. 30; p. 49, Elaine Kilburn; p. 51, MMCH/NPA; p. 52, NA No. PA-12694; p. 53, *Canada Farmer*, 1865; p. 54, BR/NSM; p. 55, BR/NSM; p. 56, David Iley; p. 58, City of Vancouver Archives; p. 59 (left), NA No. C-63256; p. 59 (right), Saskatchewan Archives Board No. R-A4557-2; p. 60, United Church of Canada/Victoria University Archives, Toronto No. 93.004C; p. 61, JMC/CMHC; p. 62, Glenbow Archives, Calgary, No. NA-227-8; p. 63, McGill-Queen's University Press; p. 64 (left), Cliché Roger Violette; p. 64 (right), © Albin Michel 1988 (*Voluptés de la douche en crinoline. "La journée de la parisienne," Panorama-Paris s'amuse*, 1900. Misette Godard private collection; p. 65, Designs by Thomas Crapper, reproduced in Reyburn, Wallace, *Flushed with Pride*. London: Macdonald, 1969; p. 67, *Farm and Ranch Review*, 5 January 1918; p. 68, JMF/GB; p. 69, Butterworth-Heinemann Ltd., from Le Corbusier, *Towards a New Architecture*. Frederick Etchell, trans. London: John Rodker, 1931; p. 71, CMHC; p. 72, Photothèque La Presse; p. 73 (top), MTRL; p. 73 (middle), MD; p. 73 (bottom), MTRL; p. 74 (left top/bottom), JMC/CMHC; p. 74 (right), USDA Forest Service, Washington, D.C.; p. 75 (left top), Henry Hope & Sons of Canada Ltd.; p. 75 (left bottom), G.H. McLaughlin & Sons; p. 75 (right), City of Edmonton Archives, No. 160-961; p. 76, from Humphrey Carver, *Compassionate Landscape*, by permission of the publisher University of Toronto Press; p. 78, RAIC; p. 80, RAIC *Journal*, January 1942; p. 82, David Brown/Tirpitz Collection; p. 83, RAIC *Journal*, April 1942; p. 84 (left), CHBA; p. 84 (right), Canadian Real Estate Association; p. 85, NB, October 1955; p. 90, Dominion Linoleum; p. 92, NA; p. 94 (left), NA; p. 94 (right), CMHC; p. 95, NB; p. 98, NB, August 1954; p. 103, *Toronto Star*, reproduced in NB, October 1955; p. 104, Dominion Linoleum, reproduced in NB, November 1954; p. 105, *Toronto Star*, reproduced in NB, September 1952; p. 106, NB, January 1955; p. 107, CMHC; p. 111, (top four) CMHC, in NB, April 1957; p. 111 (bottom two), CMHC, reproduced in NB, November 1960; p. 112 (top two) NB, November 1957; p. 112 (bottom), NB, December 1960; p. 113, CMHC, NB, June 1955; p. 118, NB, September 1956; p.119 (top), NB, May 1955; p. 119 (middle/bottom), Eaton's, reproduced in NB, October 1954; p. 120, Queen's Printer, Ontario, reproduced in NB, May 1955; p. 122, NB, May 1959; p. 123, CHBA; p. 124, NB, August 1960; p. 125 (bottom), National Sewer Pipe, reprinted in NB, February 1962; p. 125 (top), American Standard; p. 128, United Way of the Lower Mainland; p. 129, Eric Bonnyman; p. 130 (bottom), courtesy Mrs. Thomas Ibronyi, reproduced in NB, April 1960; p. 130 (top left/right), NB, February 1961; p. 132, MD; p. 133 (left), CHATELAINE magazine, reproduced in NB, August 1961; p. 133 (right), CHATELAINE magazine, reproduced in NB, September 1962; p. 134, CMHC; p. 136, NB, September 1961; p. 137 (top three), CHBA; p. 137 (bottom), Rosalind Pepall; p. 138, CHBA; 139, CHBA; p. 150, Nick, reproduced by permission of *Punch*; p. 151, Frank Chalmers, *Winnipeg Free Press*, 1967; p. 155, CHBA; p. 161, MD; p. 164 (bottom), Norris, *Vancouver Sun, 1978;* p. 164 (top), Campbell, Stuart, *The Underground House Book*. Pownal, Vermont: Gardenway Publishing, 1980; p. 166 (top), Harper/Colophon; p. 166 (bottom), HNF, 2 July 1976; p. 167, HNF; p. 173, drawings by Koren, © *The New Yorker* Magazine, Inc.; p. 174, MD; p. 182 (left) Otto + Bryden Architects Inc., Gord Erskine, B.Arch.; OAA, MRAIC, Director-in-charge, published in OCHBA *Impact*, 1991; p. 174 (right), Pella Hunt Windows and Doors; p. 184, CMHC; p. 185, Proskiw Engineering Ltd.; p. 189, Original design by Keith Taylor, reprinted by permission © Recycled Paper Products. All Rights Reserved; p. 196 (left), Joy von Tiedeman; p. 196 (right), CANMET, of National Resources Canada; p. 197, CMHC; p. 198, CMHC; p. 199, James Cooke; p. 200 (left top/bottom) © Tim Street-Porter/ESTO, All Rights Reserved.; p. 200 (right), JB/FW; p. 201, Dow Chemical of Canada Ltd.; p. 202, Royal Homes Ltd.; p. 203, Baldwin & Franklin, Architects; p. 210, Gable, Toronto *Globe and Mail*, 27 February 1992; p. 215, NRC; p. 216 (bottom), NRC; p. 216 (top), Hashimoto Boles Architects Inc. for Osaka Prefecture Housing Supply Corp., with Council of Forest Industries of Canada, Issiki Architects & Partners, Canadian Consulate General, Osaka; p. 218, Clive Webster; p. 220, Cosanti Foundation; p. 221 (right), The Obayashi Corp., Sir Norman Foster, architect; p. 221 (left), Boundary Layer Wind Tunnel Laboratory, University of Western Ontario; p. 222, © 1960 The Estate of Buckminster Fuller, courtesy, Buckminster Fuller Institute, Los Angeles; p. 223, Ron Herron; p. 224 (left), Canadian Space Agency; p. 224 (right), Canadian Institute for Political Integrity; p. 226, Alootook Ipellie.

Selected Readings

Bettison, David, *Urban Policy in Canada*. Edmonton: University of Alberta Press, 1975.

Blumenson, John, *Ontario Architecture*. Toronto: Fitzhenry & Whiteside, 1990.

Carver, Humphrey, *Compassionate Landscape*. Toronto: University of Toronto Press, 1975.

CHBA, *Competitiveness of the Housing Industry*. Ottawa: CHBA, March 1992.

CHBA, *Housing in Canada*. Ottawa: CHBA, March 1993.

CHBA, *Strategic Plan for the 90's*. Ottawa: CHBA, May 1991.

CHBA, *A Further Submission by CHBA to the Federal Government's Consultation Paper on Housing*. Ottawa: CHBA, 1985.

Clayton, Maurice, *Canadian Housing in Wood*. Ottawa: CMHC, 1990.

Clayton Research Associates and Scanada Consultants, *The Housing Industry: Perspective and Prospective*. Ottawa: CMHC, 1989

CMHC, *50 Years of Innovation*. Ottawa: CMHC, 1993.

Colville-Reeves, Lynda, *Home Style*. Toronto: Random House, 1991.

Doucet, Michael J., and Weaver, John, *Housing the North American City*. Montreal/Kingston: McGill-Queen's Press, 1991.

Humphreys, Barbara, and Sykes, Meredith, *The Buildings of Canada*. Montreal: Readers Digest, 1974, reprint 1980.

Latremouille, Joann, *Pride of Home*. Hantsport, N.S.: Lancelot, 1986

McGhee, Robert, *Ancient Canada*. Ottawa: Canadian Museum of Civilization, 1989.

Moogk, Peter, *Building a House in New France*. Toronto: McClelland & Stewart, 1977.

Nabokov, P. and Easton, R., *Native American Architecture*. New York: Oxford University Press, 1989.

Rybczynski, Witold, *Home*. New York: Viking Penguin, 1986.

Rybczynski, Witold, *Looking Around*. Toronto: HarperCollins, 1992.

Rybczynski, Witold, *The Most Beautiful House in the World*. New York: Viking, 1989.

Sayegh, Kamel, *Housing: A Canadian Perspective*. Ottawa: Academy Books, 1987.

Taylor, Lisa, ed., *Housing: Symbol, Structure, Site*. New York: Rizzoli, 1990.

Wetherall, Donald, and Kmet, Irene, *Homes in Alberta*. Edmonton: University of Alberta Press, 1991.

Index